THE HINTERLAND

CABINS, LOVE SHACKS
AND OTHER HIDE-OUTS

gestalten

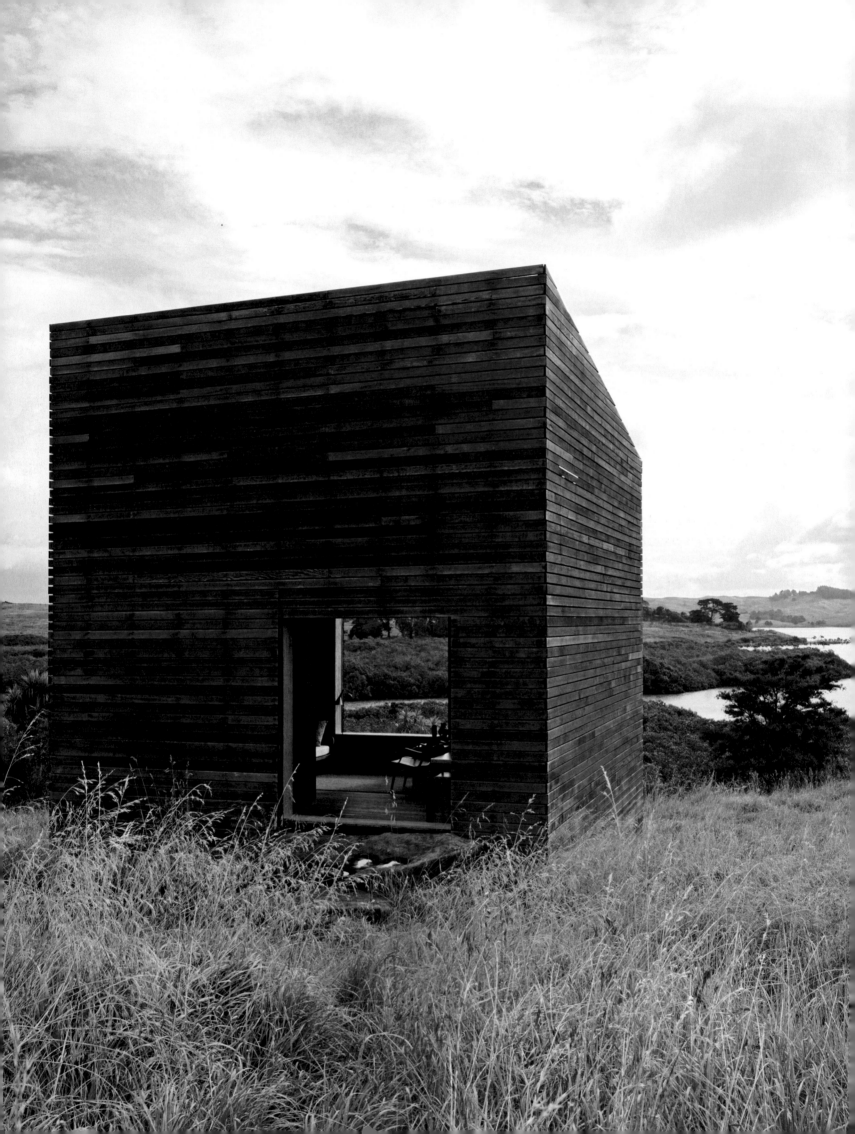

THE CALL OF
THE HINTERLAND

BY TOM MORRIS

A meadow or coastline spread out in front of you, a room full of simple furniture that means something to you, clear air, and not much else. Isolation, yes; perhaps even loneliness, but fundamentally peace and quiet: a hideout in a hinterland offers a certain type of lifestyle that many around the world long for, and it's not difficult to understand why. To many, fleeing the countryside is a rejection of things; but to others it is an acquisition. A romantic one perhaps, but one that can bring stimulation, satisfaction, and sometimes even an income.

We know the numbers and we probably know the reasons behind them. Earth's population has become a legion of city dwellers. Half of the world now lives in urban areas, and that figure is expected to rise to 66% by 2050, when over 6 billion people will reside in dense, busy metropolises filled to the brim with high-rises. They may be infested with pollution, but cities provide jobs and opportunities, culture and fun. They are magnets.

But do cities make us happy? That is the question almost everyone featured in Hinterland has asked themselves at some point. As cities swell, as housing becomes increasingly unaffordable, as infrastructure weakens under the pressure, and, it seems, life becomes ever more difficult, it is no wonder that many of us have felt the call of the wild. Although city populations are booming, some are going in the other direction. Have you never caught yourself standing at the bus stop in the rain, stuck in traffic, or signing a check each month for rent that seems unsustainable and thought: why?

Escaping the rat race is nothing new, but perhaps never before has a generation of committed city dwellers so totally devoted themselves to getting back to basics and to getting out. What is it that they crave? Over time—and the move does take time, and courage—they have realized they seek peace, quiet, and space. Safety too, whether they have families or not; and beauty, in a very different way to the way cities can be beautiful. And in the process, they realize that they are happy to sacrifice fancy furniture, mod cons, electricity, and, as you'll read in this book, even running water. In fact, this is part of the appeal and explains why, to many, a small cabin, a basic summerhouse, or even a tree house will suffice.

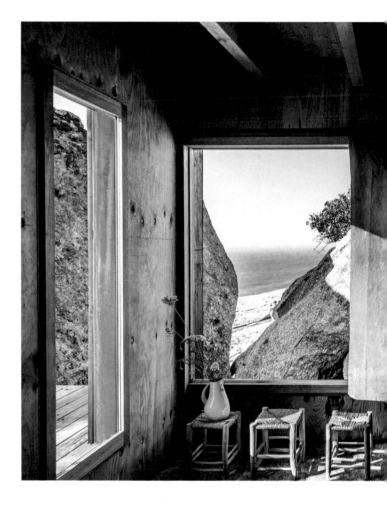

How to do it and where to go is another matter. It's telling that so many head back to the place where they were brought up. Young kids growing up dreaming of the big bright life of the city—London, Berlin, New York, Beijing—was undoubtedly a twentieth century phenomenon. Retreating back to their home turf when they have aged a couple of decades like homing pigeons is perhaps a twenty-first century one. Take the example of Leo Qvarsebo, when he built his summerhouse (p. 190): instead of choosing to build in beautiful southern Sweden, where many of his friends have second homes, or breathtaking Gotland, where his ex-wife has a house, he chose to construct his in Dalarna ❯

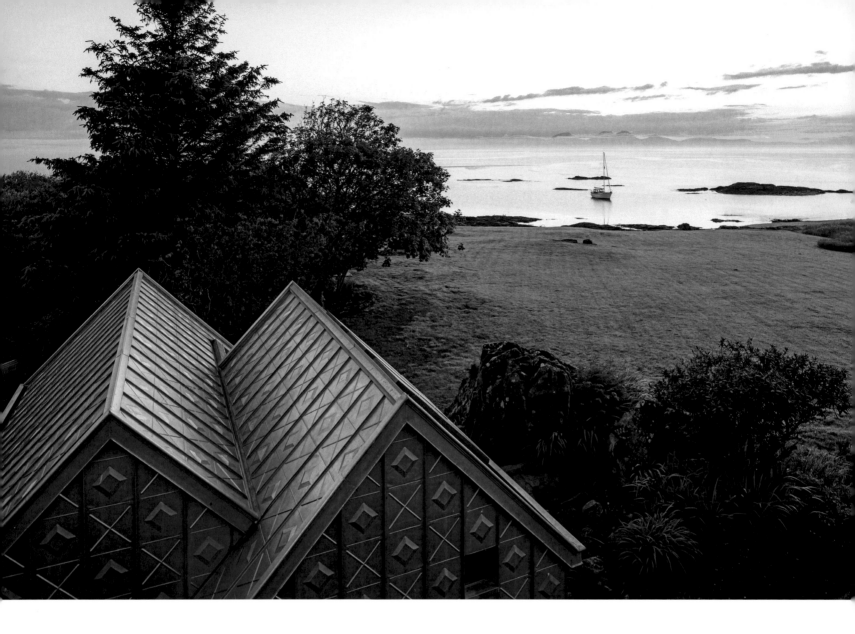

"We need something to retreat from in order to retreat in, and the best of both worlds is possible."

in the middle of the country. He admits it is a completely average and unassuming landscape, but it is where he was brought up, and that was enough.

The decision to leave the city is not only brave, but can be difficult too. Permission for building is one thing, but remote places also come with logistical problems. The isolation of the coastline in Scotland where Midden Studio is located (p. 122) meant the zinc and timber building had to be built nearby in a shed and then erected on site. The tricky terrain that a contemporary Serbian chalet was built on (p. 36), nestled on a mountainside in the west of the country, required the architects to entirely rethink how they design and then stand in as builders too. The simplicity of many of these homes is often not only a result of logistical problems, but actually this is the secret to their success.

Planning permission, judging by the gutsy aesthetic of many of the cabins in this book, is far more lax in the countryside than it is in the city. Or perhaps architects and homeowners simply regain their imagination when they are designing their hideout in far-flung places. Although they are all practical, liveable homes, the historical "folly" is alive and well in rural areas around the world today: whether that's a doorless timber cabin in New Zealand, or a triangular villa, or series of tree houses in the forests of Germany. Architecturally, many are indebted to the local vernacular, but there are few architects or owners who have not then played around with the traditional style of the area.

Renovating an existing structure is also a possibility. Run-down farmhouses, granary stores, and even Second World War bunkers provide a challenge that architects enjoy. Whether you choose to radically reinvent the existing structure or barely touch it, it can have very different results. In the case of Mase House in Switzerland (p. 276), a glass box was subtly installed on the inside of an old granary store. Granaries would traditionally be lifted

> **"Escaping the rat race is nothing new, but perhaps never before has a generation of committed city dwellers so totally devoted themselves to getting back to basics and to getting out."**

off the ground to protect them from rodents, and Savoiz Fabrizzi Architects slotted in a basement of windows underneath to create more space. The inside is modern and lined with knot-free larch, but the structure cannily retains every element of its original charm from the outside. Similarly, severe regulations limited what could be done with a subterranean bunker in the Netherlands (p. 156), but simple, flexible furniture was casually placed inside, and the space is surprisingly homely.

For many reasons building in the countryside allows a bit more room for imagination. Many of these homes have won awards and are exemplary pieces of residential architecture, but they are never dour or academic. Architects, it seems, find their sense of humor in the countryside.

Hideaways can be luxuriant but they need not be expensive. If this is your dream home, adding elements in increments—even if they are essential amenities—can be a fundamental part of the process. As is making it by hand, as partners Lilah Horwitz and Nick Olson discovered with their House of Windows in West Virginia (p.214). They were walking in a forest on one of their first dates and decided to make a place they could call their own (they lived in separate cities at that point). Money was tight so they scoured junk shops and reclaim yards for materials to build their simple shack—including many disused windows. Then they built it from scratch. It's not the easy way, but it is the most meaningful.

Their glasshouse is simply furnished inside, and sparseness is a common trait in many hideaways. Furnishings are often basic, and they are also free of unnecessary clutter. It's in stark contrast to many urban apartments. In cities, we store so many personal things—ornaments, pictures, and bits—perhaps to remind ourselves what makes us individual when we feel like another faceless number in a large population. We need that subjectivity in a city. It is surprising how many people ditch sentimental objects and meaningful art works in remote places. Perhaps living the slow life is all we need to remind us of what makes us particular.

The interiors of countryside cocoons are also linked to the lifestyles played out in them. A place to read, a place to sleep, some facilities to cook, and a wide window to look out from: is there more you really need? Not according to the global set of architects and homeowners in this book. Nor is space really that essential. When Cheshire Architects started work creating the twin cabins in Eyrie, New Zealand (p. 238), the disused farmland had planning permission that would allow a 1,500 square meter mansion. Instead, the firm designed two dinky hideouts, in reaction to the large, luxuriant palaces that increasingly line the Kiwi coast. Trading down to a 29 square meter footprint rather strangely required negotiation with planning authorities, but, as the designer says, small is sometimes best. With a view like that, do you really need two living rooms?

Existing far away from cultural institutions, friends, shops, and distractions can be difficult. Making a living is less easy than in urban centers, and that is why many flit and float between urban and rural homes. Hideouts and retreats are in their very nature co-dependent on the city. We need something to retreat from in order to retreat in, and the best of both worlds is possible.

Centuries ago, we made our living in rural areas with farming, landowning, agriculture, and crafts. Cities were for leisure: they were places to venture to on the weekend for eating well and entertainment. Today the city still pulls, but its attraction is now largely based on work, on weekdays. It is the pastoral spots of the world we now seek pleasure in; pleasure that is subtler than the enjoyment a city brings, but pleasure that is probably more tangible and longer lasting. Cities make us feel alive, but do they actually make us feel human? ◆

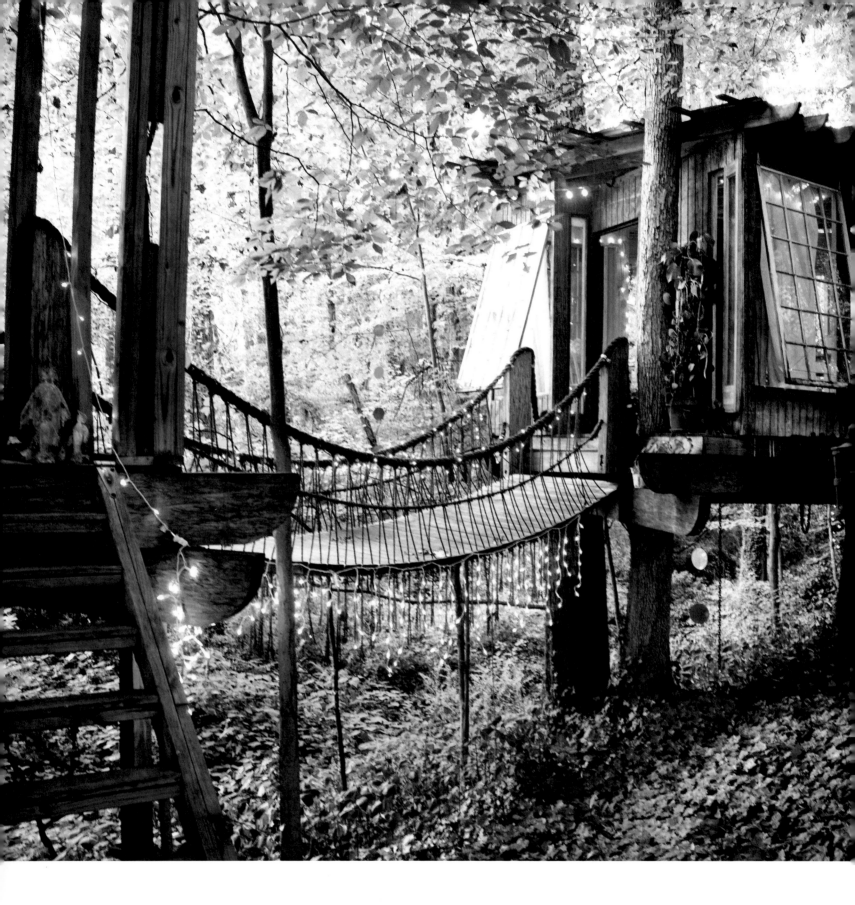

The designer of this forest hideaway built his first treehouse when he was just eight years old. Simplifying the notion of a treehouse to its most elementary form, his childhood sanctuary consisted of a sole two-foot plank in a ten-foot tree. From this humble perch, a young mind roamed free and schemed up future incarnations of the treehouse he might build should his allowance catch up with his dreams. This formative time between the trees informed Peter Bahouth's career as Executive Director of Greenpeace and a dedicated environmental activist. His adult treehouse champions a preservationist attitude at once local and original. Erected in the lush forests of the deep South, the charmingly ramshackle structures double as a treasure trove of salvaged artifacts, antiques, fossils, and forgotten ephemera from yesteryear. The three rooms span across seven trees linked by rope bridges—an alluring assemblage of southern hospitality and all things past. ◆

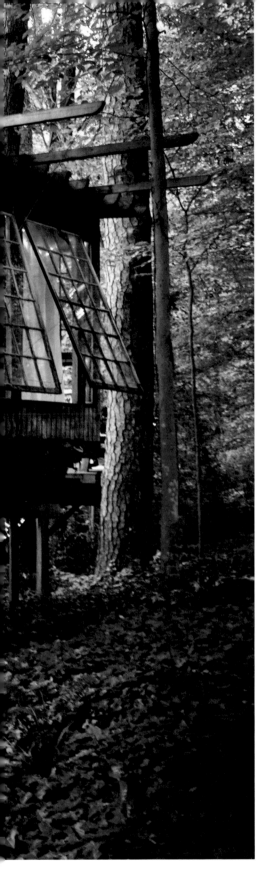

SOUTHERN COMFORT

PETER BAHOUTH

Fairytale quality rope bridges connect
three endearing tree houses, reigniting
the Peter Pan in all of us.

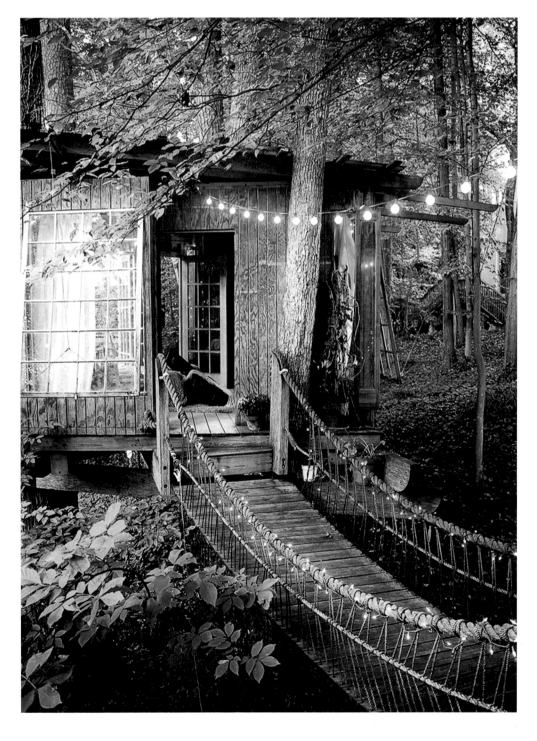

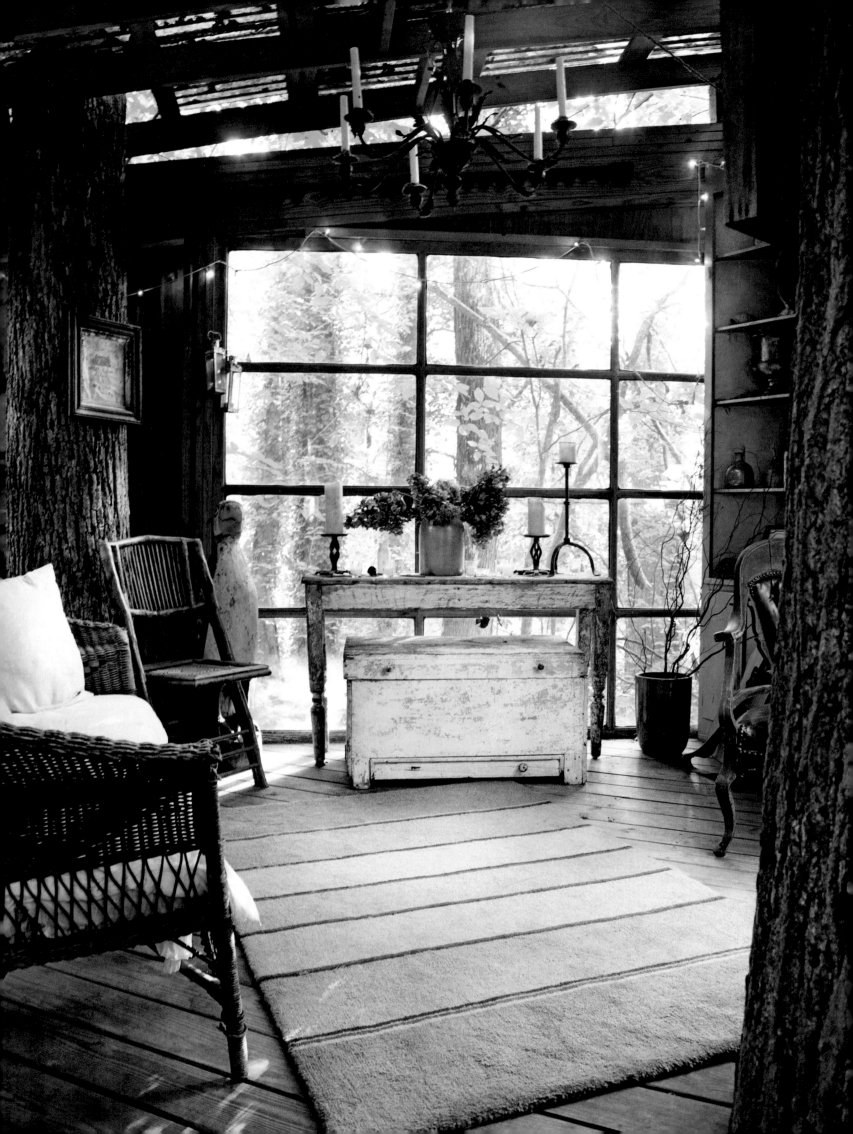

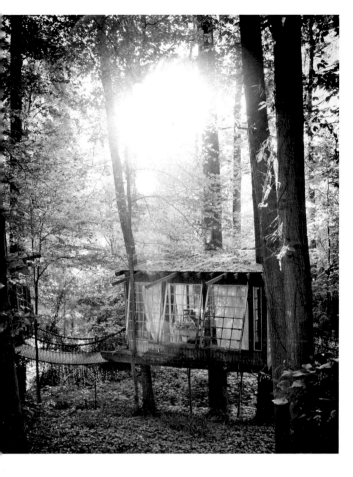

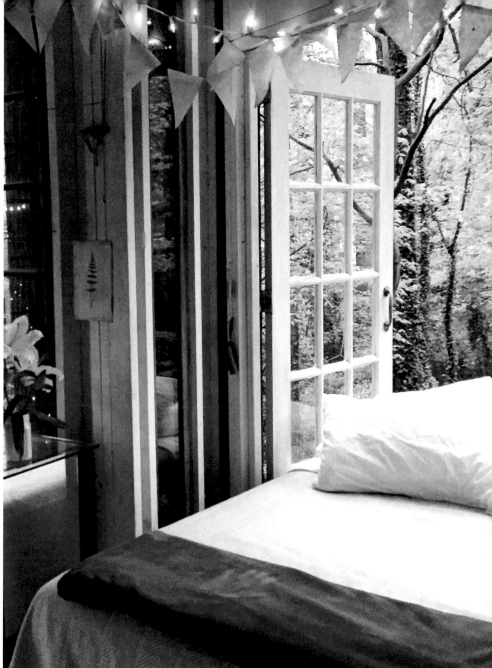

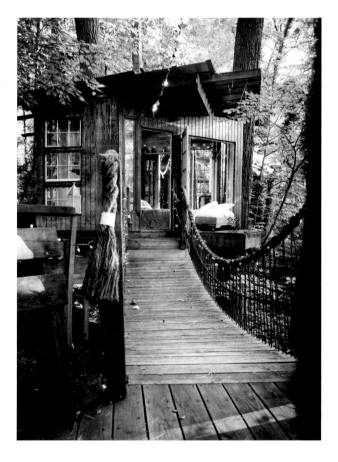

"From this humble
perch, a young mind roamed
free and schemed up
future incarnations
of the treehouse
he might build should
his allowance
catch up with his dreams."

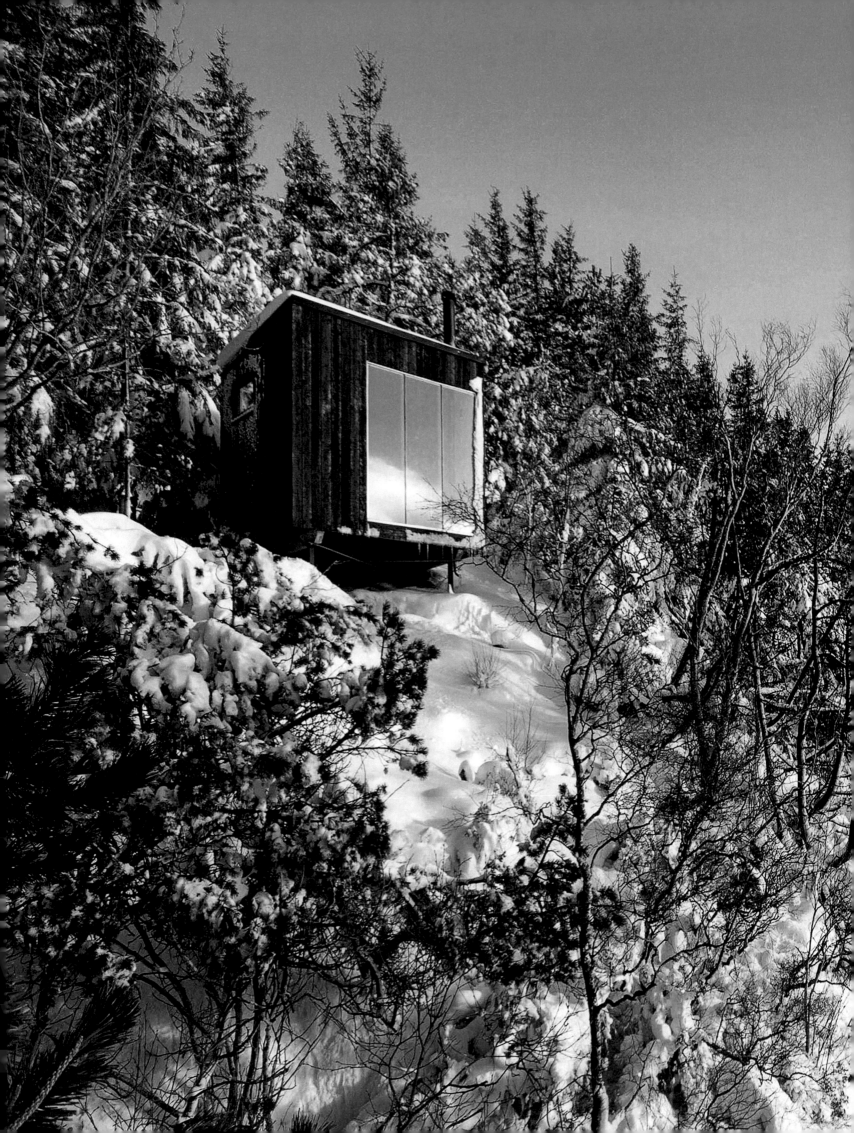

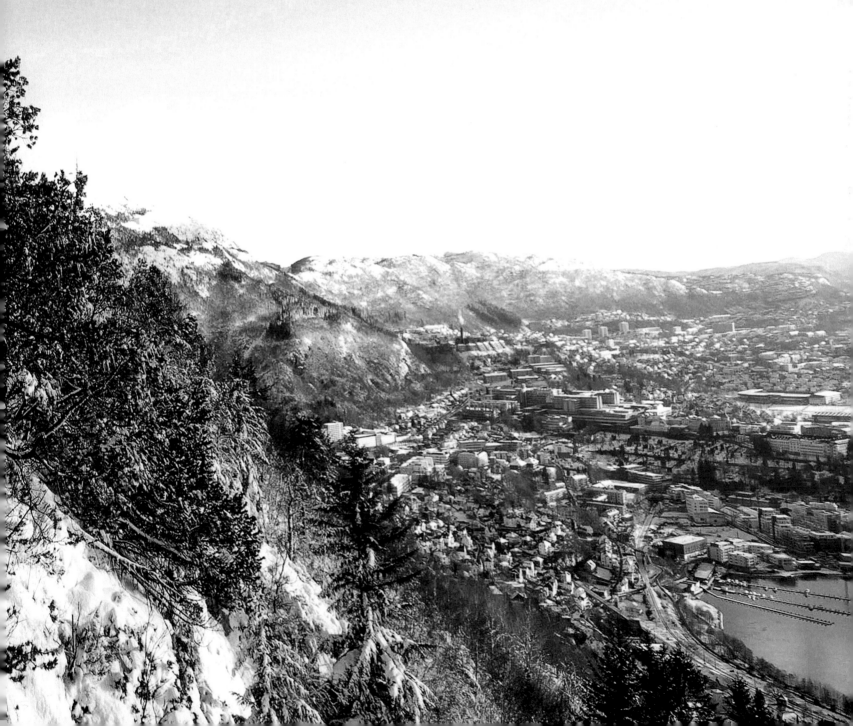

PORTAL IN THE PINES

OPA FORM

Follow Alice through the rabbit hole
and into a Norwegian sauna where disbelief suspends
over the city below.

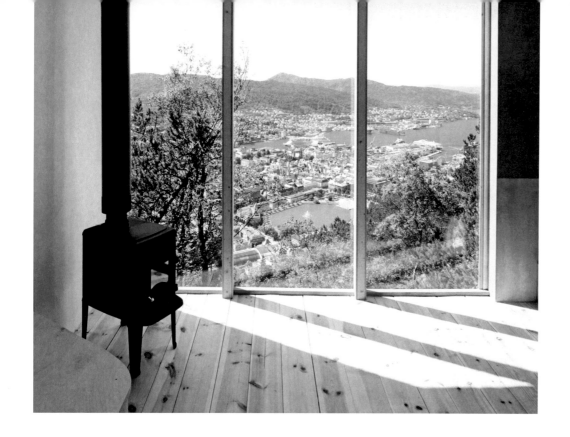

"The inconspicuous hideout fills the void between cabin and tent, reveling in the exhilarating panorama of the coast of western Norway."

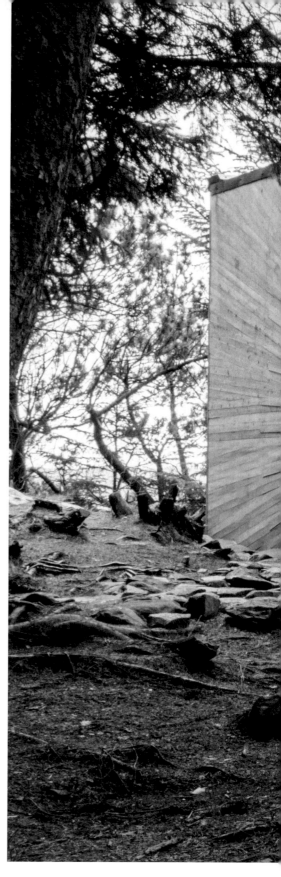

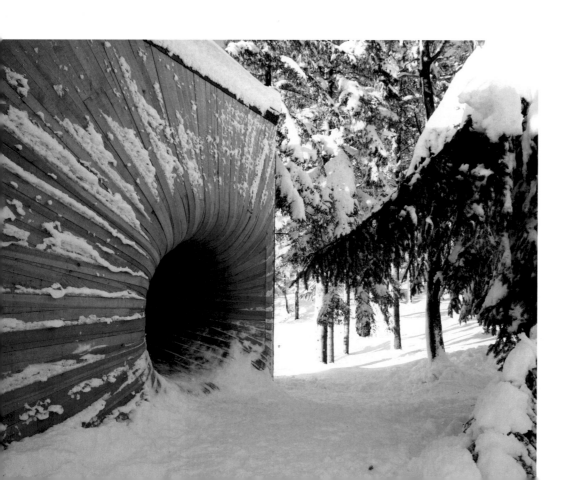

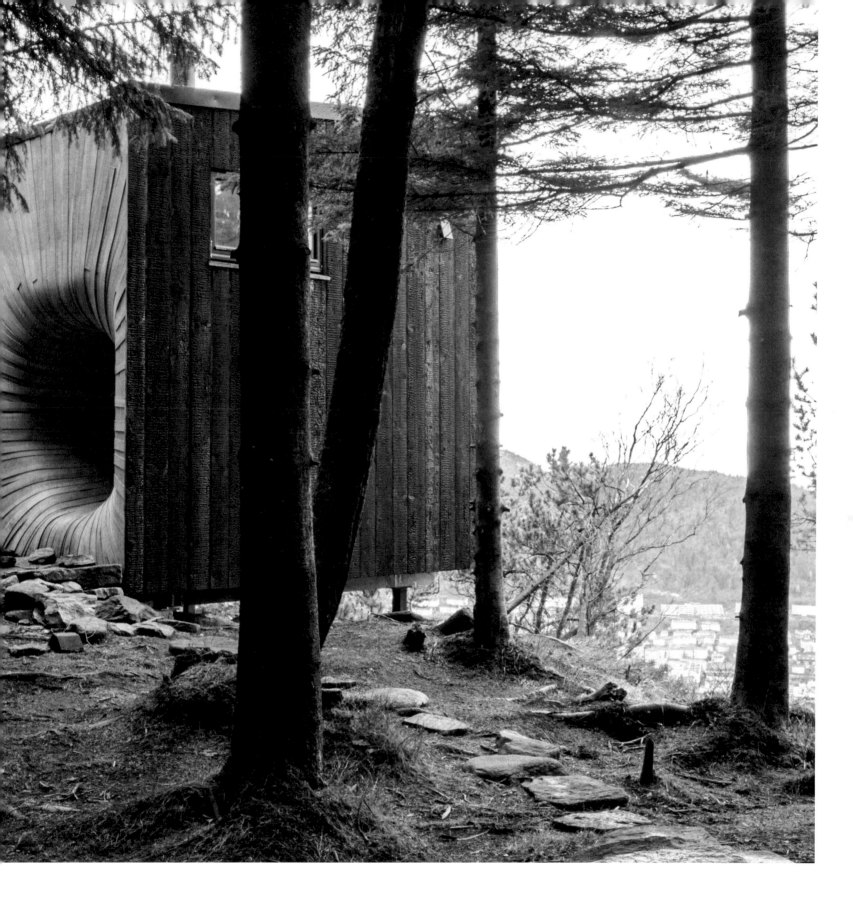

Hidden between the trees atop the region's most famous mountain, a mysterious wooden vortex pulls guests into a serene refuge. The inconspicuous hideout fills the void between cabin and tent, reveling in the exhilarating panorama of the coast of western Norway. Before entry, an alluring tunnel made from bent planks of raw larch wood beckons. The mysterious passage behaves as an enticing portal bridging the realms of the known and unknown. Overnight guests, local hikers, and families with small children converge at the floating cube—a cottage remote in spirit but not proximity. Minimally adorned, the transcendent interior beguiles the senses as one faces the steep descent down to the city below. An otherworldly forest encounter accessible to all, this hotel room with a view occupies the border between wilderness and city to awaken the most honest of our primal instincts. ◆

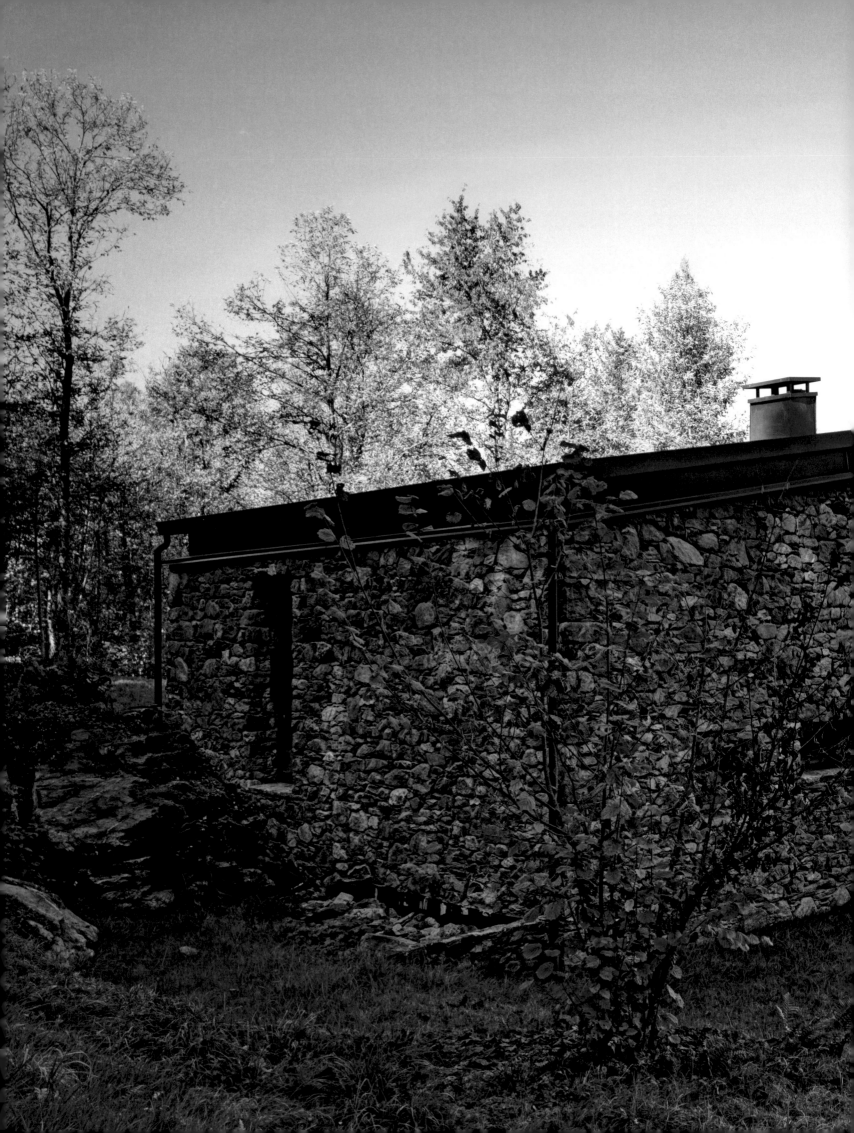

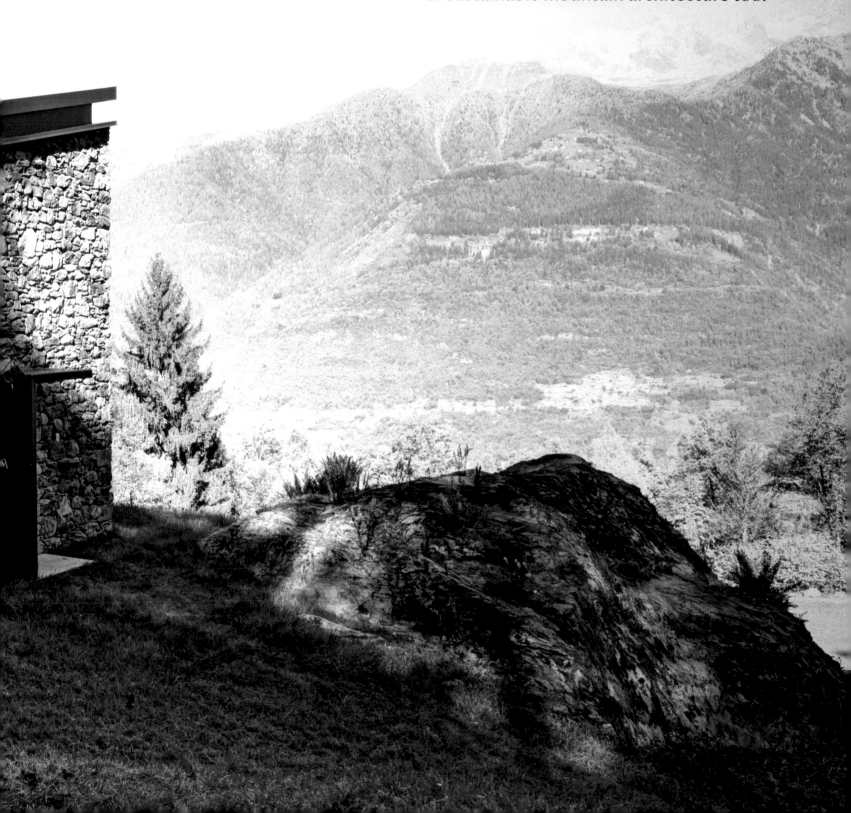

SITTING PRETTY

EV+A LAB

Casa Vi is a home of sentimental value
for its owners, but a smart example
of sustainable mountain architecture too.

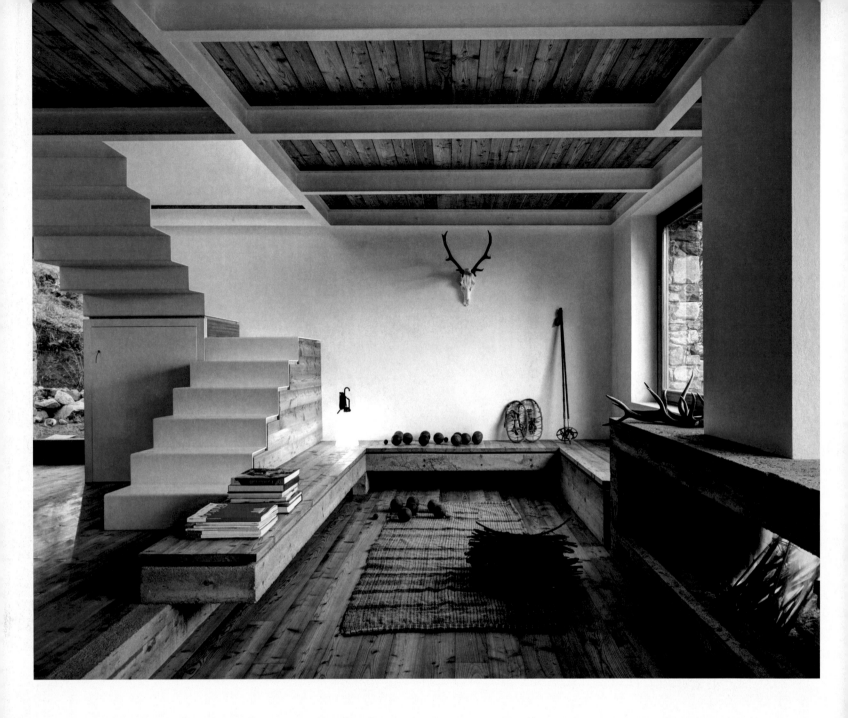

Piateda is a quiet town in the Italian mountains—population 2,200—located about 100 kilometres north of Milan. It is near the city of Sondrio in the Orobic Alps and 1,000 meters above sea level. At the end of a private mountain road there, Casa Vi sits surrounded by meadows and trees. The only house nearby is the home of the Casa Vi owner's sister. The edifice was once a stable made of concrete blocks, where they kept two young horses when they were young. The owner Laura did not have to look far when she decided to turn it into a home; she worked with her architect husband

Alfredo Vanotti, founder of EV+A Lab, on the project. The brief was to try and replicate Laura's childhood memories in the peaceful area for the couple's young daughter, Eva Virginia. Nostalgia was very much part of the process: "My wife asked me to renovate this ruin because she spent her childhood there, living in the house now owned by her sister close to our Casa Vi," Vanotti shares. "She would play in the wood with friends. They didn't have a TV or PC but they didn't need them: they were happy simply playing in nature. She wanted to relive those magic moments once again with me and our child." ›

right_ **Windows were added to bring in as much light as possible.**

top_ **The interior is open plan and decked out simply, while a fireplace adds to the atmosphere.**

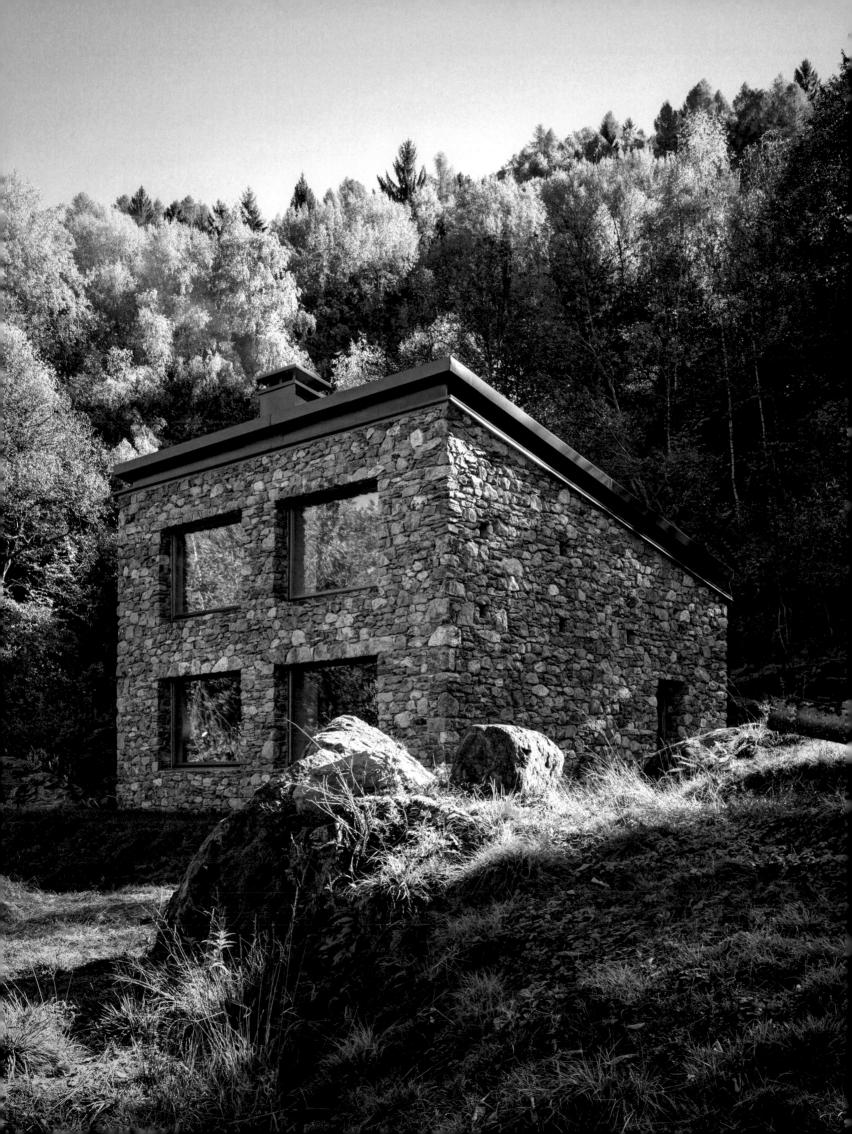

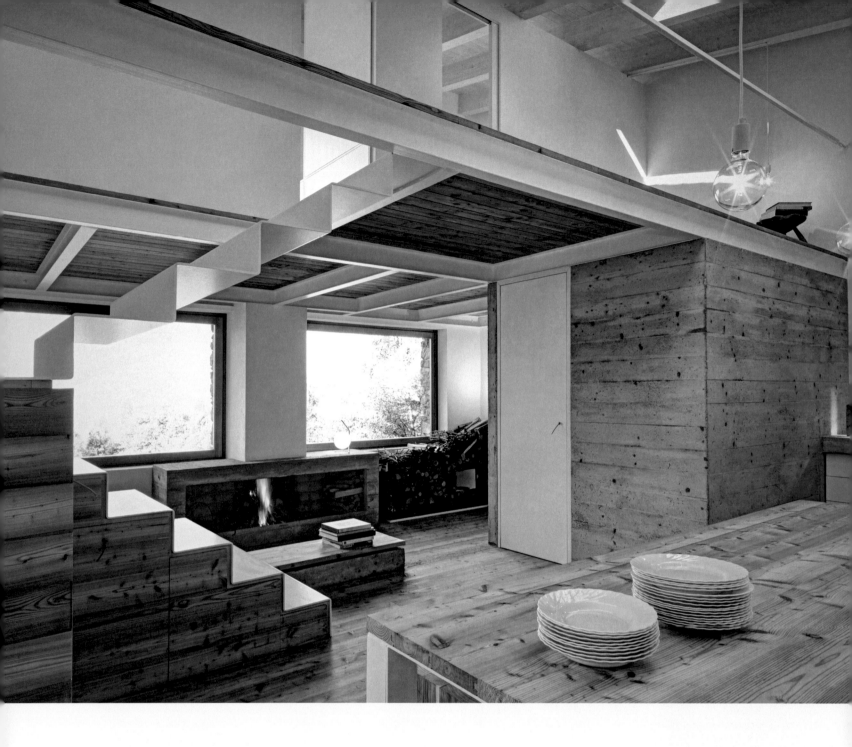

This mission to feel part of the natural world was fundamental to Vanotti's vision. His first idea was to create huge windows and implement a skylight to make contact with the outside. "We can observe every change of weather," he delightfully observes. "Everyone who enters the house feels at home. There's a sense of peace, serenity, and happiness because it seems the sun enters the house too, thanks to the big windows."

The large windows also serve another important purpose: to create a house that is sustainable and economic in its consumption of energy. It largely lights itself and, for much of the year, keeps itself

warm too. The floor and furniture were fabricated in larch wood. Its perfume "completes the work of bringing the outside in," as Vanotti asserts.

Keeping this sense of lightness, of keeping barriers to a minimum, dictated the interior too. On the ground floor is an open-plan box with a living room and kitchen that all merge into one unit, broken up only by a cement block that contains the bathroom.

There are various sections of built-in furniture that help create gathering points for family life in this wide space, all of which took shape on Vanotti's drawing board. Concrete, wood, and iron are the main ›

top_ **Concrete and larch define the interior of the chalet.**

right_ **A staircase zig-zags its way through the internal box.**

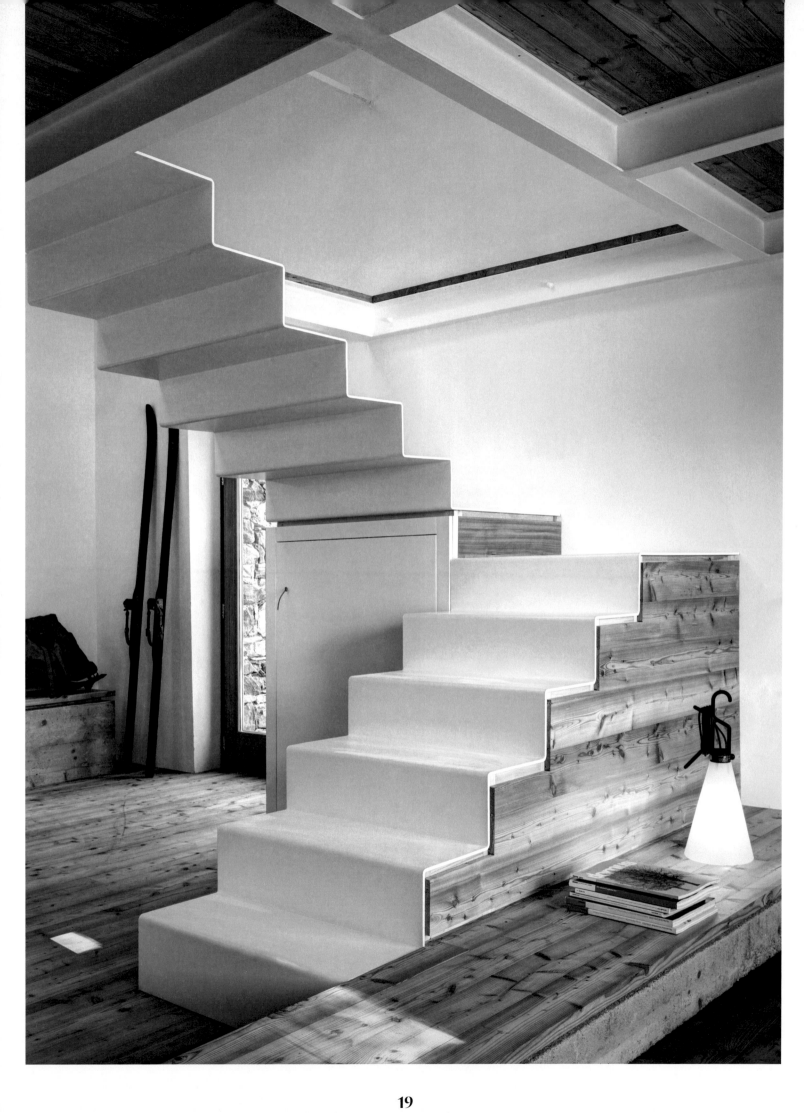

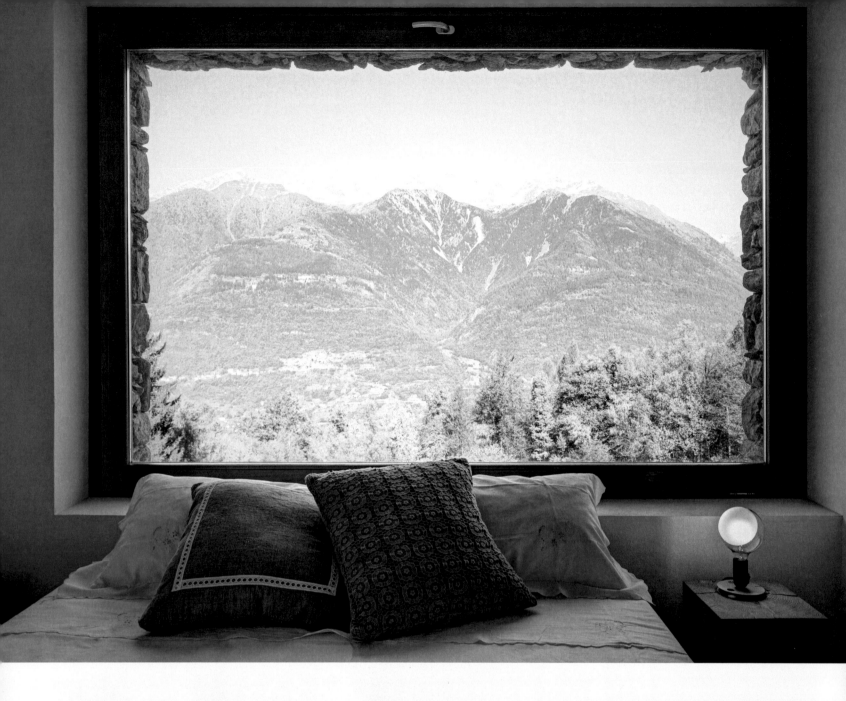

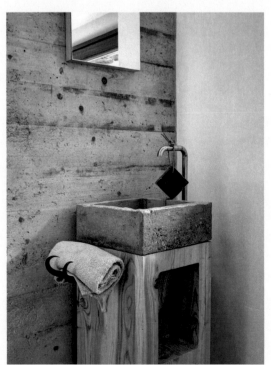

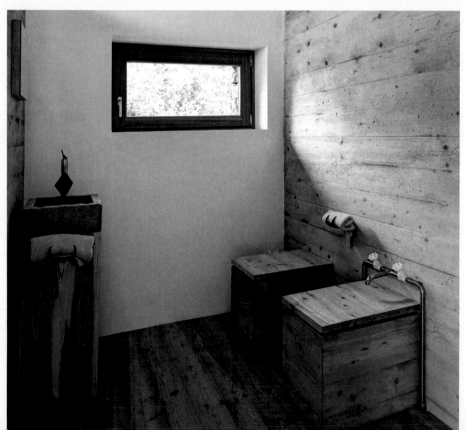

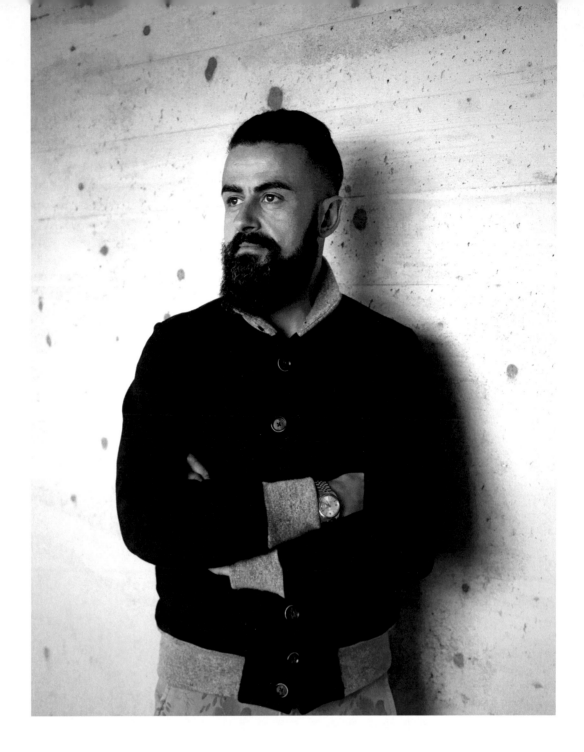

"Landscape influences my design—not the other way around."

components, making Casa Vi something of Gesamtkunstwerk. There is a visual unity to the combination of these materials for everything ranging from shelves that double up as benches to kitchen surfaces. To break up the uniformity, zig-zagging staircase snakes up inside the middle of the home, leading upstairs to two bedrooms and a loft that is used as a study.

Casa Vi is a gutsy take on Alpine living—a pair of antlers in the living room is a wry nod to this—but Vanotti says this home is more traditional than appearances might suggest. "After a careful analysis of the context, after studying sunlight and technology and the values of mountain architecture, I realized the project through a reinterpretation of modern construction techniques using materials from the past," he explains. "I believe that mountain architecture is a perfect example of sustainable architecture." The exterior still formally refers to rural houses with its sloping roof, coating of stones, and lack of eaves. Although this house has sentimental value to the couple and their young child, it has professional meaning to architect Vanotti too: "Fundamental to my work is the deep analysis of the context and constant research in order to offer the best solution concerning integration into the landscape," he explains. "Landscape influences my design—not the other way around." ◆

top_ **Architect Alfredo Vanotti.**
left_ **A picture window looking over the valley. Even the toilets were custom made from the house's key toolkit of concrete and wood.**

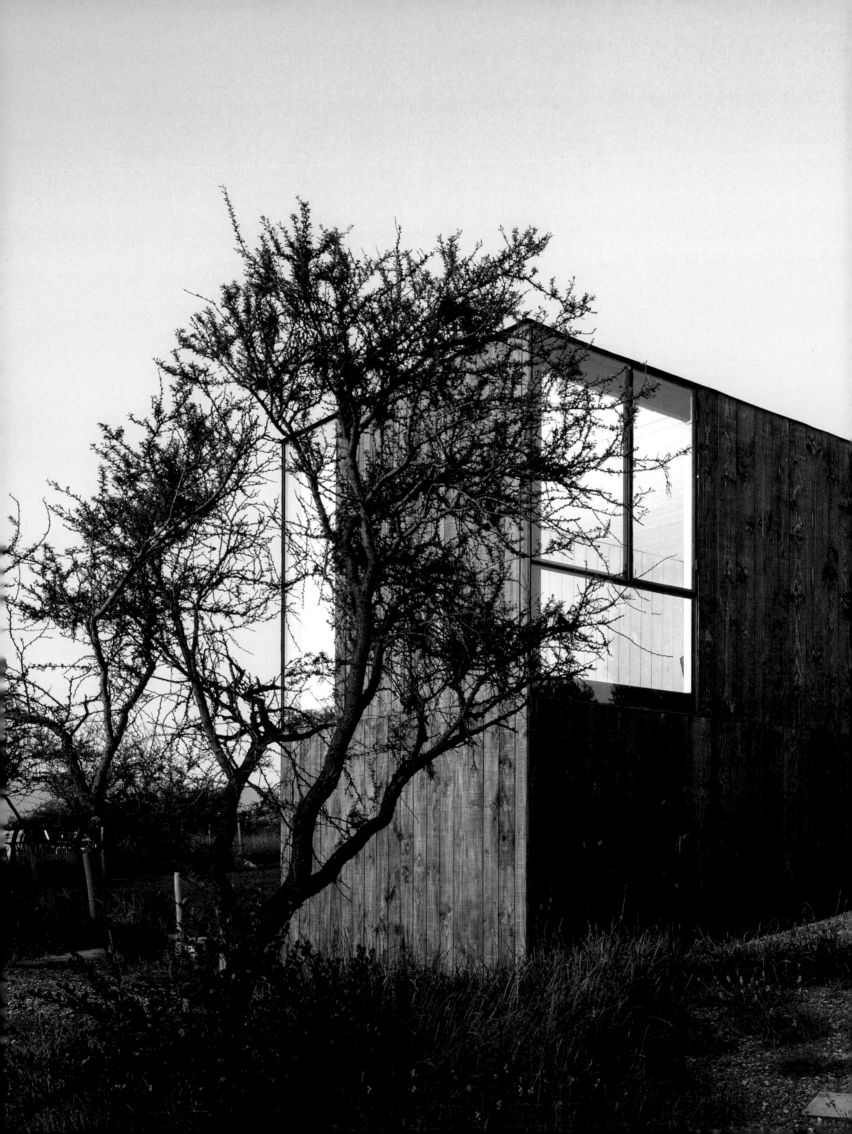

SOUTH AMERICAN SERENITY

RICARDO TORREJON & ARTURO CHADWICK

Unobstructed views
over meandering hillsides covered
in low-lying brush stage
a tranquil backdrop for holiday retreat.

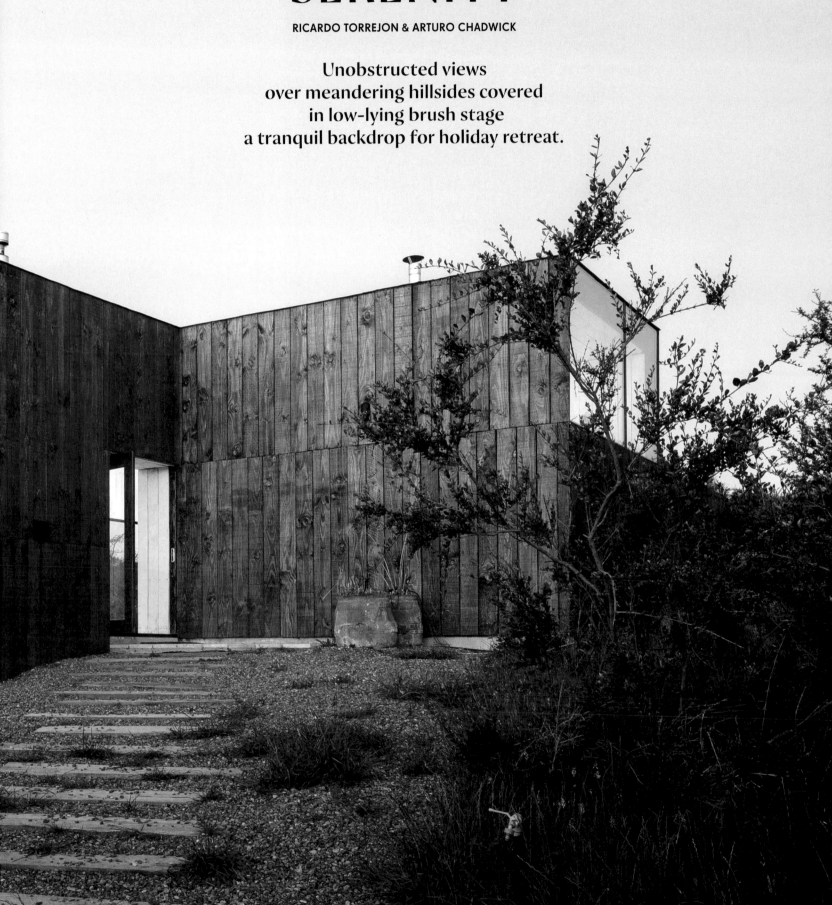

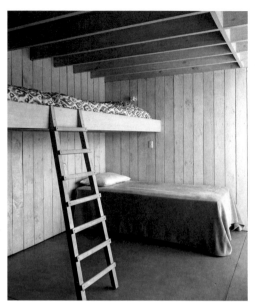

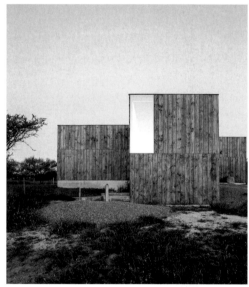

A four-winged weekend holiday home stretches over an expansive rural site. The coherent volume situates on a flat clearing on the upper part of a gentle slope, offering impressive panoramas of the Chilean countryside. A reduced palette of materials favors natural woods over industrial finishes. The lofty interior wings organize according to desired exposure throughout the day, attracting the sun along the northeast during the mornings and providing spaces for retreat on the south-west wings to escape the afternoon heat and heavy winds. Solid walls bleed into generous openings that relate to both the immediate context and distant views. This combination of solid and void supports a simultaneous experience of prospect and refuge. Vertically oriented, the pine planks from the exterior wrap through the interior to accentuate a feeling of height that continues from the interlocking rooms out into the private garden.

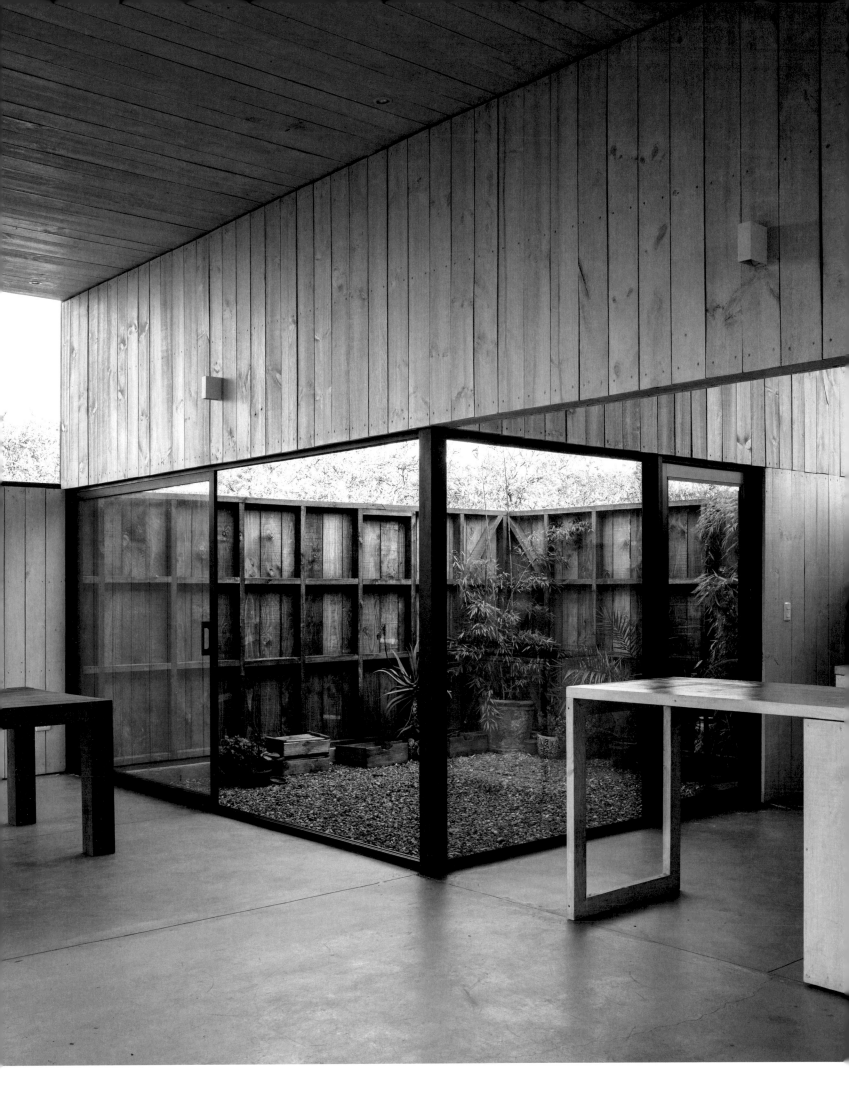

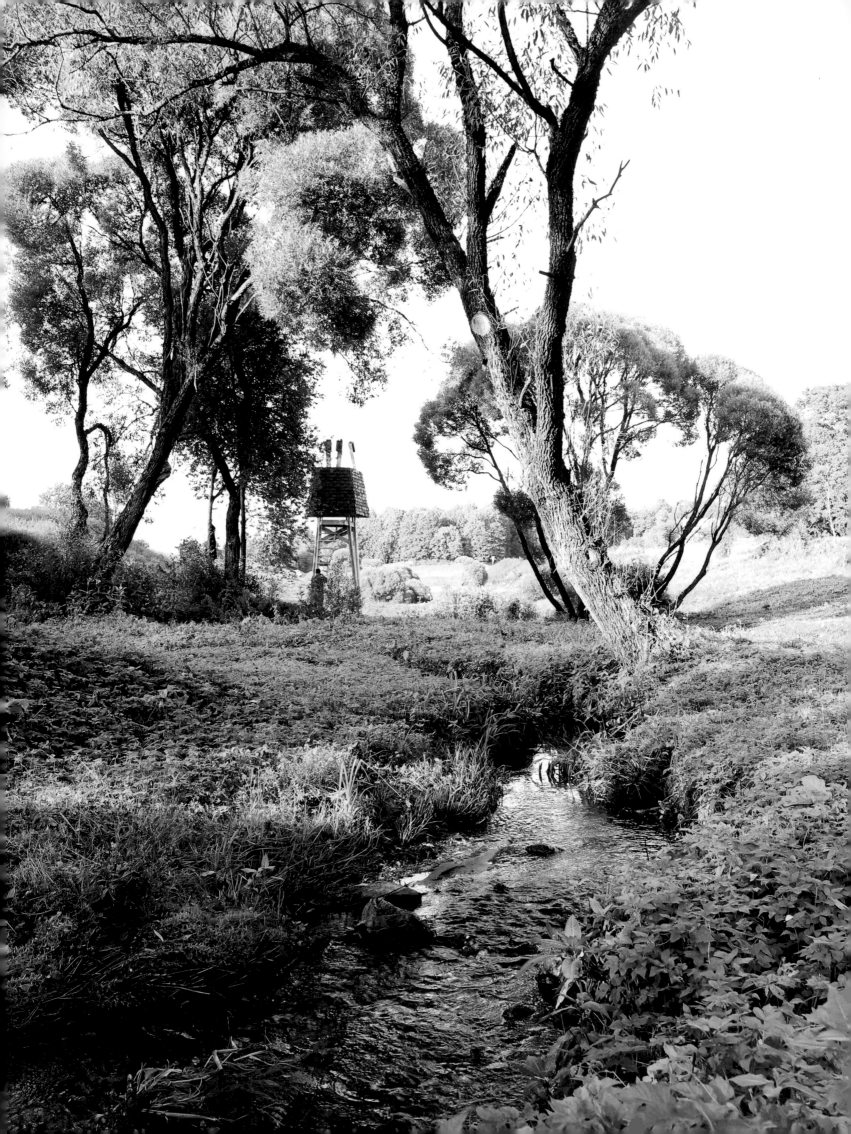

WILD THING

RTU INTERNATIONAL SUMMER SCHOOL

Emerging from the trees like
a curious woodland creature, the aptly named Wild Thing
drifts over a picturesque meadow.

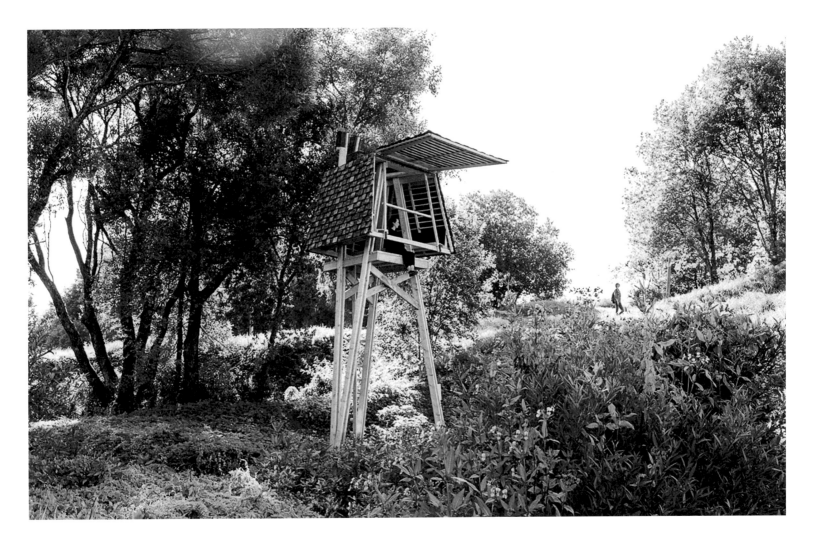

Sometimes one must look up towards the trees to find where the wild things are. The tiny ele-vated tree hut functions as a wilderness observatory for surveying the grounds. Hovering high in the air on a set of stilts, the cabin seats up to six people at a time on two benches. Two of the cabin walls open up as needed, transforming the secluded shelter into a lookout tower over the diverse Pirtsupite Valley. Dark shingles coat the exterior of the hideout and contrast with the light reclaimed timber used for the framing, stilts, and ladder. Responding to a prompt from the local municipality that the valley was wild, but not wild enough, the endearing project makes minimal contact with the land. Instead, the floating micro cabin tempts nature to thrive under and around it—a celebration of and offering to the land. ◆

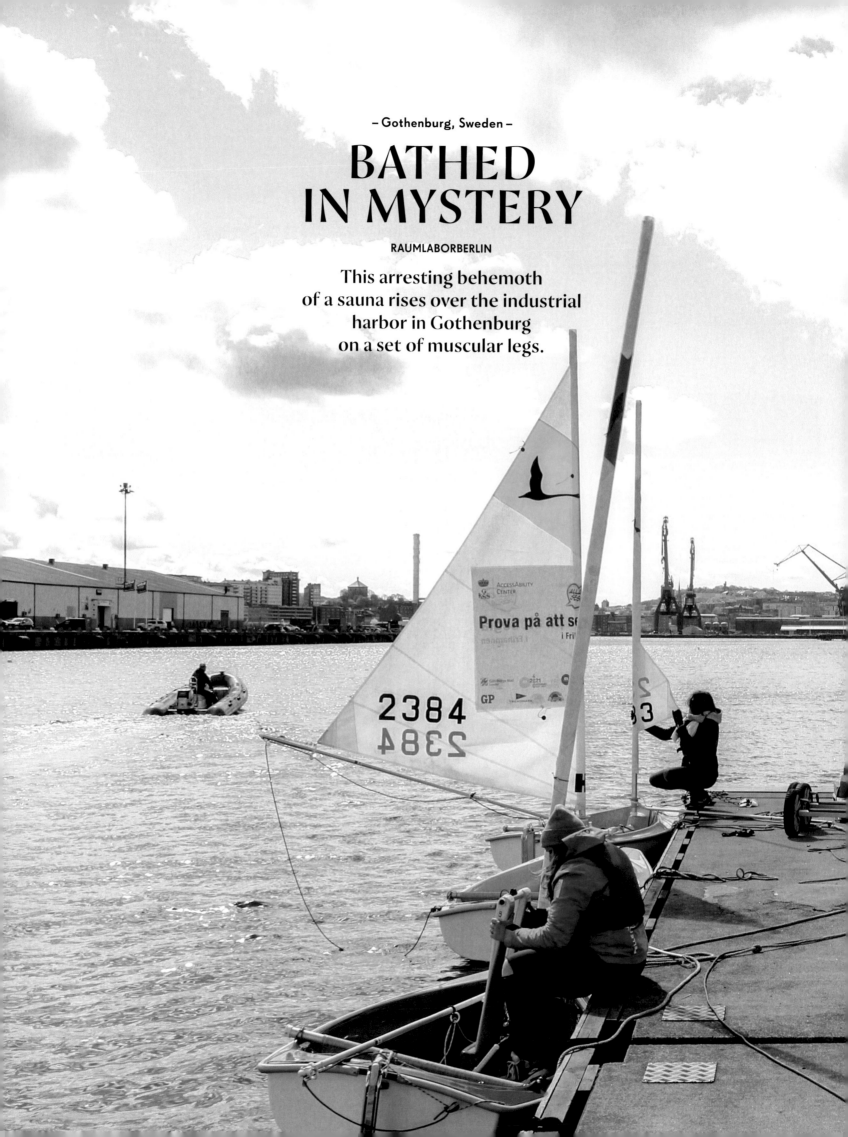

– Gothenburg, Sweden –

BATHED
IN MYSTERY

RAUMLABORBERLIN

**This arresting behemoth
of a sauna rises over the industrial
harbor in Gothenburg
on a set of muscular legs.**

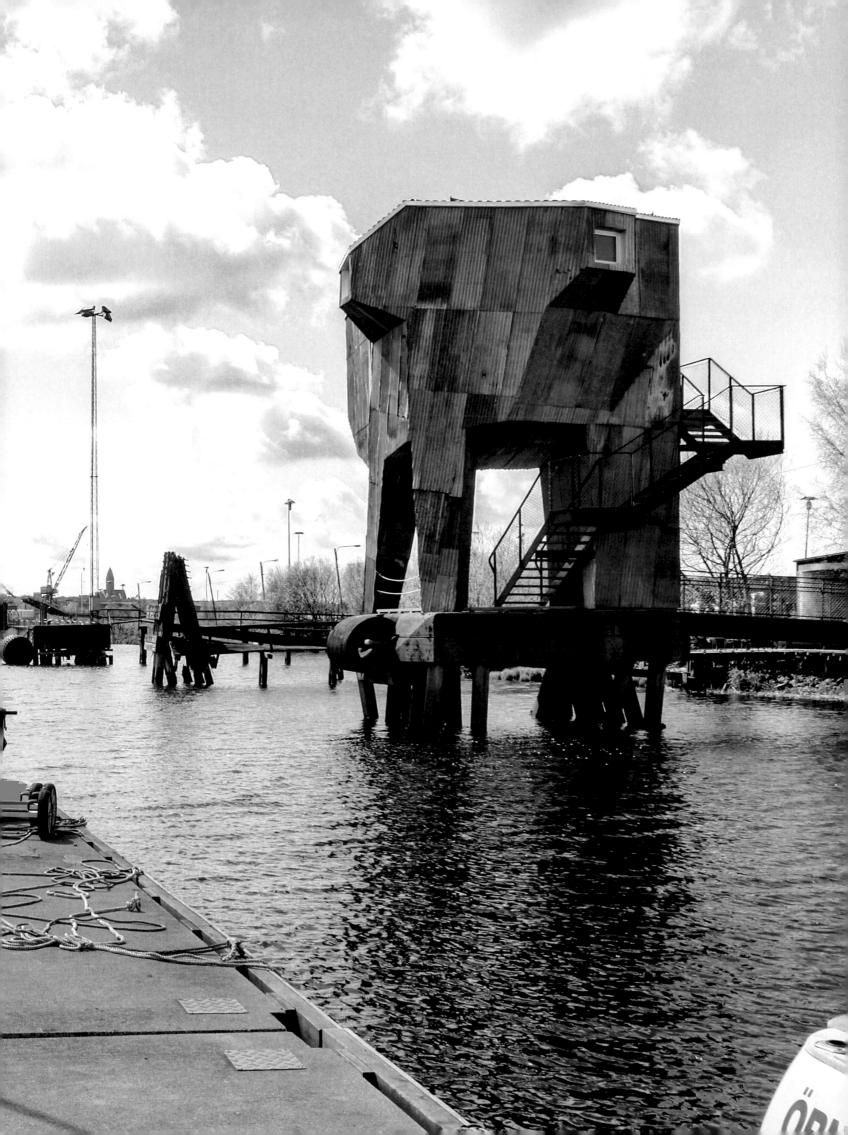

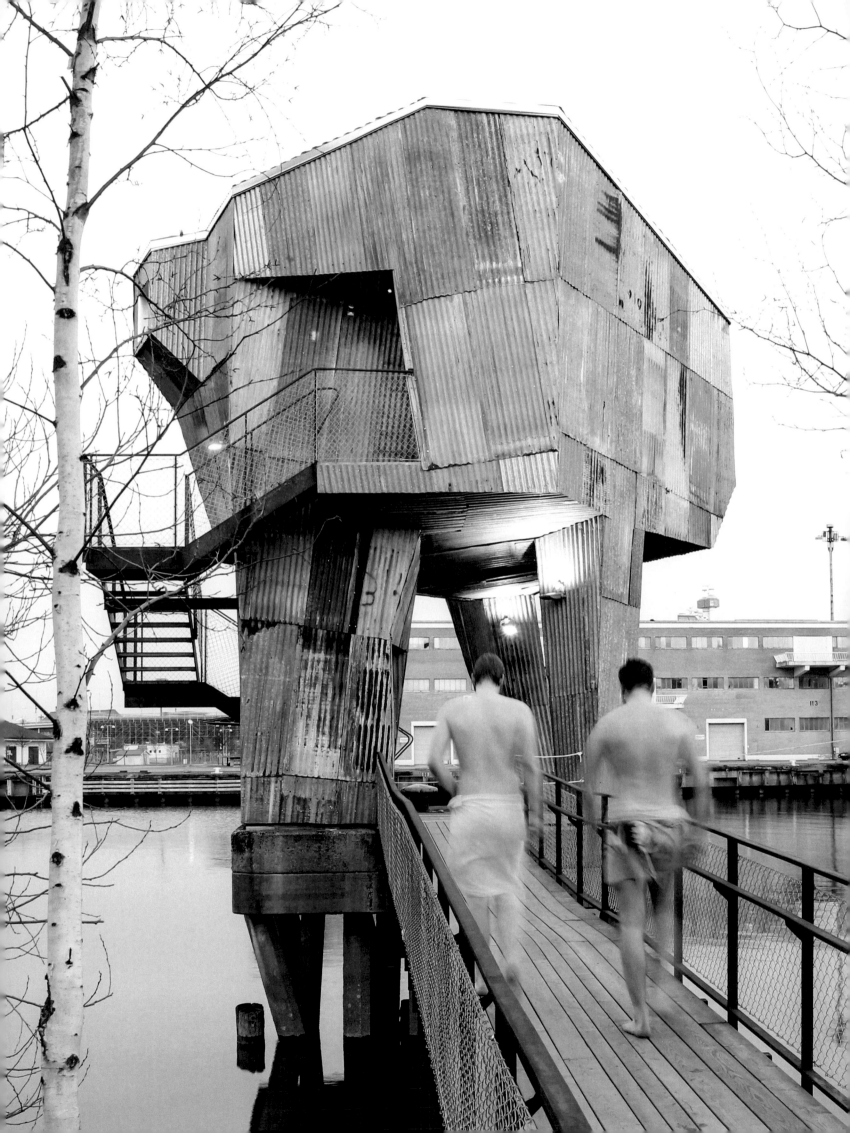

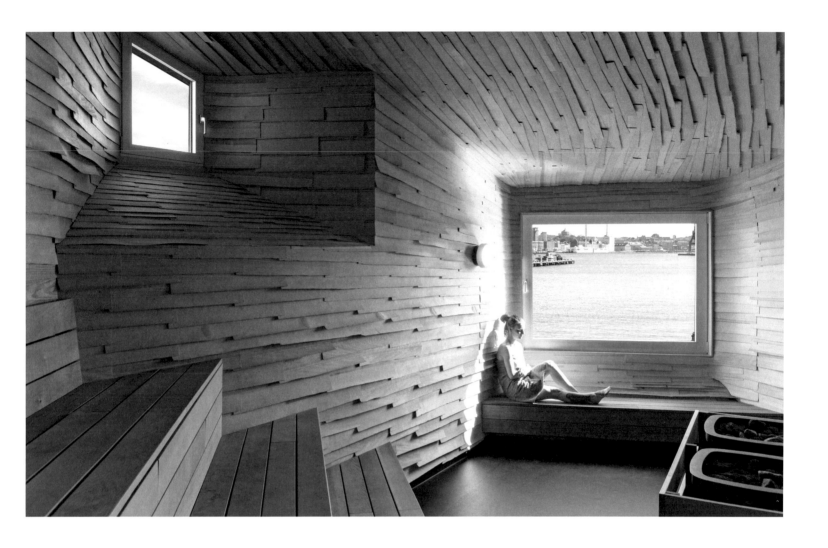

"Like a stranded shipping container washed ashore, the subtly idiosyncratic sauna becomes a provocative commentary on the old city and its imaginative future."

As if witnessing a mythical sea creature slowly awakening from a slumber in the depths of the ocean, a biomorphic sauna casts a hypnotic shadow over the harbor. The rusty, irregular skin of corrugated steel exudes a curious post apocalyptic air. Those daring enough to pilgrimage up to the beckoning beast ascend the staircase leading to the inner sanctuary. Cloaked in mystery, the sauna's protective armor transitions to a tranquil universe as soon as visitors cross the threshold. Slender horizontal shingles of light larch wood softly undulate through the surprisingly Scandinavian interior. A bench below a generous window looks out over the harbor, offering a faint reminder of the sauna's contorted exterior of weathered naval metal. Like a stranded shipping container washed ashore, the subtly idiosyncratic sauna becomes a provocative commentary on the old city and its imaginative future. •

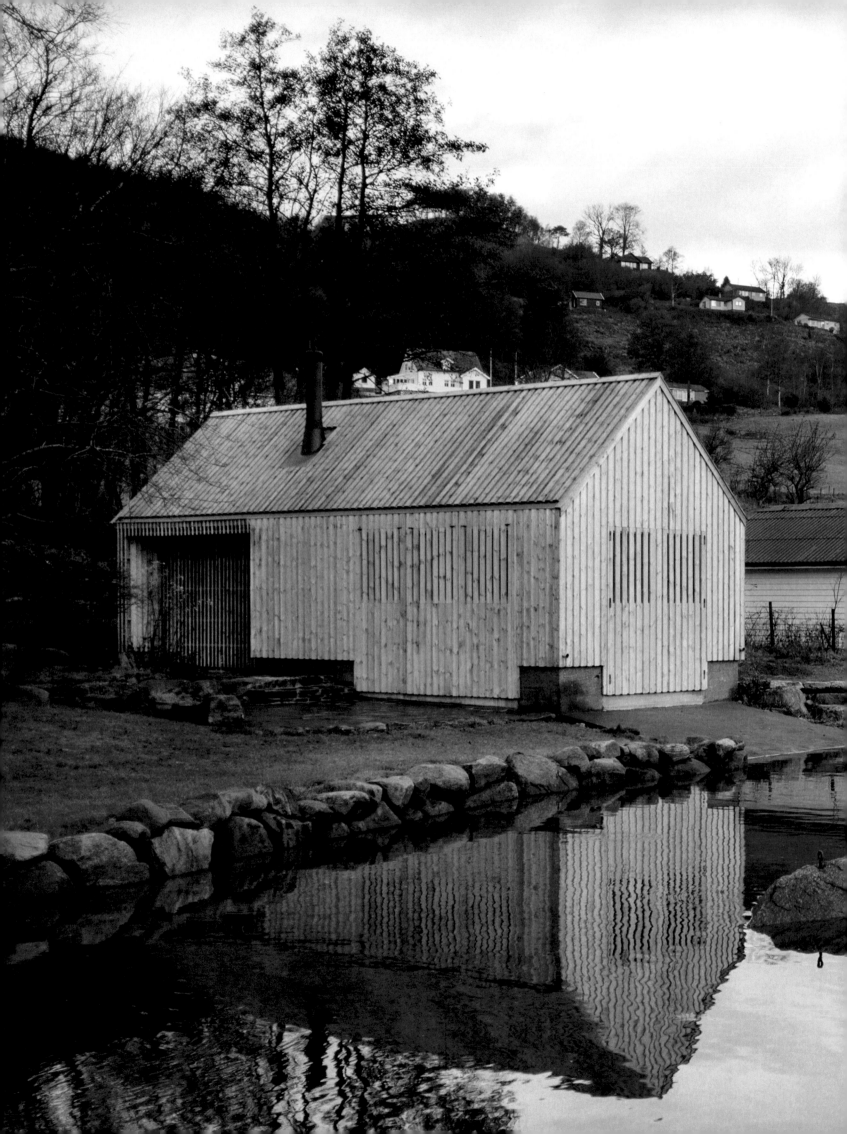

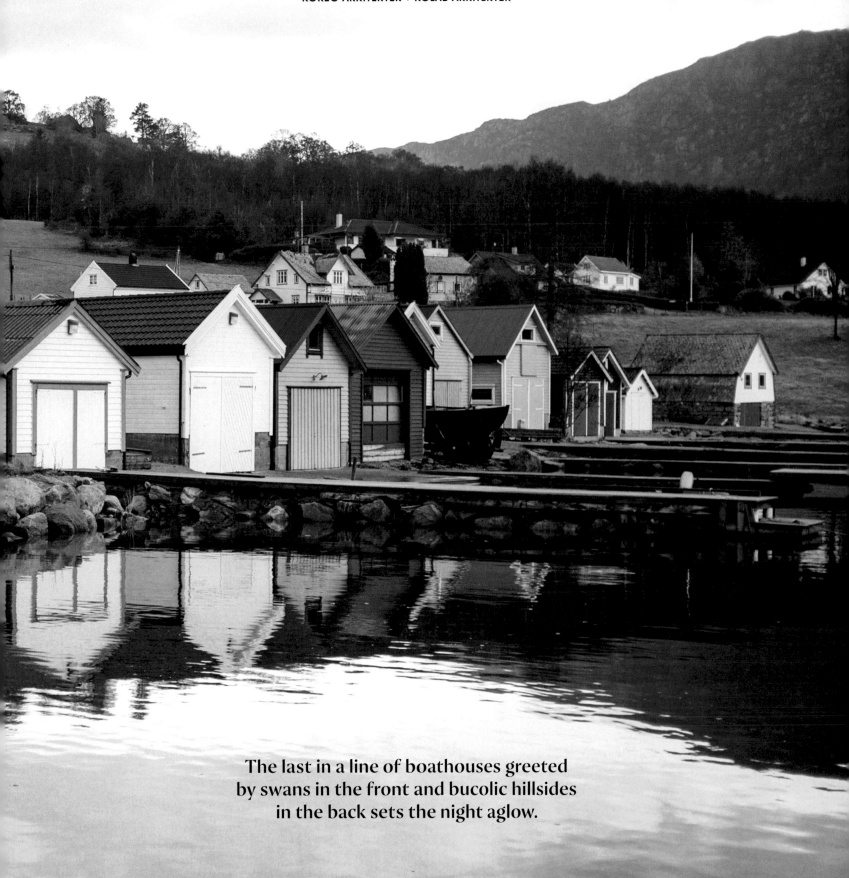

LIGHTHOUSE

KOREO ARKITEKTER + KOLAB ARKITEKTER

The last in a line of boathouses greeted
by swans in the front and bucolic hillsides
in the back sets the night aglow.

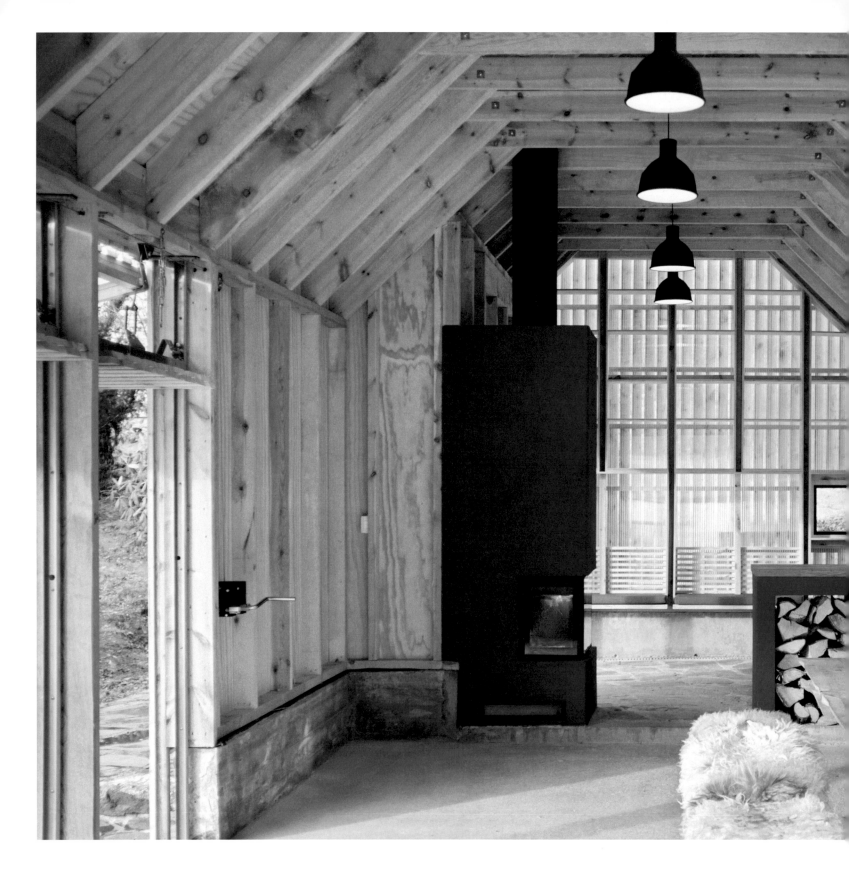

Breathing fresh life into a classic Norwegian landmark, a wooden boathouse takes this common coastal typology and updates it for an idyllic getaway. A local carpenter and next door neighbor built the pitched roof pine shelter. Each of the cabin's four sides responds to different influences found on the fjord. To the east, the building stands as the last and most discreet in a long row of boathouses. In the west, the structure greets a grassy terraced garden. Towards the south, the cabin enjoys immediate contact with the fjord. And in the north, the project overlooks a small intimate forest in an otherwise exposed context. Heated by a single fireplace, the boathouse welcomes in the landscape in the summer and provides a sturdy sanctuary during the formidable winters along the shore. Gaps in the pine planks spark subtle transitions between opacity and transparency, privacy and exposure, darkness and light. ◆

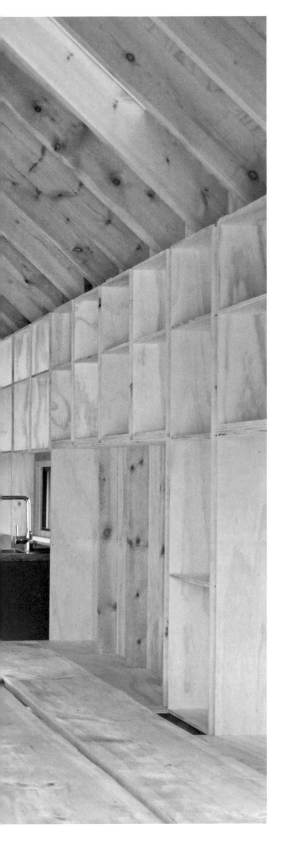

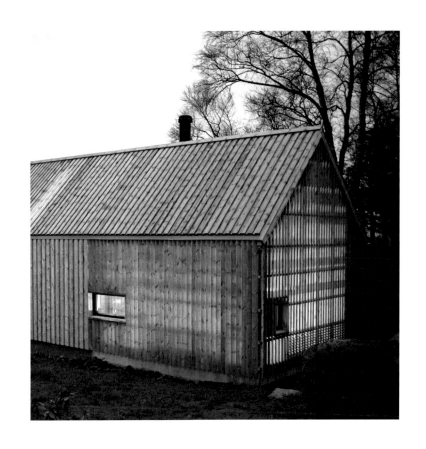

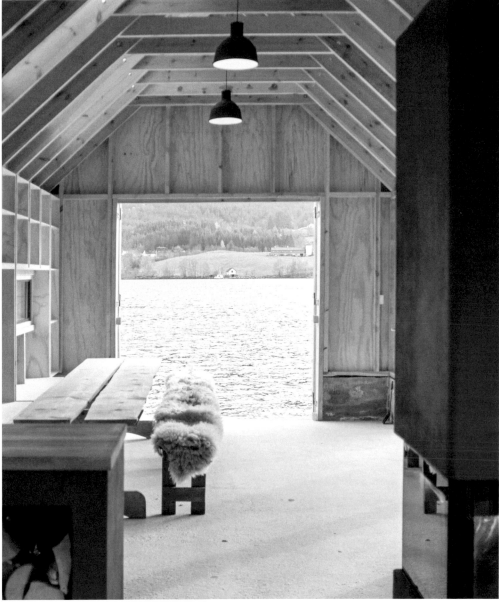

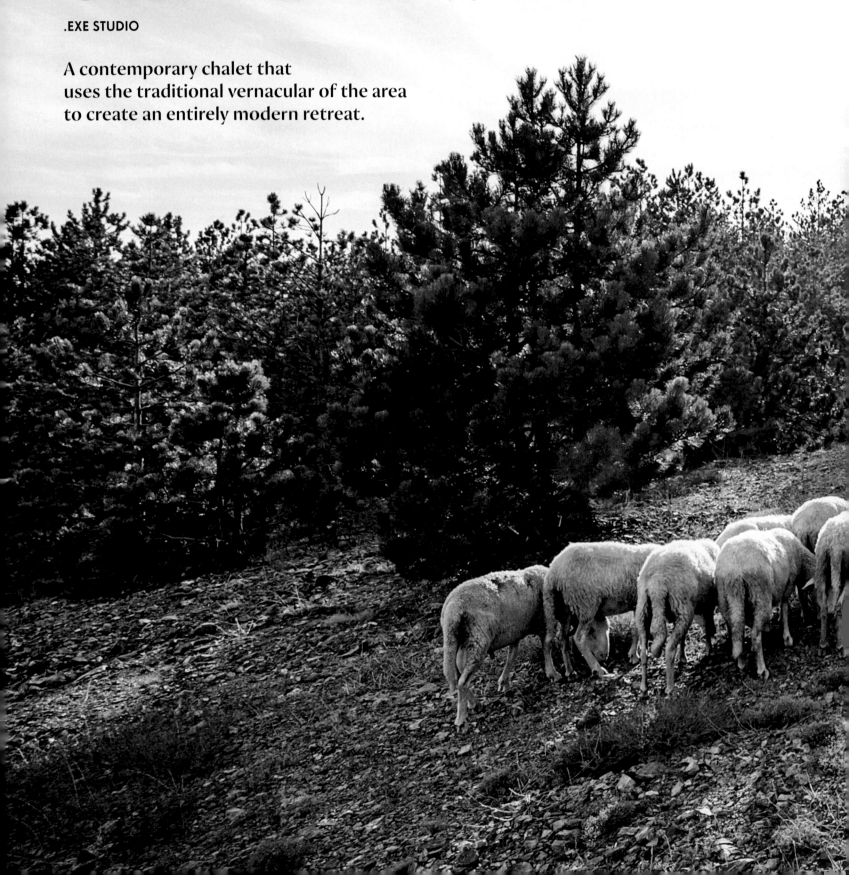

– A hillside in Serbia –

LIGHT AND DARK, OLD AND NEW

.EXE STUDIO

A contemporary chalet that
uses the traditional vernacular of the area
to create an entirely modern retreat.

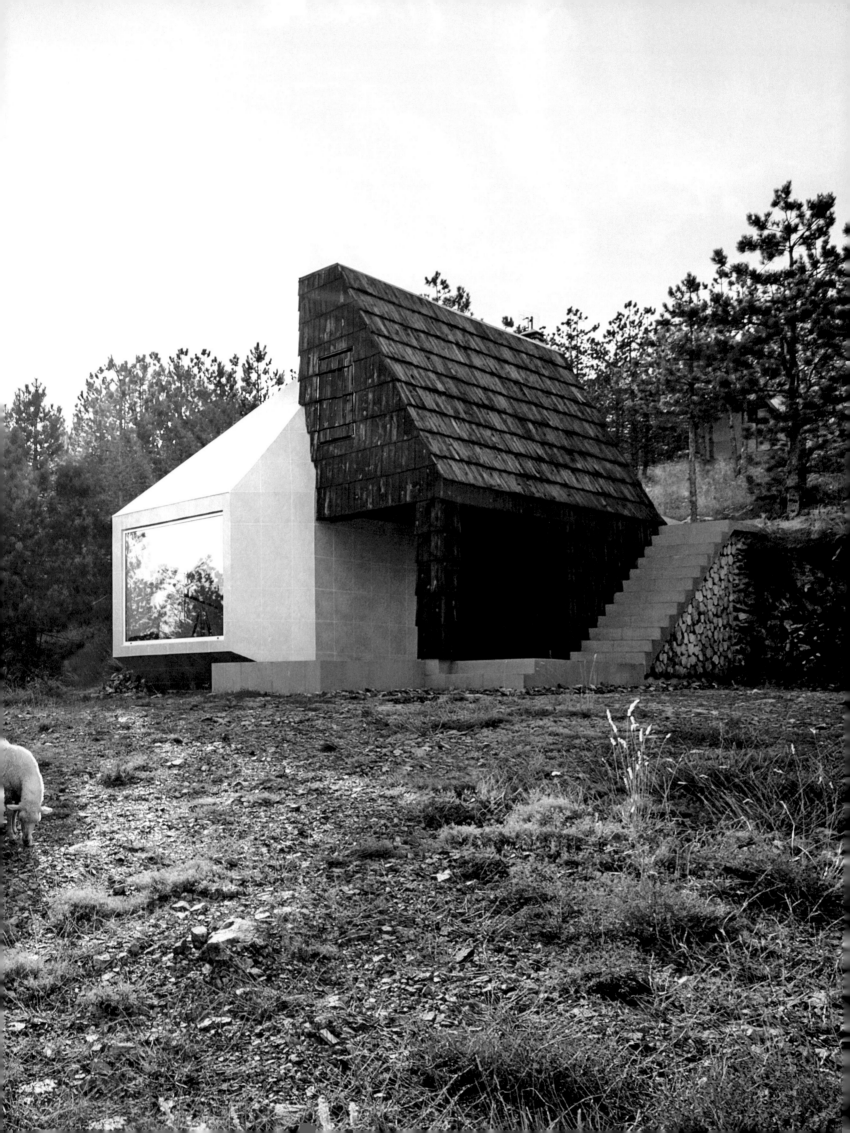

As conspicuously contemporary as this chalet may first appear, it was the local building vernacular that actually stimulated its architects, Andreja Mitrovic and Tijana Mitrovic. "We were inspired by the model of the traditional Serbian chalet for the design," shares Tijana. The Serbian pair, founders of the .exe studio, had spent four years living and working in China before returning home and finding this spot in Divcibare—on the slope of Mount Maljen in western Serbia—to build their dream holiday home. They were looking for a place to disconnect from city noise so the rustic setting seemed fitting. "But we tried to merge the traditional with a contemporary aesthetic. The house was designed as a symbiosis of two contrasts: old and new," she continues.

The pair deconstructed the components that make up a traditional mountain home in their design process. They took the basic elements—base, walls, and roof—and literally turned them on their side. On one elevation is the black wood shingle that would usually adorn a chalet roof and on

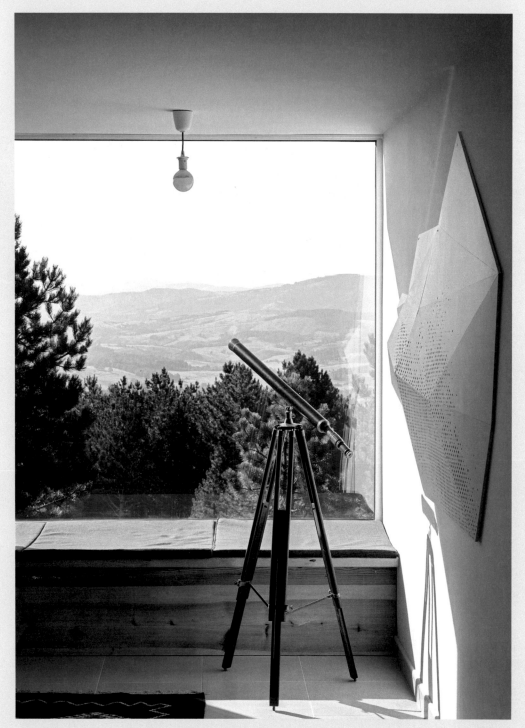

> ## "The house was designed as a symbiosis of two contrasts."

the other is the white ceramic tile, coating the main volume of the house. The materials were selected with an appreciation for durability and in order to compliment the overall form. The light and dark offers a striking duality, matching the contrast between the old and the new.

"Although the plot had been overrun with small pine trees, it still bears the original character of the open field. To minimize disturbance to the site, and as a reference to the surrounding hilly terrain, the house is built into the hillside," explains Mitrovic. Constructing the 76-square-meter home was not without difficulties. "The inaccessibility of the terrain and the lack of electricity and accommodation were all challenges that we dealt with constantly. The biggest problem was the installation of the ceramic tiles on the 'light' element of the house. It was very inaccessible, slippery, and unsafe."

The result is a home whose strikingly unfussy modernity allows for complete calm and solitude. It is fundamentally a vacation house and the couple refrain from keeping too much there. Simplicity is its nature. The centerpiece is a grand picture window with a broad seat placed in front. There are simple armchairs in the living area, sliding beds in the sleeping quarters upstairs, and very little else. "We chose this spot on the mountain for the house ❯

left_ **The view through the one wide window is the only entertainment the owners need.**

right_ **The exterior borrows from traditional Serbian chalet architecture and simply tips it on its side.**

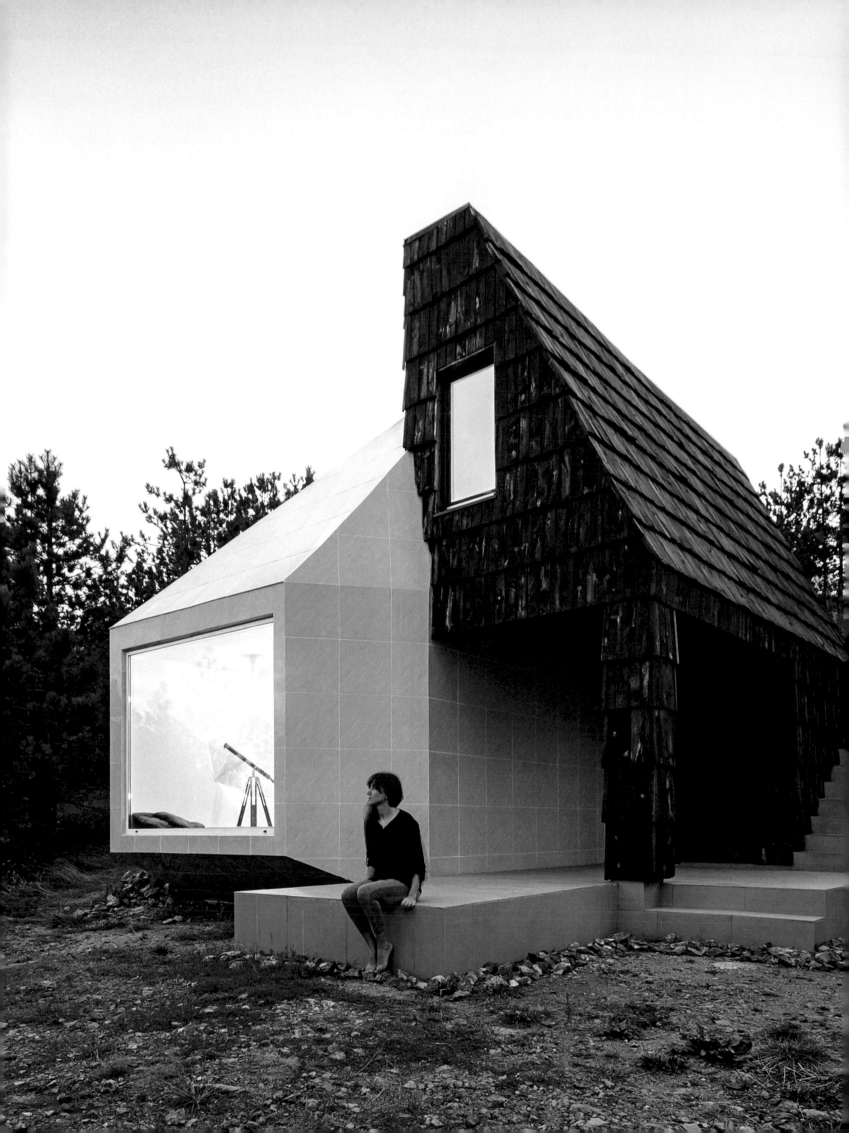

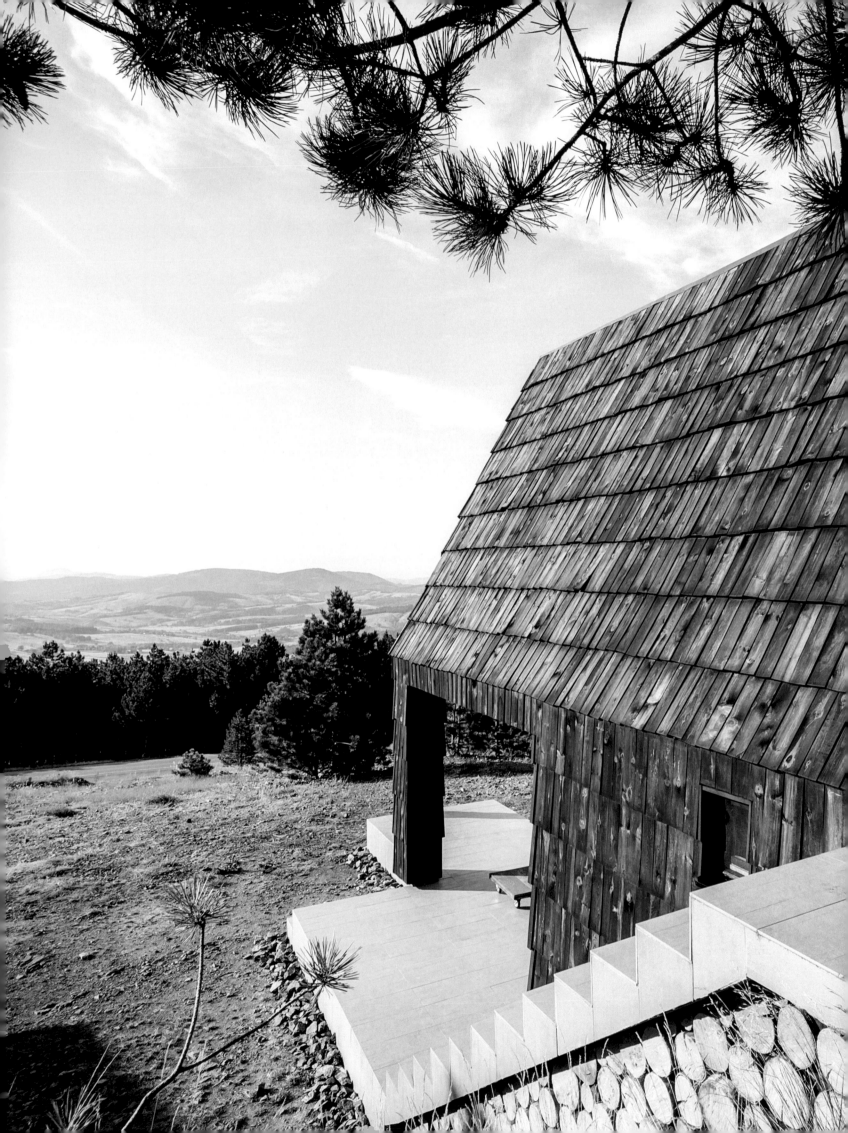

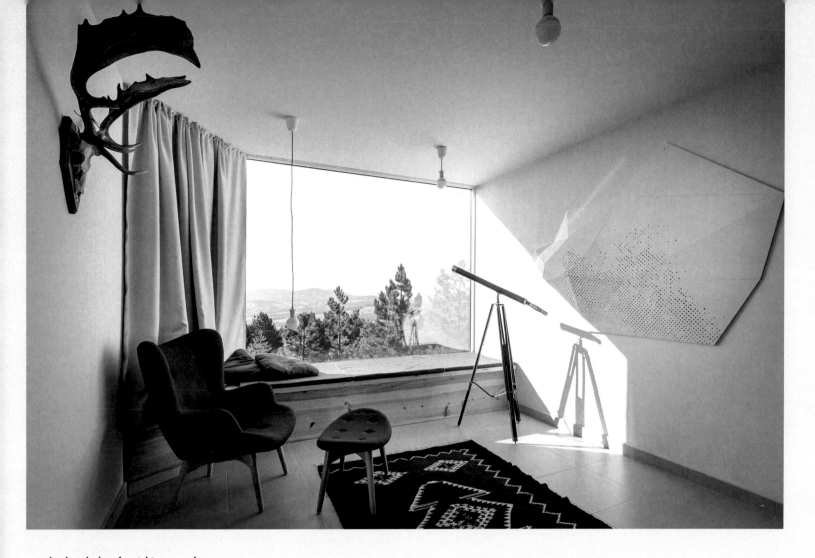

top_ In the chalet, furnishings are kept sparse and simple.

left_ Beneath old pine trees, black wood shingle adorns the roof.

so we could provide ourselves with a space where we could disconnect from the noise of the urban environment," says Tijana. The pair, usually based in Belgrade, make it to Divcibare whenever possible and appreciate the chance to switch off. It is intentionally basic and designed as an eco-chalet with limited resources: It is supplied with natural mountain spring water, solar panels provide green energy, and a natural thermal flywheel releases the summer heat during the wintertime. The house sits in the middle of the landscape but barely affects it—and respects it.

The chalet is bright in the summer, but also warm and comfortable in the winter, when the couple enjoys viewing the dramatic barren landscape from the window. "The surrounding vegetation changes throughout the season, giving a completely different feeling," says Tijana. The forest provides various berries and plants and there is a rich local farming heritage. "The pine trees that surround the site release a special smell that you can enjoy every morning."

Although the cabin provides an escape from working life in the city, Andreja and Tijana see this sanctuary as being part of the future of .exe. Not only is it a showpiece of the firm's abilities, but the couple hopes to use it for small workshops, giving them the opportunity to switch their design process from the urban to the natural environment. That will require an Internet connection, which, for now, they are happy to do without as they quietly hunker down on the mountainside. "Just to stay here and enjoy the view and smell the trees," says Tijana, "is an unforgettable experience." ◆

> **"The chalet is bright in the summer, but also warm and comfortable in the winter, when the couple enjoys viewing the dramatic barren landscape from the window."**

X MARKS THE SPOT

ASLAK HAANSHUUS ARKITEKTER

In the deep wilderness of Norway,
on the edge of an expansive national park,
two cabins — one old
and one new — converge between the
snow-covered trees.

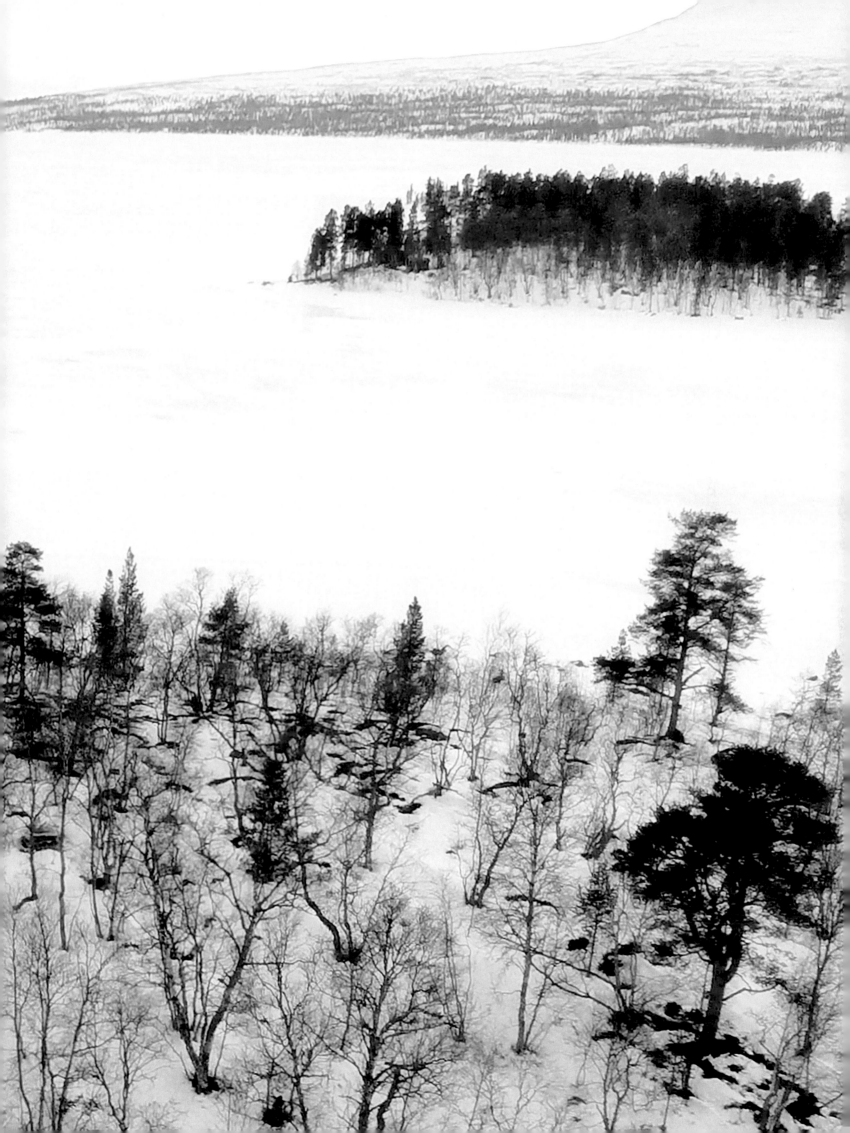

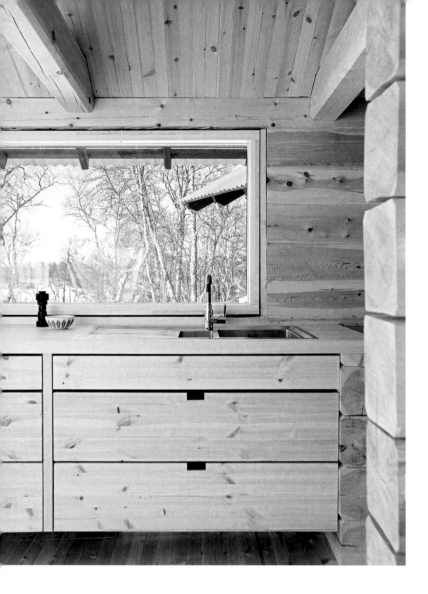

Two extant cabins become a single retreat on the border of one of Norway's largest continuous areas of wilderness. The pair of log cabins, one of which dates back nearly a century, converge in a bisecting addition. Huddled under the eaves and protected from the inclement weather, past and present unite under a shared roof. Lifted off the ground, the cabin sits on a wrap-around deck that hosts a welcoming social point in the summer and a needed buffer from the elements during the icy winter months. Time passes slowly here, marked by fresh tracks in the snow, the arc of the sun through the sky, and the gradual thaw of the water as the days grow longer. Blending historic and modern elements, the forest retreat and its large picture windows adopt a revelatory stance toward a majestic expanse of the remote Fermunden National Park. ◆

**"Time passes slowly here,
marked by fresh tracks in the snow,
the arc of the sun
through the sky, and the gradual
thaw of the water
as the days grow longer."**

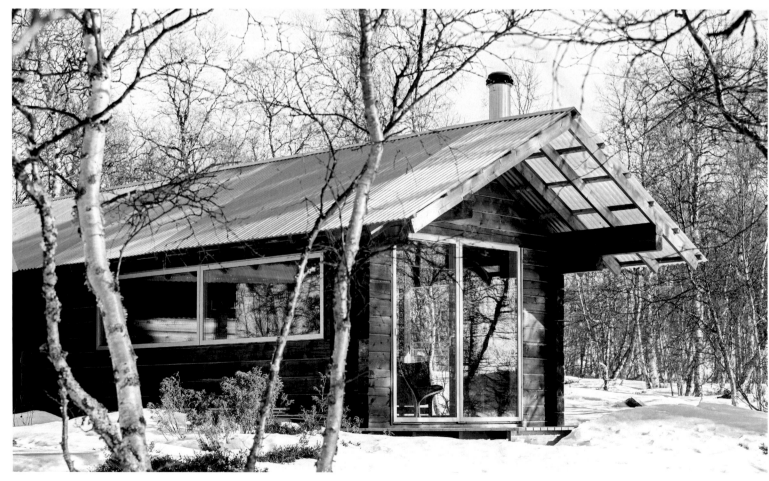

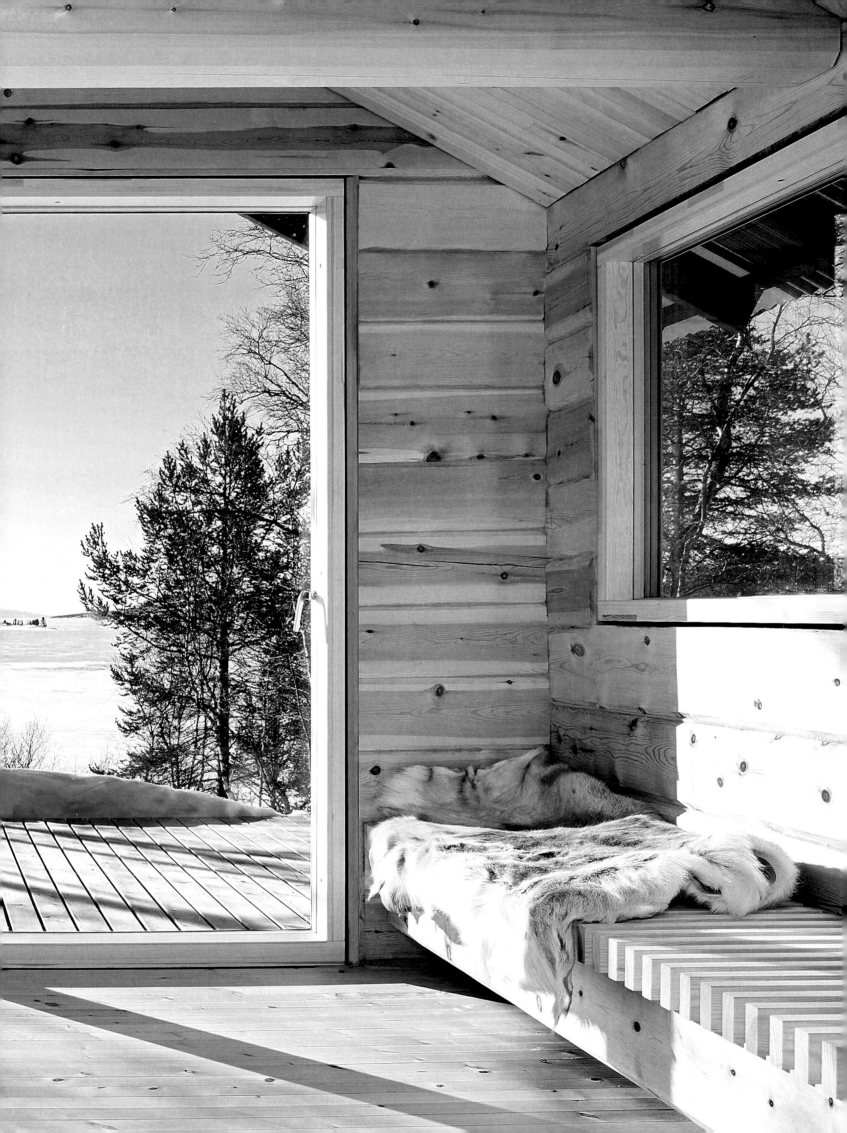

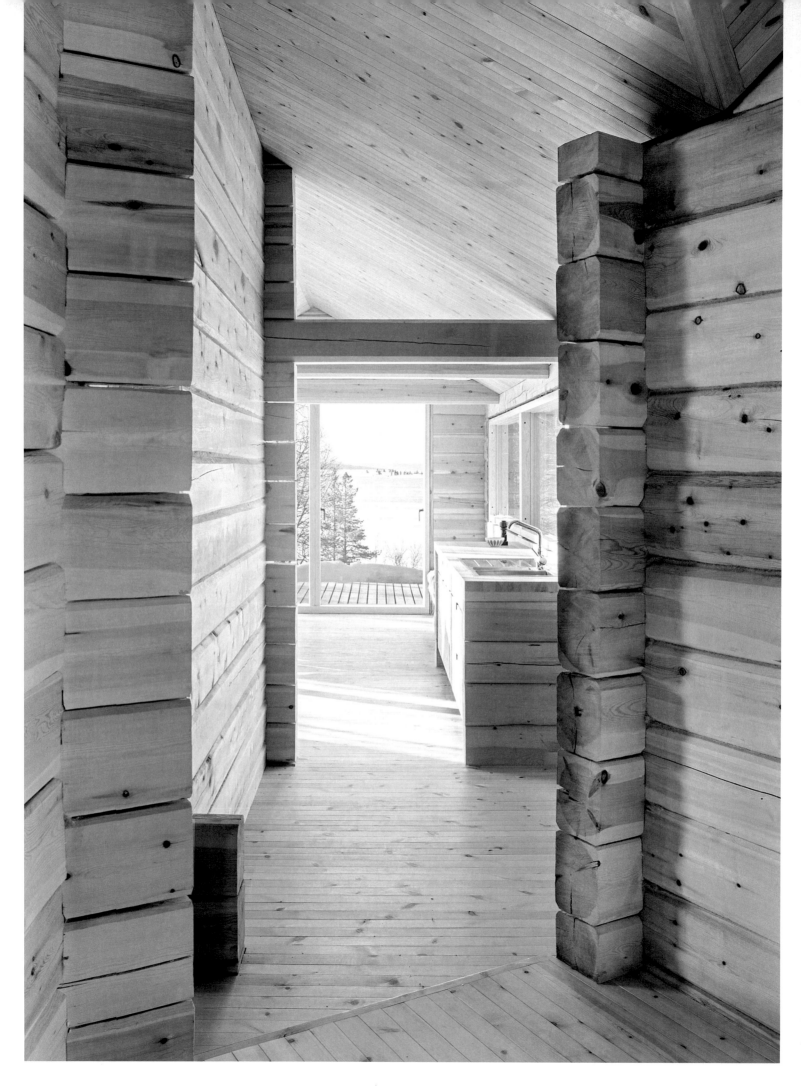

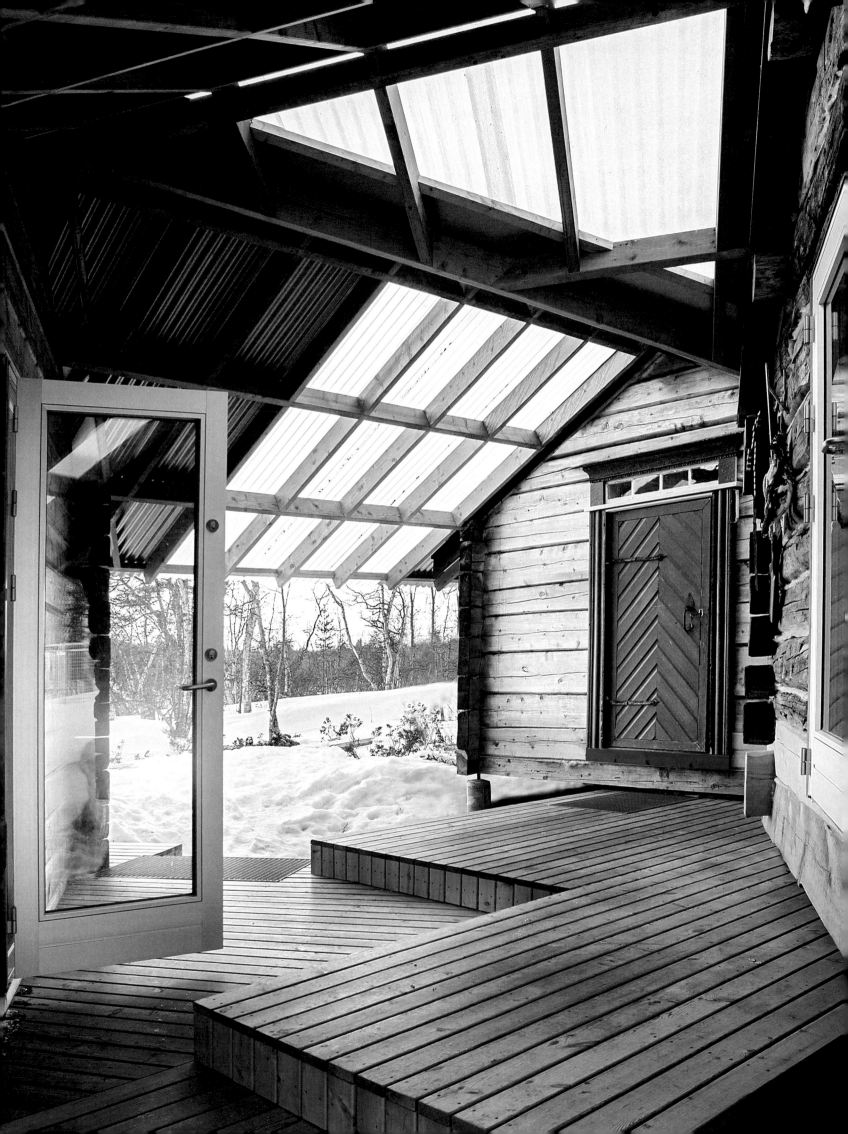

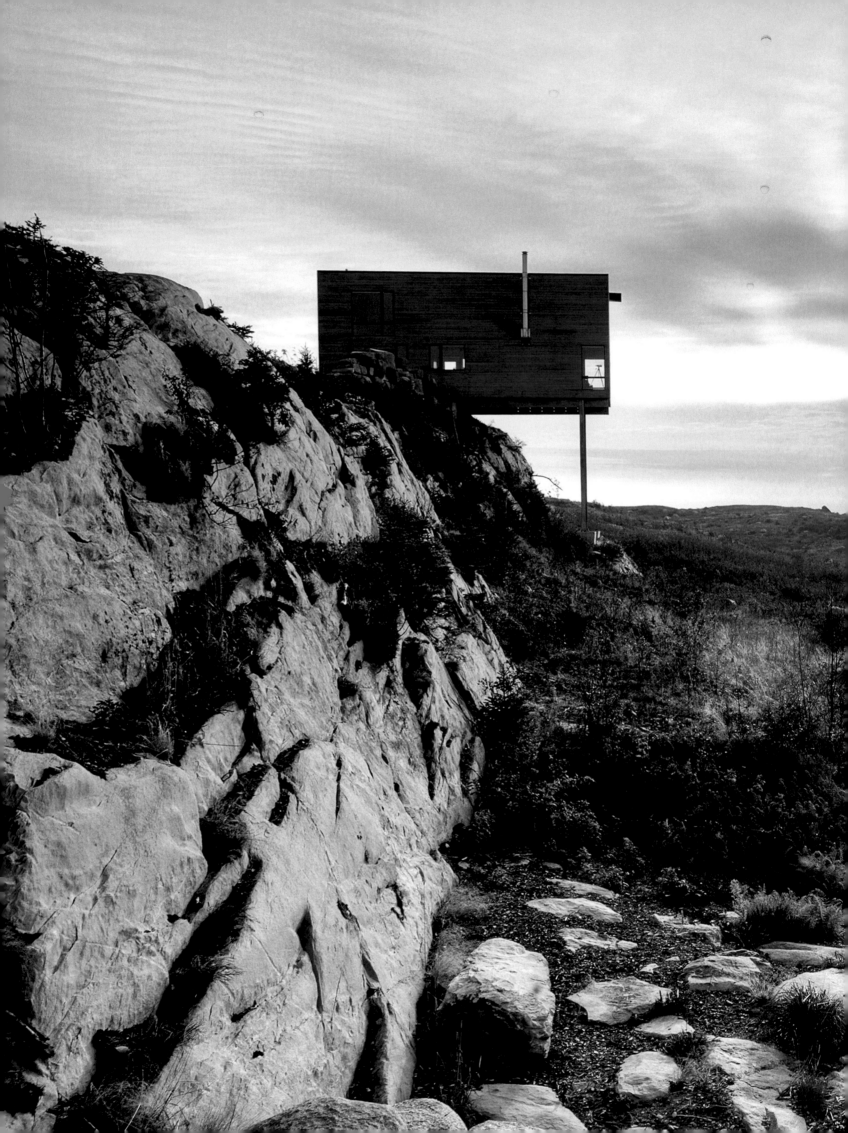

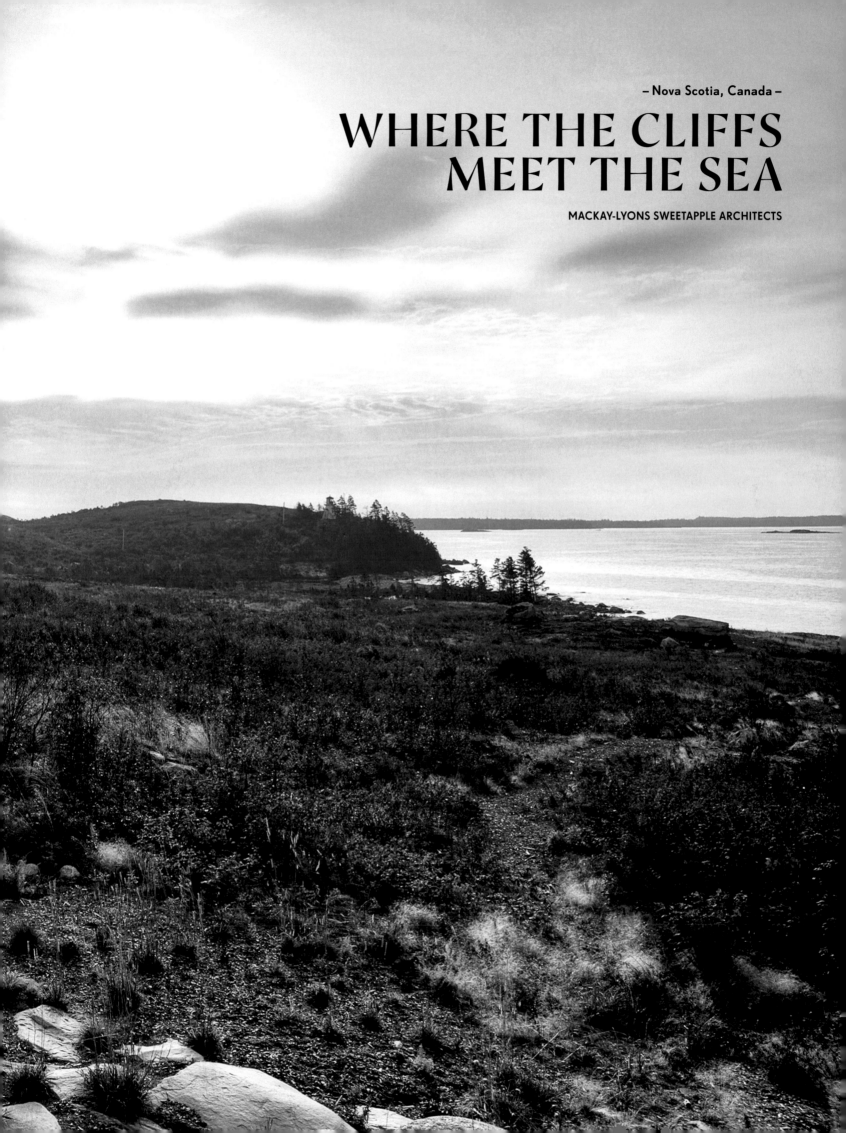

– Nova Scotia, Canada –

WHERE THE CLIFFS MEET THE SEA

MACKAY-LYONS SWEETAPPLE ARCHITECTS

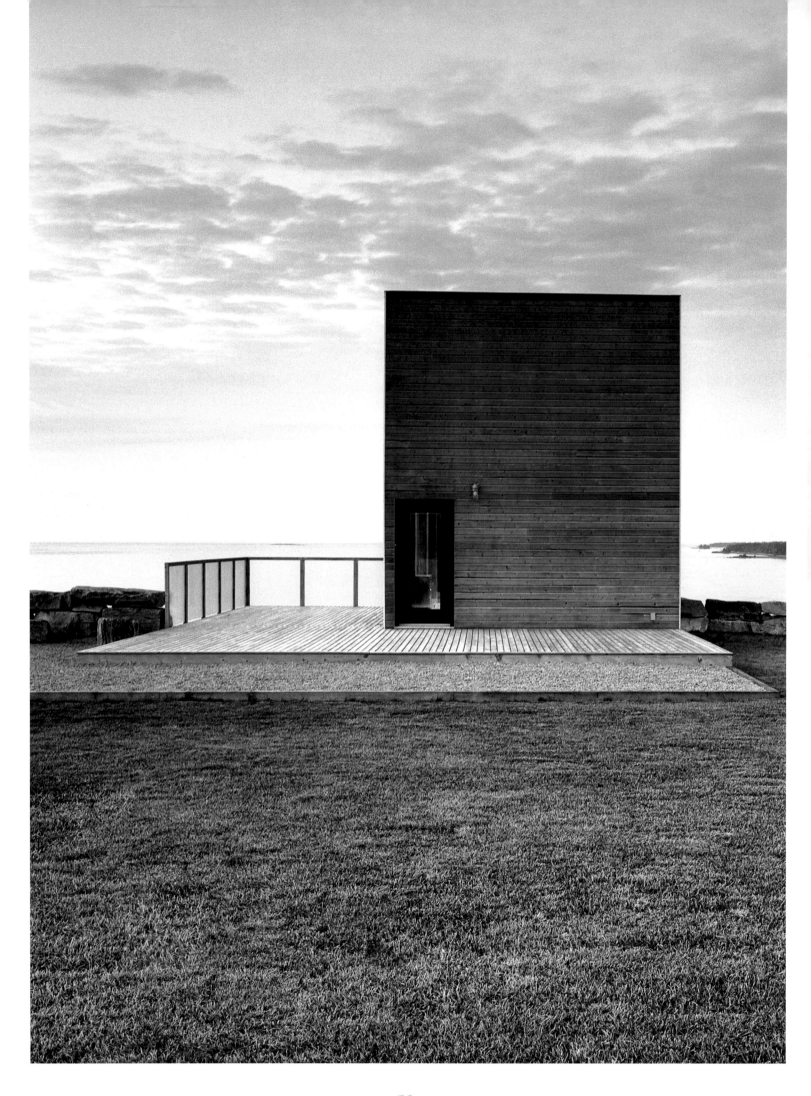

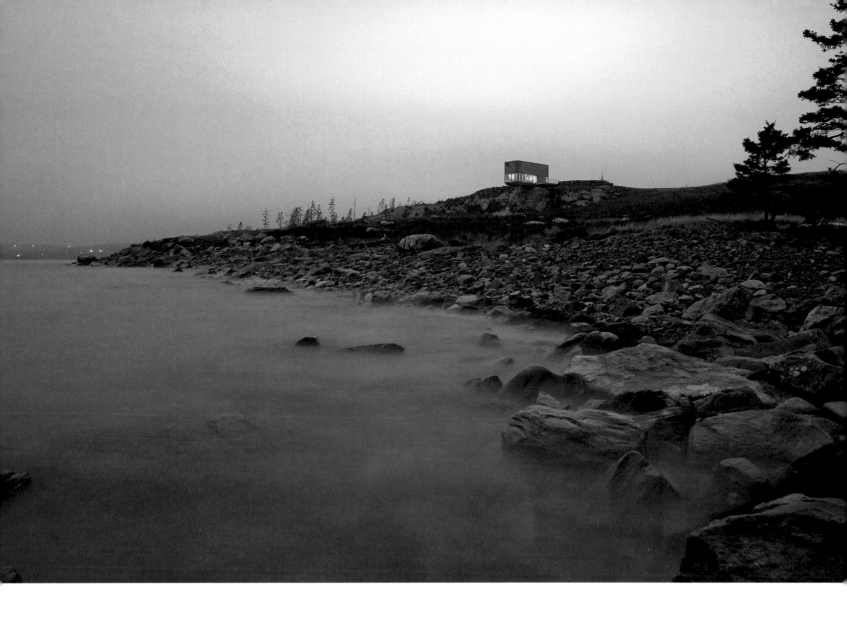

Elegant summer home becomes seaside icon, soaring off a cliff with a dramatic leap into the horizon.

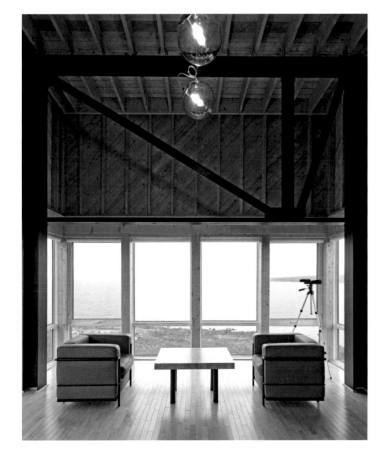

Precariously balanced off a bedrock cliff, this striking cabin braces for its launch out to sea. The commanding retreat demonstrates an extreme expression of austerity combined with an ambitious aesthetic temperament. As the first in a series of structures slated to materialize over sweeping bluffs of the Atlantic Coast of Nova Scotia, the abstract wooden box heightens the experiential qualities of the endless sky as it meets the unadulterated shore. From the land, the cabin and its material frugality feel firmly rooted in the earth. From the sea and the protective interior, the volume appears to take flight as it juts off the cliff. A soaring living space leads out to a generous deck facing due south. Here, one can observe the stirring maritime vista from an outlook of monumental modesty. •

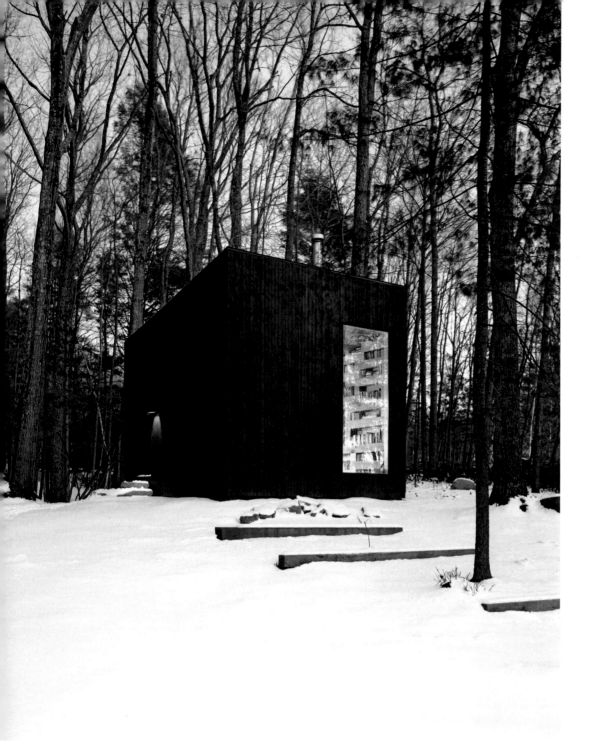

THE LIVING ROOM

STUDIO PADRON AND JASON KOXVOLD

This secret room in the forest of Upstate New York cloaks its inner sanctum behind mysterious walls of blackened wood.

> **"When in use, the secret library casts a bright glow over the crisp white snow."**

As the trees fall bare and the snow piles high, a monolithic black form comes into focus. The charred cube recedes into the wilderness of the surrounding forest during certain seasons and lighting conditions. The cabin's foreboding exterior hides a more welcoming experience just within. This blackened armor gets checked at the door, revealing an interior haven of warm red oak. Wrap around shelves hold 2,500 books inside the tiny library. Guests may warm their hands by the cast iron stove or cuddle up on the bed or in a chair with their book of choice. When in use, the secret library casts a bright glow over the crisp white snow. Each book will elicit a different experience inside the introspective nook. After one's imagination has roamed free, visitors may note their time spent in the library by adding a private message to their book—a growing time capsule of literary and personal achievement. ◆

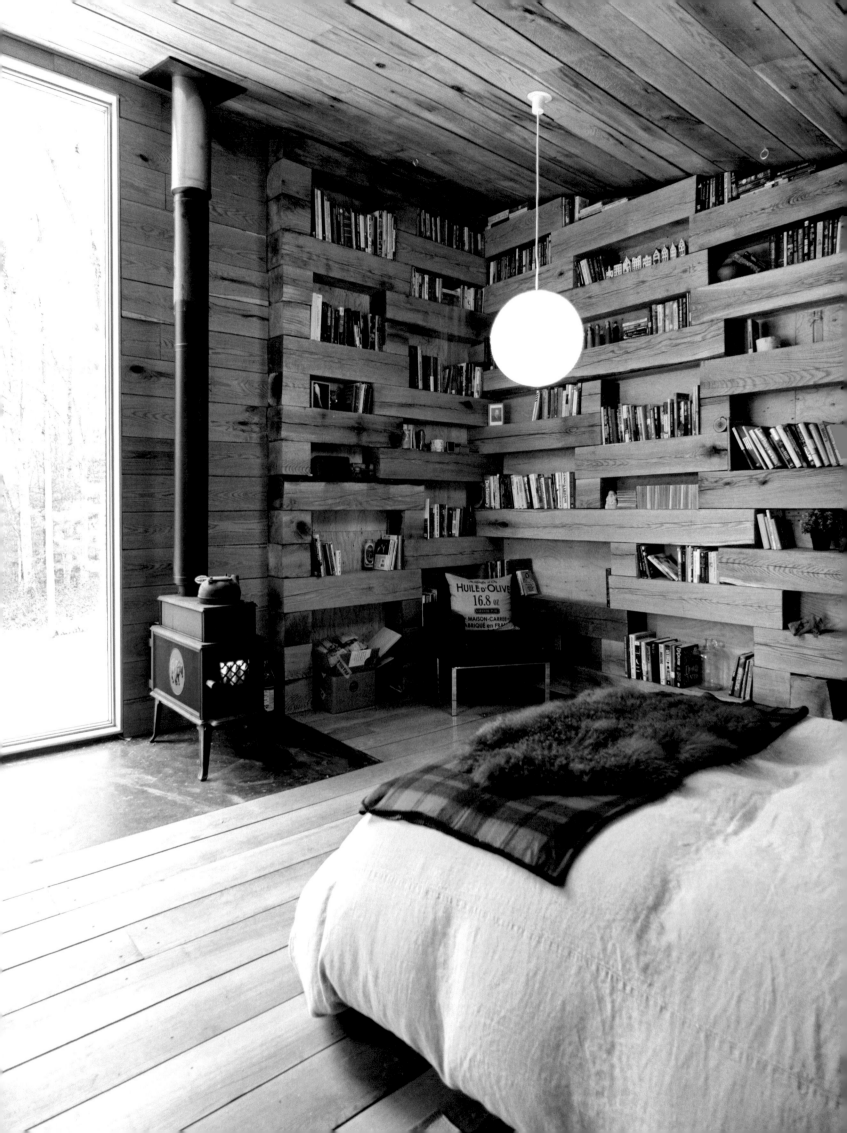

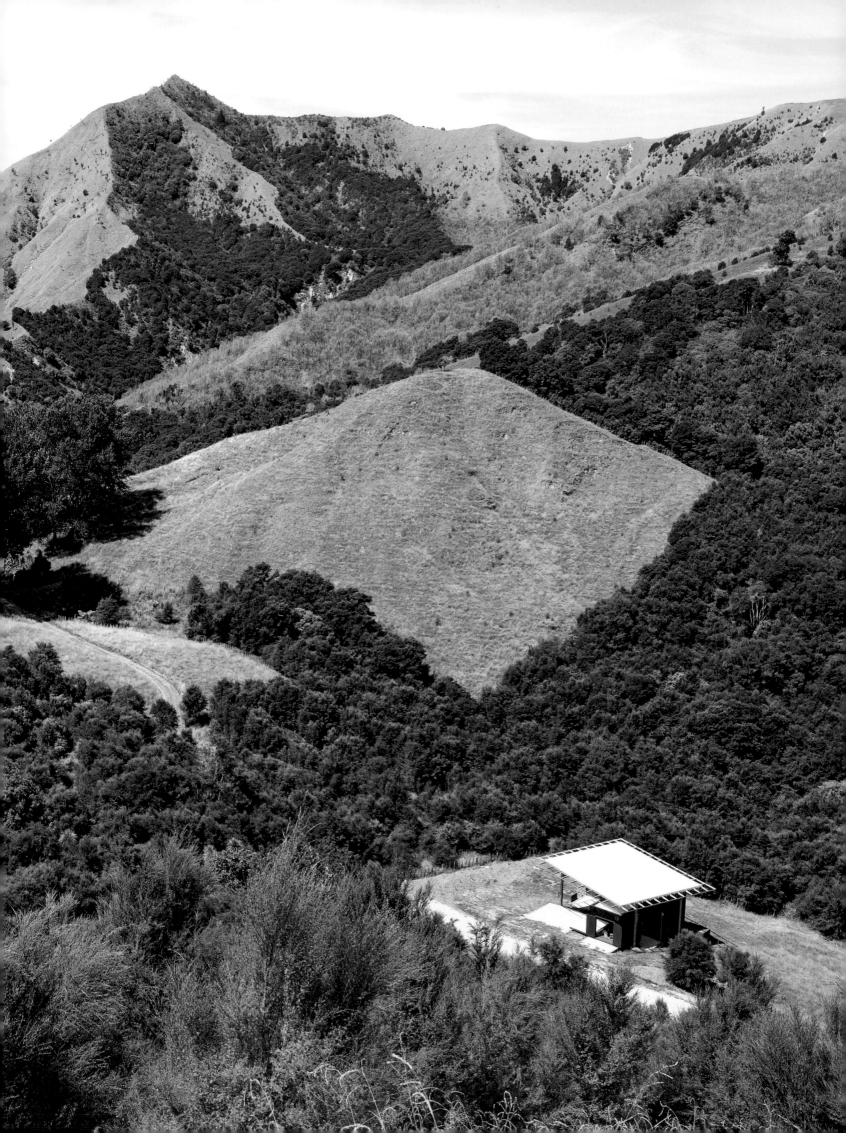

COUNTRY GRAMMAR

SAROSH MULLA

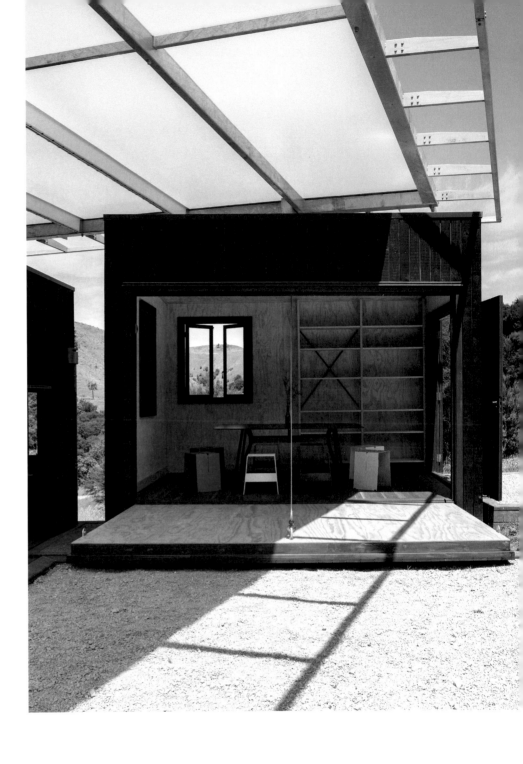

This cluster of
classrooms celebrates
open-air learning
on a scenic basin of
the Longbush
Ecosanctuary.

A community endeavor in every sense of the word, this welcome shelter on the grounds of a pristine ecosanctuary reconnects visitors with their wild side. Built by volunteers with donated materials, the casual center thrives as a site for advancing environmental education and conservation efforts along the East Coast of New Zealand. The design borrows from picturesque painting and scenography techniques to highlight the way humans have engaged with the environment in New Zealand over time. Beneath a large canopy, which acts as a secondary horizon in the hill country, three timber enclosures gather around collective gardens to form a sheltered courtyard. The arrangement of the enclosures frame curated views of the landscape that draw together complex and contradictory uses of the land. Within each view, the building becomes a teaching tool and a lens for considering one's role within the ecology and regeneration of the environment. ◆

> "A lens for considering one's role within the ecology and regeneration of the environment."

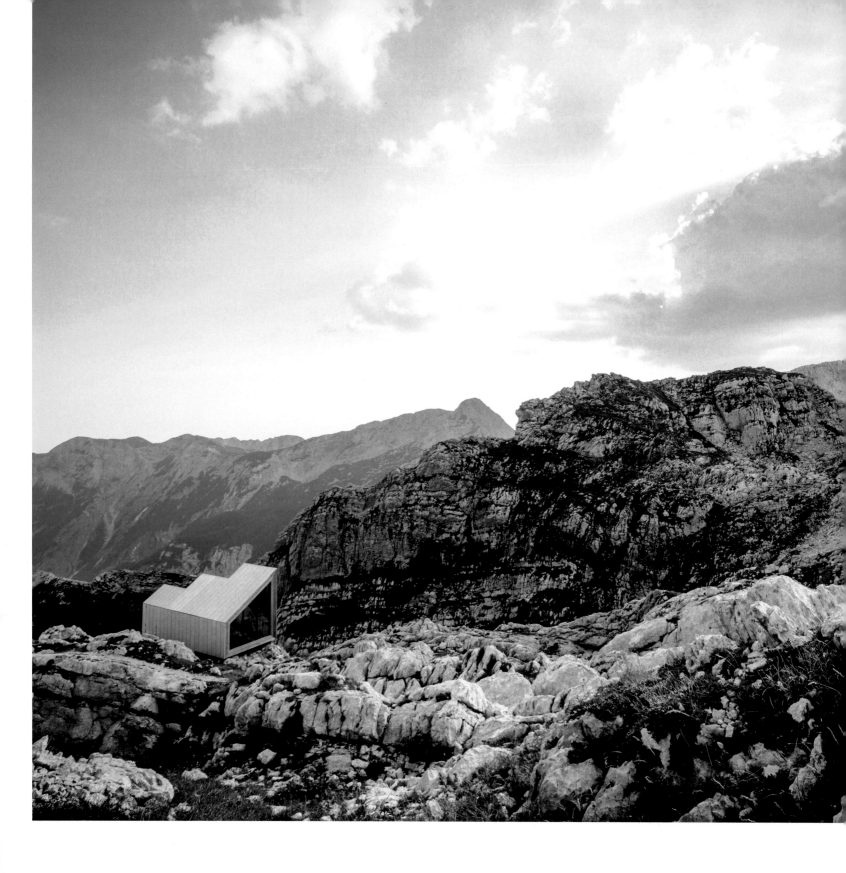

S et on a summit below Skuta Peak, the third highest mountain in Slovenia's Kamnik Alps, an iconic shelter for adventure-hungry climbers braves the extreme alpine climate. The visceral nature of the refuge taps into the humbling and harsh conditions of the terrain and the inherent risk of undertaking such expeditions. Defiantly poised to withstand dramatic jumps in temperature, avalanches, wind, and snow, the fearless form angles open toward the sky while exerting a light but firm presence upon the ground. Hosting up to eight mountaineers at a time, the shelter divides into three sections; one for cooking, one for communal gatherings, and a third for sleeping. The two main faces dissolve into the thin air. This liminal barrier of floor-to-ceiling glass dares travelers to confront the line between safety and fear, exposing a sheer drop from cliff to valley. Combining symbolism with tradition, this high mountain refuge adopts a dual role as exalter and challenger of its prodigious surroundings.

◆

EDGING TOWARD DAWN

OFIS ARHITEKTI

A saw-toothed shelter
that makes even a non-believer fall
to their knees in reverie reaches
towards the heavens atop
a precipice in the Kamnik Alps.

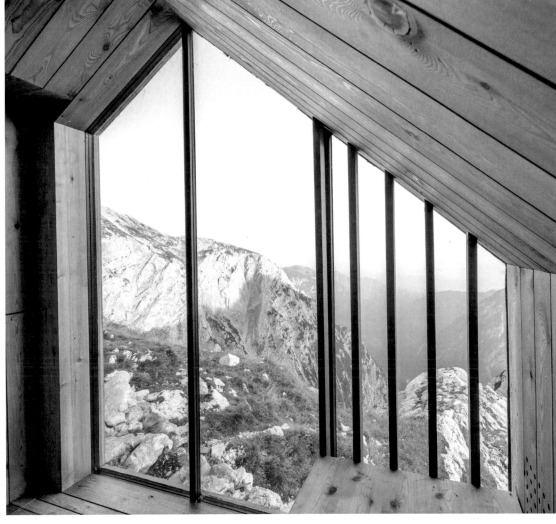

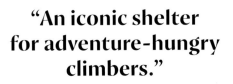

"An iconic shelter
for adventure-hungry
climbers."

EDEN IN THE ESTUARY

WHALE! ARCHITECTURE

Conceived as a stranded whale on a land of ancient ash, a house rises from the grounds in an act of nostalgia.

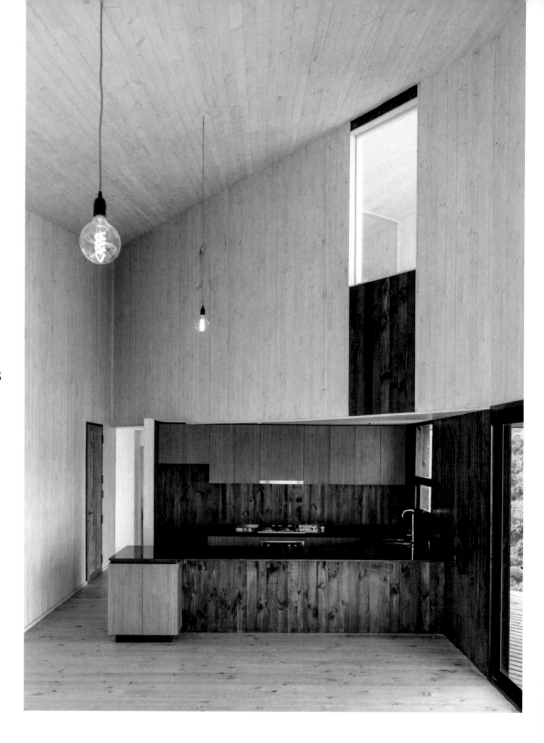

A home in a remote region off the coast of Chile reads as an abstracted whale sunning its back in the January sun. The pale gray exterior calls to mind the shades of stones collected along the shore. Maintaining a vivid reverence towards the delicate nature of the site and its rich textures, colors, and wild vegetation, the angular home bows respectfully to the land. Keeping a distance from the beach, the waterfront hideout defers from the environmentally complex context to construct an escape at once cultural, historic, and poetic. The retreat acts as a somber nod to the ruins of a nearby slaughterhouse and an homage to the enduring presences of whales just off the Pacific. This ghostly outer cloak gives way to a lucent interior punctuated by wraparound expanses of glass. Negotiating the line where concealment meets exposure, the residence oscillates between enigma, symbol, and shelter. ◆

"The pale gray exterior calls to mind the shades of stones collected along the shore."

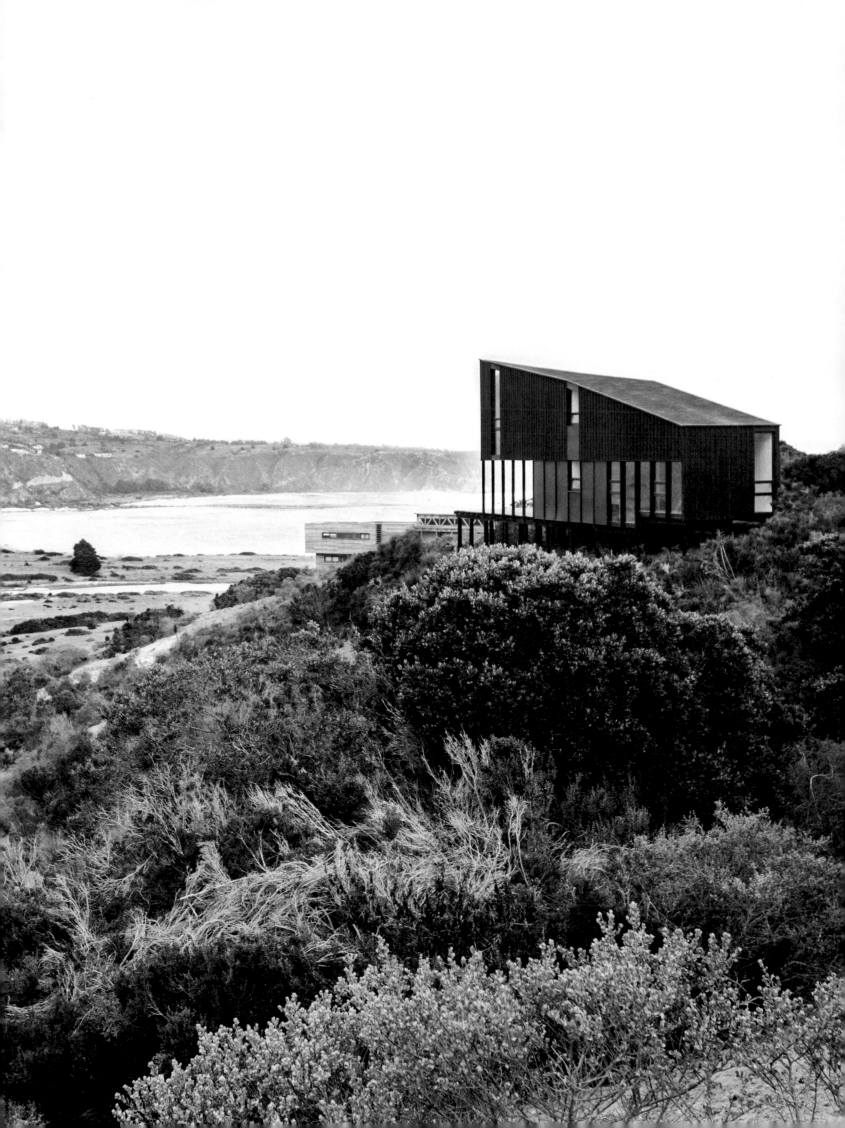

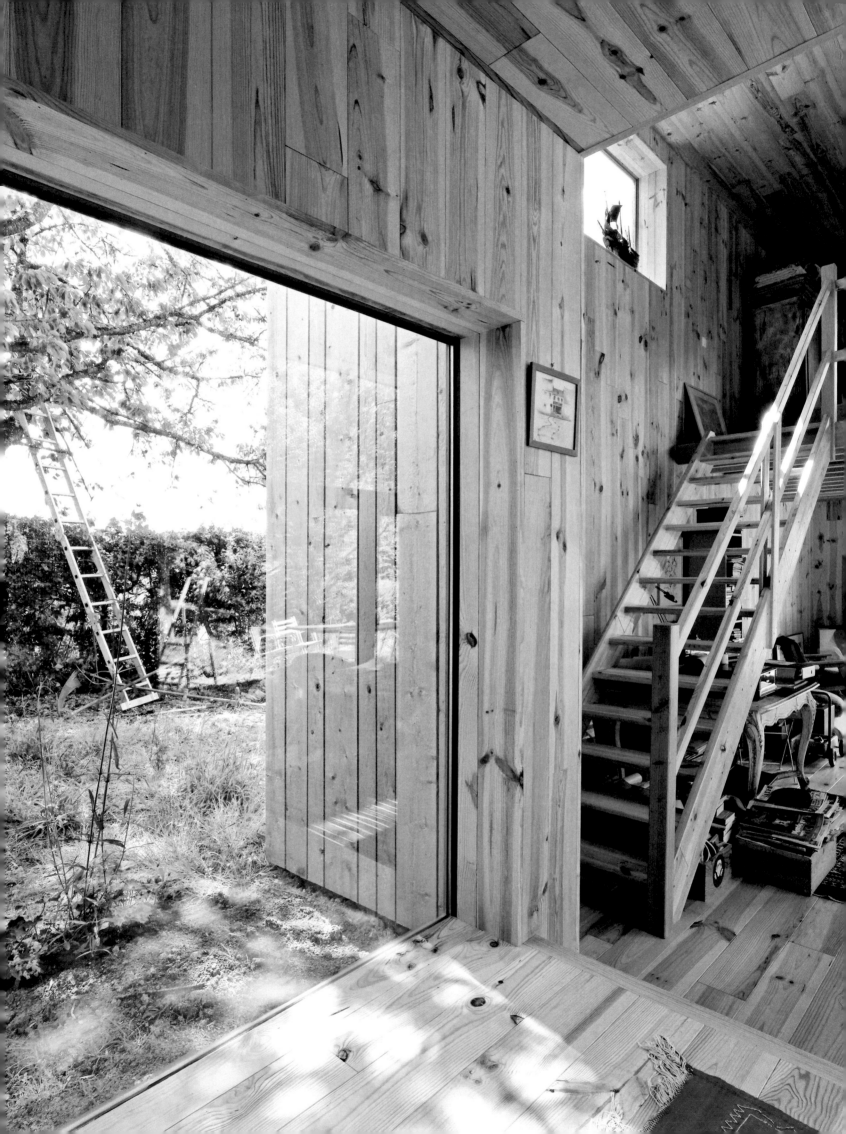

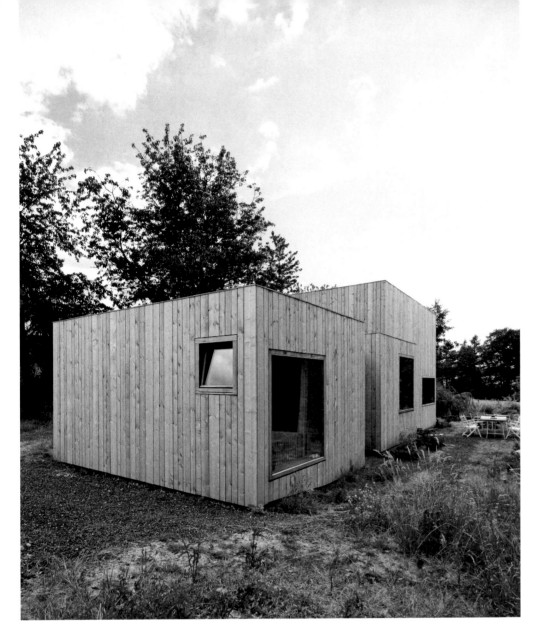

CANDID COUNTRY

M ARCHITECTURE & V.O.

A modest home of interlocking cubes invites the verdant scenery surrounding a Belgium village into every room.

Four shifted volumes come together to form an uplifting Belgian retreat. Adapting to the inclined site, the informal gathering of cubes suggests further growth over time. The interconnected structures inspire visceral relationships between man and nature. From a private terrace to a dining room overlooking the valley, each cube outlines a unique view of the land. The regional spirit of the holiday house culminates with an elevated space for observing the tall grass rustling in the meadow. A slender staircase up to the rafters reveals a cozy sleeping loft, where one can nest while never straying far from view. The open dining room pours into the terrain as mild breezes infused with the scent of wildflowers waft by. Dashes of color lead the eye through the sun-dappled home of warm finishes. Cherry red area rugs, an azure blue patterned tablecloth, and a lemon yellow shower animate the home—memorable accents in playful harmony with the emerald green hues of summertime. ◆

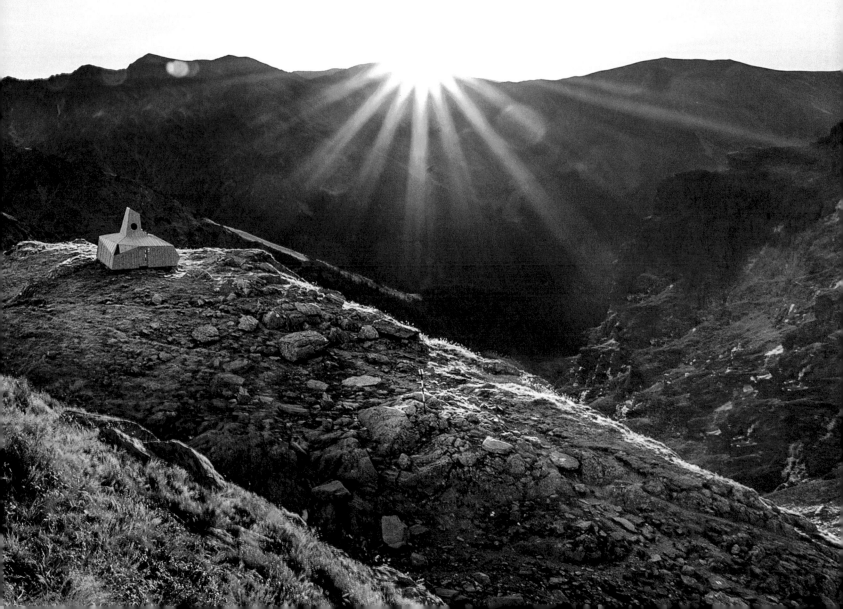

– Southern Carpathians, Romania –

SHINE A LIGHT

MARIUS MICLAUS

Lifted in by helicopter,
a refuge for rescue teams
and intrepid hikers
lights up the night sky
on the highest mountain
range in Romania.

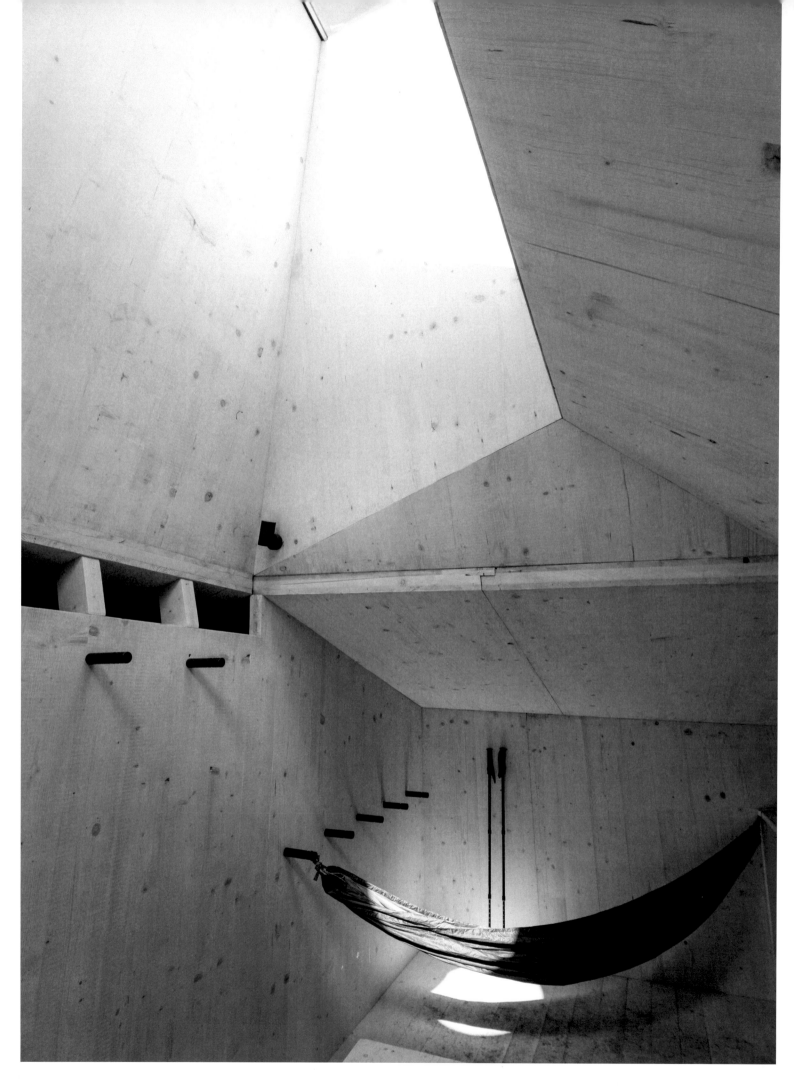

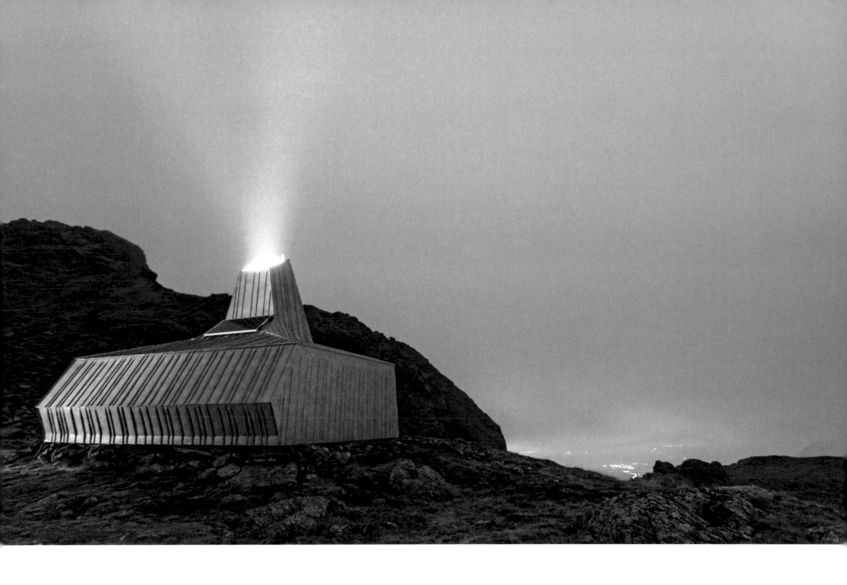

"By night, the building transforms into a reassuring beacon, shining light into the dark sky."

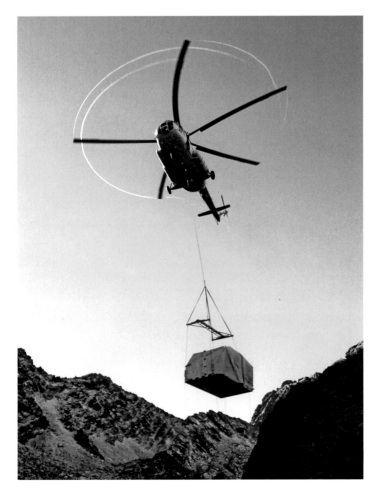

For those who choose to scale the formidable Fagaras Mountains, the tallest mountain peaks in Romania, a high-altitude resting place for the weary traveler awaits. The shelter, flown in by helicopter, appears 2,100 meters above sea level, where the air grows thin. Offering respite from the abundant snow and cutting winds as well as first aid for those in need, the cabin hosts a mountain rescue team and maintains bright, welcoming quarters for up to 19 travelers at a time. By day, the striking design guides explorers to safety. The pale bluish green exterior—reminiscent of the moss covered stones scattered across the land—makes the cabin easy to spot in a vista of awe-inducing mountainscapes. By night, the building transforms into a reassuring beacon, shining light into the dark sky—a comforting message to the lost that they have been found. ◆

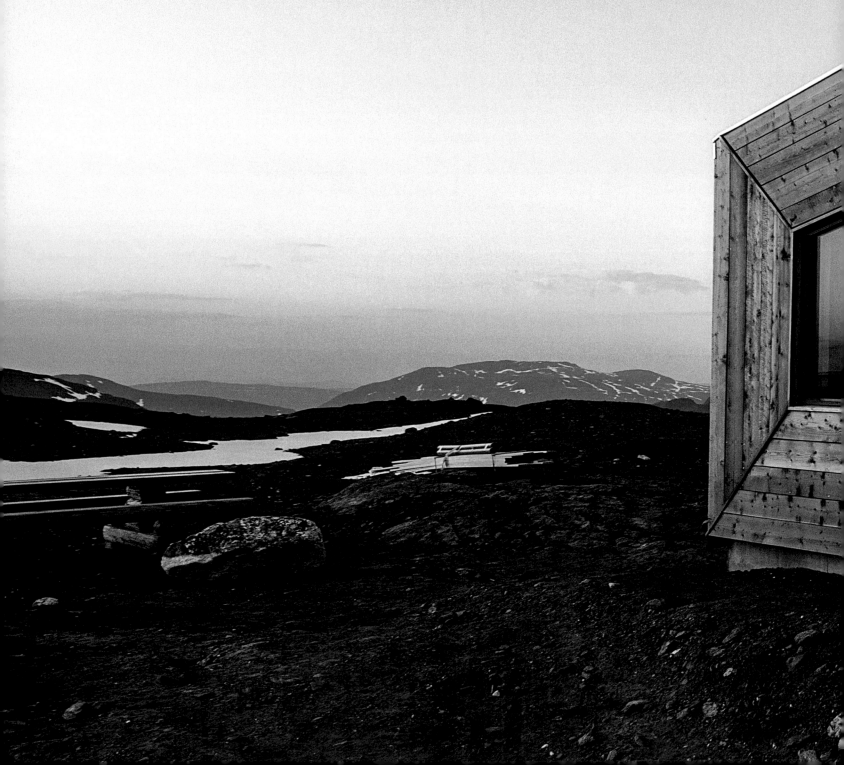

GLACIAL GETAWAY

JARMUND/ VIGSNAES AS ARKITEKTER MNAL

Amidst the formidable landscape of Northern Norway,
a safe haven for travelers
exalts the setting as much as it reveres it.

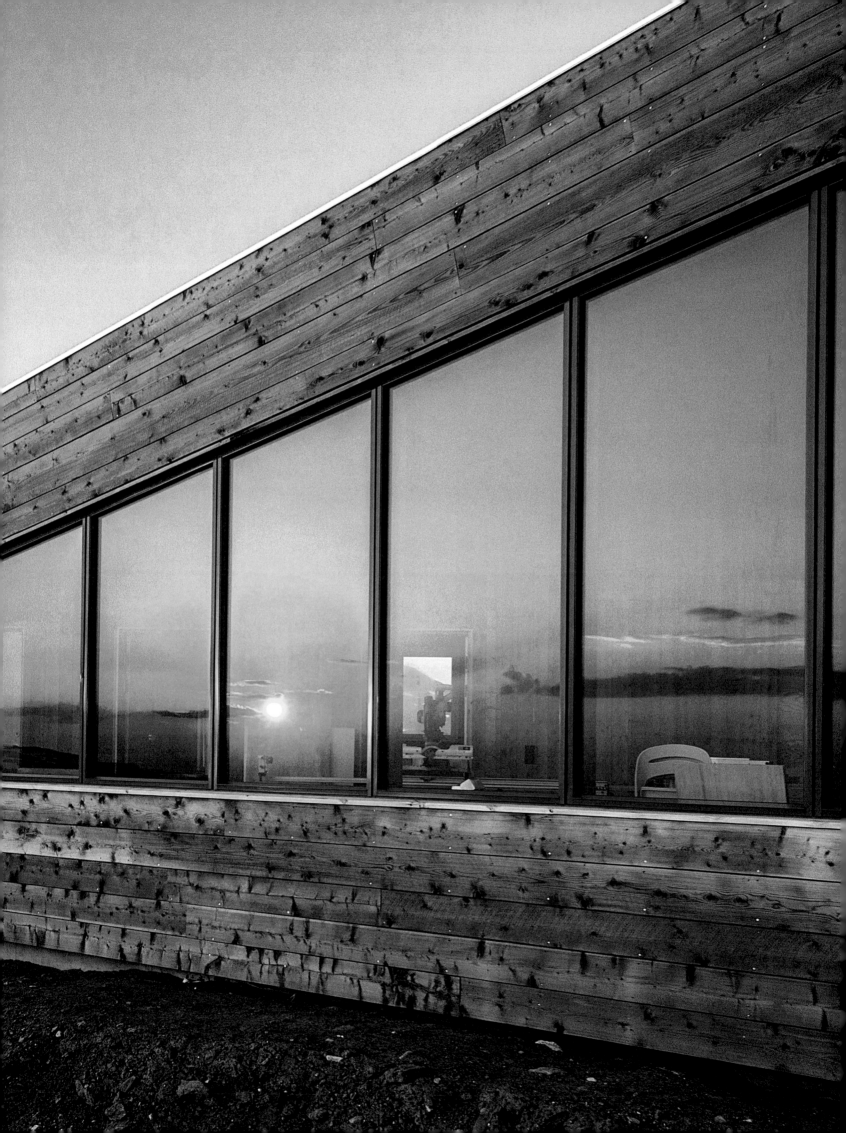

For those who prefer the road less traveled, a gracious cabin awaits. The shared shelter for up to 30 appears in a location so remote that guests can only reach it by foot or by ski. Located 1200 meters above sea level, the cabin enjoys a spectacular siting in the company of majestic mountain ranges and glaciers. The retreat forges a protective barrier to the rugged Nordic landscape—a safe haven for marveling at the dramatic vistas and rock formations while remaining sheltered from the regions harrowing winds and arctic freezes. The eye-catching yet neutral volume mimics the topography of the mountaintops. Generous windows open out in two directions, one set facing the mountain range and the other facing the mountain plateau and valley. These windows act as portals to the outdoors from within. When seen from a distance, these same windows dissolve the structure into a subtle form of mirrored camouflage where snowy peaks and vibrant sunsets return the manmade back to the natural world. ◆

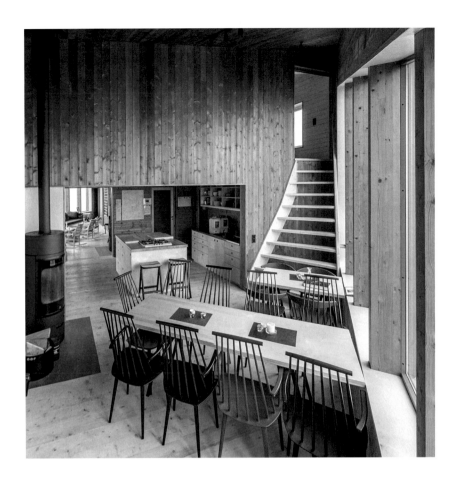

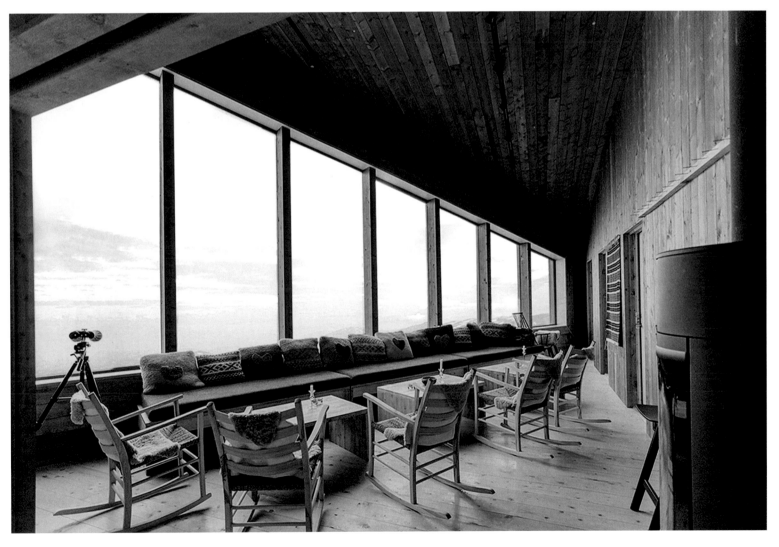

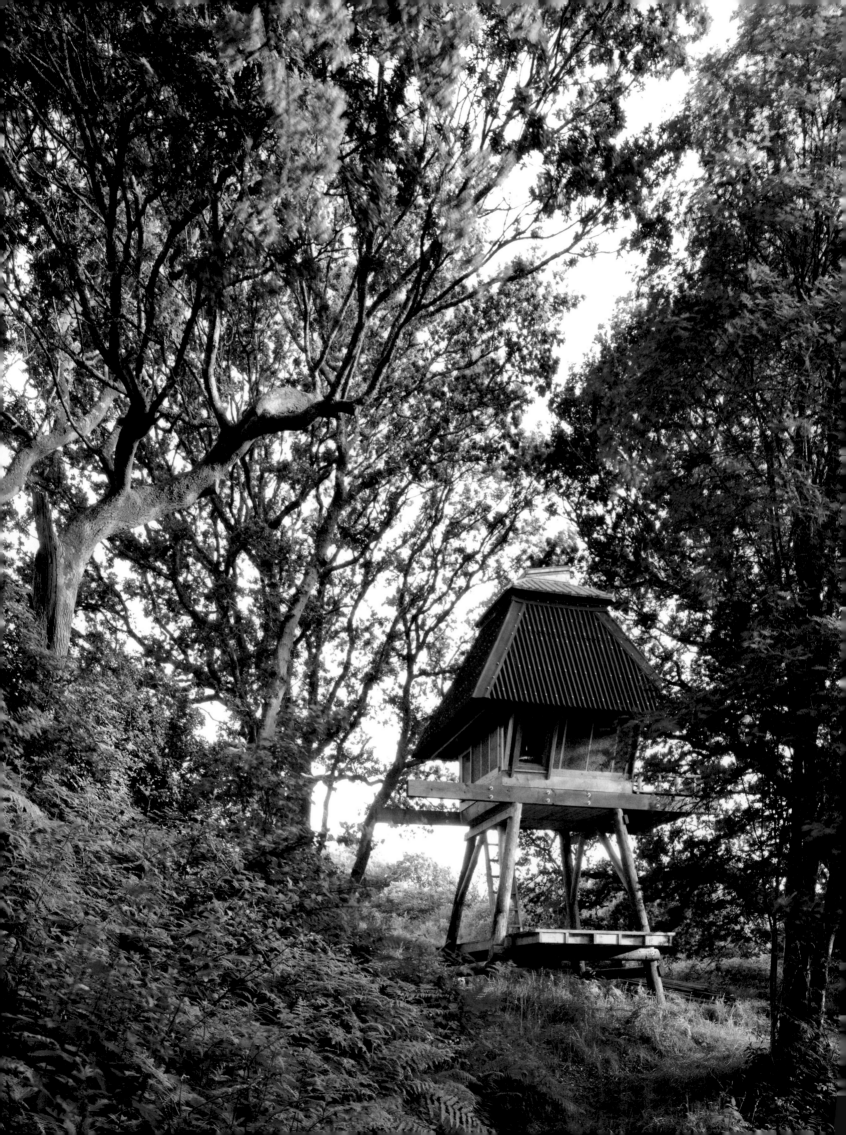

A HUT ABOVE

NOZOMI NAKABAYASHI

Japanese sensibility and a dash of English country charm converge in this protected treetop cottage perched amidst a cluster of benevolent oaks.

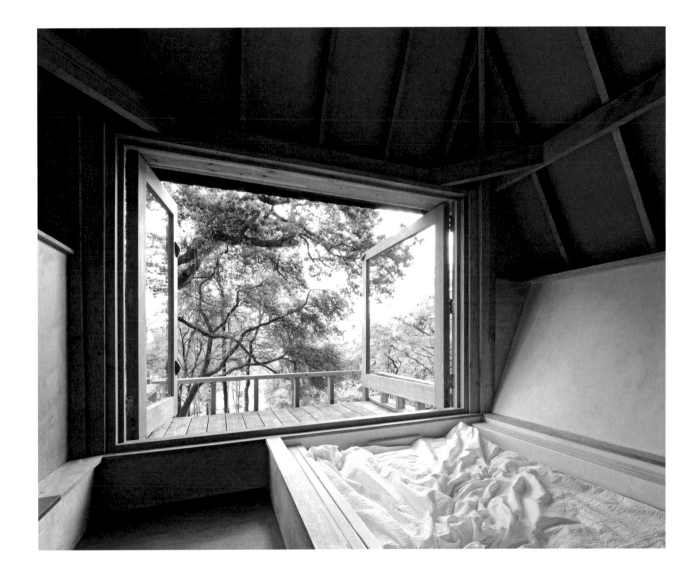

Pens glide easily over the page inside this aerial writer's refuge. The small hideaway finds its forest legs as it mingles with the treetops. The endearing hut walks the line between an English cottage and a Japanese treehouse. Hugged by a small patch of oak forest in a greater agricultural field, the elevated cabin allows its guest to see without being seen. Broad views stretch across the fertile fields all the way to the nearby lake. The overnight retreat fosters creative outlet above the earth and among the branches. Comfort and suspense intertwine like new leaves, offering a humble space for contemplation and respite. Generous picture windows complete the space, weaving into a private sun deck high above the ground. From this privileged vantage point, the refuge expands its impression well beyond its diminutive footprint to commune with the forest and the soundtrack of an abundant wildlife. ◆

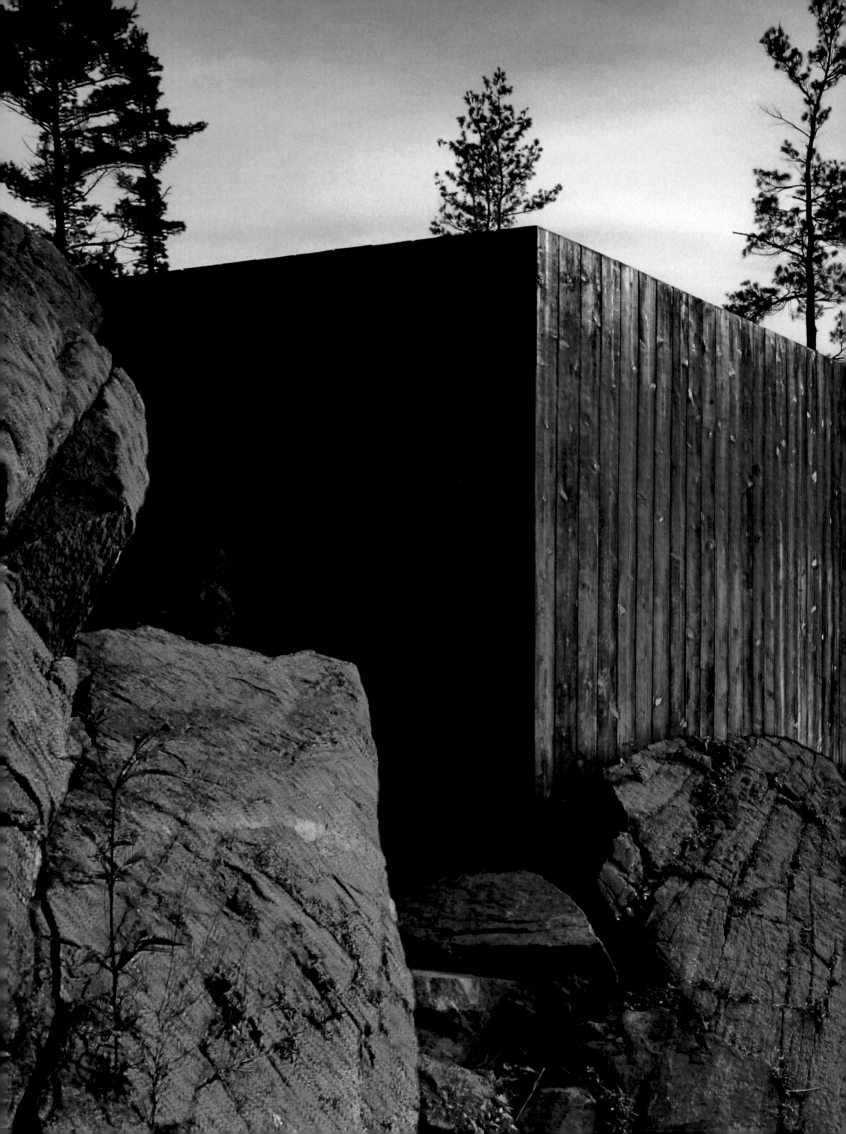

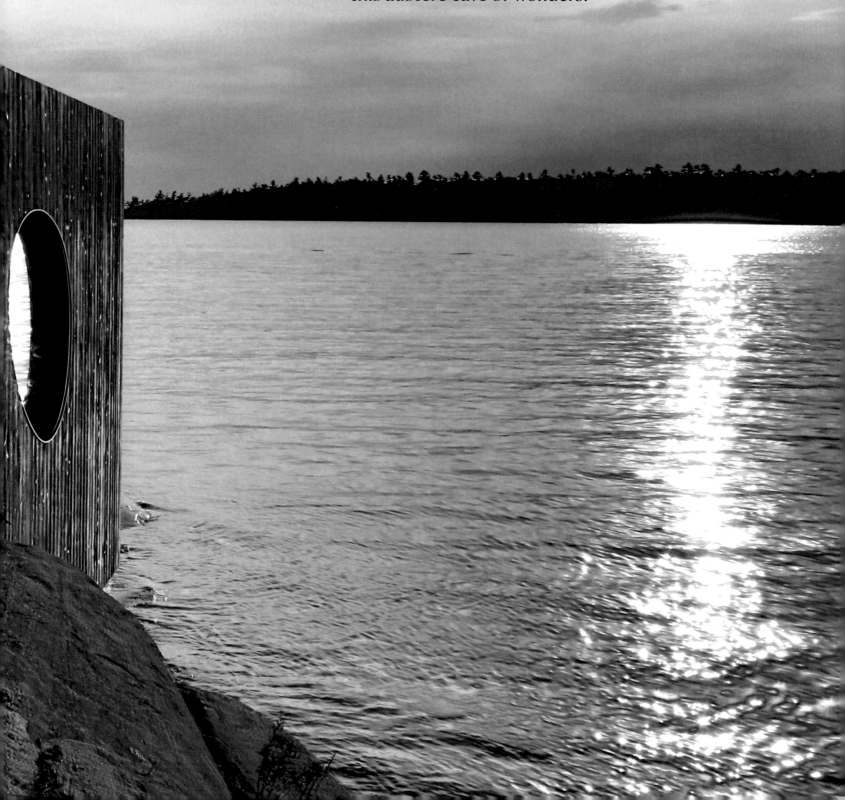

ISLAND GROTTO

PARTISANS

Straight edges, clothing,
and expectations are thrown to the wind inside
this austere cave of wonders.

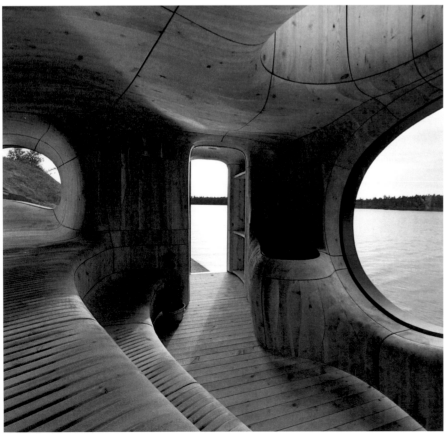

Teetering at the precipice of a craggy island in Canada's most pristine wilderness, a discreet wooden box shrouds a voluptuous sauna within. The secretive sanctuary draws inspiration from the Italian grotto—a water-filled cave concealed within unsuspecting rock formations. Old-world craftsmanship and new-world sustainability coalesce inside the richly sculptural space. At one with nature, the protective and sensual experience engages in a reverent dialogue with the trees, rock, lake, and sky. Charred cedar cloaks the exterior in a weathered patina, imprinting a reassuring familiarity usually only gleaned through the passage of time. By contrast, the warm, curvaceous interior emulates the swirling waves of Lake Huron as it mirrors the Precambrian shield—a soft, undulating rock surface worn over billions of years. The lustrous glow from within enhances the sun-kissed atmosphere above the Georgian Bay, while the pre-aged exterior carefully veils this raw intimacy from the outside world. ◆

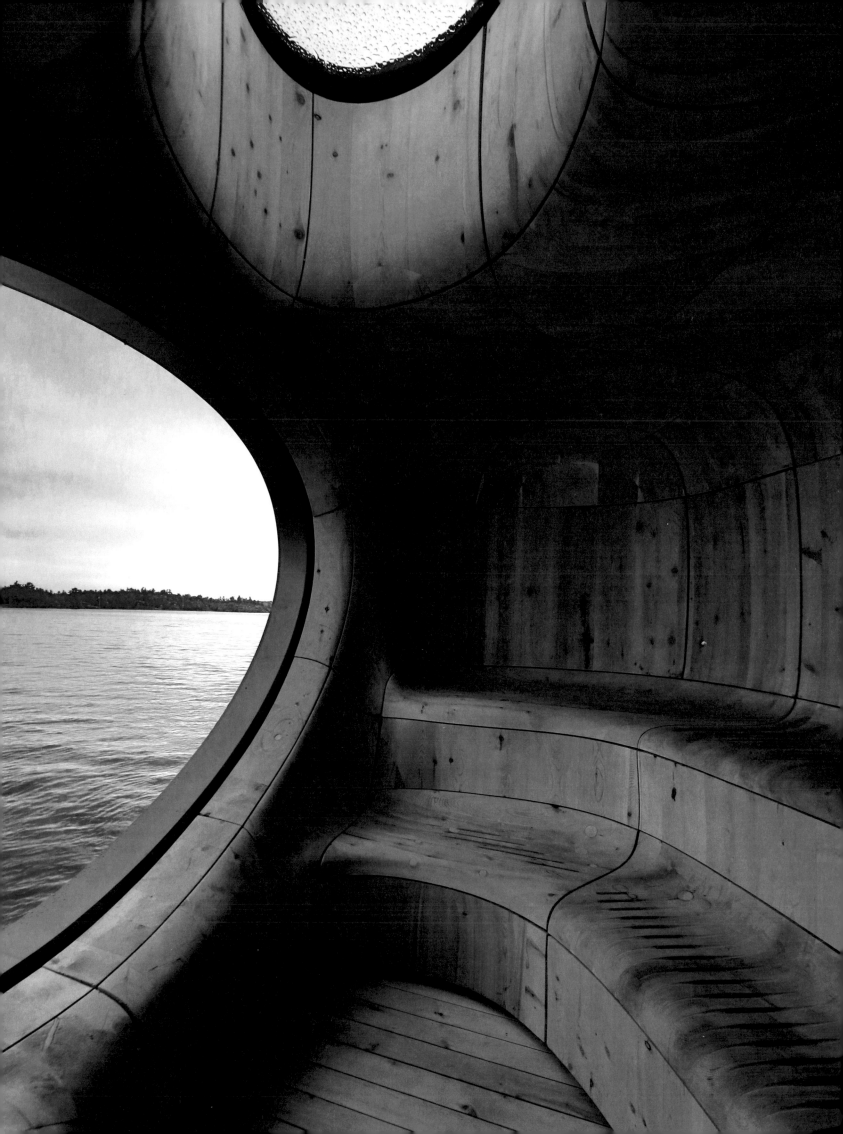

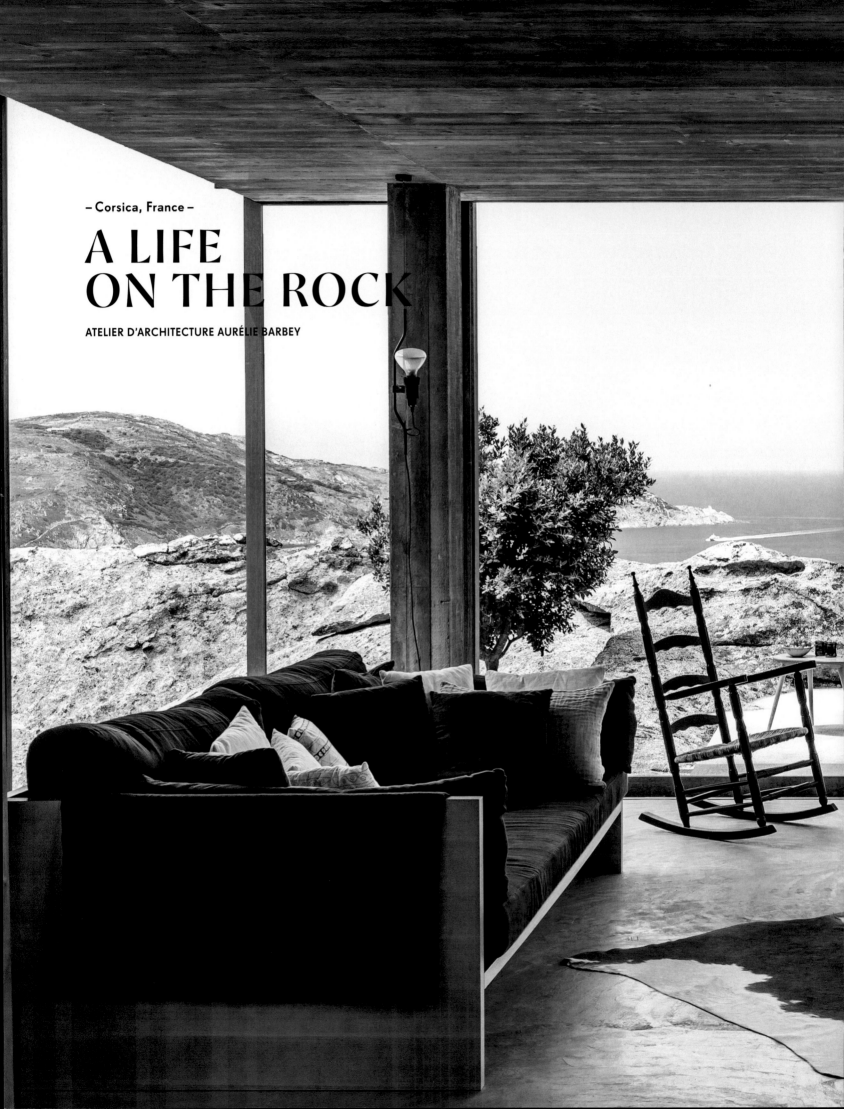

– Corsica, France –

A LIFE
ON THE ROCK

ATELIER D'ARCHITECTURE AURÉLIE BARBEY

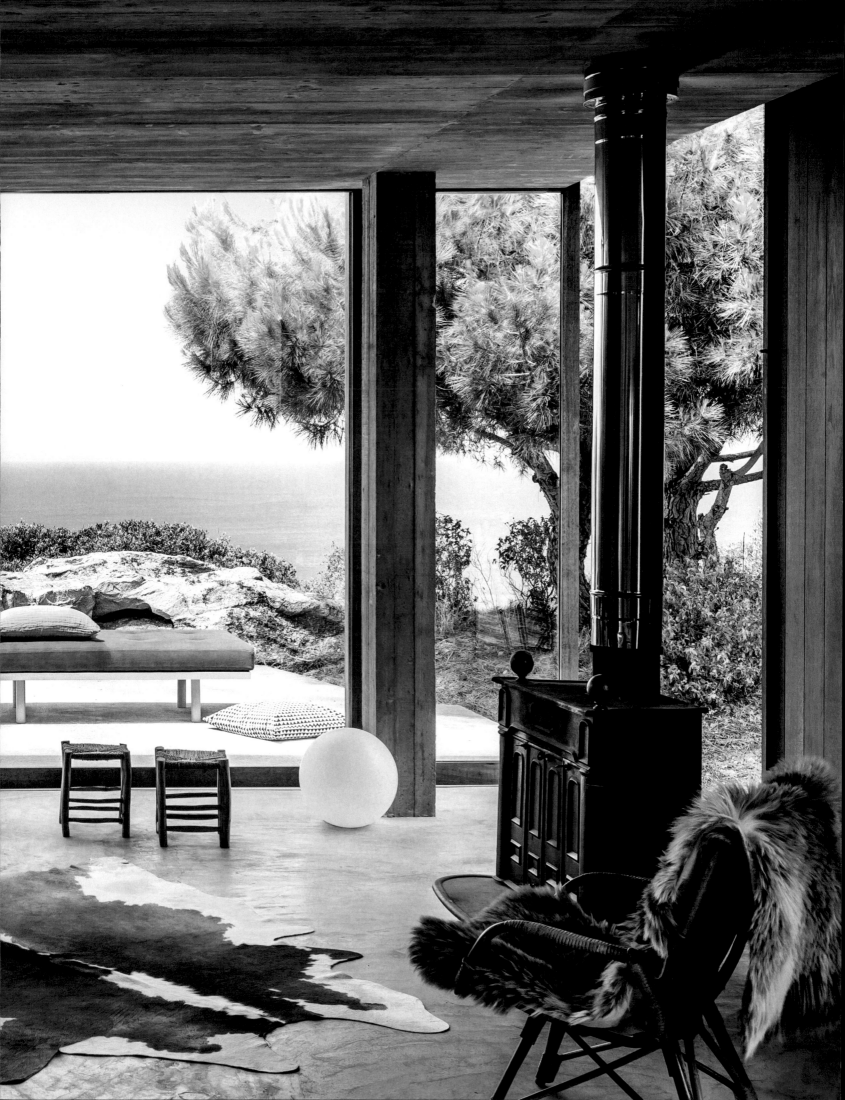

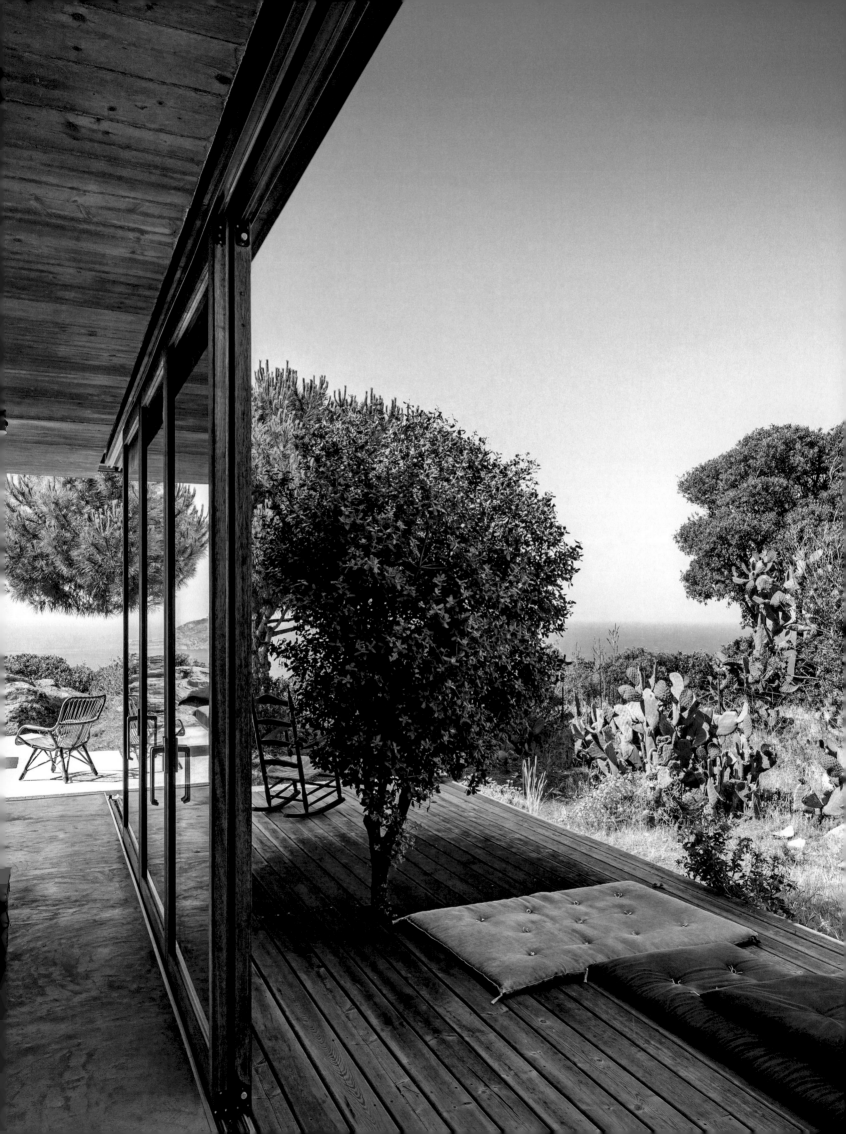

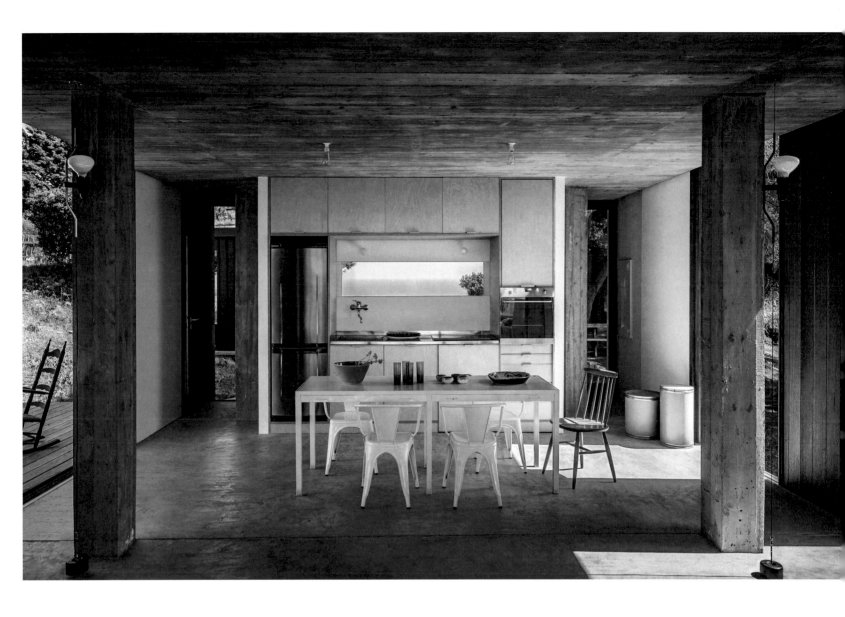

Between the imposing boulders on the coast of Corsica, a modest seaside cabin occupies nature's exhilarating interstices.

Basking in an uninterrupted view of the Mediterranean, this beachfront getaway negotiates a dynamic dialogue between home and site. The residential intervention deftly maneuvers between monumental boulders and native vegetation. Composed of a main building and three supporting huts, the house floats on pilotis and faces out towards the maritime horizon. The understated vacation home works with rather than against the dramatic scenery, lightly taking its place amidst the proud rock formations and the pine and oak forest. As doors and windows are thrown open to let in the salty breeze, the living room lures visitors out onto the sundeck and towards the sea beyond. This deck winds its way around the house, dying into a muscular boulder on one side and meandering around an existing tree on the other. Intended as a series of follies, the retreat finds shelter and grace alongside its regal neighbors—rock, sea, sky, and forest. ◆

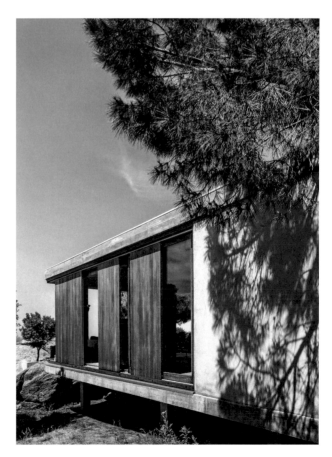

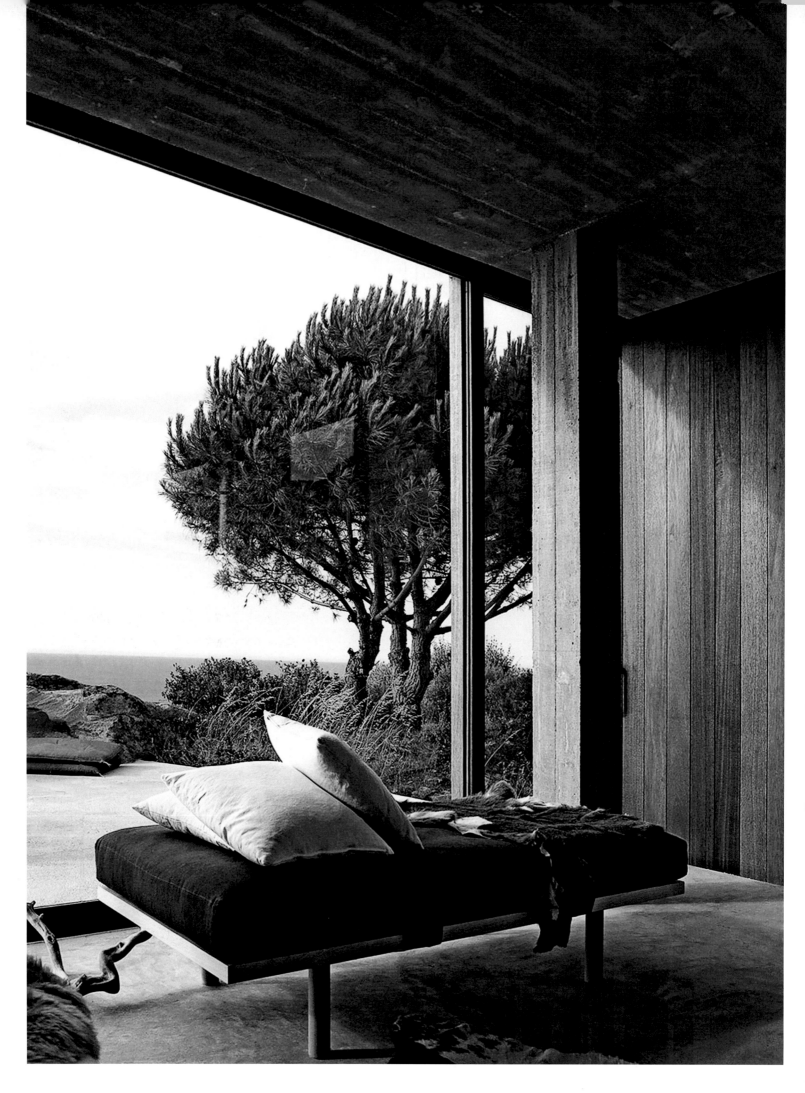

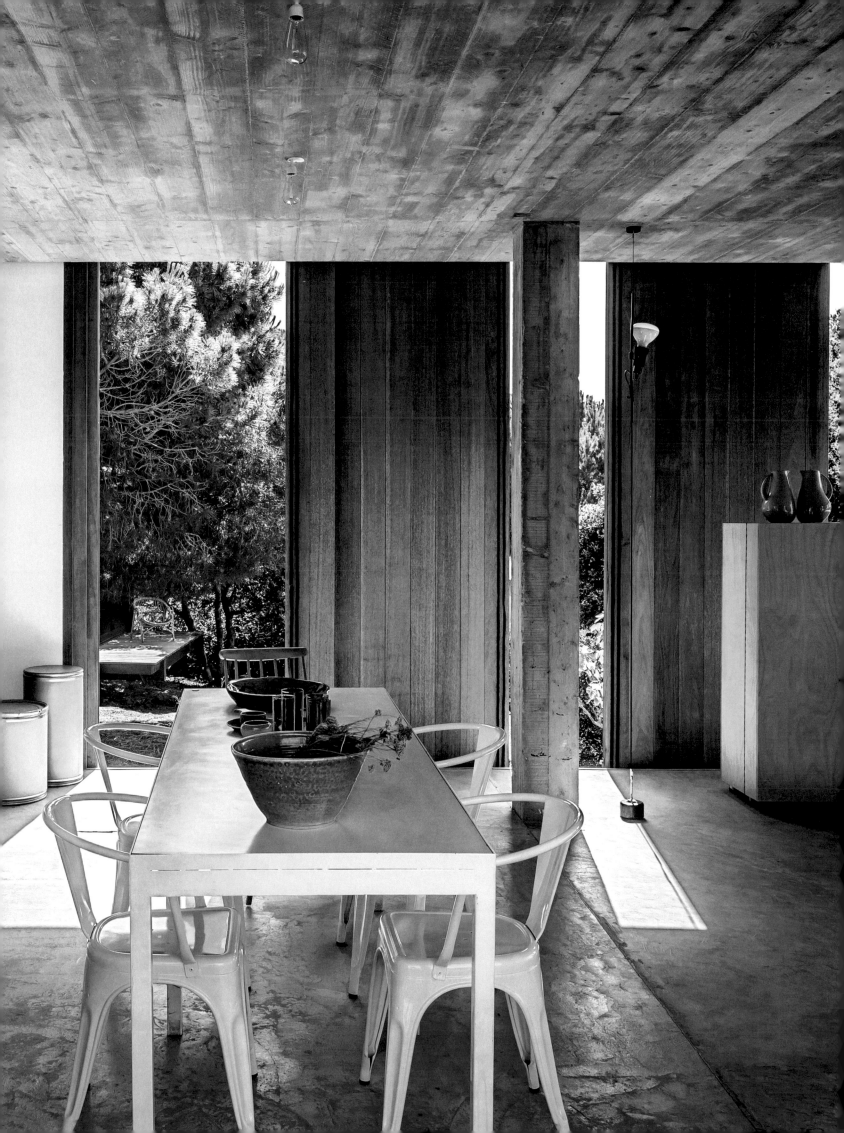

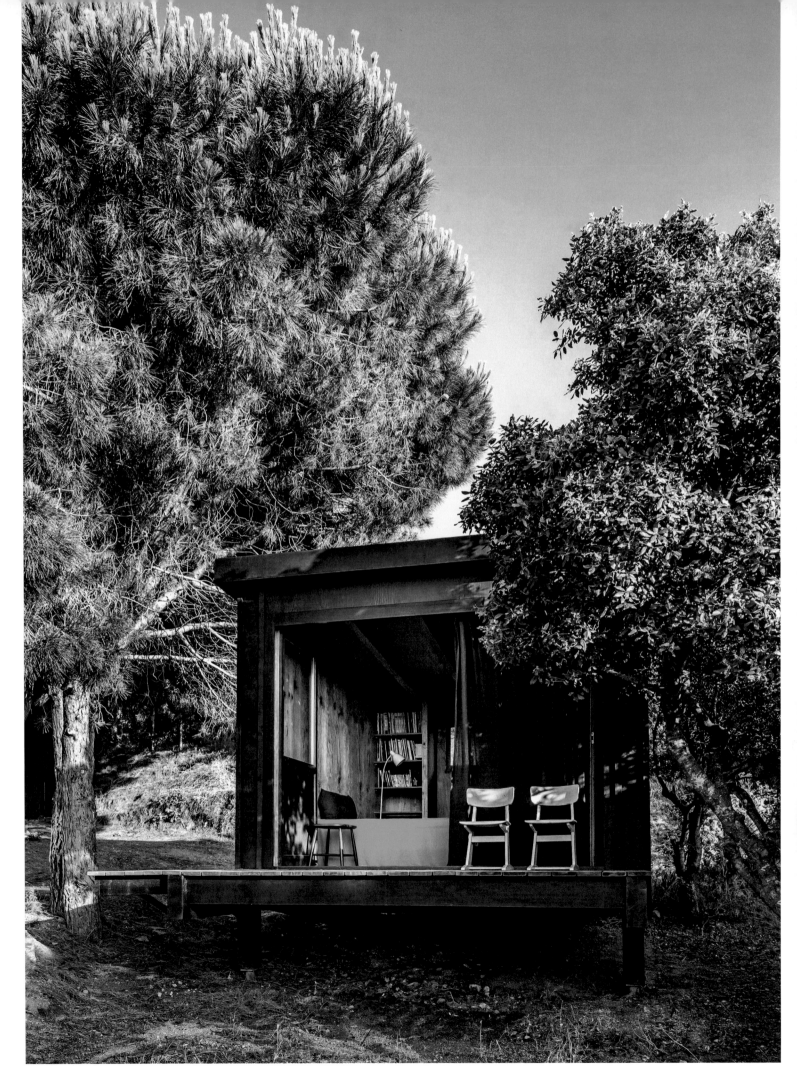

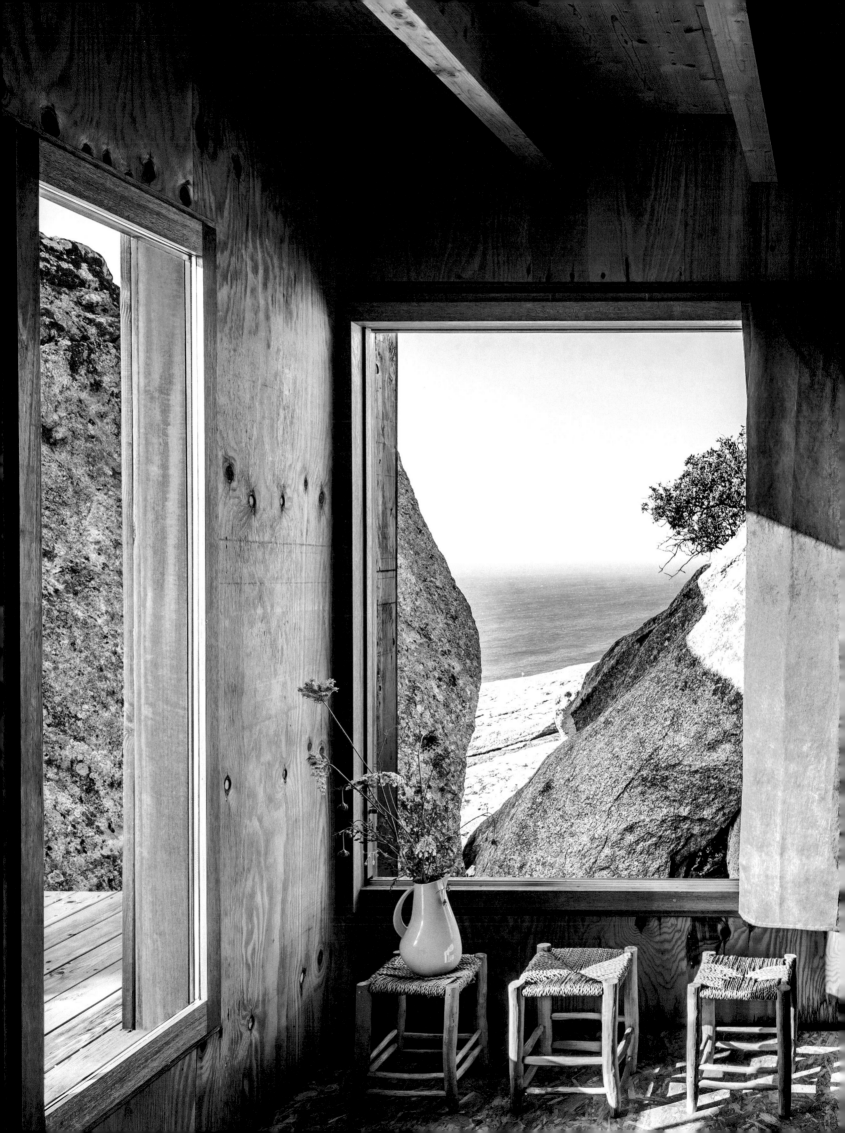

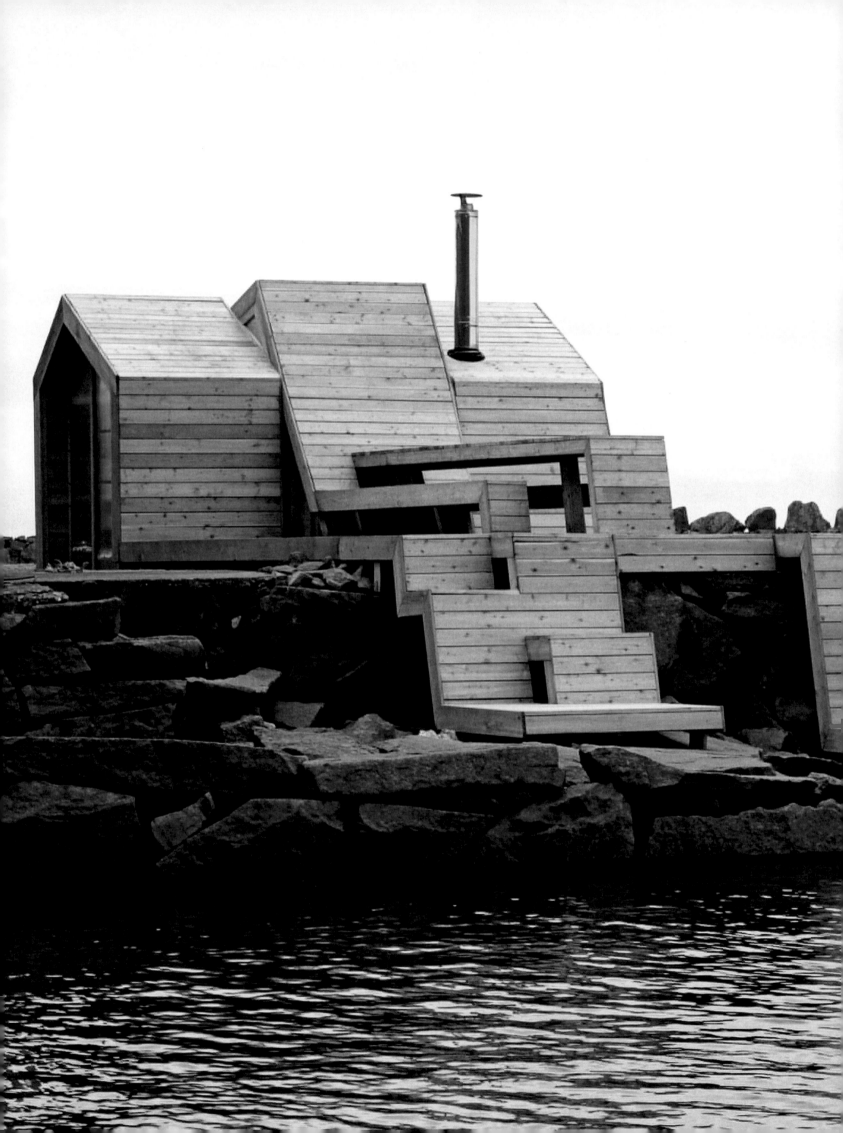

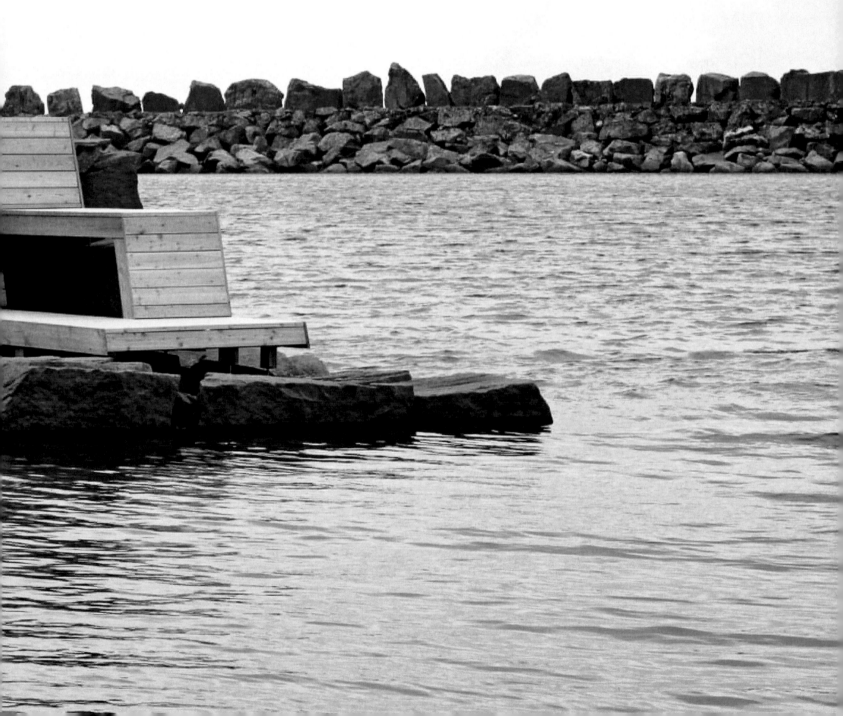

BAND OF OUTSIDERS

**SCARCITY AND CREATIVITY STUDIO &
OSLO SCHOOL OF ARCHITECTURE AND DESIGN**

*From sauna to sundeck,
an undulating topography
of wooden bands
rises and falls over a rocky quay
on the Norwegian shore.*

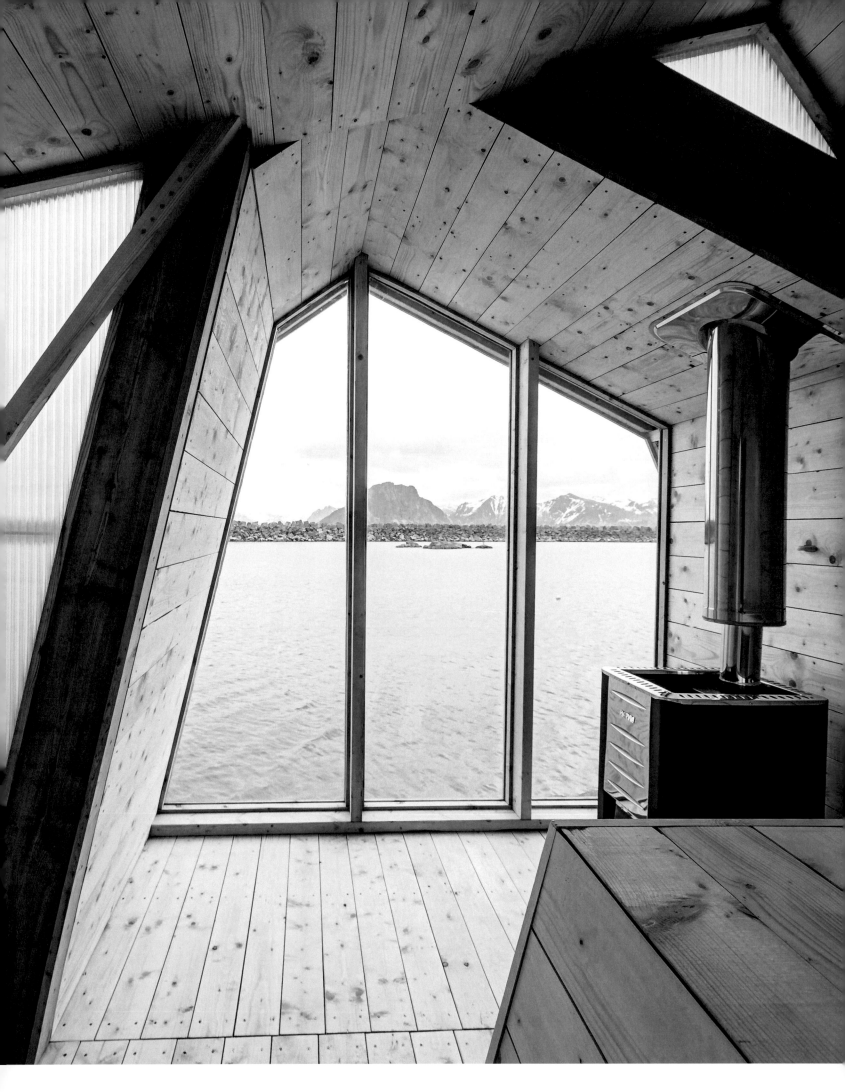

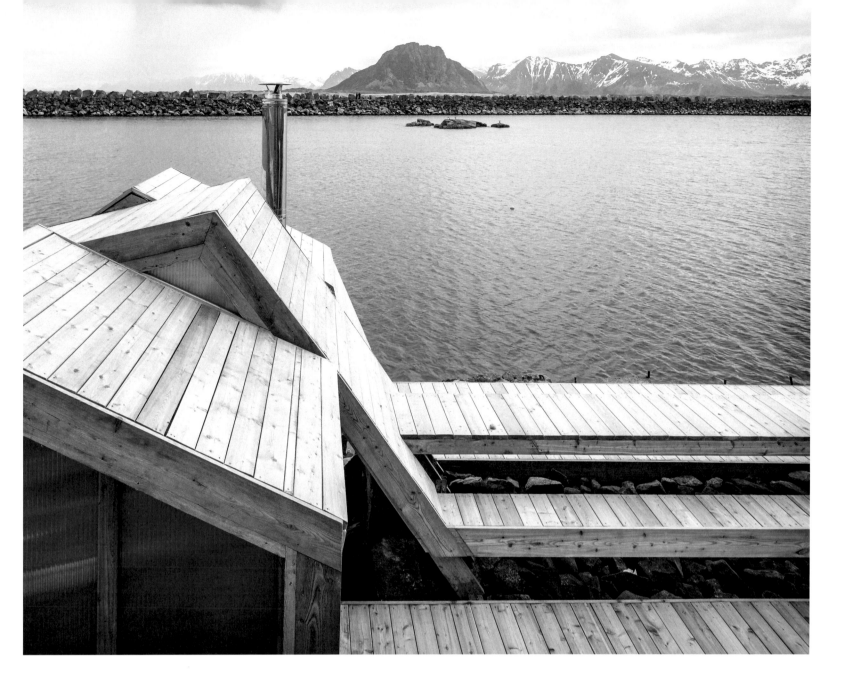

"The delicate strips rest lightly over the craggy pier, adapting to rather than altering the sensitive yet formidable surroundings."

Bands of Siberian larch wood run up and over a rugged jetty. As the strips ebb and flow, they form an expressive sauna and summer gathering spot. North of the polar circle in a Norwegian fishing hamlet that dates back to the 1900s, the articulated topography entices from the blustery shore. Three flexible, folding striations emerge from the rocks and stretch out independently from one another. These articulated strips craft four individuated outdoor spaces and an angular sauna within. A compelling abstraction of the dramatic environment, the manmade outdoor landscape casually moves from social sundeck to a space for cleaning fish and a cold dip area for cooling off between sauna visits. The considered intervention tiptoes over the fragile site. The delicate strips rest lightly over the craggy pier, adapting to rather than altering the sensitive yet formidable surroundings. Echoing the uniquely formidable landscape, where jagged mountains violently interrupt the expansive horizontal datums of the North Sea and its many fjords, the rhythmic and nuanced intervention introduces a new refuge and horizon line. ◆

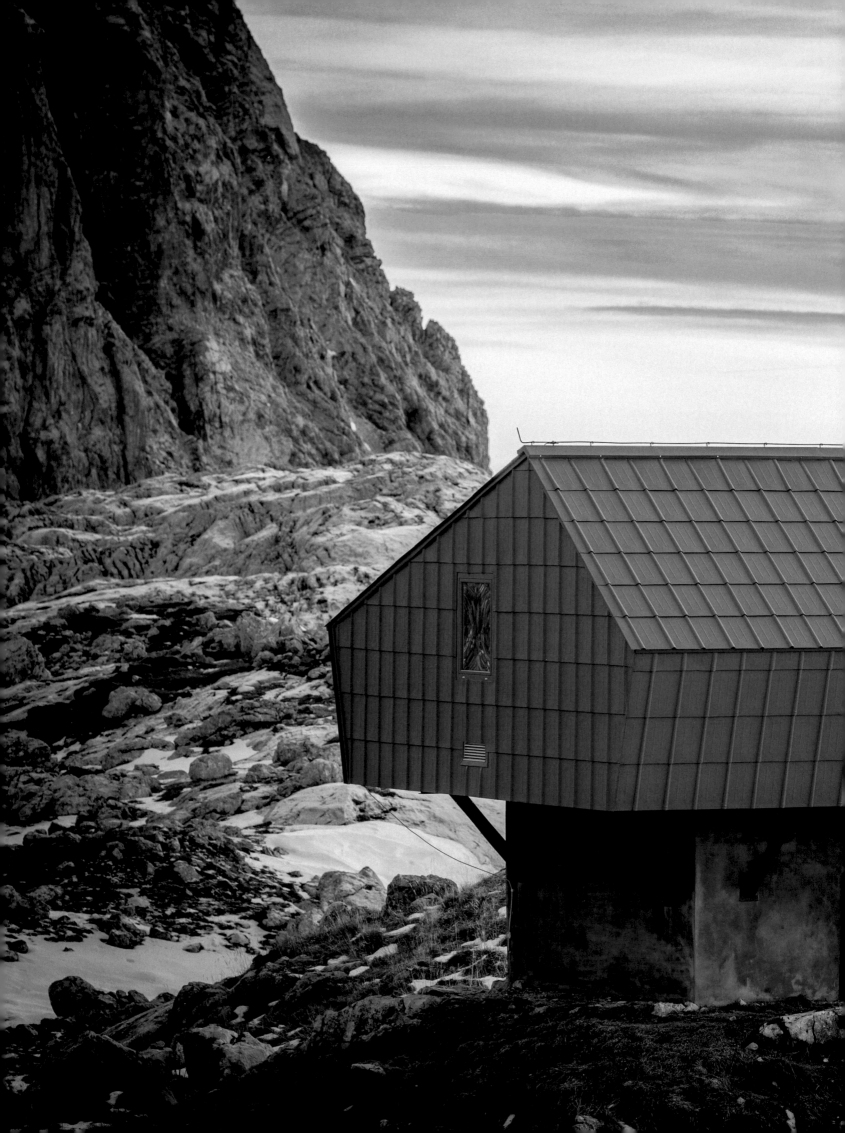

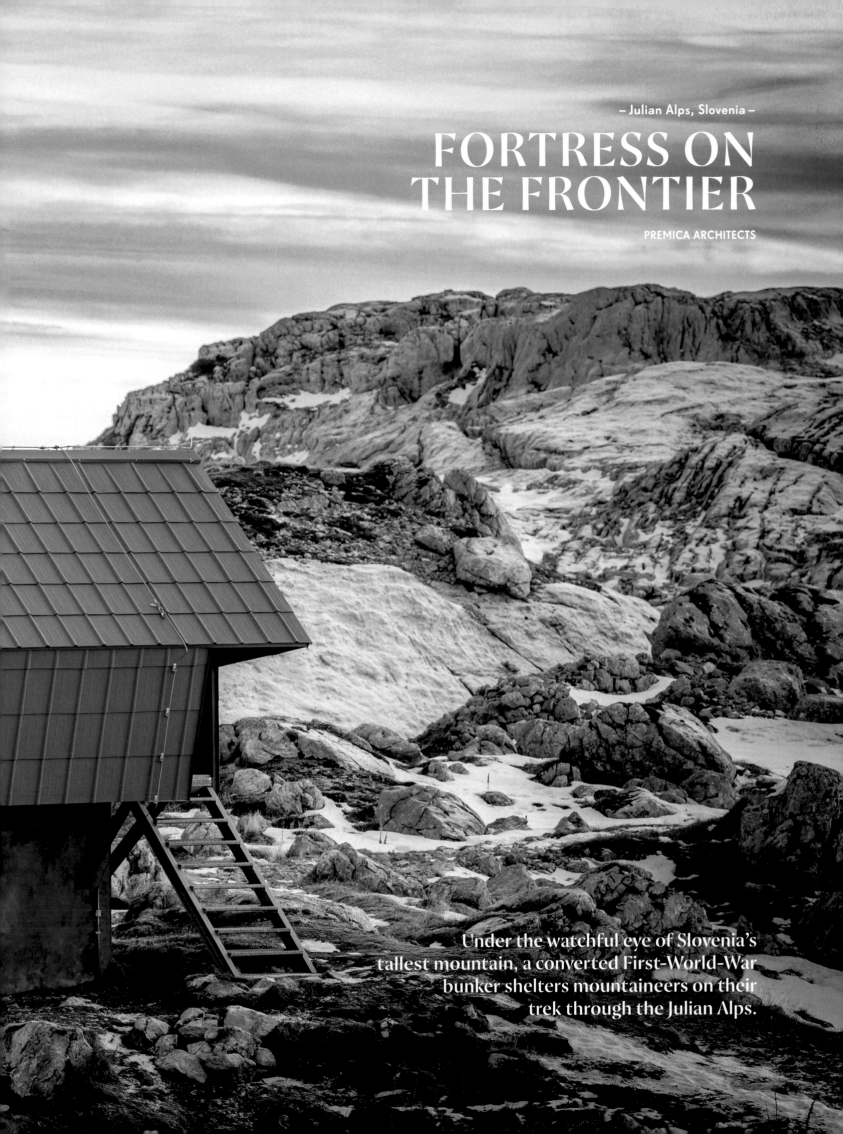

FORTRESS ON THE FRONTIER

PREMICA ARCHITECTS

Under the watchful eye of Slovenia's tallest mountain, a converted First-World-War bunker shelters mountaineers on their trek through the Julian Alps.

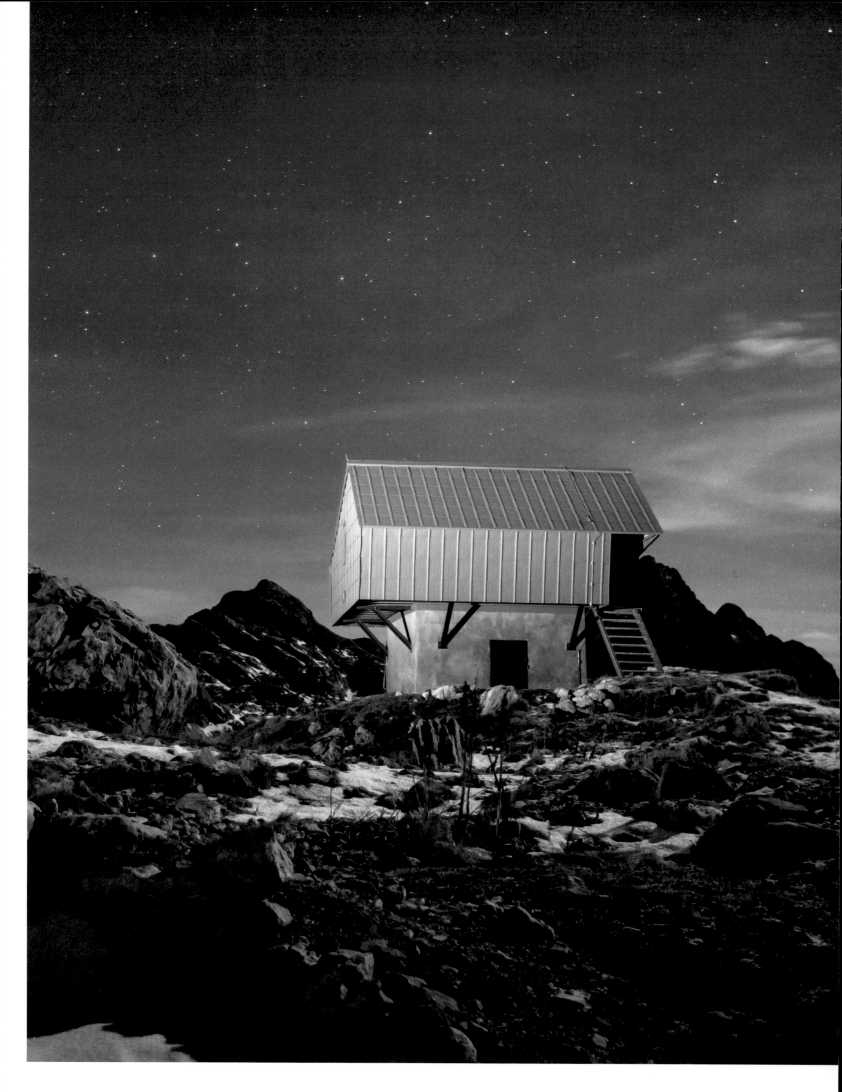

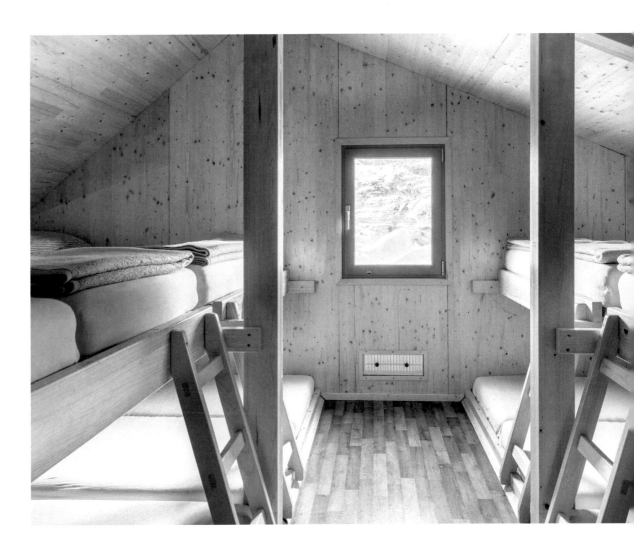

> **"Once inside,
> guests are offered
> a simple resting
> place and welcome
> reprieve
> from the storm."**

In the remote reaches of the Slovenian Alps, a cabin grafts onto a bunker dating back to the First World War. The theatricality of this unexpected pairing makes the shelter an unmissable sight for the sore eyes of weary travelers. Visible across vast expanses of the high-altitude mountain ranges, the shelter for mountaineers functions as a welcome haven in the tempestuous upper reaches of the frigid wild. The remote site stands more the 2,000 meters above sea level and once served as an active military site during wartimes. A single stair leads up and into the mysterious hybrid form. Once inside, guests are offered a simple resting place and welcome reprieve from the storm. Stitching together past and present, the intrepid form reads as a coat of armor, shielding from the gail force winds and treacherous snow. From within, visitors may rest their heads on their personal bunks and gaze out at a panorama fit for the gods. ◆

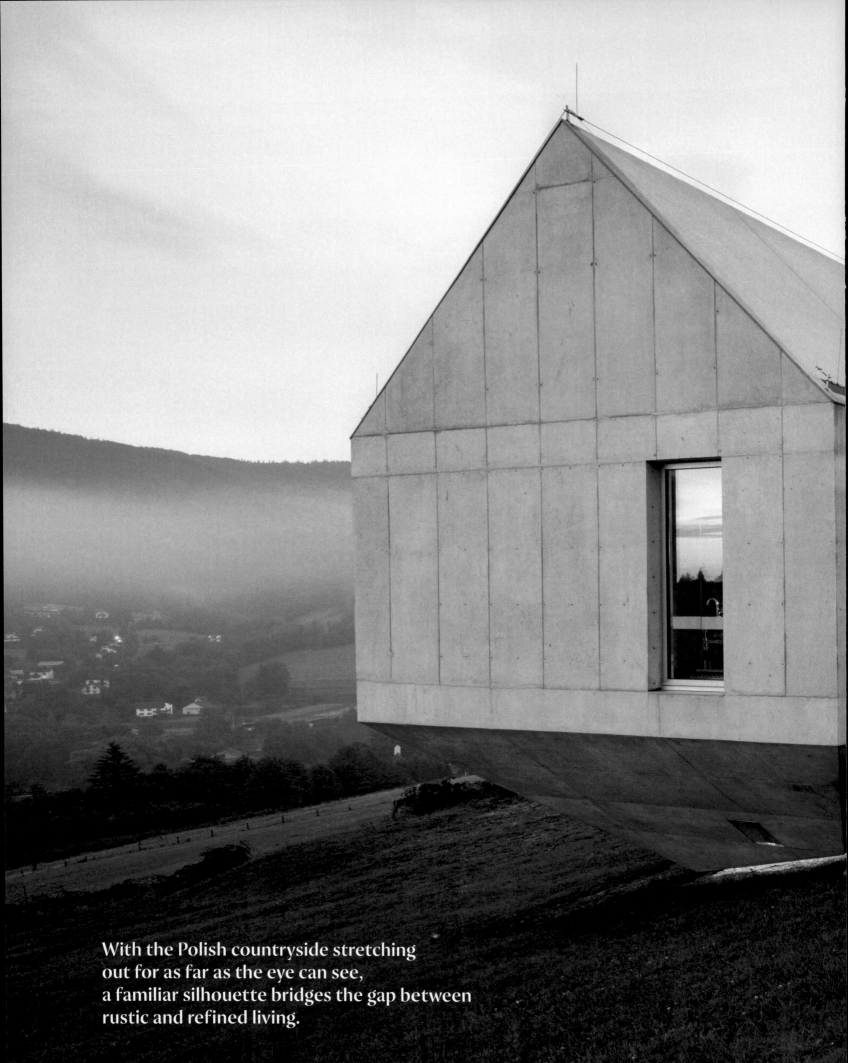

With the Polish countryside stretching
out for as far as the eye can see,
a familiar silhouette bridges the gap between
rustic and refined living.

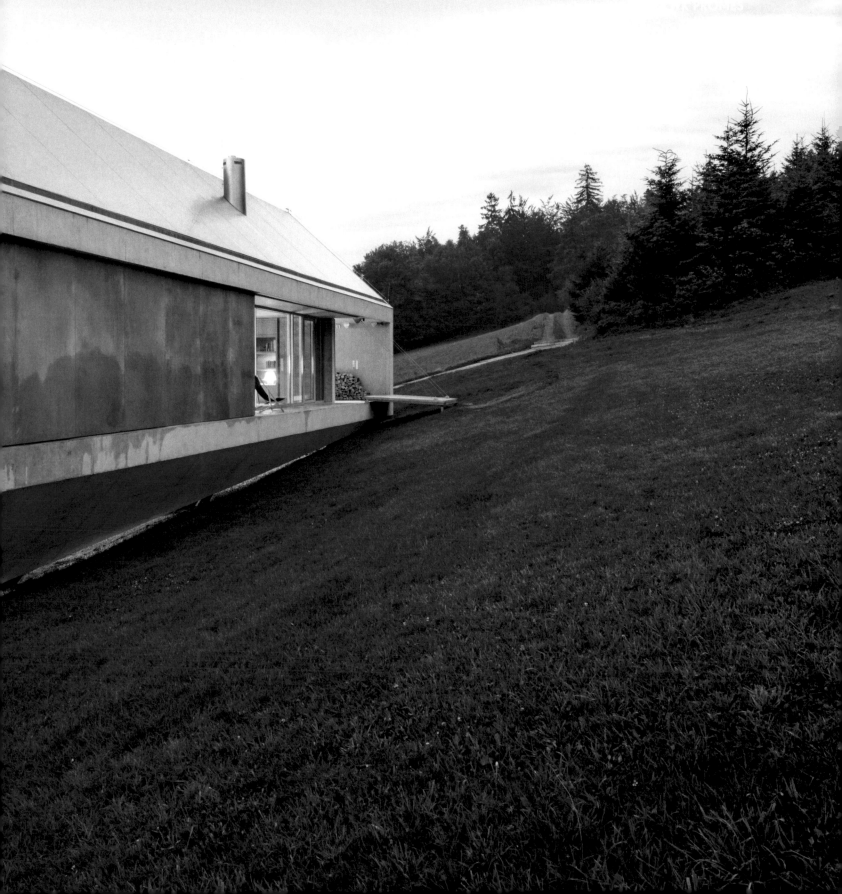

A BRIDGE IN
THE VALLEY

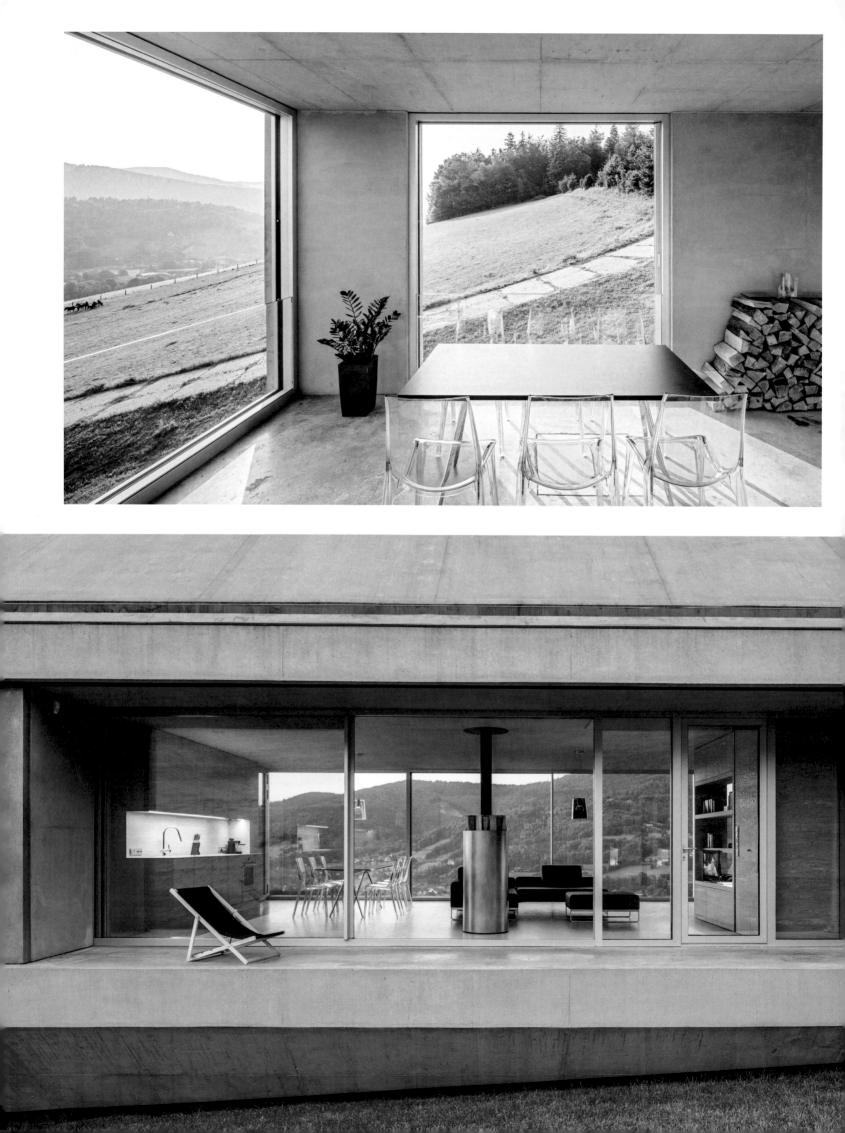

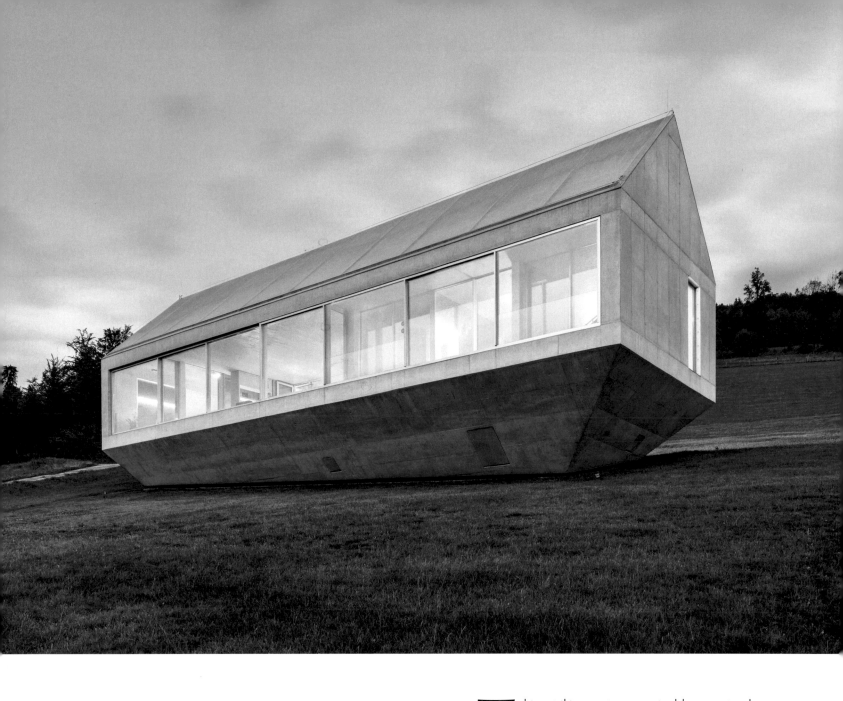

"Placed on a steep slope, the house resembles an ark floating over the fields as it lifts up off the ground for water to run past."

This striking yet recognizable country home stands as the only manmade structure visible for miles. Referencing the traditional shape of the classic pitched-roof barn, the residence extends along a low-lying horizontal datum. The home takes on a monumental quality as a mighty mass of concrete fills in the commonplace barn outline. Placed on a steep slope, the house resembles an ark floating over the fields as it lifts up off the ground for water to run past. With only one corner touching the earth, the single level interior pushes the most private areas of the home a safe distance into the air. Floor-to-ceiling glass opens up the two main faces of the house to the wilderness, becoming an equalizing frame for viewing the land. During periods of vacancy or inclement weather, a draw-bridge and sturdy wall shift into place, transforming the home into an impenetrable fortress. When in use, walls fly open, sun chairs move onto the terrace, and the fields weave into an endless backyard. ◆

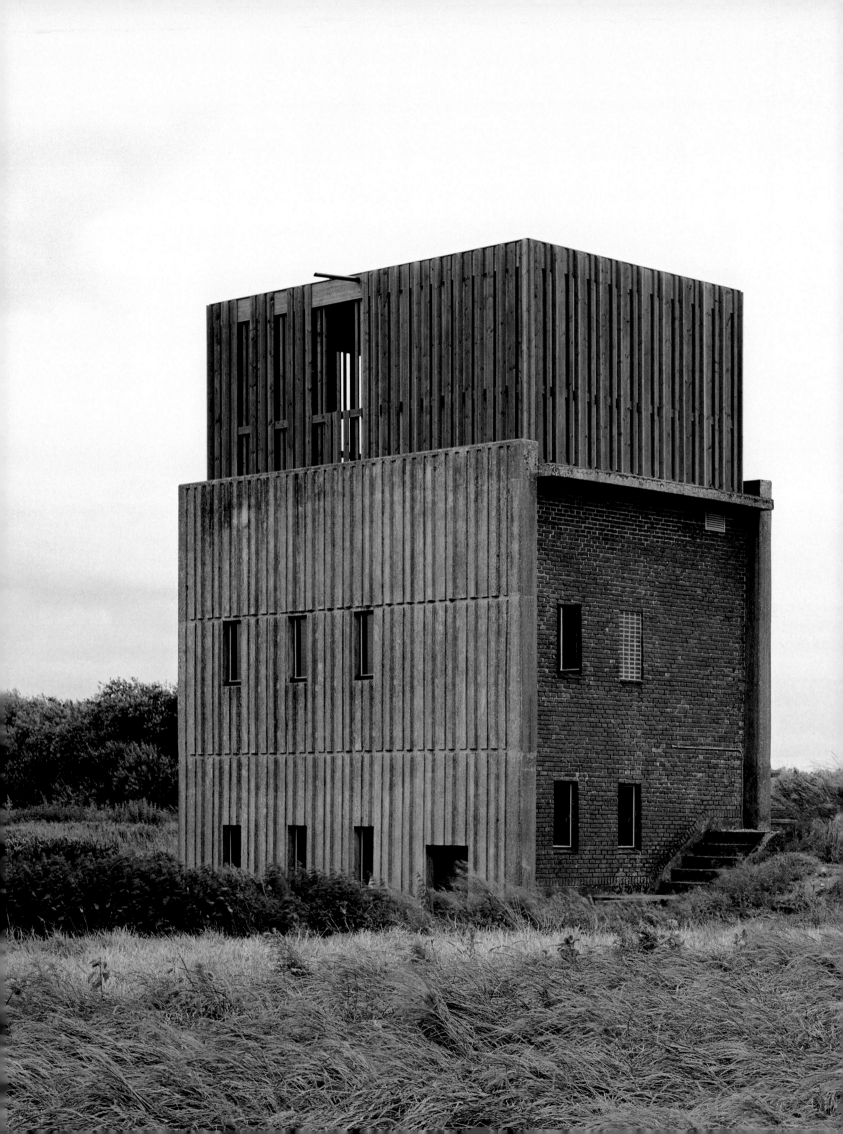

– Ringkøbing-Skjern, Denmark –

TAKE ME TO THE RIVER

JOHANSEN SKOVSTED ARKITEKTER

Where the delta ends
and the Danish plains begin,
a trio of mid-century
pump stations transform into
noble lookout points.

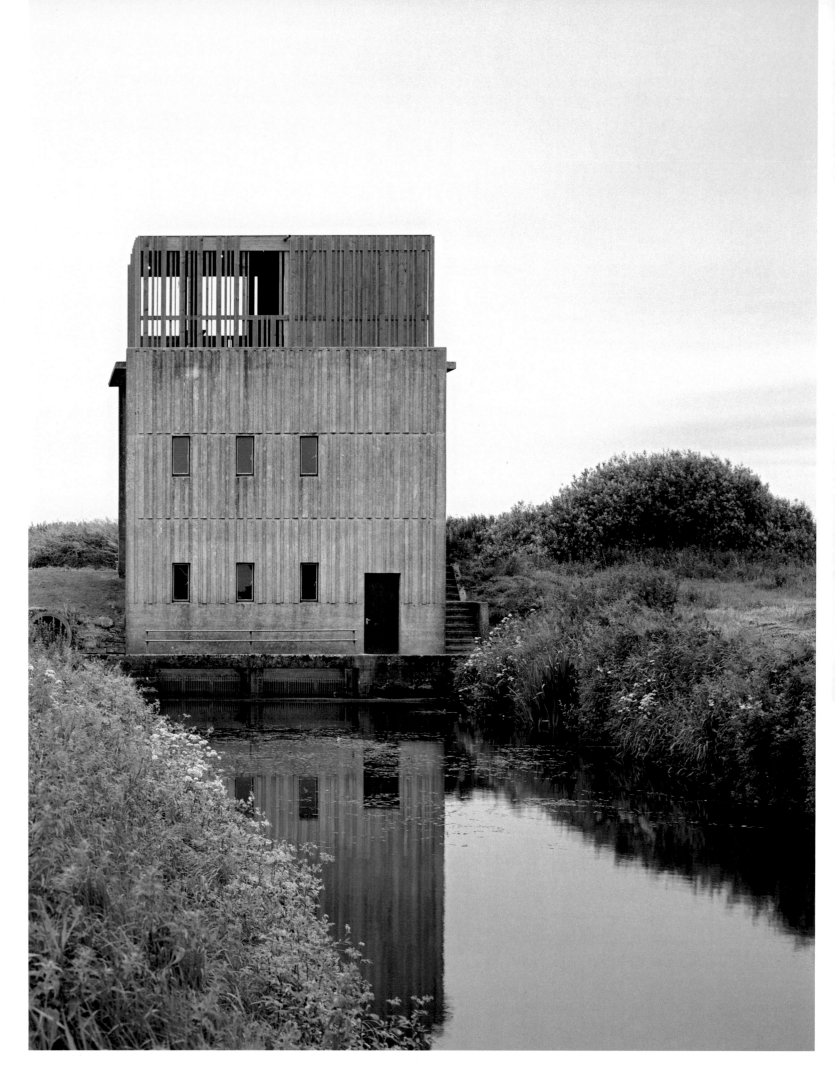

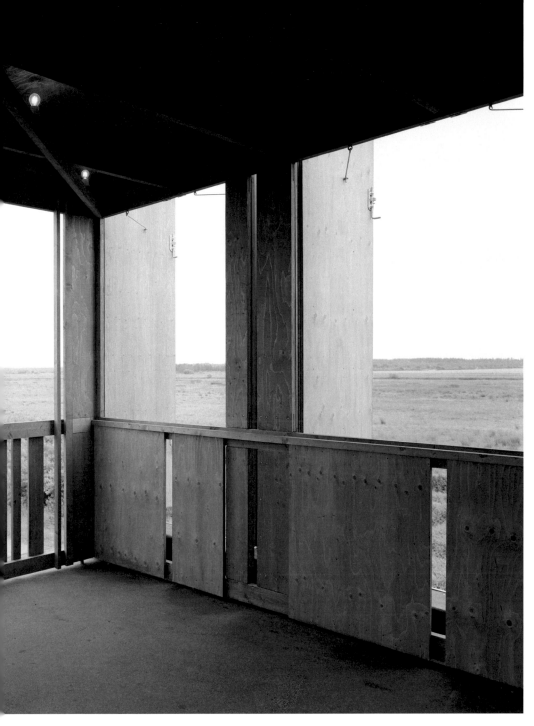

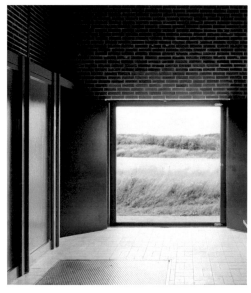

"The vertical relief of the extant concrete façades recalls the surrounding plowed furrows of the fields and soil banks lining the river delta."

Three pump stations from the 1960s find their second life as flexible exhibition and event spaces with indoor and outdoor lookout points over the landscape. The simple wooden extensions reiterate the proportions and rhythm of the original pump station reliefs. Complimentary yet unified, the gesture forges a direct link between past and present. Unsentimental and raw in their materiality, the vertical relief of the extant concrete façades recalls the surrounding plowed furrows of the fields and soil banks lining the river delta. The wooden additions bring a human scale to the project, challenging the robust, heavy character of the earlier structures while strengthening their presence in the Danish grasslands. Centered on the water's path, the pump stations' processional quality marks the transition of land as it moves from nature to architecture and back again. •

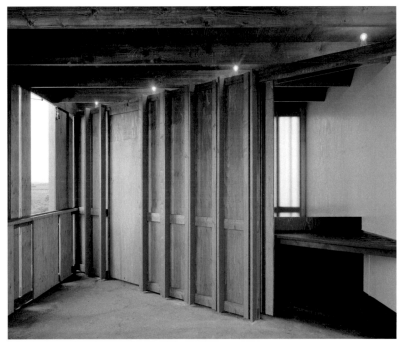

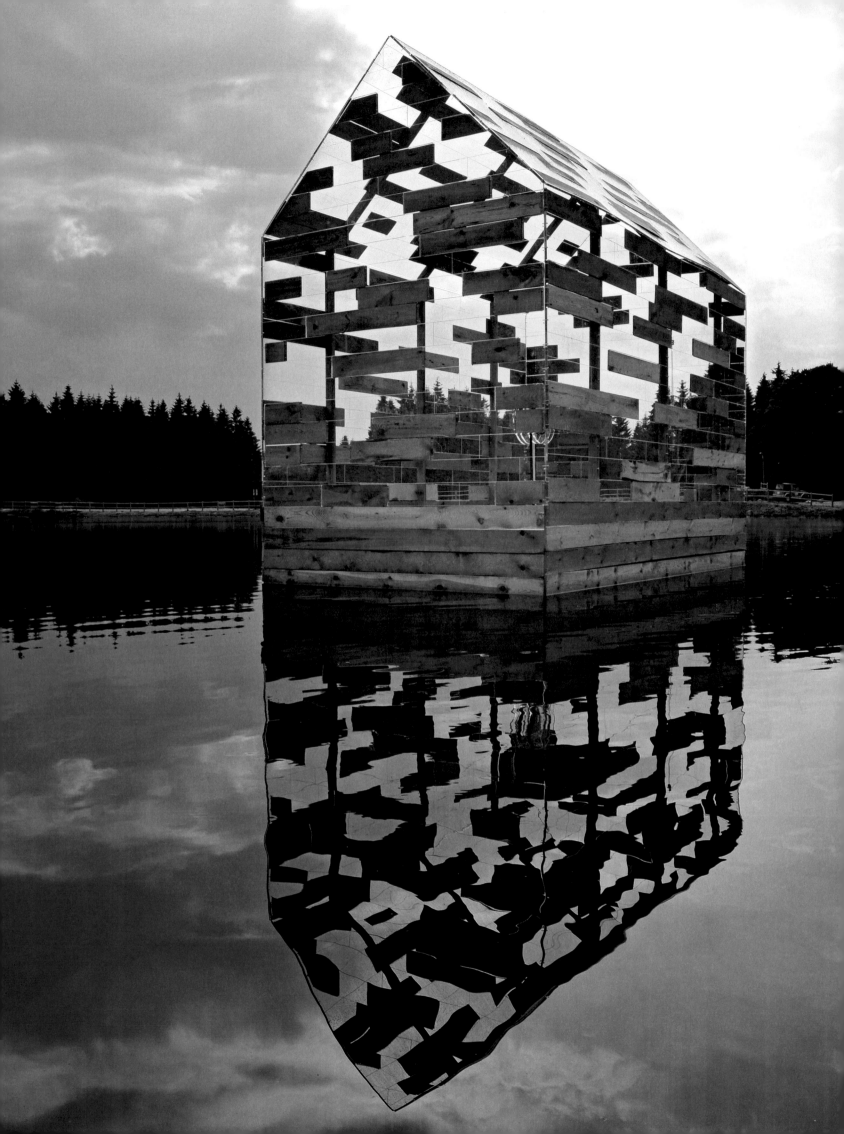

WALDEN'S RAFT

FLORENT ALBINET AND ELISE MORIN

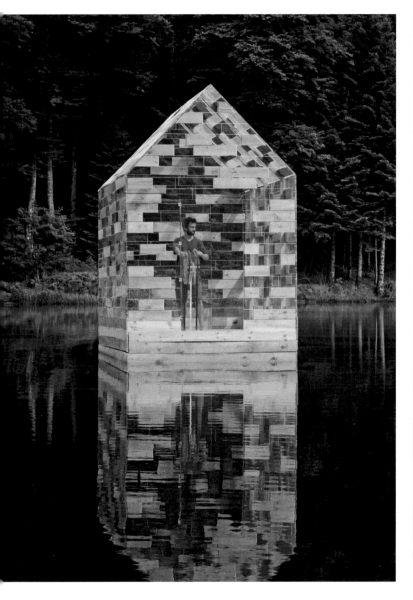
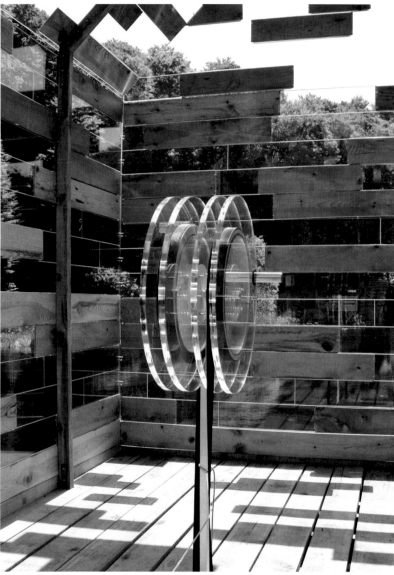

A habitable mirage steeped in ephemeral archetypes delicately drifts over the water on the Lac de Gayme

A tribute to Henry David Thoreau's cabin built in the woods of Walden Pond, this ethereal shelter floats on Lac de Gayme in the Auvergne region of France. The hybrid raft and cabin drifts peacefully over the water, providing refuge for reflection and introspection. Occupying the liminal space between opacity and transparency, the mobile vessel deconstructs the classic pitched roof cabin in a captivating striptease of shimmering mirage. On the shore, cabin and visitors merge with the landscape. Once boarded, the cabin sets sail and primitive and modern rituals begin to mingle and inform one another. As the raft reaches toward the sun, it casts off its rustic wooden frame for a skin made of light, lake, and, sky.

◆

HIDE AND SEEK

JASON VAUGHN

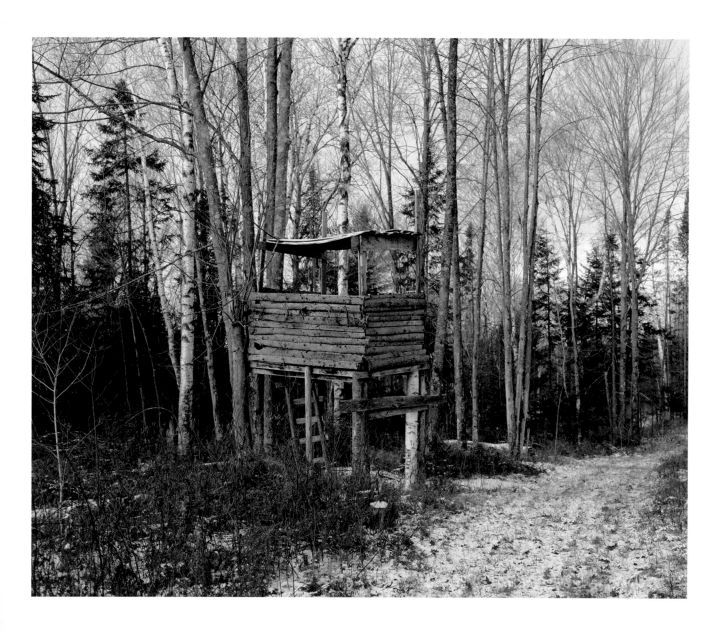

A collection of haunting photographs
shot in the remote reaches
of Wisconsin documents a fading vernacular
found in the solitary hunter's cabin.

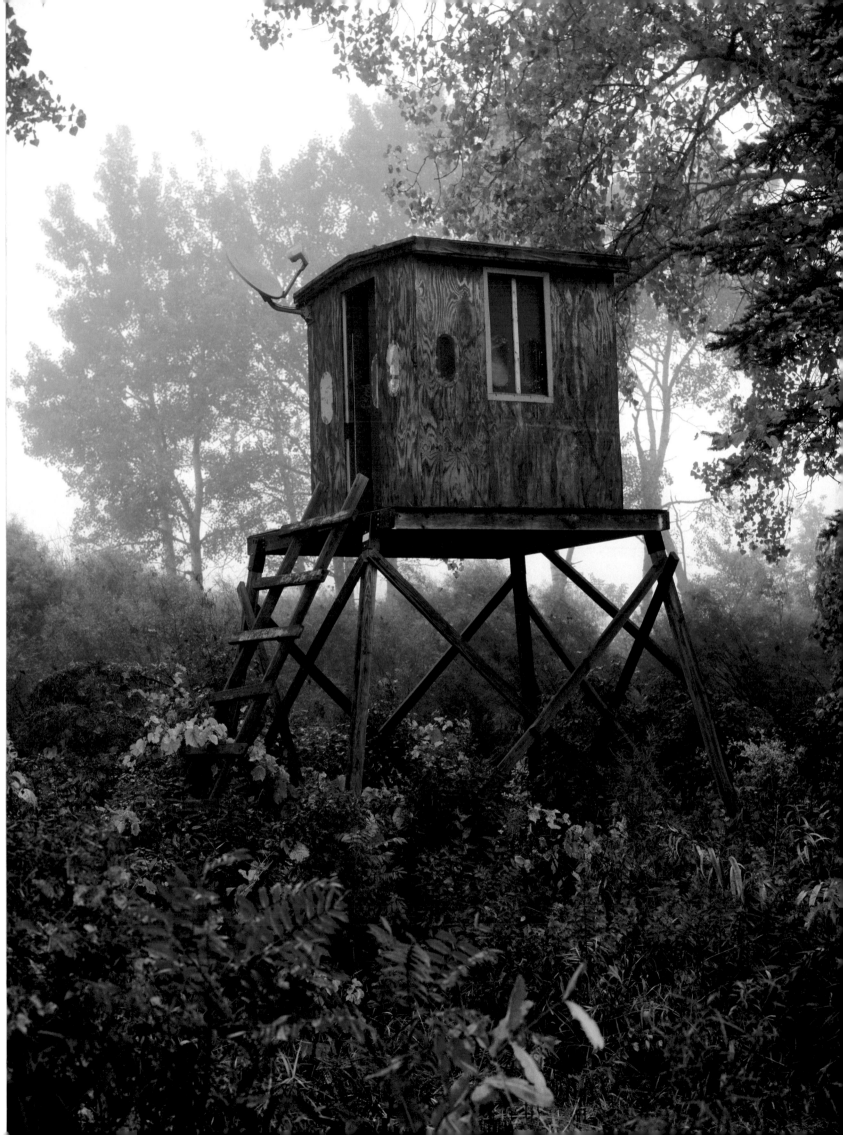

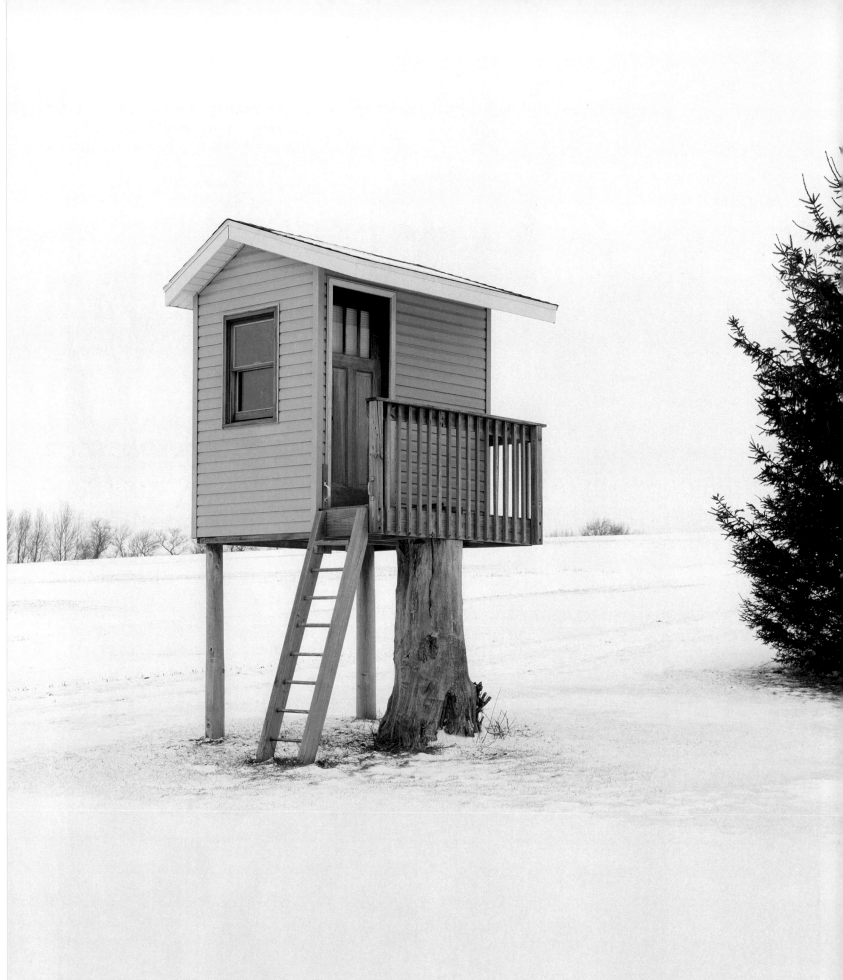

"Their pastime centered not on violence but on a oneness with nature inside these mysterious, ramshackle structures."

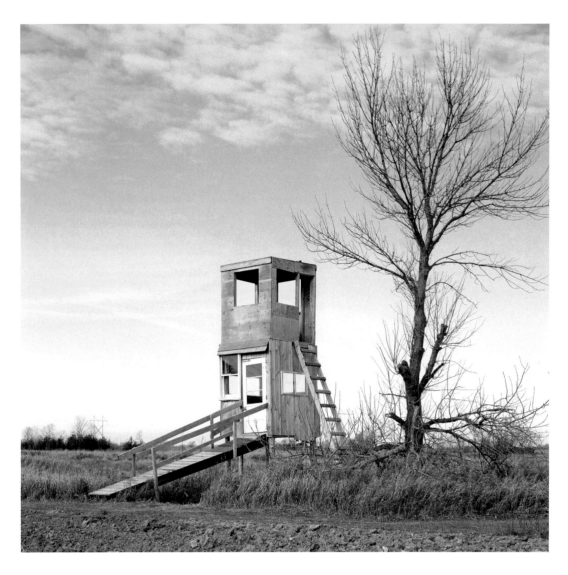

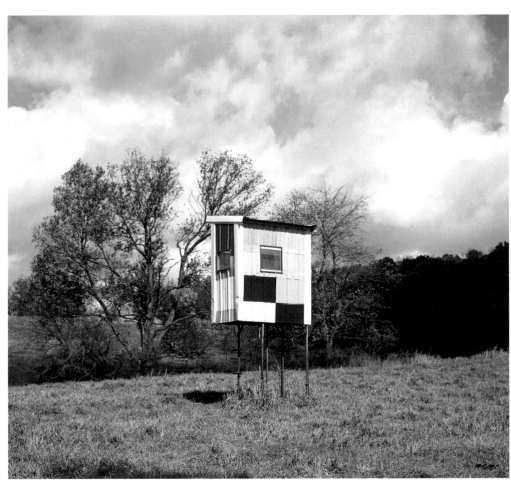

107

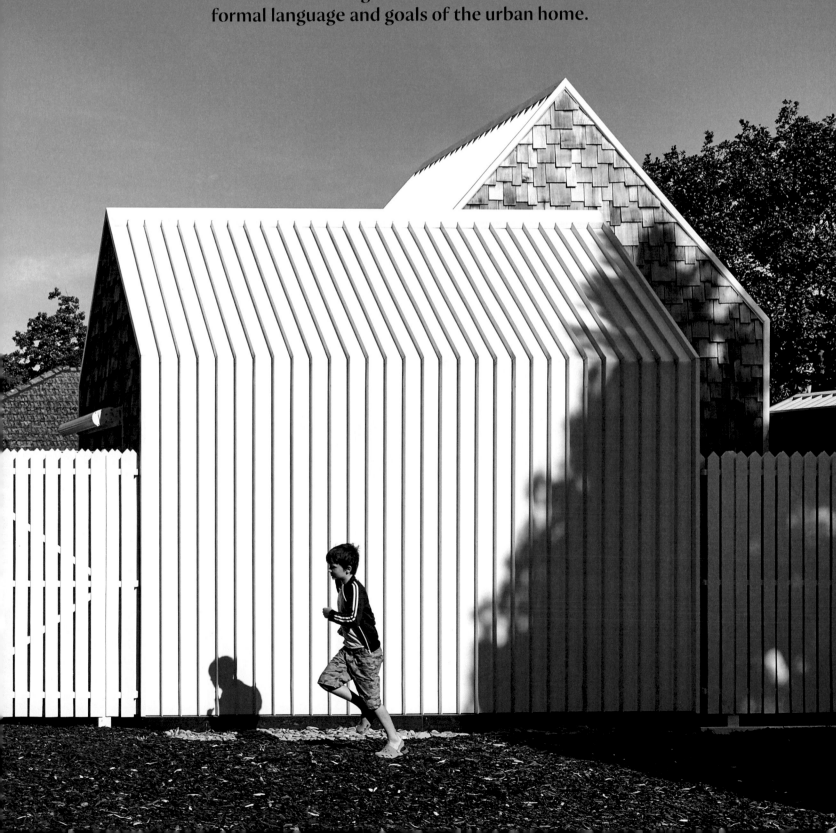

HOME SWEET VILLAGE

AUSTIN MAYNARD ARCHITECTS

A cluster of structures bordered by courtyards
and shared gardens reframes the
formal language and goals of the urban home.

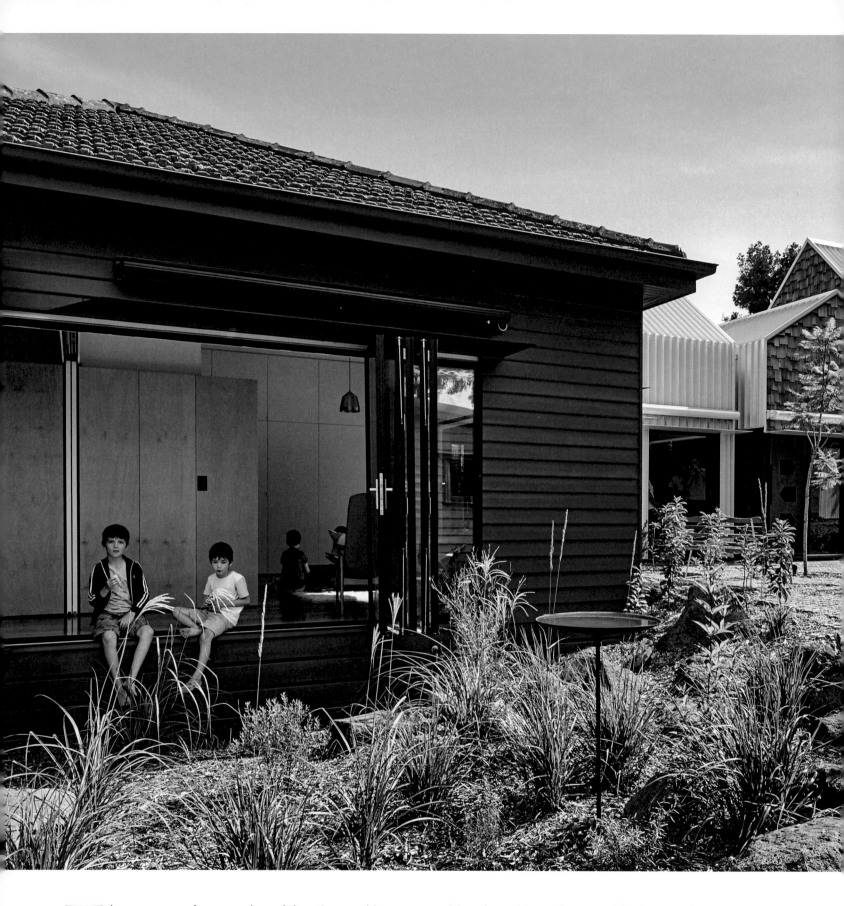

This renovation for a couple and their 8-year-old twin sons transforms their extant house into a lively village for community, art, and nature. Inspired by sketches the twins drew of their dream house, the restoration and expansion exudes a childlike quality at once playful and familiar. The series of intimate pitched roof volumes behave as a village from the outside and an interconnected home from within. Interspersing shingled cabin charm with sleek modern striations, the home intentionally

blurs the public and private. The front yard converts into communal garden, inviting neighbors to share in the bounty of the fertile vegetable patch. Sustainable and socially conscious, the collective home carves out personal space for each family member. The boys lounge with their favorite books on a indoor net suspended in the air while their parents sneak off to unwind on their rooftop terrace or in the peaceful garden library. ◆

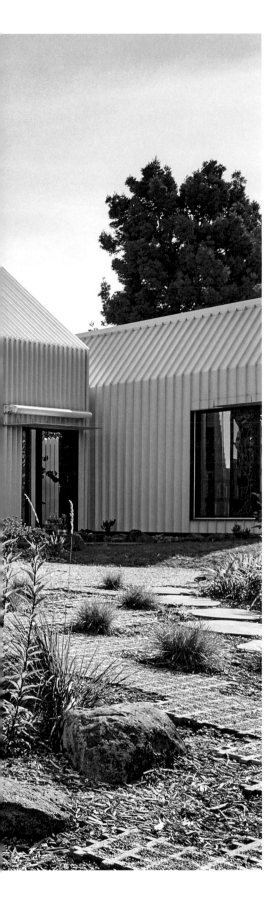

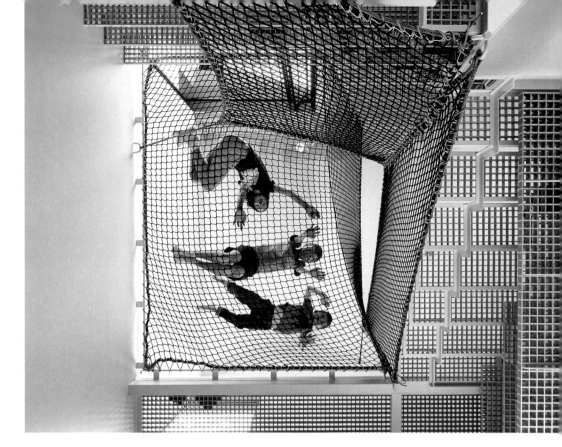

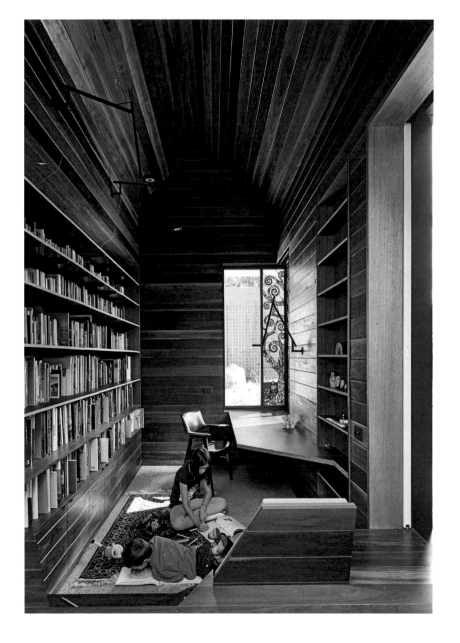

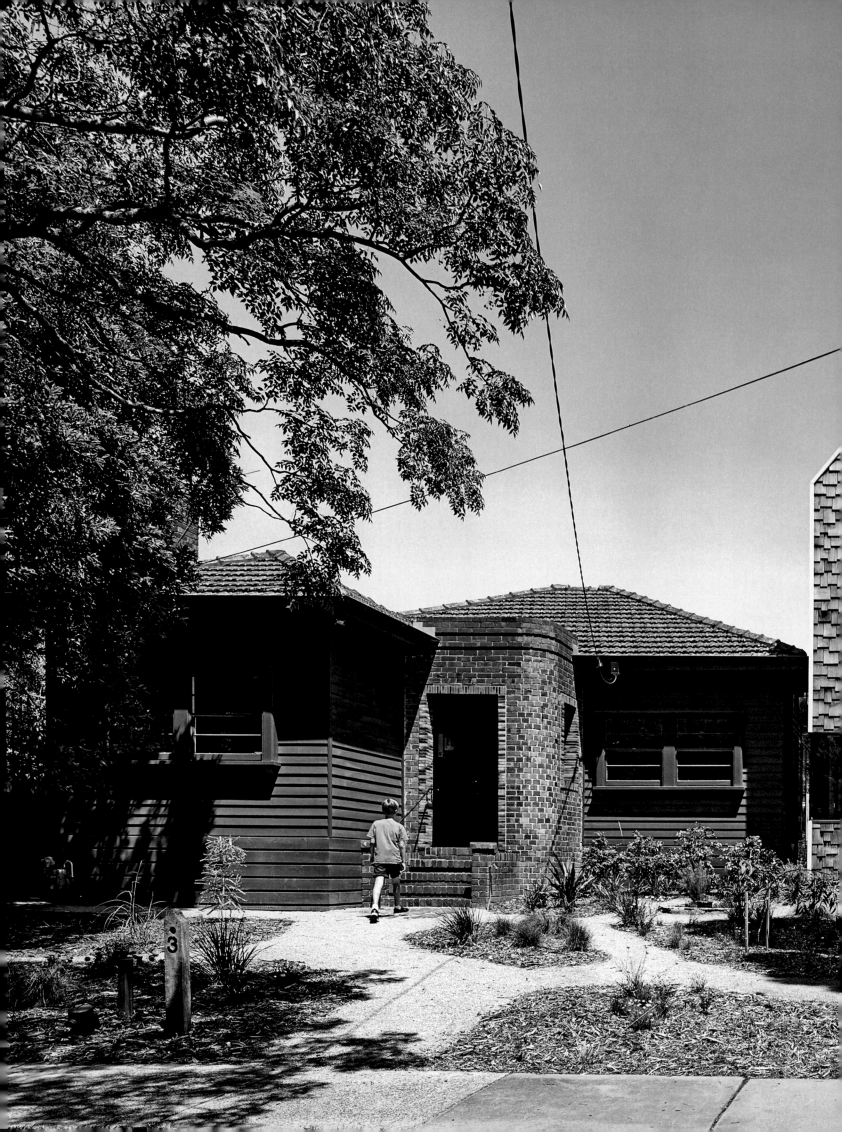

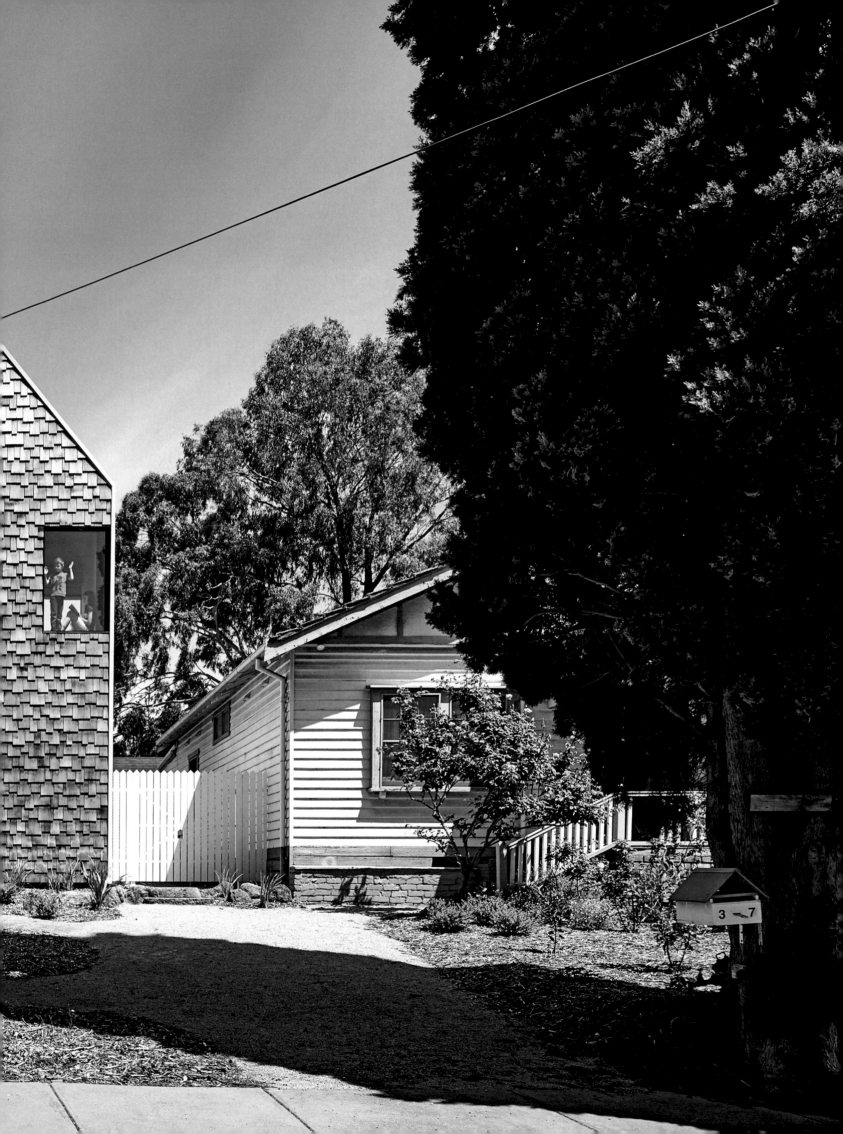

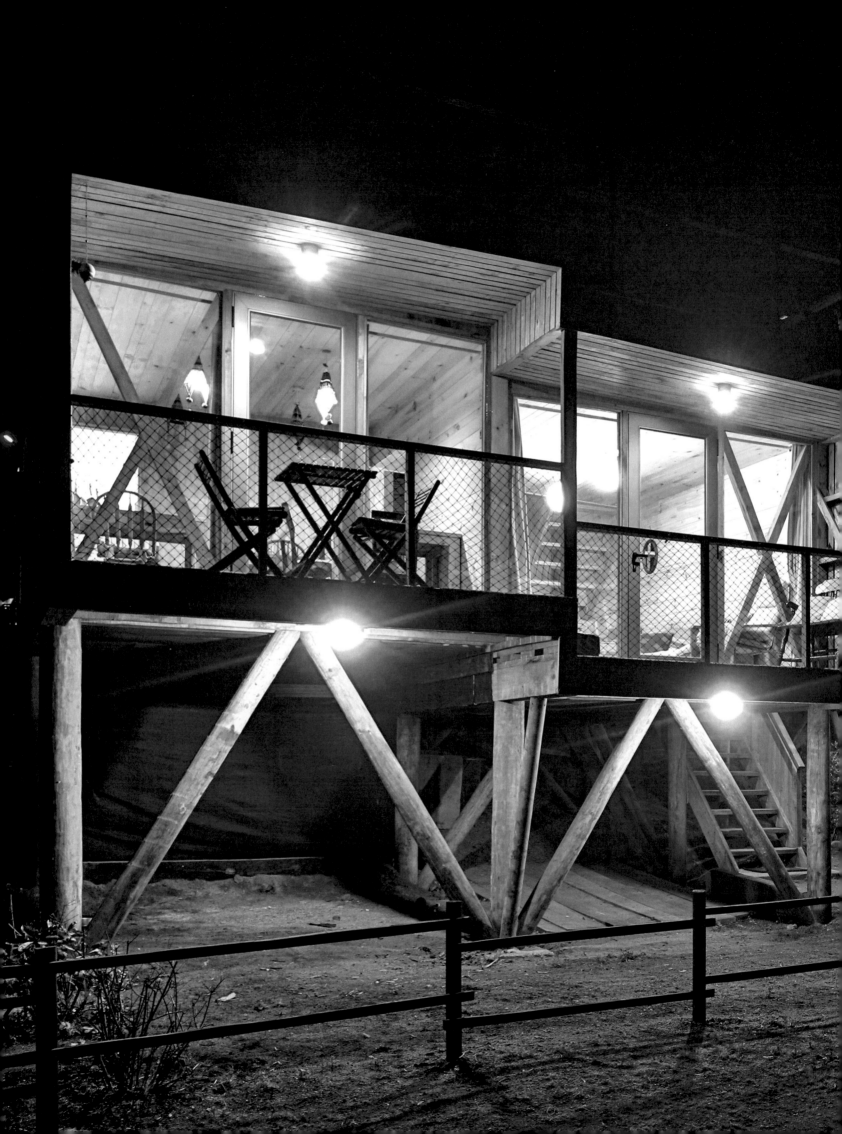

COASTAL QUINTET

GABRIEL RUDOLPHY & ALEJANDRO SOFFIA

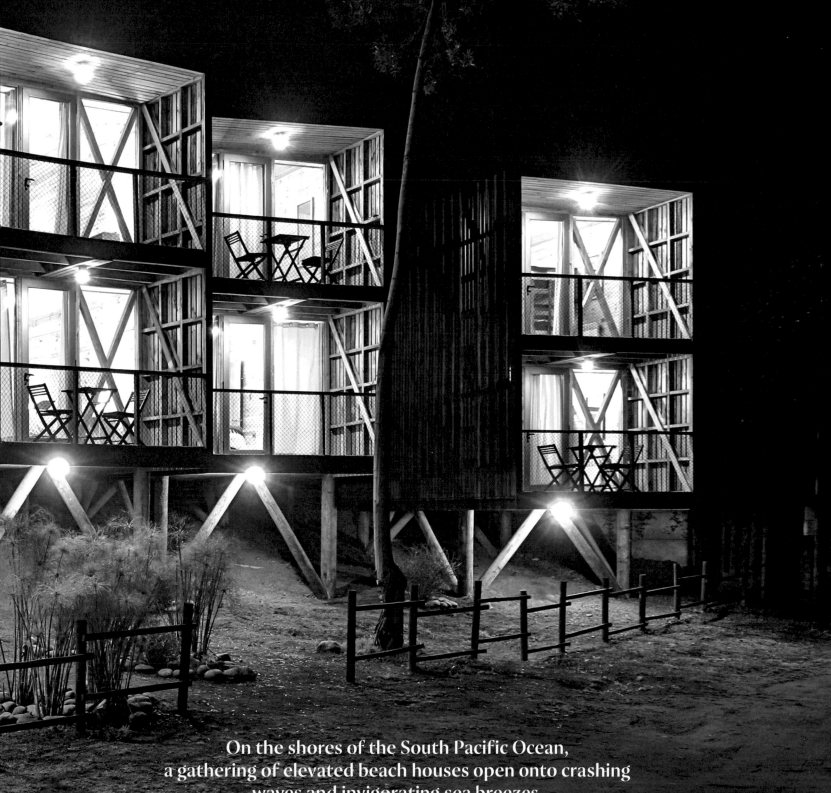

On the shores of the South Pacific Ocean,
a gathering of elevated beach houses open onto crashing
waves and invigorating sea breezes.

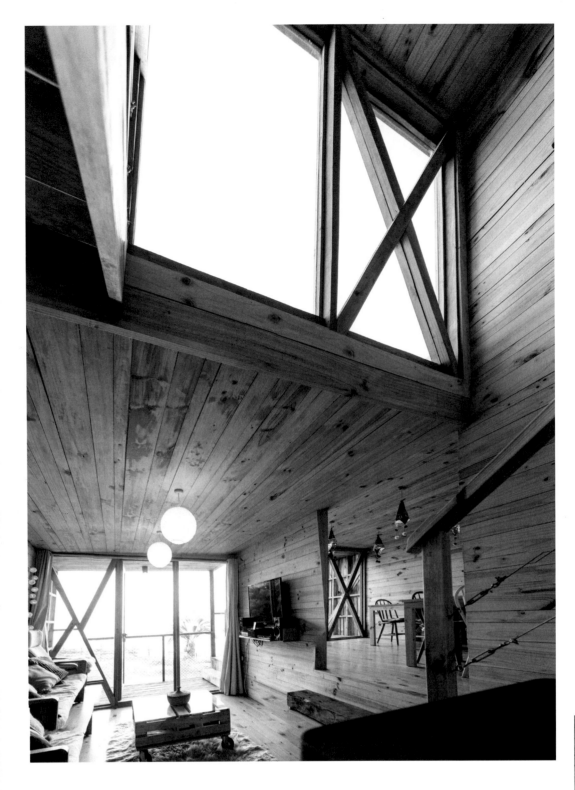

A handsome hostel hovers over an idyllic stretch of Chilean beachfront. Wrapped in local pinewood from inside to out, the suites tread lightly on the site as they float several feet off the ground on wooden stilts. Tapping into a shared desire to unplug and unwind, the rural retreat embraces local craftsmanship and a life spent in tune with the gradual rhythms of nature. Private covered balconies extend the ocean-facing volumes out towards the horizon. Spacious and bright, the open interiors transition seamlessly from one room to the next. Even when safely tucked indoors, the untamed coast remains an omnipresent figure permeating every space. Each of the low-key getaways culminate in a rooftop deck where guests can gather and admire the surf. Maximizing views out to sea, the holistic hostel dismantles the stresses of daily life and releases them into the ether. ◆

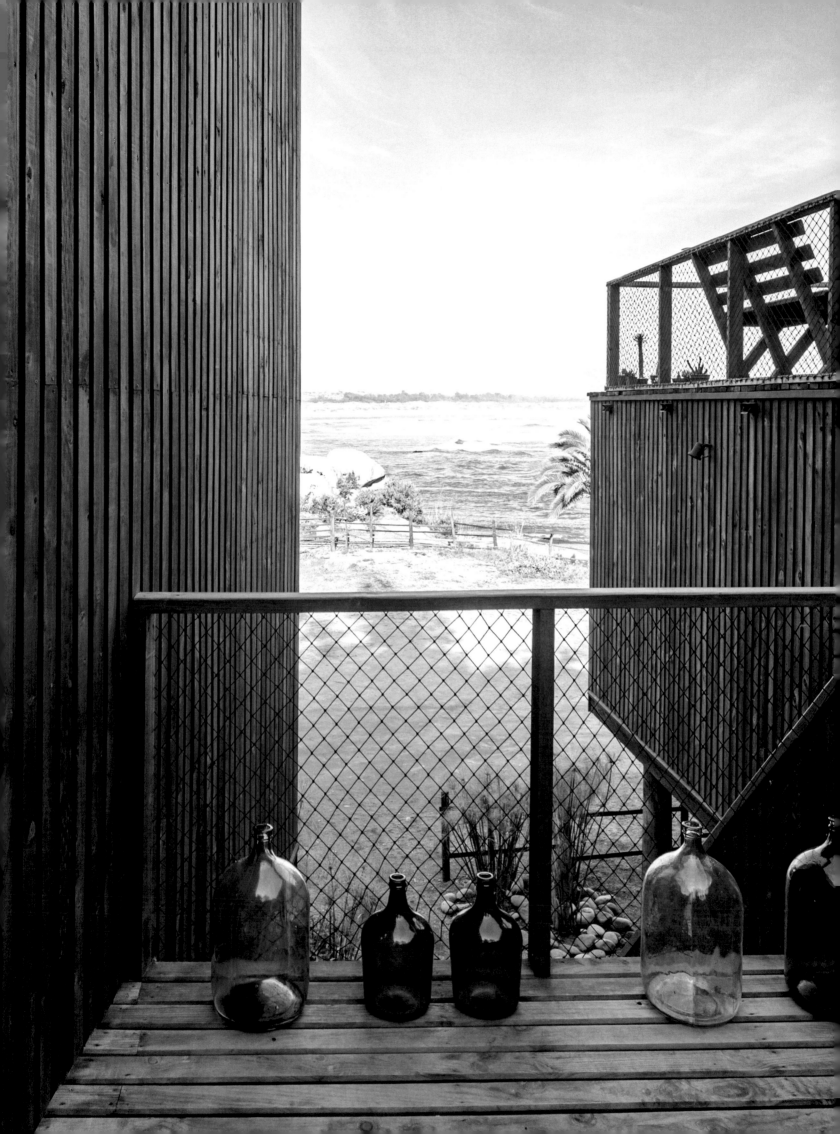

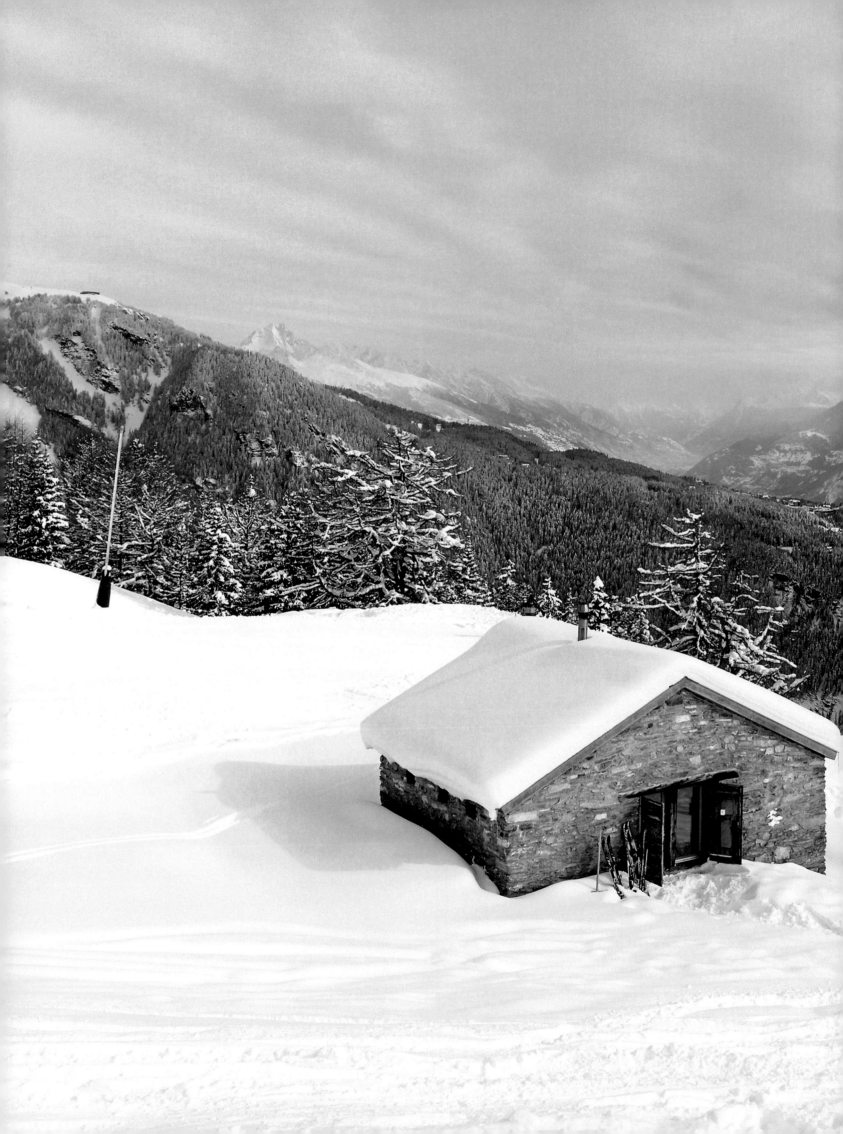

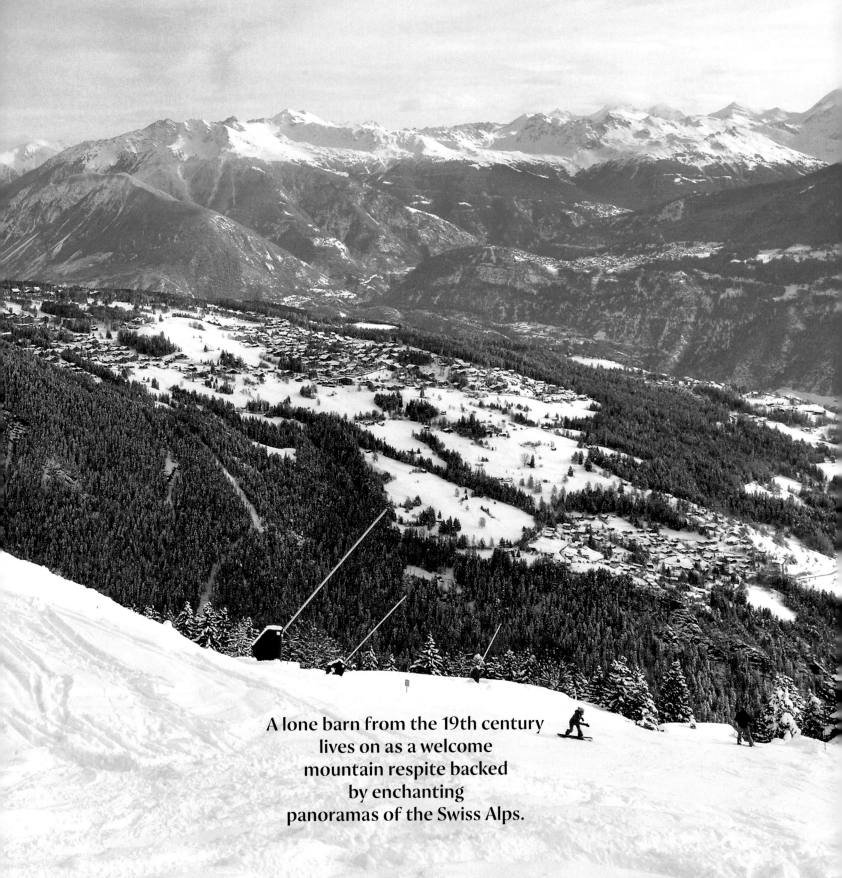

SNOW DAYS

SAVIOZ FABRIZZI ARCHITECTES

A lone barn from the 19th century
lives on as a welcome
mountain respite backed
by enchanting
panoramas of the Swiss Alps.

D ating back to 1878, a rustic barn persists on its secluded slope 1,760 meters above sea level. Before this recent conversion, the structure was used for housing during the pasture season with the animals sheltered on the ground level. The original charm remained intact over the centuries despite small modifications. Distinctive yet typical, the spirit of the barn drives this final incarnation. Added annexes were dismantled to reveal the cabin's initial shape. Now used as a holiday home for winter skiing, the timeless form enjoys a privileged position on the Swiss Alps. The masonry walls remain untouched, save for one large band of glass overlooking the valley. This horizontal opening brings in sunshine to the warm larch interiors and frames a vivid, shifting scene of the expansive mountain ranges. Emphasizing the comfort of the barn while keeping its rudimentary style, the building spends much of the winter months endearingly obscured under the banks of snow. ◆

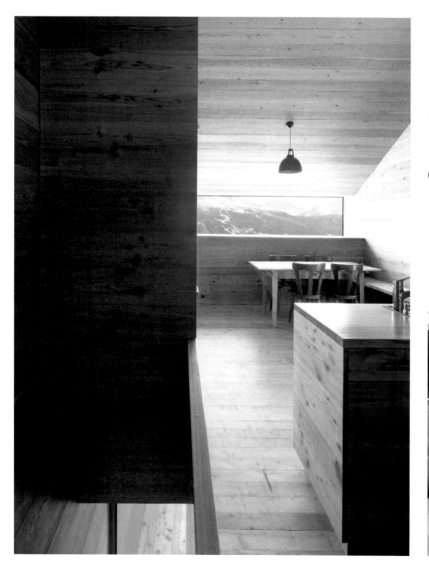

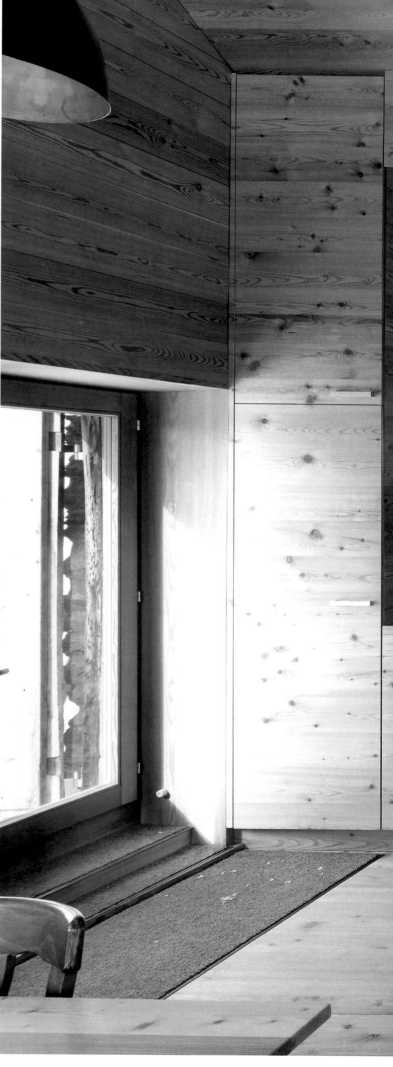

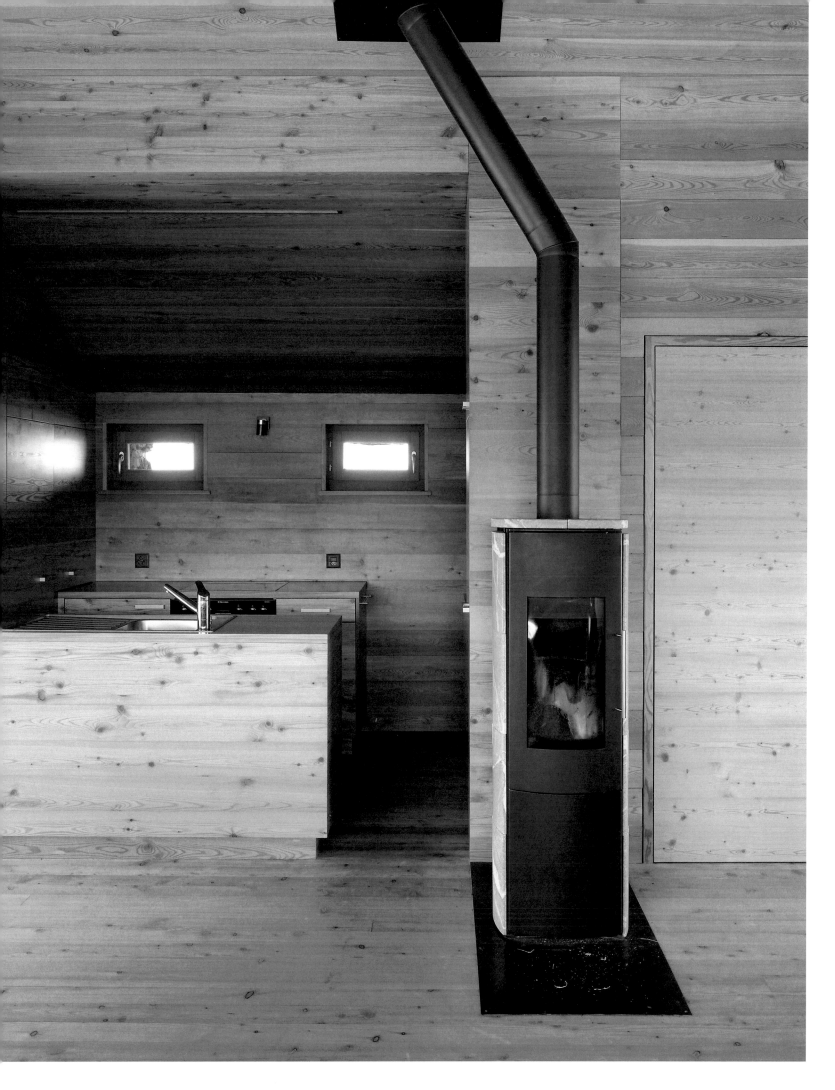

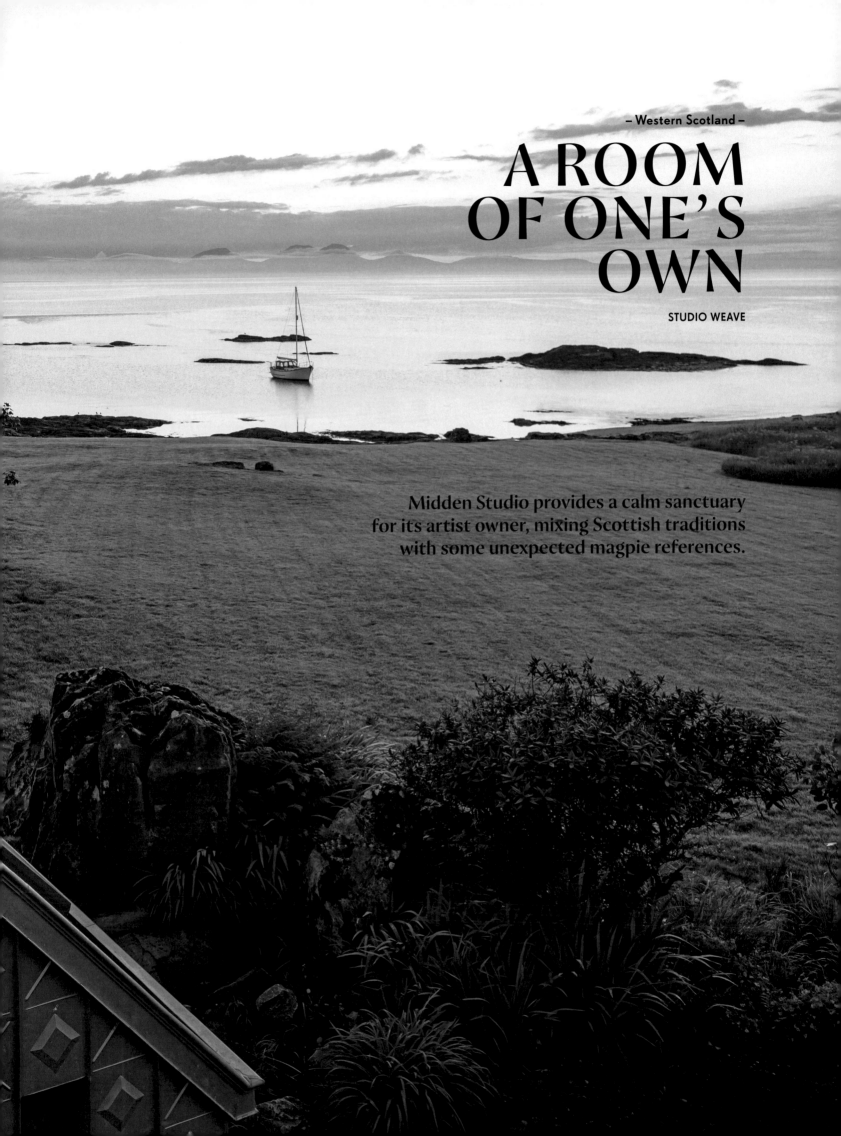

A ROOM OF ONE'S OWN

STUDIO WEAVE

Midden Studio provides a calm sanctuary
for its artist owner, mixing Scottish traditions
with some unexpected magpie references.

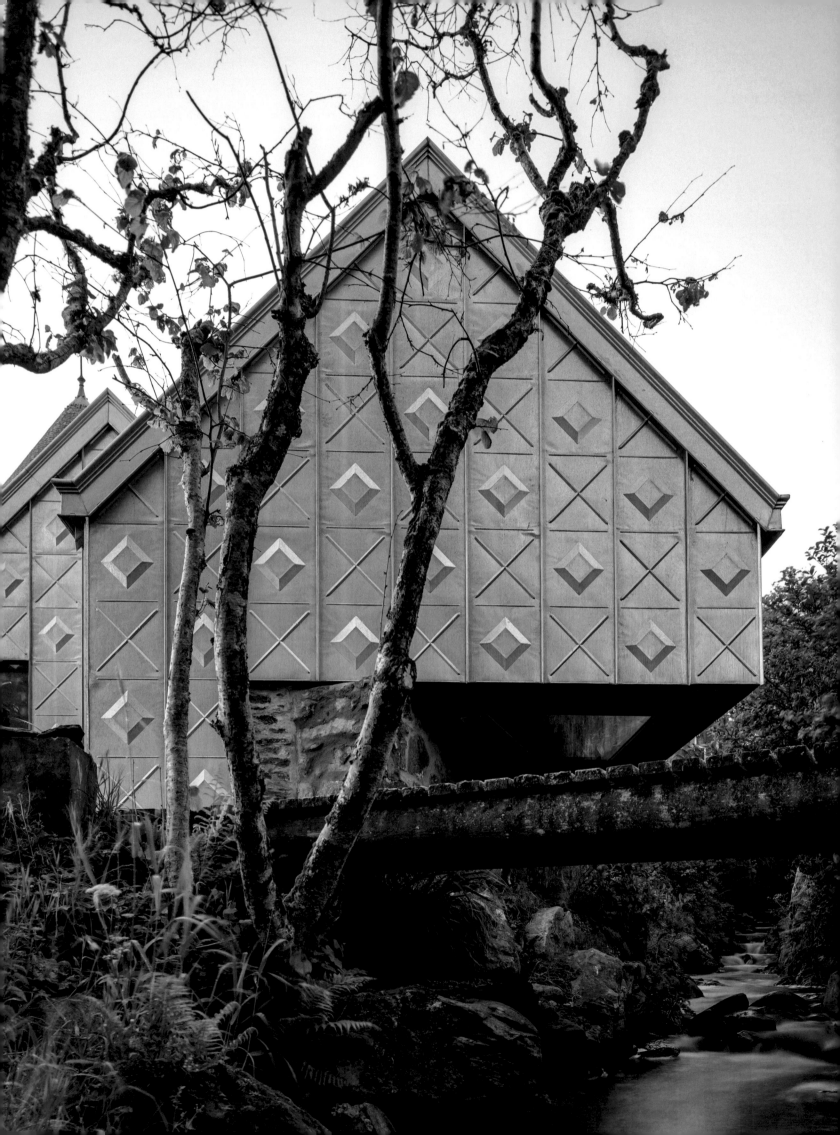

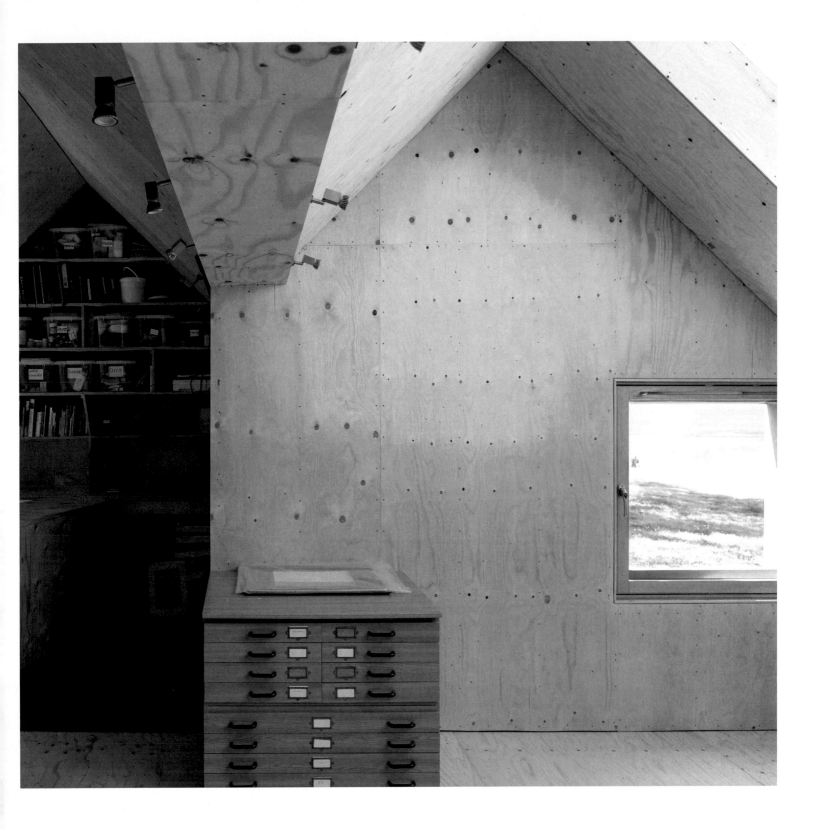

magining the lovechild of granite rock and a Victorian house is an unlikely starting point for a remote retreat, but was the angle taken by London-based Studio Weave when master planning this zinc-coated artist's studio in Scotland. Throwing in references to the ruins of a sixteenth century Scottish castle, a fourteenth century Italian palazzo, and an eighteenth century Neapolitan church were the final magical realist touches: not to mention naming it after a dunghill.

Studio Weave has a healthy pedigree of outlandish projects, including a narrowboat cinema, a 300-person bench, plus a large handful of tiny pavilion-like structures across the UK countryside. Making the sublime out of the small-scale is something the architecture studio excels in, and this 36-square-meter ›

> "The studio now cantilevers over the stream, with a window in the floor peering over the gushing water."

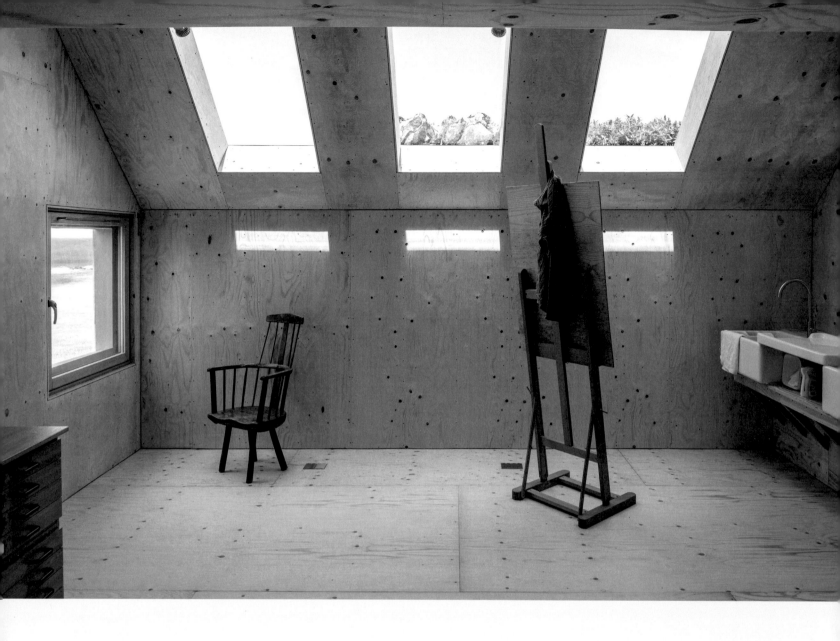

project—designed for an artist originally from the area—is no exception.

Midden Studio ("Midden" is an old term for "dump," so-called because this site is close to a stable where horse dung would be left) was completed in 2015. The studio sits in the middle of a property that stretches from the sea up to a hill. "The building was aimed at unlocking a stream in the middle, which was the third component of what makes the site really special," says Eddie Blake, the leader on the project. The studio now cantilevers over the stream, with a window in the floor peering over the gushing water.

The London-based artist owner wanted a studio, but also a place of escape. She was an open-minded client interested in ideas as well as the practicalities of getting a warm place to work in close to the sea. She wanted it to somehow represent Scottishness, without being explicitly Scottish, which conversely is how the Italian references were called in. "Scotland is far more international than it's viewed. It looks outwards a lot more than England in a funny way. England is the parochial one, whereas Scotland has this deep continental relationship," explains Blake. Case in point is the ruins of Crichton Castle on the east coast, which originally borrowed elements from the Palazzo dei Diamanti in Naples. That meta link was implemented in Midden Studio: referencing a reference. These were brought to life in the zinc armature of the edifice, a heraldic pattern of crosses and diamonds. The double-pitched roof is a local tradition, and the result is an entirely intentional hodge-podge. "It's meant to be a resolved, complete ›

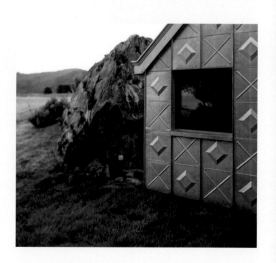

top_ **The walls are lined with expensive plywood that can be renewed after the artist has splattered them with paint.**

right_ **A window looks directly over the stream below.**

126

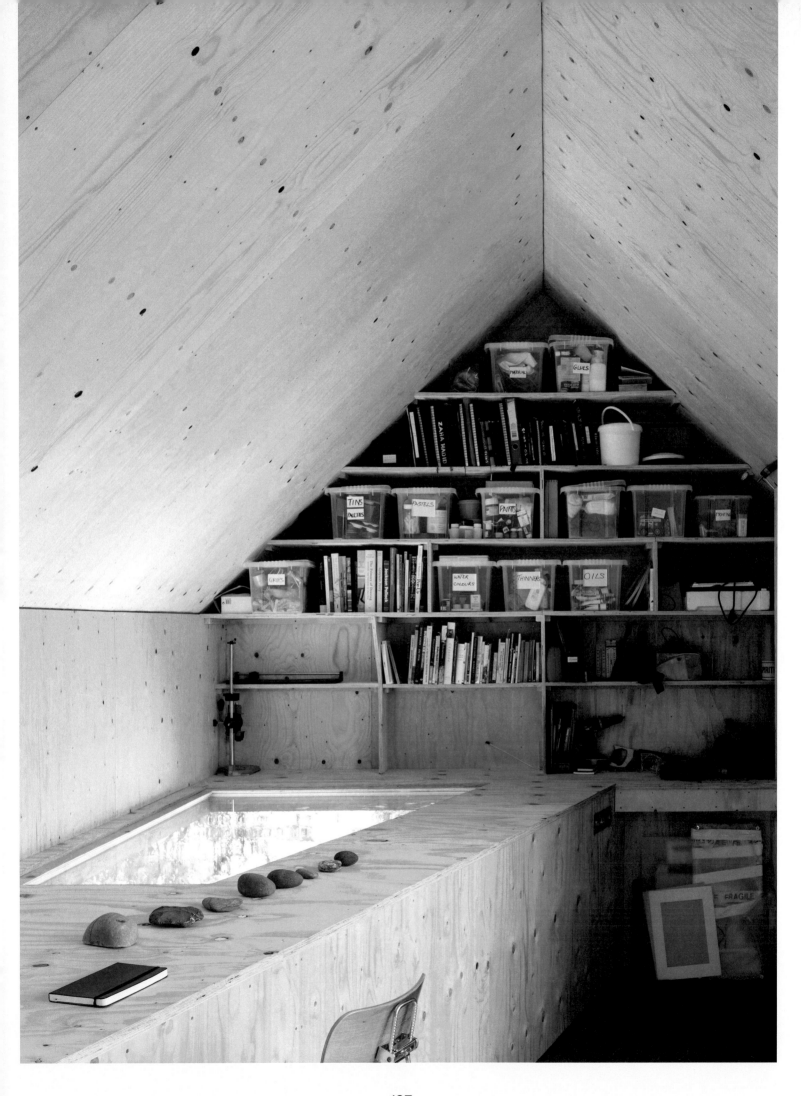

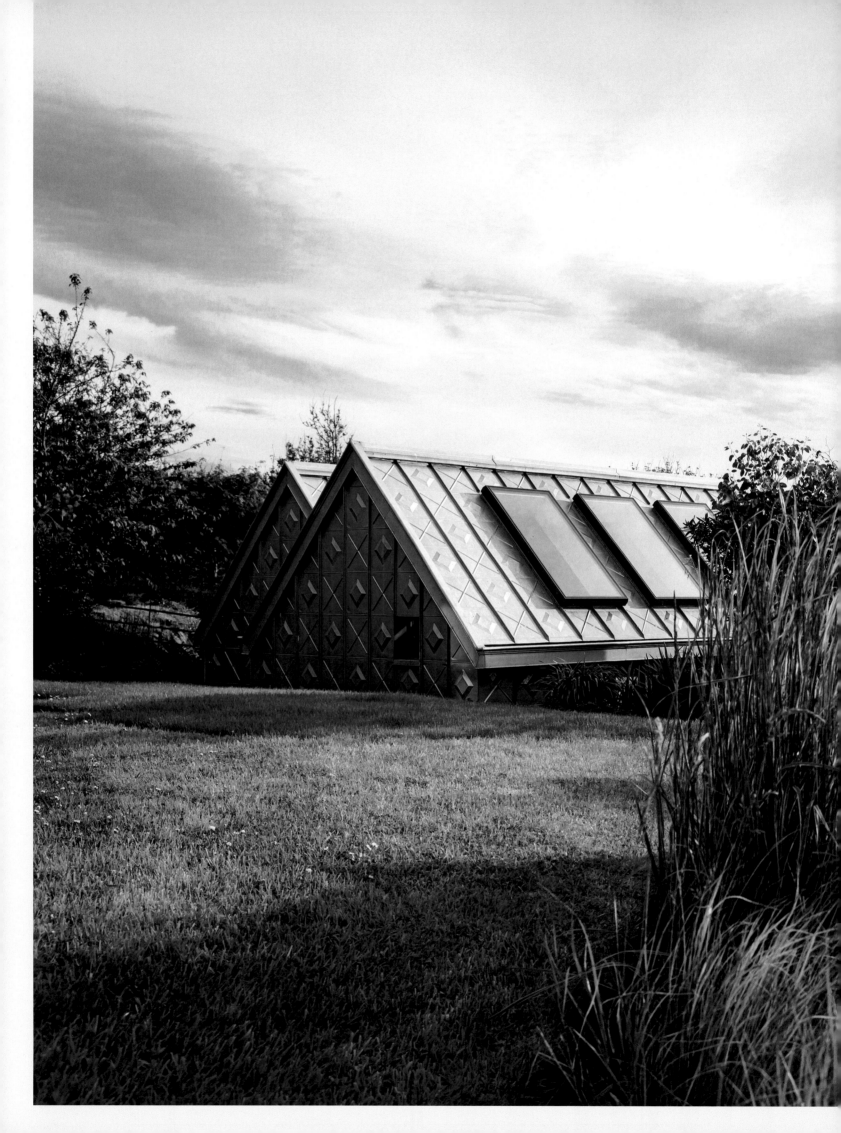

"The double-pitched roof is a local tradition, and the result is an entirely intentional hodge-podge."

homogenous thing, but with loads of disparate parts chucked at it," asserts Blake.

Scotland has a tradition of using sheet metal in building, usually corrugated iron, but the zinc used here offered another advantage. The site is remote—over three hours from Glasgow—and the cabin was manufactured in a nearby shed with the help of local contractors and then moved here and constructed above the brook. Zinc was also used to allude to the granite found locally. "Granite doesn't look like granite when it's carved, it has a different sense," Blake says. "And somehow zinc's shininess and hardness references that."

A metal exterior, especially in these wild climes on the Atlantic, means the building will change over time, and Studio Weave fully intends Midden Studio to evolve as a structure. Internally, too: cost-effective plywood is used to line the interior, which can be easily replaced once it acquires a few scuffs and splashes as the artist uses it. "Weirdly though, now the client is keeping it pristine because she likes it so much," Blake jokes. Midden Studio is a living, breathing thing and change is elemental to it. "A building starts when you do the first drawings, but you don't really know when it finishes. It's certainly not 'finished' now," the architect states.

One thing is certain though, and that's that it will gradually blend into the landscape, despite—or maybe because of—its incongruent references. Midden Studio was intended to both stick out and sink in; to be alien but also of its place. Blake asserts that is how all significant, memorable architecture in non-urban areas starts. "The first time someone put a spire on a church in the middle of a country village would have been a bit far out! Now they feel completely right. That's the way it goes." ◆

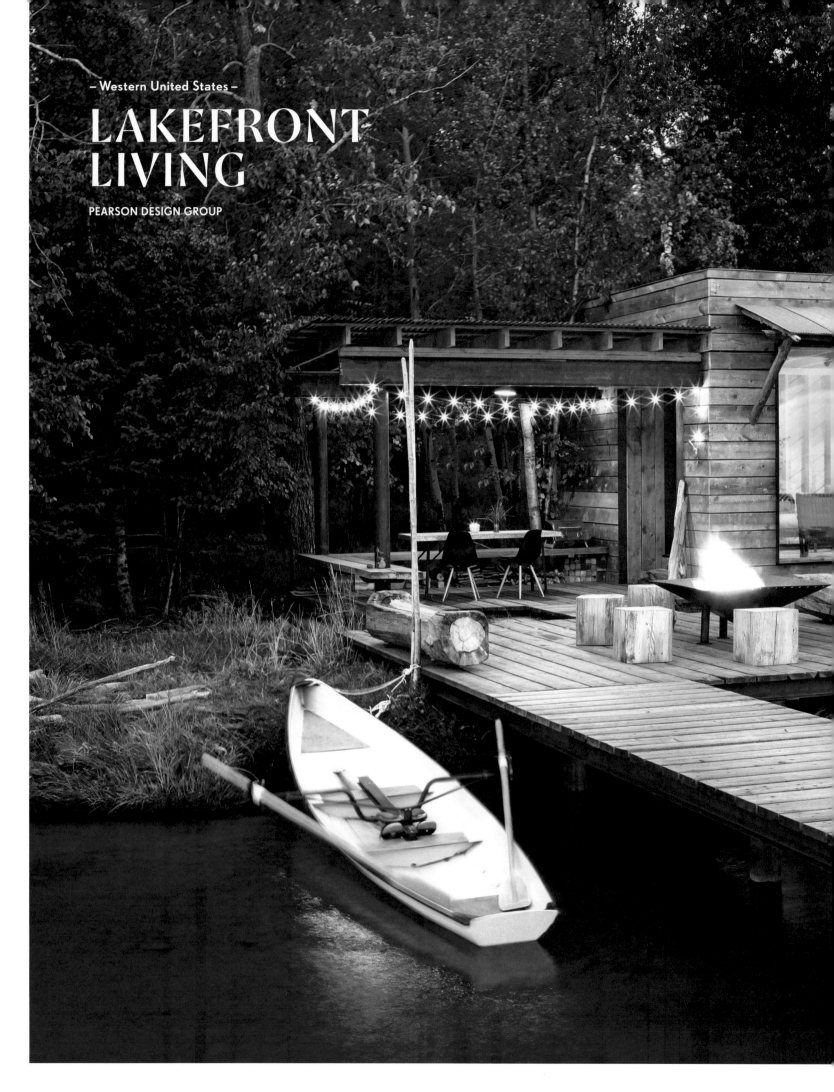

LAKEFRONT LIVING

PEARSON DESIGN GROUP

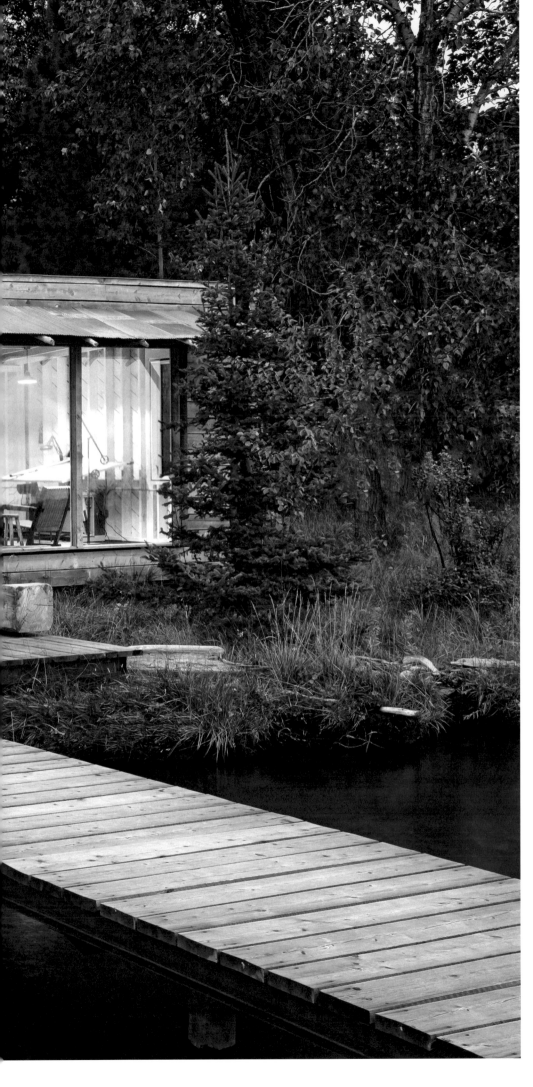

**Just off the shores
of Flathead Lake,
a woodland cabin and
its cozy guest house
stage an idyllic summer
sanctuary.**

A pair of lakefront cabins emerge out of the low lying aspen meadows in rural Montana. Located on the northern shore of a scenic lake, the shelters refine country living to its most romantic incarnation. The two structures can be reached by land or by water. On foot, guests first encounter the two-level main cabin discreetly nestled into a grove of trees. This two-bedroom cabin integrates broad openings to the landscape and an inviting screen porch for whiling away a summer day in dialogue with friends and nature. By water, one can dock their canoe on the grassy shore and make their way down a wooden jetty to their very own private guest house. The modest one-room studio looks out over the dock and Flathead Lake. A large porch draped in string lights becomes the cabin's open air living room, complete with a fire bowl to gather around as the nights grow brisk. When the sun sets over the waterfront, the cabins adopt a casual, easy grace at once regional and contemporary. ◆

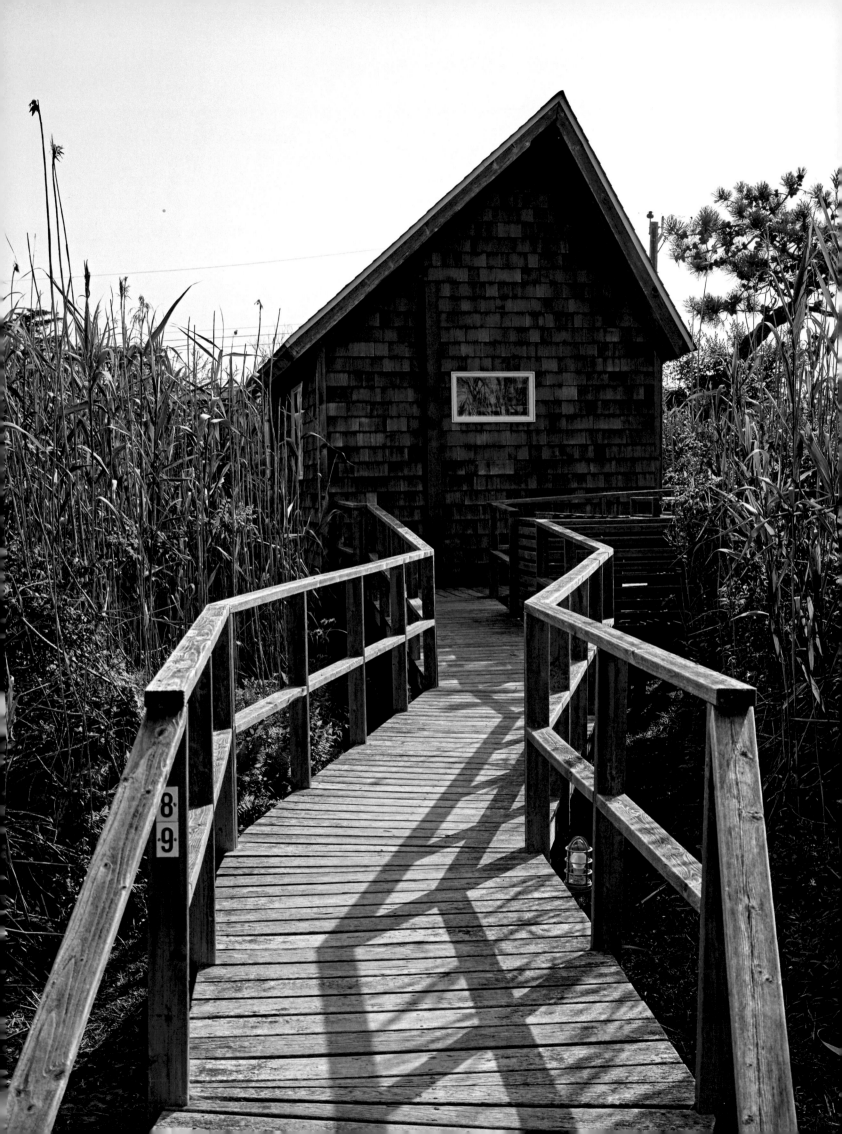

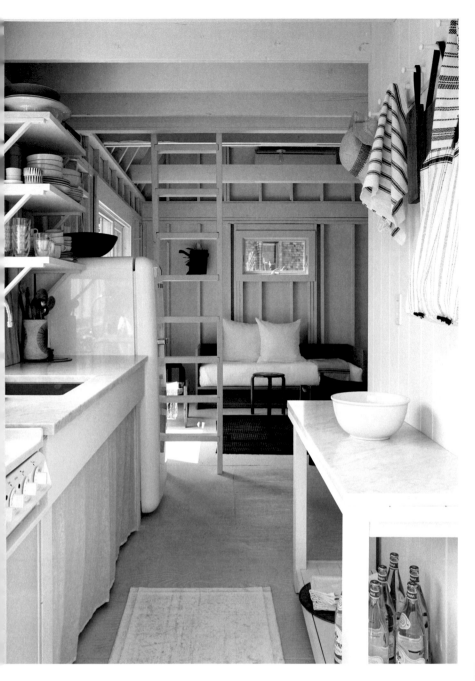

SUMMER ROMANCE ON FIRE ISLAND

ANN STEPHENSON & LORI SCACCO

Just a stone's throw away from the bustle of New York City on the western end of Fire Island, a charming A-frame from the 1940s renews its timeless romance.

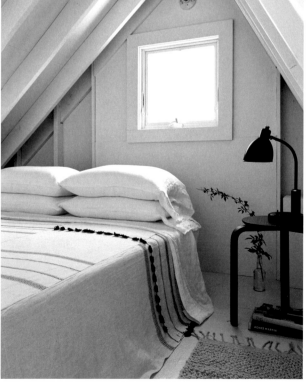

A meandering wooden walkway through the tall, rustling grasses leads to an askew A-frame steeped in country charm. The shingled sanctuary, originally built in 1945, resides in a tranquil meadow on Fire Island. The weekend getaway for a couple in the arts transports the Manhattanites back to a simpler time. The car-free island replaces roads with boardwalks and city traffic with the lull of the lapping waves. Ripe with idiosyncrasies and an old-school seaside patina, the home's historic roots remain at the forefront of the loving restoration. High rafters, large sliding doors that extend onto a generous deck with an outdoor shower, and a sleeping loft above expertly disguise the home's tiny footprint. Daybeds and white linens accented with an eclectic mix of vintage and international treasures cultivate a breezy, effortless atmosphere. Framed by the ocean on one side and the bay on the other, the cottage welcomes in the sound of the breaking waves as a summer lullaby. ◆

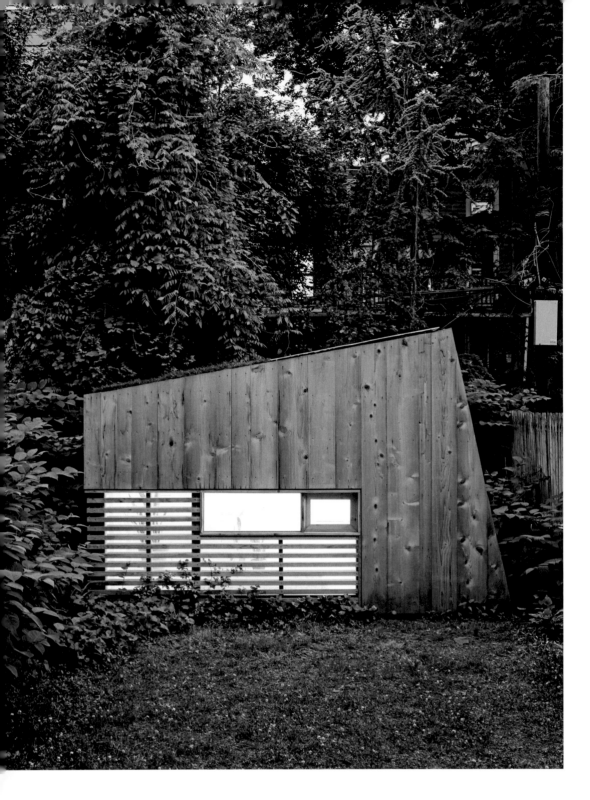

HOME-GROWN

HUNT ARCHITECTURE

A garden studio behind
a Brooklyn
townhouse stands
as a compelling
reminder that one
needn't go far to get away.

> **"In the evening,
> the studio glows warmly
> from the sky-light
> and slatted wall,
> illuminating
> the backyard and
> surrounding trees."**

A garden studio in the backyard of a Brooklyn townhouse provides welcome escape for its architect owner. The skewed wooden retreat crafts a space of solitude within the immense landscape of New York City. The tiny wooden hideout offers an opportune spot for enjoying a book, an afternoon nap, or an evening of tinkering. Constructed of humble materials including salvaged cedar siding, the modest form stages views to the ground, garden, sky, and trees. With all references to the urban surroundings removed, a doubling of horizontal slats allow views out while restricting the prying eyes of neighbors. In the evening, the studio glows warmly from the skylight and slatted wall, illuminating the backyard and surrounding trees. The home away from home came to life over the course of a three-month period, built with a free hour here and a spare weekend there. Exploring the limits of a confined space, the backyard retreat changes the question of what can you do in a space to what can a space can do to you. ◆

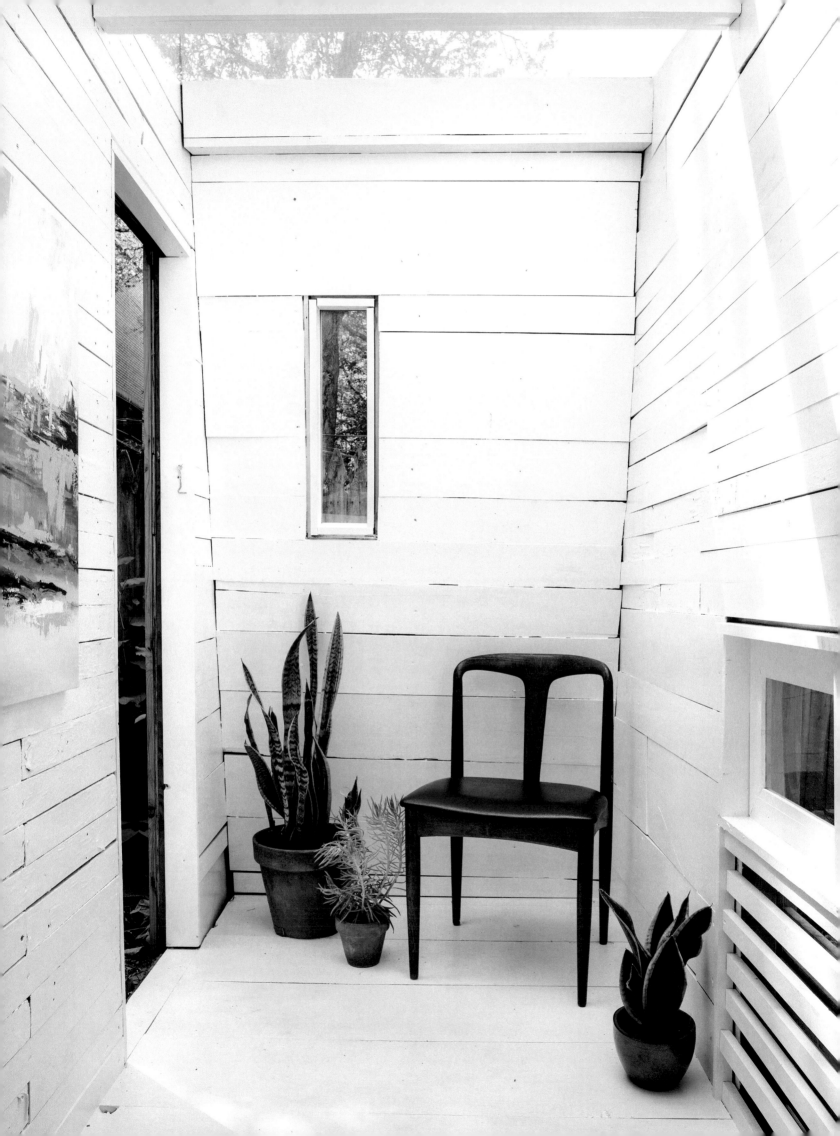

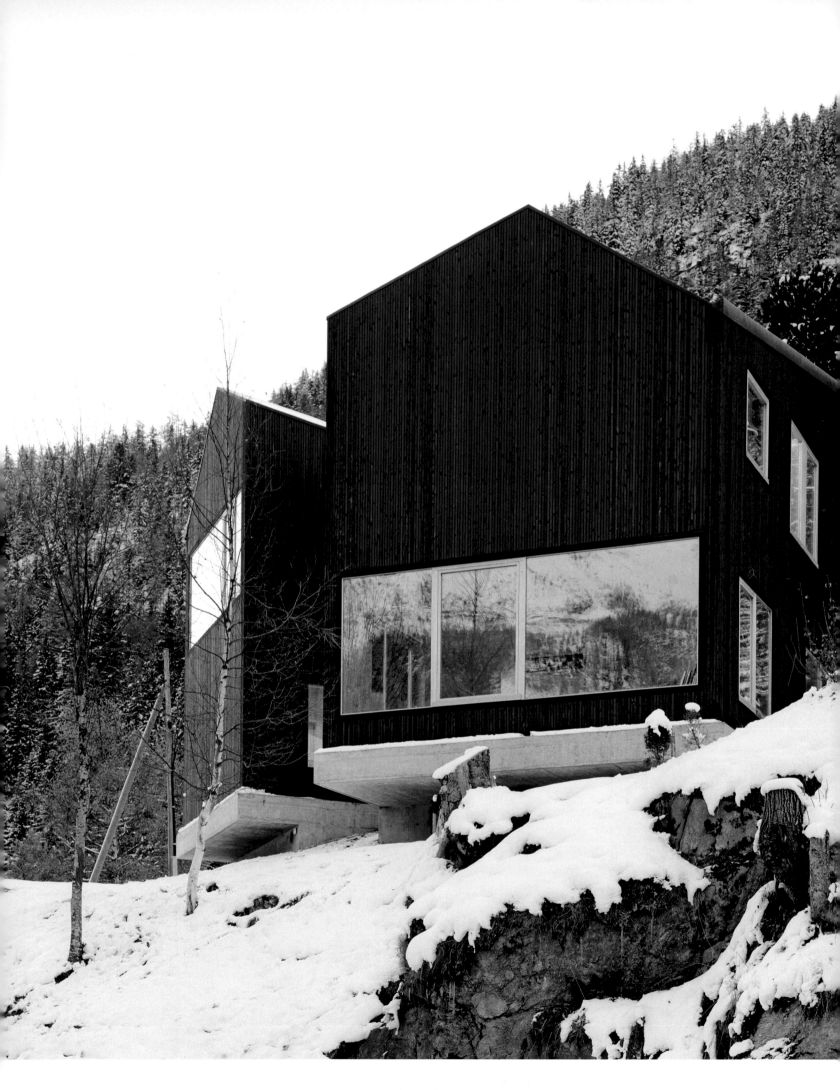

ALPINE PROMONTORY

LACROIX CHESSEX

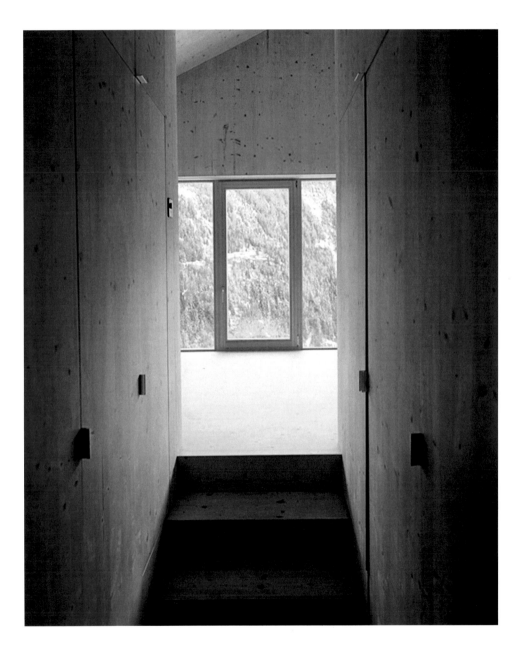

The Swiss Alps encircle
a mountain retreat steeped in history, awakening
the senses at a prominent altitude.

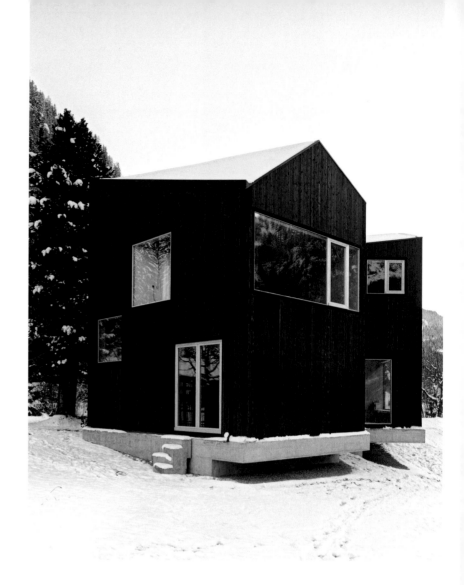

In a sleepy hamlet above the road to the Col de la Forclaz, an alpine lodge adds to the local memory. The form and scale of the structure recalls the traditional huts for storing grain found throughout Valais. From the mountainside, one sees only a single silhouette in the form of an M, resembling the rocky ridges that encircle it. From the valley side, the view of two volumes raised from the ground evokes the archetypal children's drawing of their home. Two large windows, one in the living room on the ground level and the other on the first floor, allow the landscape to seep through the building. The two windows each command an opposing façade, forging a visual reference between the two sections of the chalet while framing swatches of the expressive, snowcapped surroundings. A subtle nod to the historic Swiss barns and agricultural huts of the region, the understated design carves out a legacy in the space where the past and future intersect. ◆

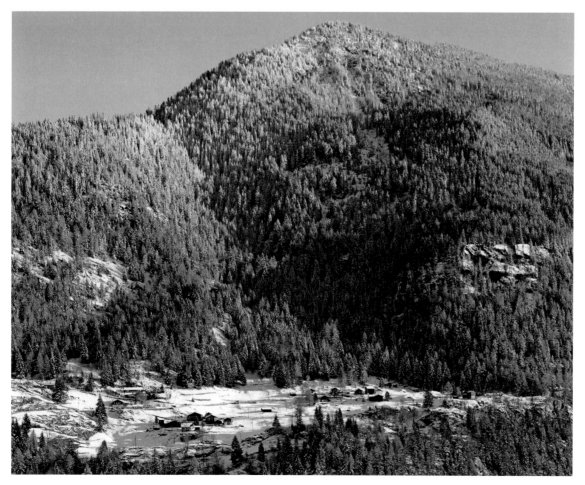

"From the mountainside, one sees only a single silhouette in the form of an M."

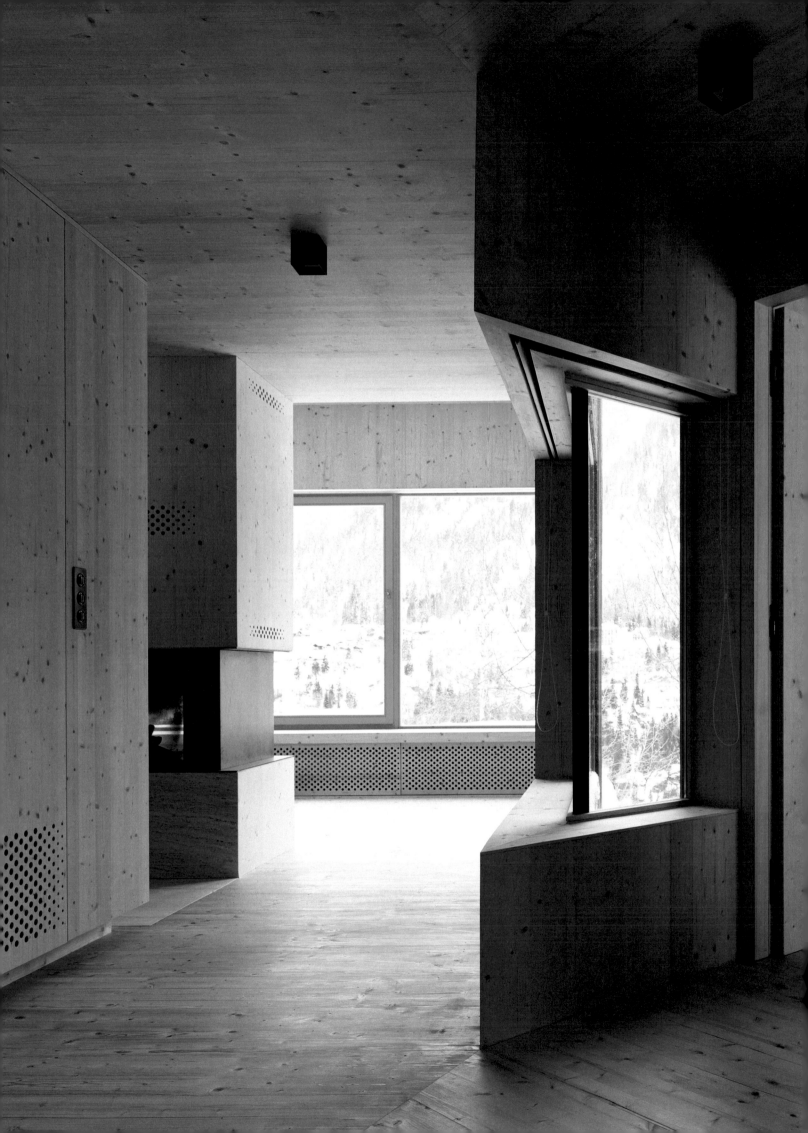

– Québec, Canada –

AUSTERE ASCENT

YH2 ARCHITECTURE

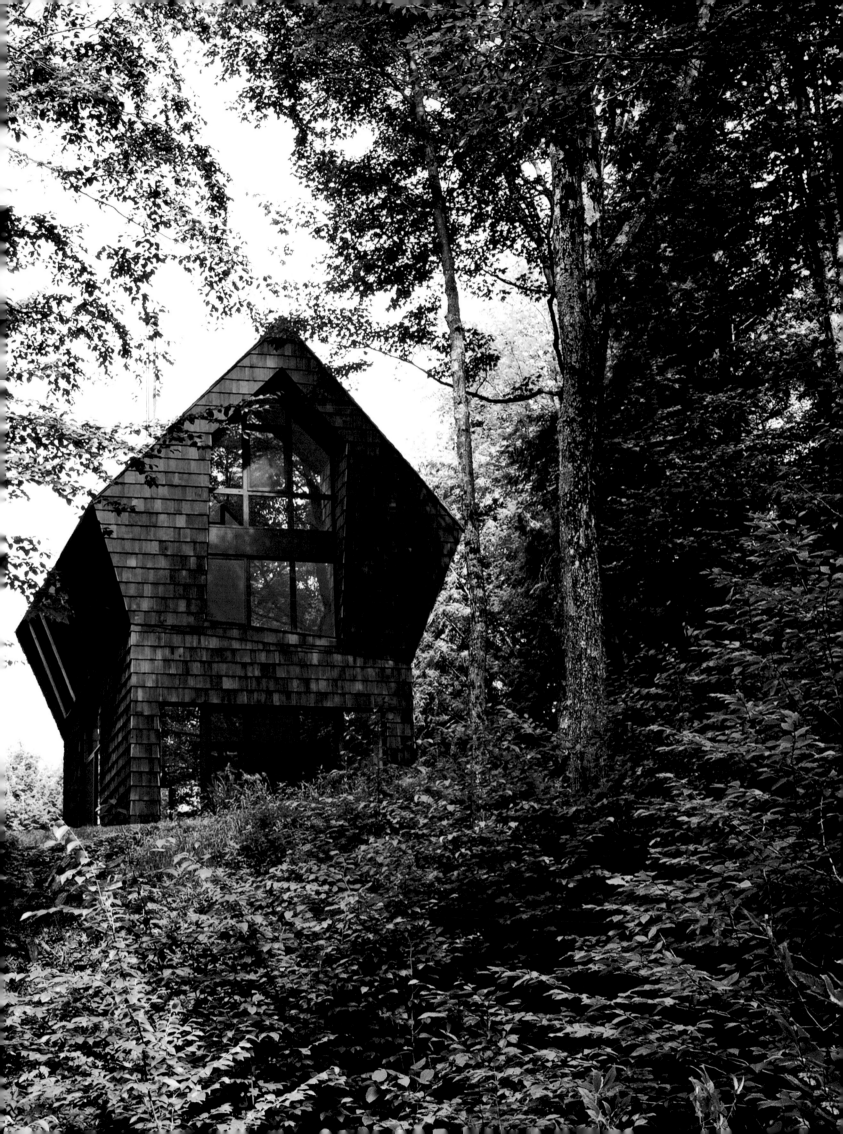

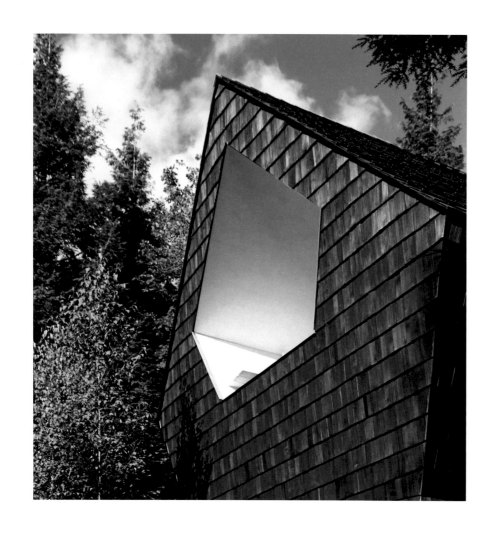

"With a nod to all that came before, the top floor concludes with a pentagonal terrace—a protective white perch for prospect and refuge."

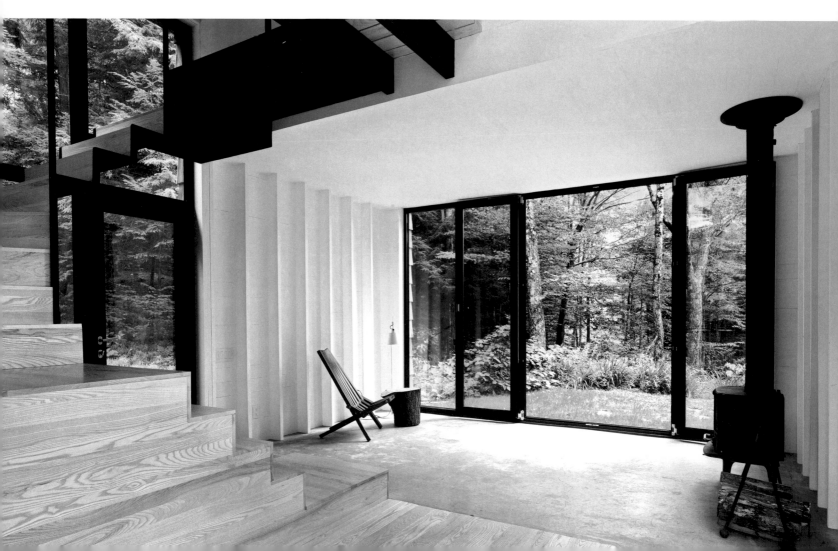

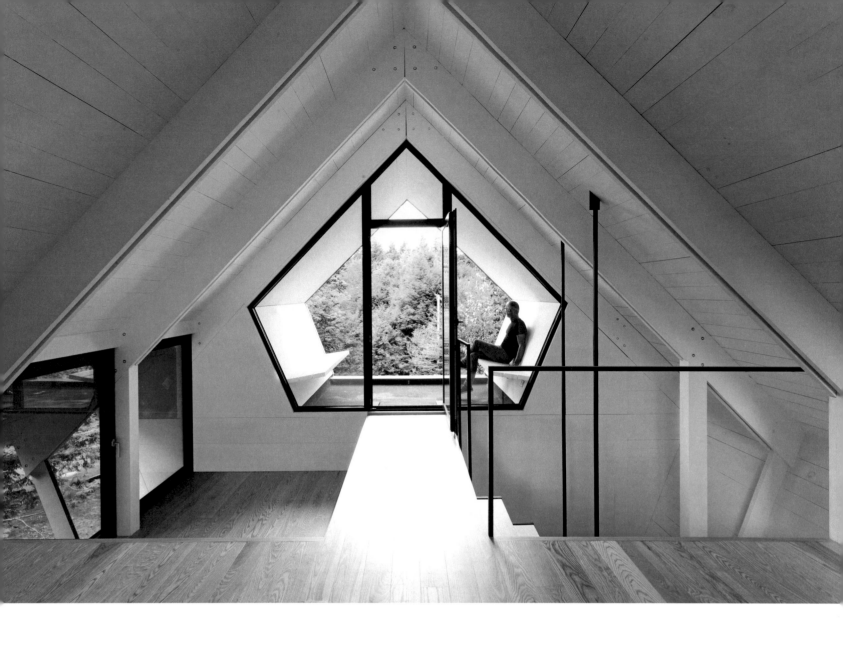

Crowned by a pentagonal addition filled with light, the final incarnation of this forest refuge turns a humble shed into a handsome haven.

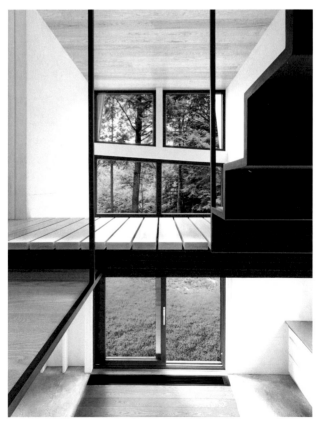

The third phase of a shed turned forest refuge preserves the natural surroundings as it embarks on its ascent through the leaves. Extending from one to three floors, the summer home mimics the natural growth of the woods that surround it. Leaving the original footprint untouched, the addition turns the once low-lying structure into a pitched-roof cabin that sidles up to the treetops. Recalling the bark of tall conifers, a dark cedar cloaks the exterior volume. The vertiginous, white interior choreographs luminous, double height spaces. Generous openings soften the modern interior and fill each room with large swatches of the picturesque scenery. The fluid transition between additions produces an airy ground floor with a direct link to the forest's soil. Above, each room opens onto a vast vertical atrium punctured by a delicate stair. With a nod to all that came before, the top floor concludes with a pentagonal terrace—a protective white perch for prospect and refuge. ◆

– South Fyn Archipelago, Denmark –

SHELTERS
BY THE SEA

LUMO ARKITEKTER

Scattered over nineteen coastal
locations on the remote South Fyn
Archipelago, these discrete refuges open up
to the sea by day and the stars by night.

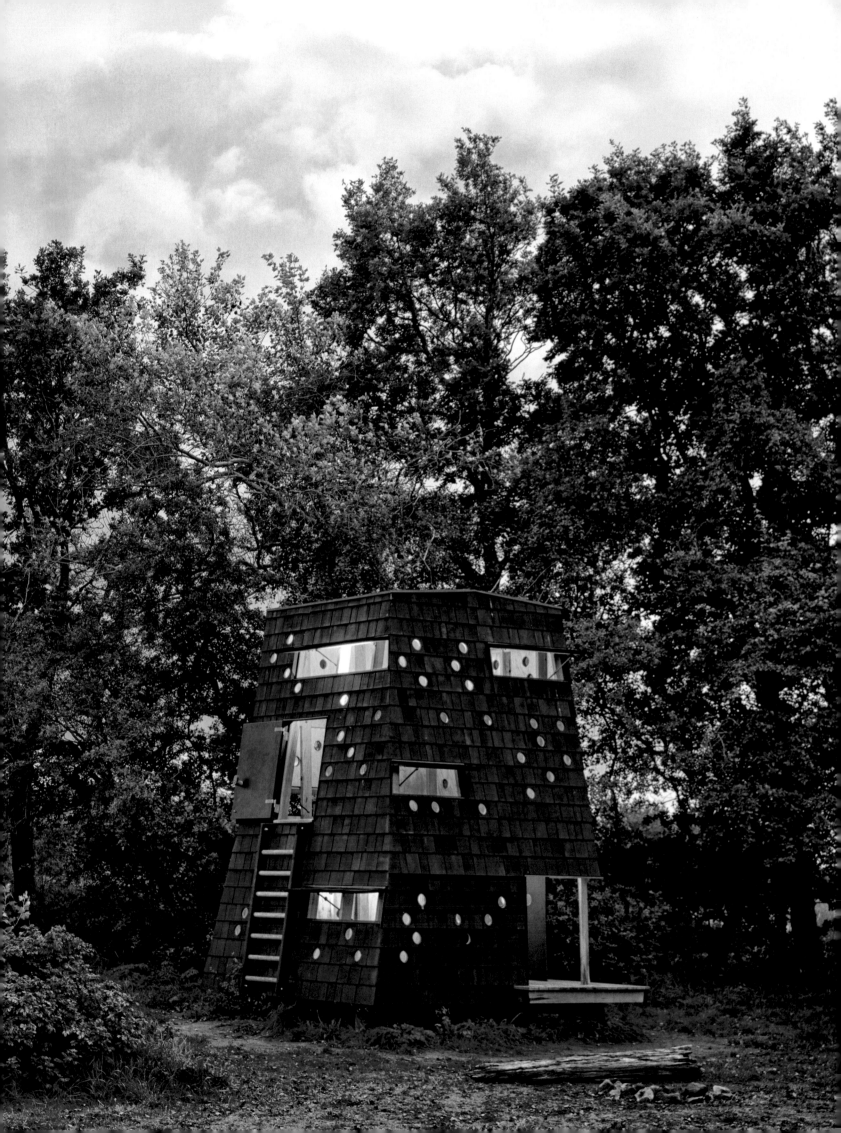

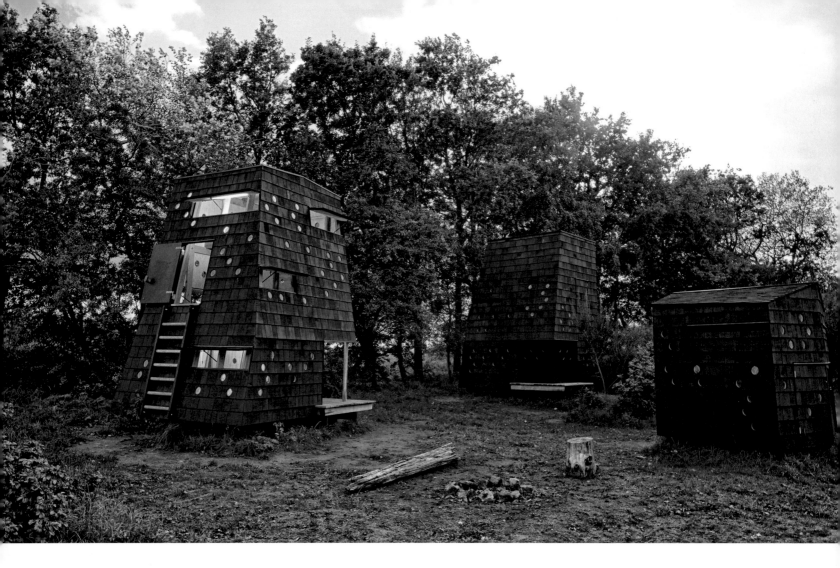

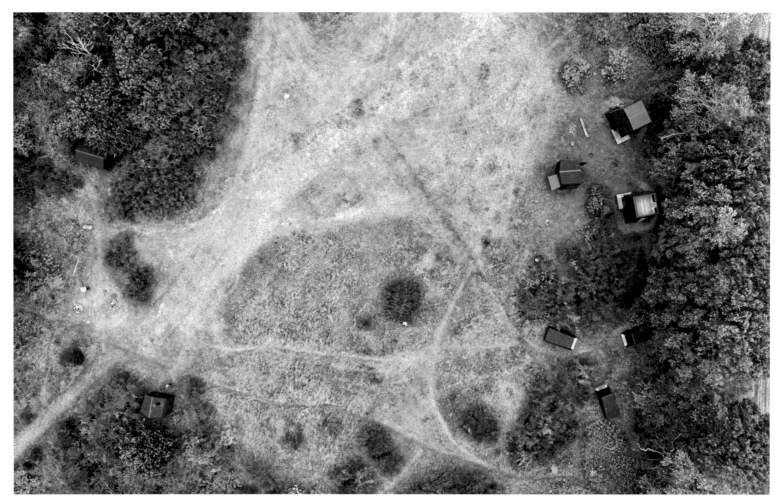

ozens of shelters dotting a Danish archipelago celebrate local fishing culture and their distinctive vernacular. Arranged into communal clusters or stoically placed on their own, the project spans over five shelter types and 50 individual cabins. The various shelter models harken back to the old-fashioned livewell, where the fishermen stored their daily catch. Named after a corresponding fish, each cabin typology ranges in size and ambition with the "Monkfish" providing three levels of bird watching all the way up to the "Garfish," which sleeps six to seven people at a time. The distinctive yet complimentary shingled landmarks reinforce the experience of and intimate proximity to the Scandinavian coast. These striking asymmetrical shelters beckon visitors to observe the lunar orbit across the night sky and the tactile nuances of the lapping waves at the shore. The versatile campgrounds exude an air of mystery that excite the senses by day and make for an exceptional evening under the stars by night. ◆

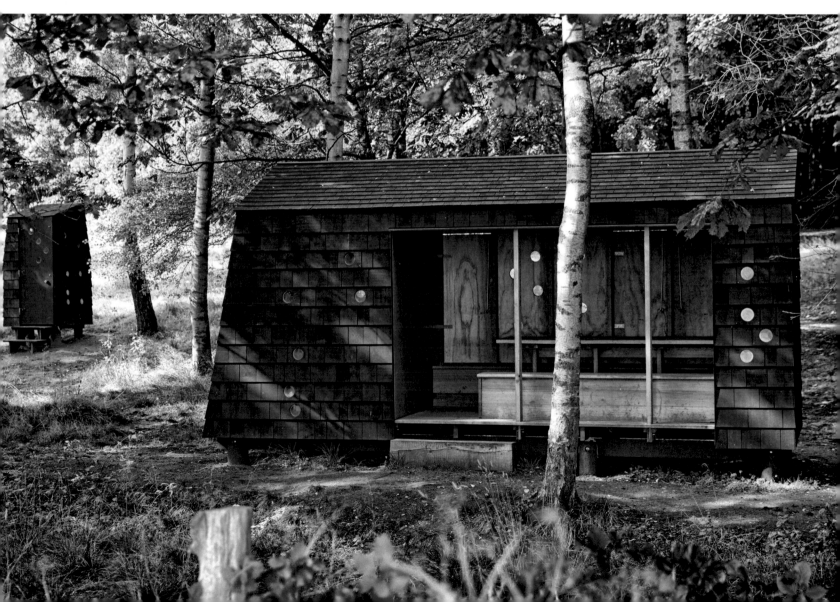

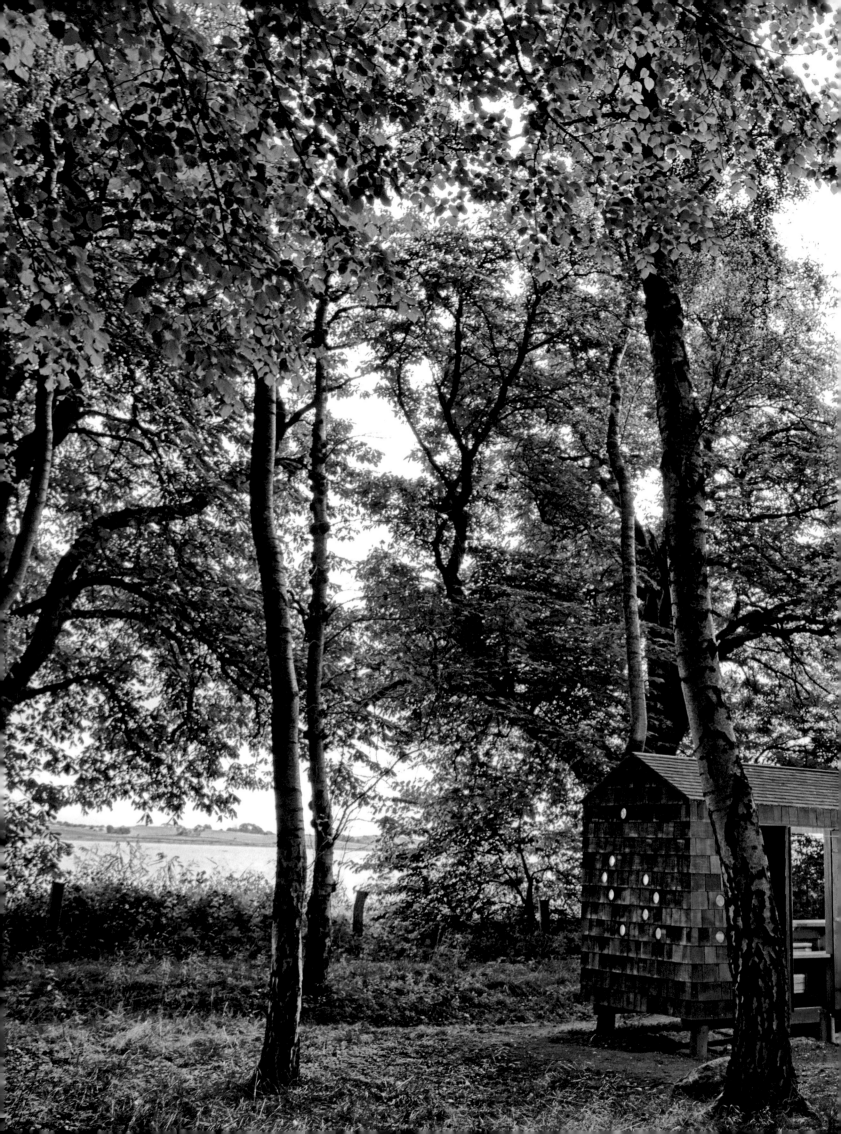

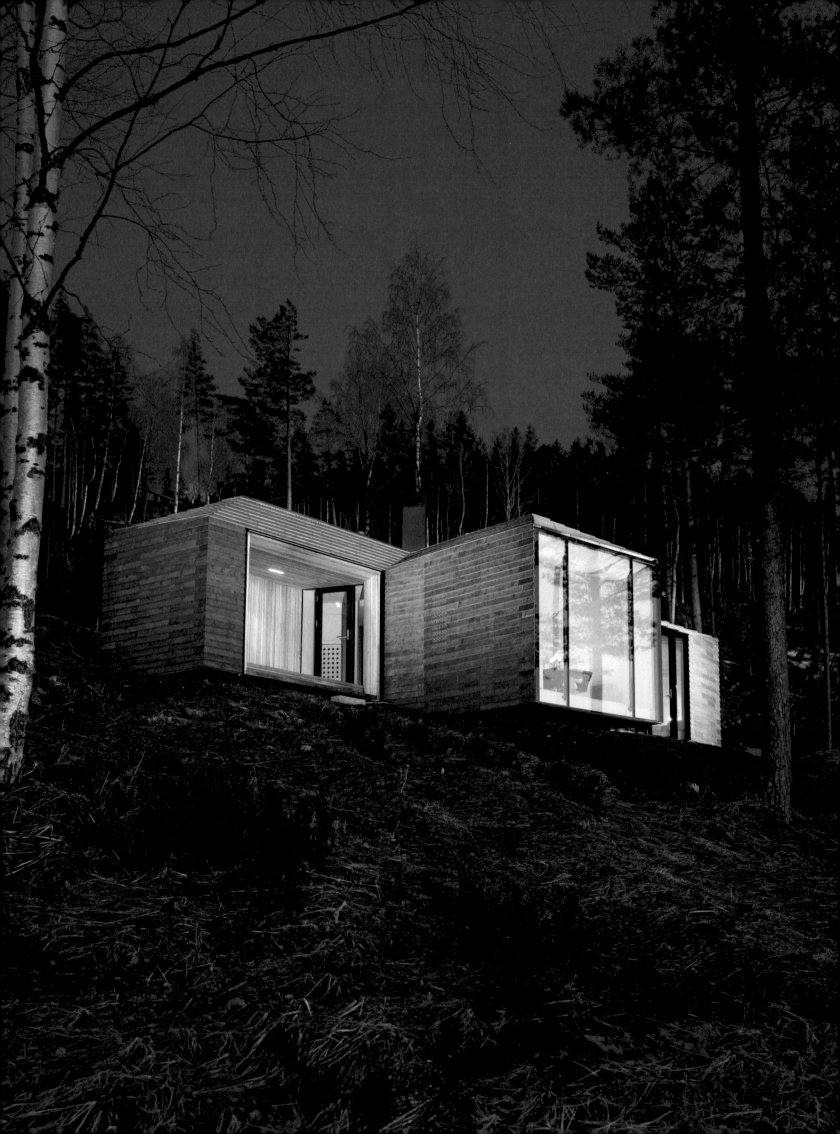

NORDIC NEST

ATELIER OSLO

Basking in the
mesmerizing
panoramas above
Lake Steinsfjorden,
an angular cottage
gives way
to a tranquil
internal sanctuary
of soft curves.

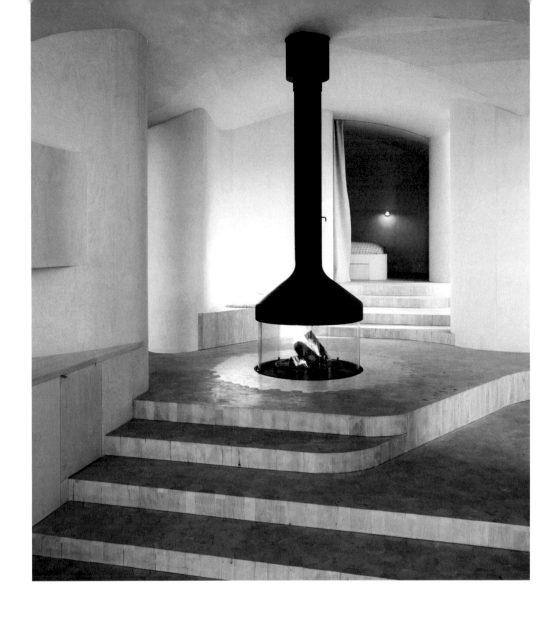

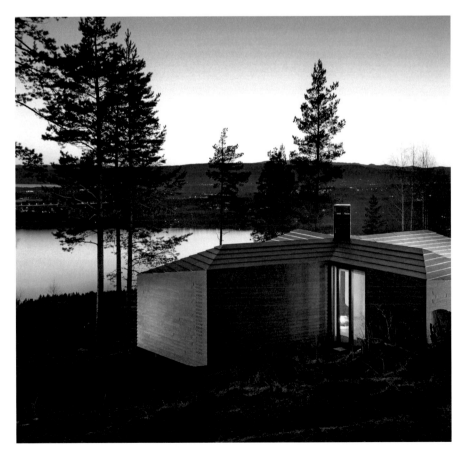

Overlooking lake Steinsfjorden in a remote Norwegian forest, this timber cottage sits on a steep slope above the water. The self-sufficient cabin unplugs from the stresses of city life and the power gird. Sheltered from the gusty winds that sweep through the region, the country home originates from several outdoor spaces that pull light deep into the interiors. The seemingly recti-linear cottage dissolves into an ethereal and fluid refuge of curving walls and ceilings. The floor follows the terrain demarcating subtle level shifts and mezzanines—stopping points for rest and reflection. Recalling the charm of an outdoor campfire, the inset fireplace holds a magnetic command over the center of the cabin. The poignant fireplace stays visible from all levels, ena-bling guests to enjoy its warmth from up close or from a more private vantage point. When the air turns crisp, one can retreat behind walls of glass that expose revelatory horizons dotted with the silhouettes of ancient trees. ◆

151

INTO THE TREETOPS

BLOOT ARCHITECTURE

This angular expansion
of a Dutch country home
rises towards the sky
while never losing site of its
mid-century roots.

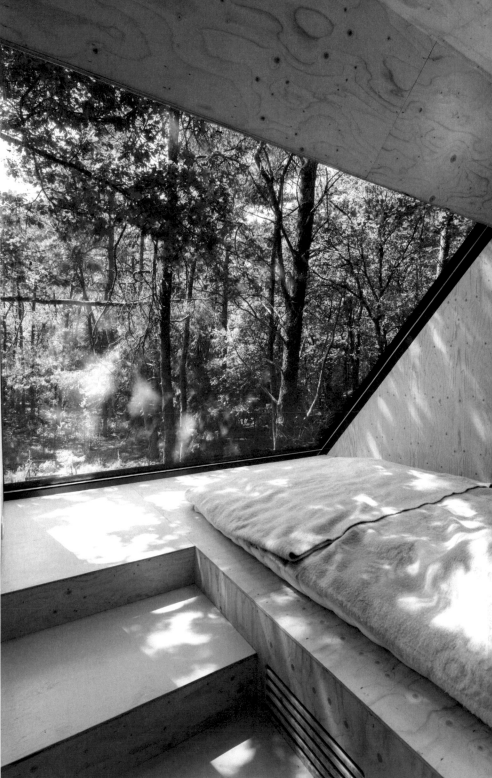

B uilt atop an existing holiday home from the 1950s, this compact sculptural addition remains largely hidden in its forest setting. The rooftop extension climbs out of the original structure, stretching towards the great vista of open grasslands ringed by forest. In line with the values of the original house, the new addition shares an understated attitude while introducing a fresh, updated identity. Hanging stairs link the extant living room to the new wing above, accentuating the contrast between old and new. The rooftop extension leads to a private window seat where once can take in the setting sun and diverse flora and fauna. Culminating in a large oblique win-dow, this personal nook allows the family to live within the trees without sacrificing creature comfort. The untreated larch extension contrasts with its brick base—a treehouse ascending into the leaves. ◆

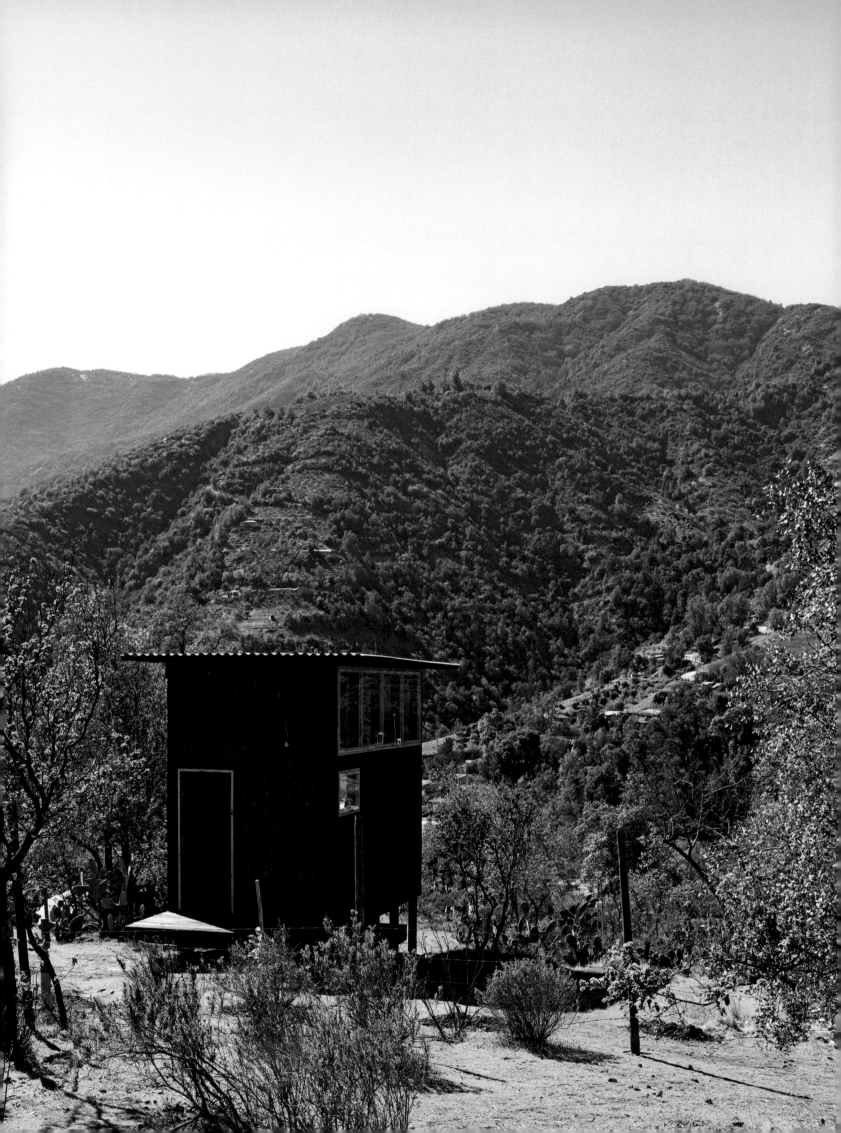

BUCOLIC SOLITUDE

DRAA – NICOLAS DEL RIO ARQUITECTOS

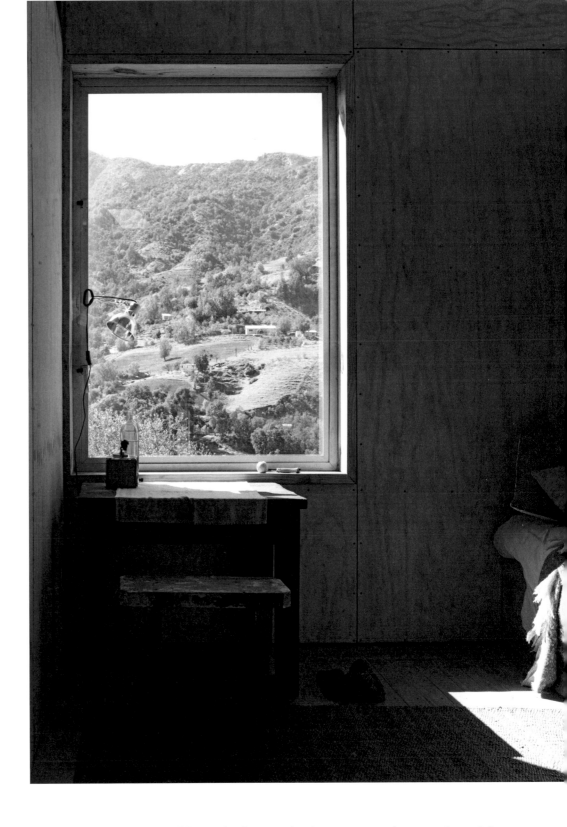

**A tiny mountain hideout
with views as far as the
eye can see forges a dialogue
with the picturesque
Chilean coastal ranges.**

Before the automobile era, a winding road linked the capital and the port across this pictorial coastal range. Brimming with historic traces of bygone eras, the region harbors a host of derelict monuments, battle sites, and long-since abandoned gold mines. An academic couple drawn to the melancholic atmosphere of the storied countryside carved out a space for sanctuary, informed by the faded markings of an almost mythical history. Keeping the dwelling to the utmost minimum, the cabin distills life to the basics. A place to eat, sleep, and read for two, the tiny shelter of charred wood pushes all other activities into the vast outdoors. Views of the pastoral valleys hang like landscape paintings, filling the interior with a contemplative reverie. A place to see and be seen, look inward and outward, the permanent-tent-turned-micro-cabin-on-stilts colors our common past with a fresh outlook on the future. ◆

TAKING SHELTER

B-ILD

A wartime bunker nestled
in a fort in the Netherlands that was transformed
into a cavernous vacation home.

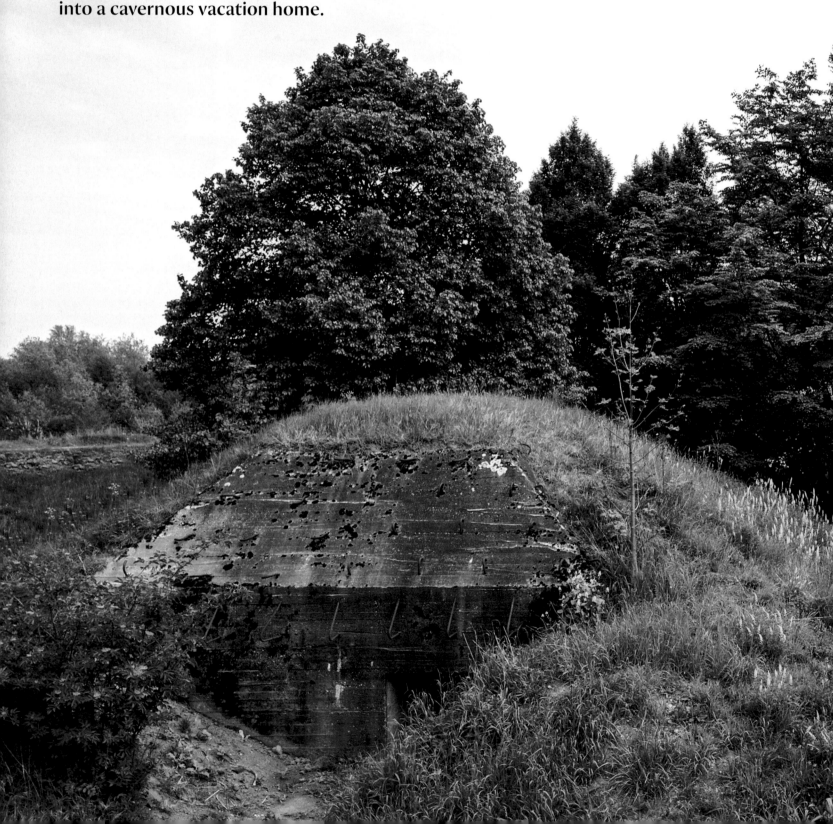

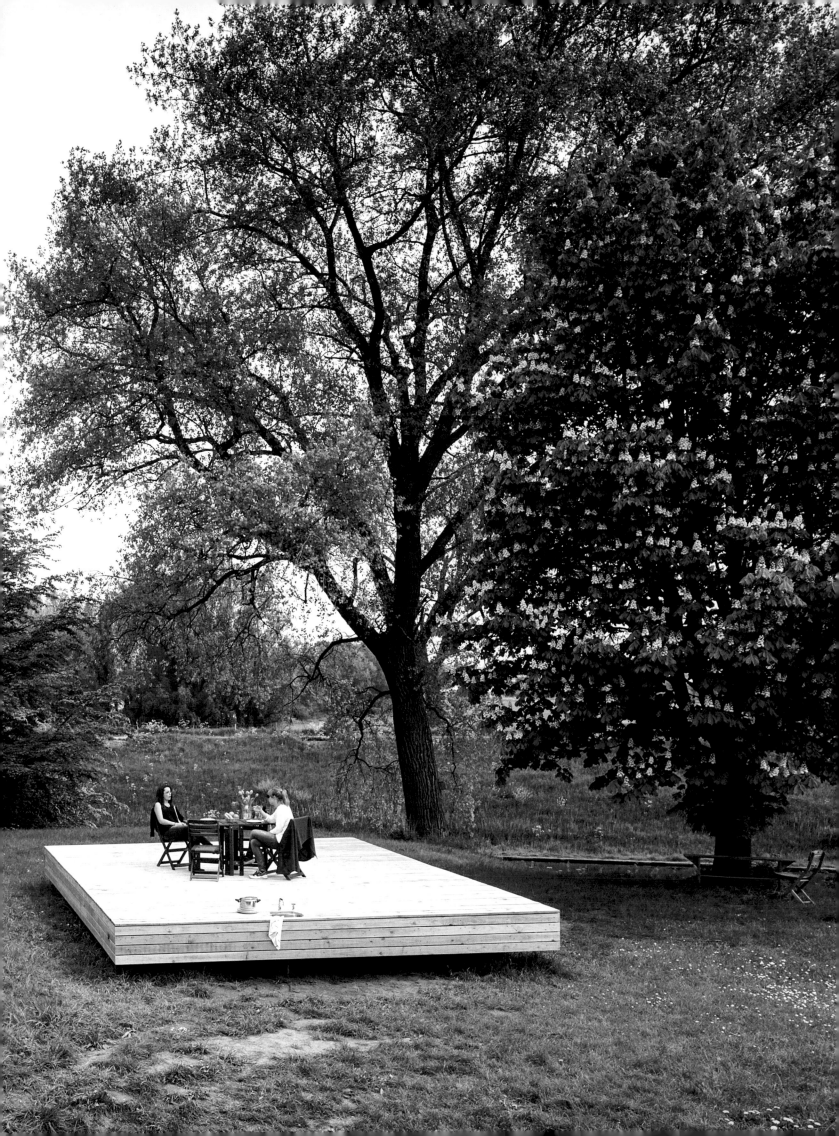

Fort Vuren is a fortress in the Netherlands that dates back to the mid-nineteenth century. It was built as part of the Nieuwe Hollandse Waterlinie, a line of defense that stretches up and down Dutch waterways that would flood land in the event of an invasion. During the Second World War, a bunker was built on Fort Vuren where soldiers could hide from enemy fire. After the war ended, it quickly fell into disrepair.

"Sheep found their place in it and bats liked the atmosphere," says the administrator of Fort Vuren, Ben Spee. "Farmers liked to use it for all kinds of purposes."

As part of an advertising campaign for the office Famous in 2014, the dilapidated, half-buried bunker was transformed into a holiday home. The campaign included a competition in which the winners could use the newly restored bunker for a period of two months as a holiday retreat. The

spruce-up, led by Belgian architectural firm B-ILD, proved so popular it has remained open for gutsy holidaymakers since.

"The bunker had to serve as a pleasant holiday home for a family of four people," says Bruno Despierre, the architect who led the restoration at B-ILD. By its very nature, the bunker was dark, cavernous, and largely inhospitable, not to mention covered in graffiti. "Because of its limited surface area, we tried to design an interior that is as functional as possible and doesn't leave a square inch unused."

The usable surface of the main room measures just 9 square meters, with a height of 1.8 meters, and the challenge was to find a way to turn it into a subterranean place that people would actually like to holiday in—a challenge that B-ILD embraced. "One of the reasons we were excited to develop this project were the strict restrictions. We tried to maintain the special identity of the bunker while still creating an intelligent response to the brief from the client," says Despierre. The bunker is protected by the Dutch Commission for Monuments. "We tried to find creative solutions for the different functions that are necessary for a holiday hideaway such as sleeping, dining, cooking, and storage."

The architects turned to Le Corbusier's holiday home in the south of France, Le Cabanon, to determine how to work with

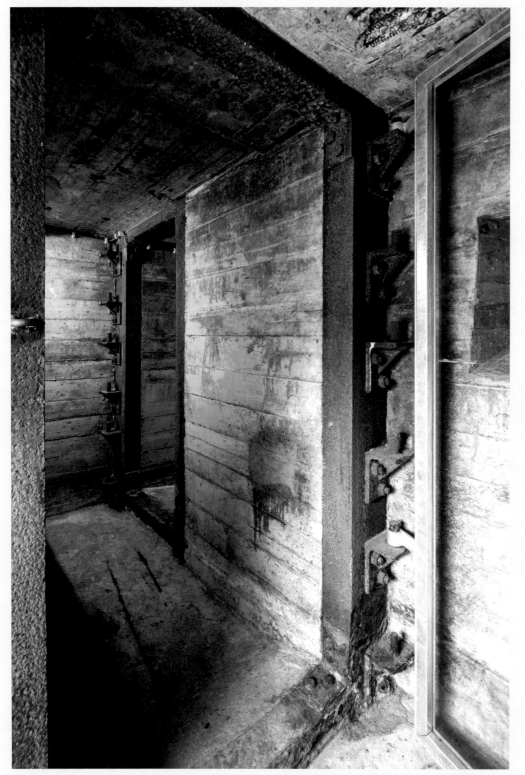

"We tried to find creative solutions for the different functions that are necessary for a holiday hideaway such as sleeping, dining, cooking, and storage."

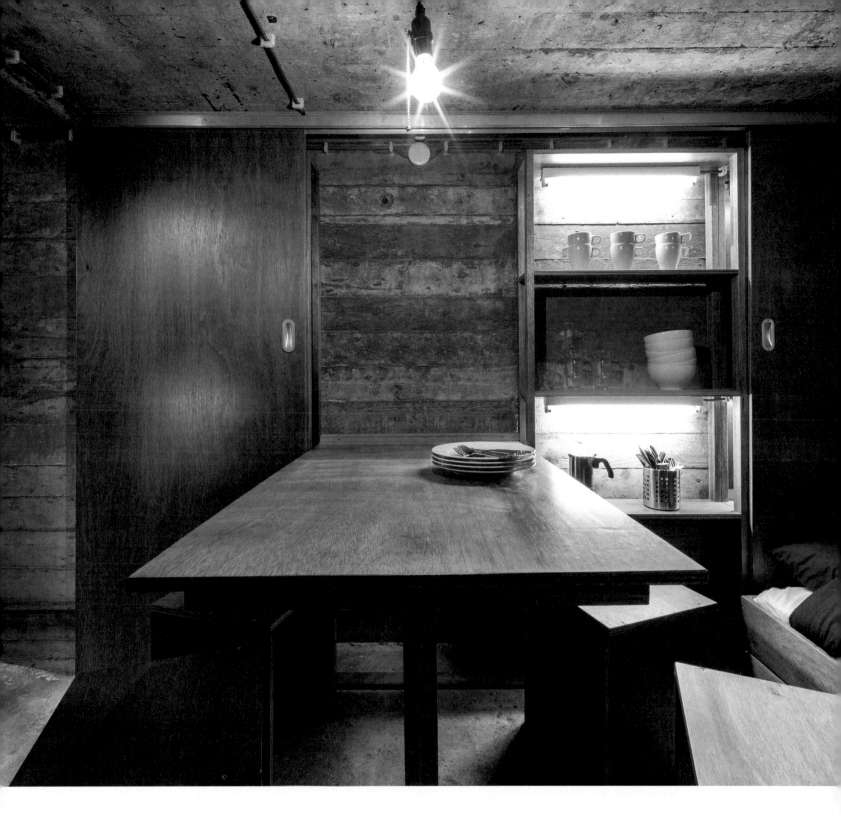

such a small space. A narrow kitchen area was positioned in the entranceway to free up the central living room (showers and toilets are located elsewhere on the fort). Flexible, custom-made wooden furniture was designed to exploit the space, and all furniture can be stowed away to open up the multipurpose living area. The dining table is on hinges and the upper beds can be folded up against the wall, while the lower beds can be slept on at night and lounged on during the day. There are storage units under the beds that slide out and plenty of stools that double up as nightstands or as steps to get to top bunks.

The choice of materials was important of course: B-ILD decided to work with warming meranti plywood for the construction ❯

*left*_ **A modern glass door opens the concealed walkway into the bunker.**

*top*_ **Inside the dining area, furniture is multi-purpose but comfortable, transforming into a bedroom at night.**

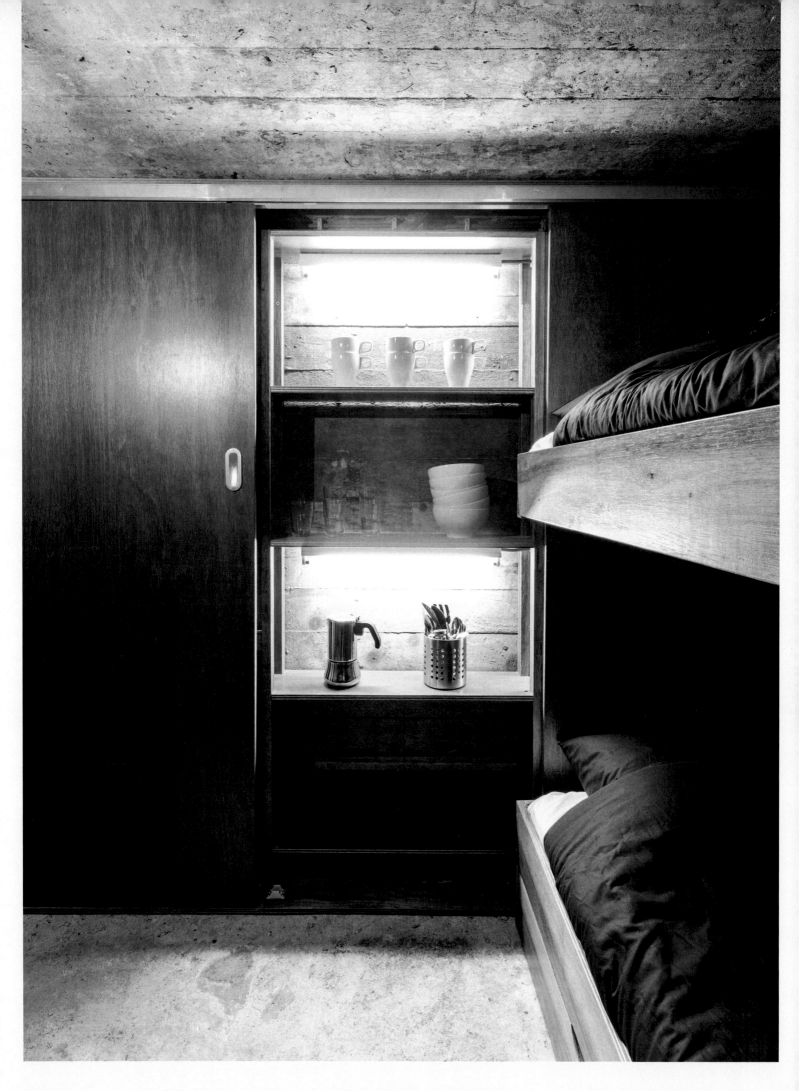

160

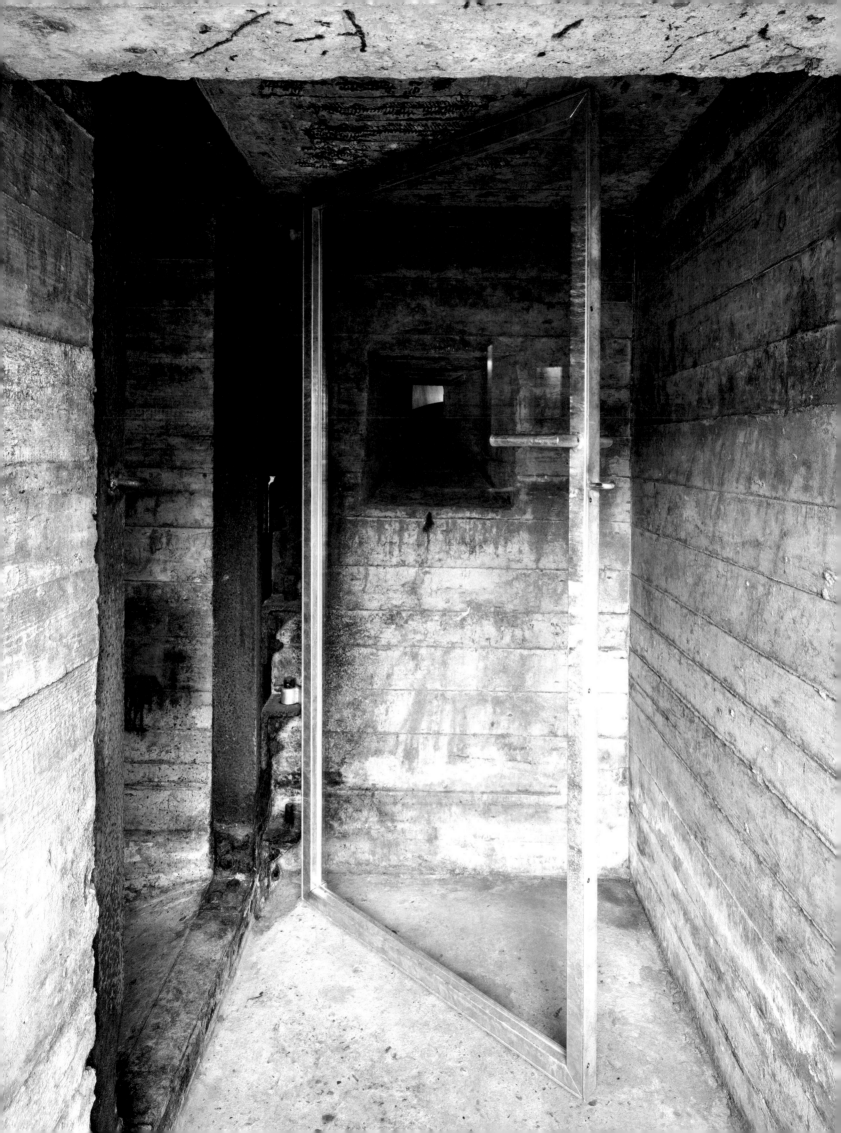

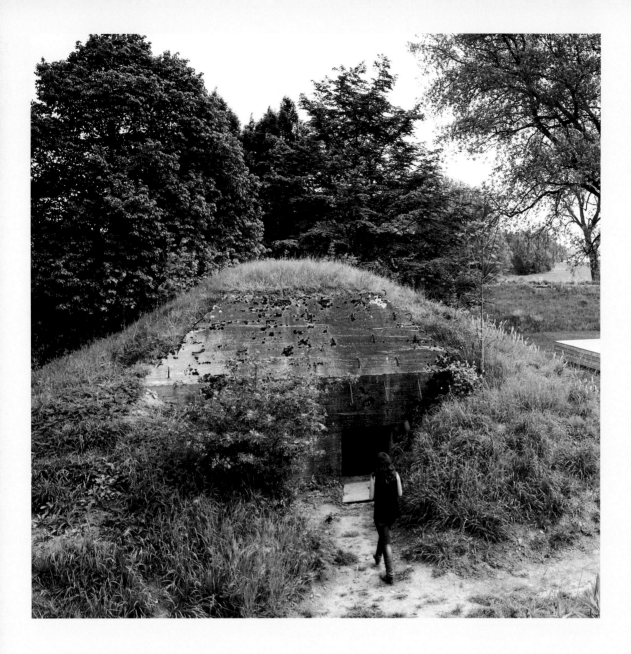

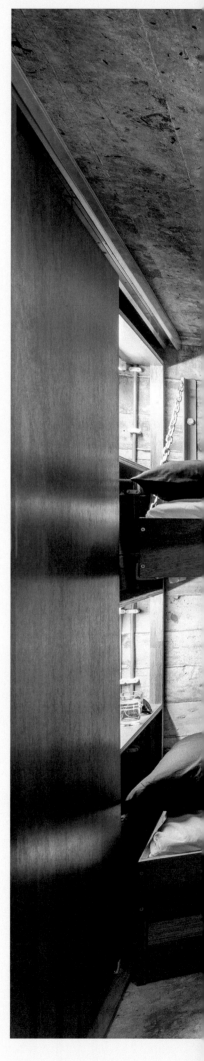

top_ **From the outside the bunker is unasuming and conceiled.**

right_ **Bunkbeds are cleverely arranged to comfortably sleep four in the bunker's main room.**

of all interior furniture to contrast with the hard, monolithic concrete. Clever, cozy lighting was also installed.

However, average summer holidays rarely involve whiling away hours inside, which is why B-ILD created a deck at ground level to make the most of the panoramic views and green surroundings on the fort. The dimensions of the deck are identical to that of the circumference of the bunker downstairs (minus the thick walls, giving visitors an indication of just how monolithic they are). The same wood that the concrete was originally cast in was used to construct the deck,

and it is slightly raised to provide storage underneath.

"The floating deck outside is the only element which we added to the bunker," explains Despierre. "This terrace allows visitors to enjoy the environment and surrounding water. It's an outside living space where they can camp or sunbathe."

And then retreat down to the bunker when the sun goes down: bearing in mind the bunker was originally intended to sleep 12, there's more than enough room to go around. ◆

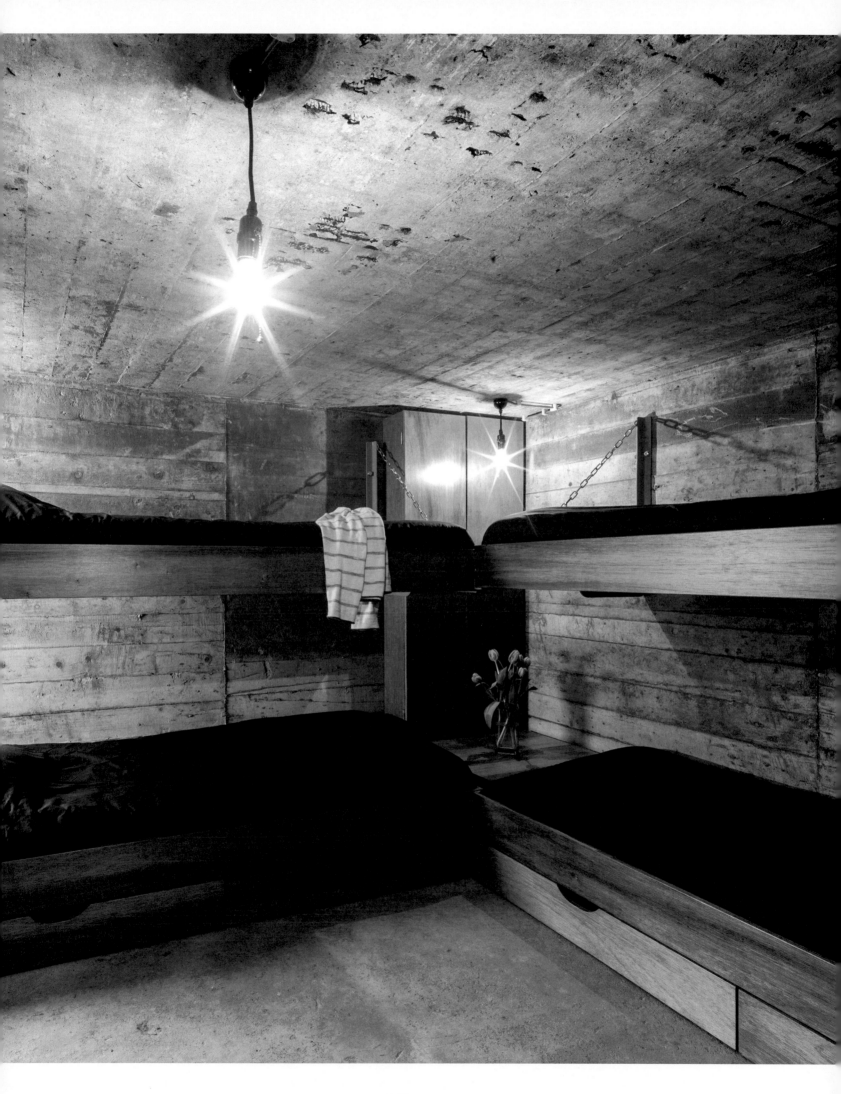

RAINFOREST REFUGE

ATELIER MARKO BRAJOVIC

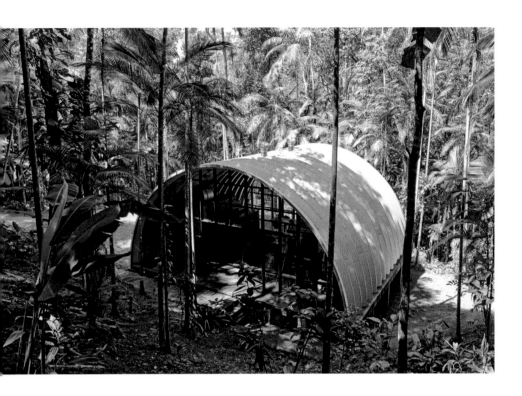

A manmade arch, emblematic of the tropical surrounds, swoops through the untamed wilderness in a gesture of captivating coexistence.

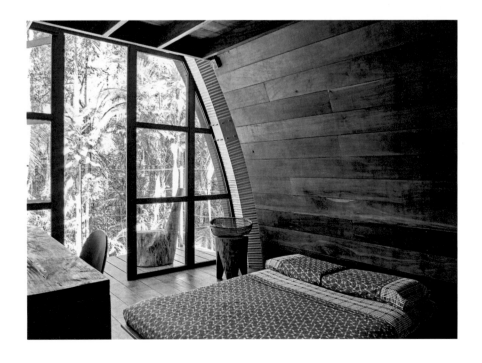

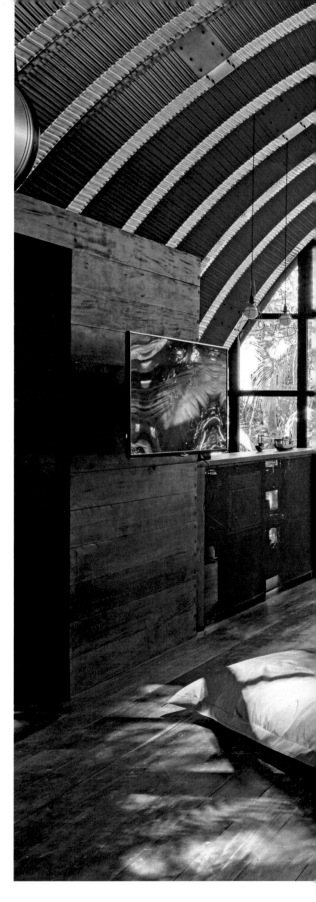

> "The lightweight shelter balances its industrial materiality with an alluring jungle spirit."

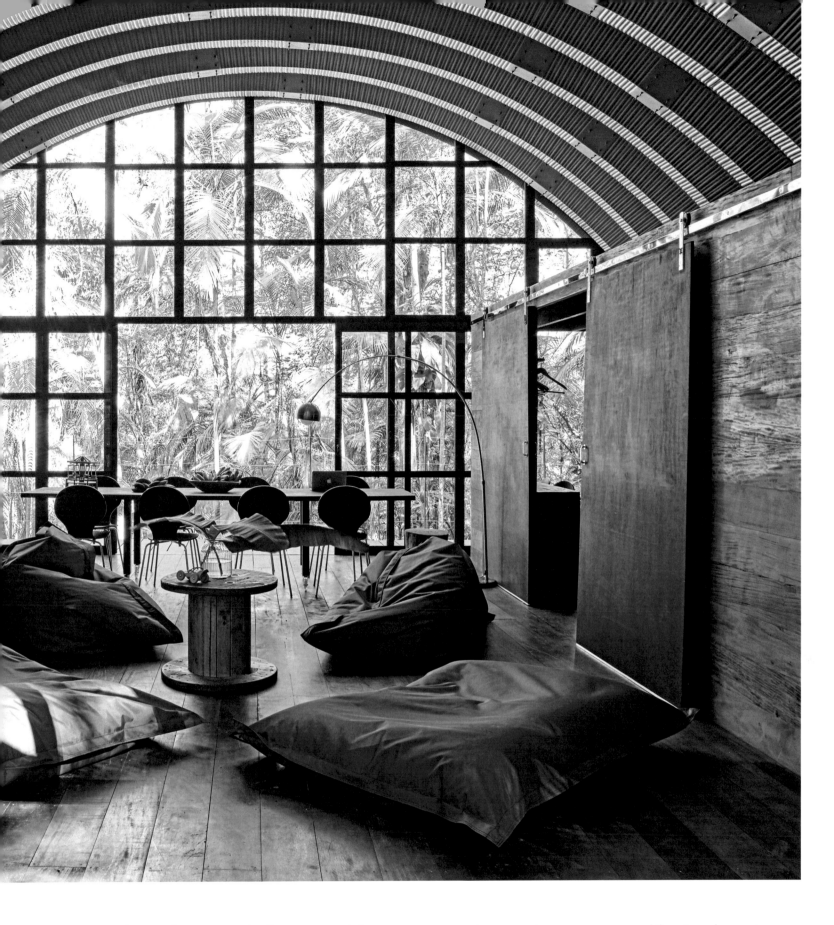

In the lush Brazilian rainforests atop the Perequé waterfall, an iconic arched shell houses two couples and their children. Simply known as "arca" to locals, the enviable landmark conjures up playful imagery of a ship docked in the middle of endless vines and palm fronds. The stand-alone weekend retreat mimics indigenous Brazilian houses hidden between the leaves. Stripping away barriers to nature, the arched shell caps each end in glass. These massive windows turn the space into an exhilarating observation point, encouraging an up close and personal dialogue with the astonishing biodiversity just outside. Drawing from the structural logic of tropical plants and their ability to span great distances, the lightweight shelter balances its industrial materiality with an alluring jungle spirit. A rare bird spotted through the trees, the sculptural hideout questions where nature stops and home begins. ◆

BREAK
IN THE DAY

SA.UND.SA ARCHITETTI

A cabin-turned-outdoor temple
high up in the hills of the Italian countryside
peels open to let the light shine through.

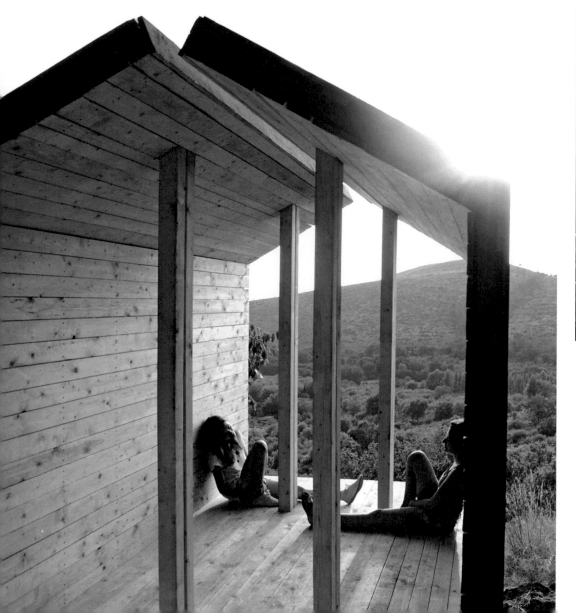

"The figural folly
amplifies the landscape,
providing a haven
for meditation and
prayer."

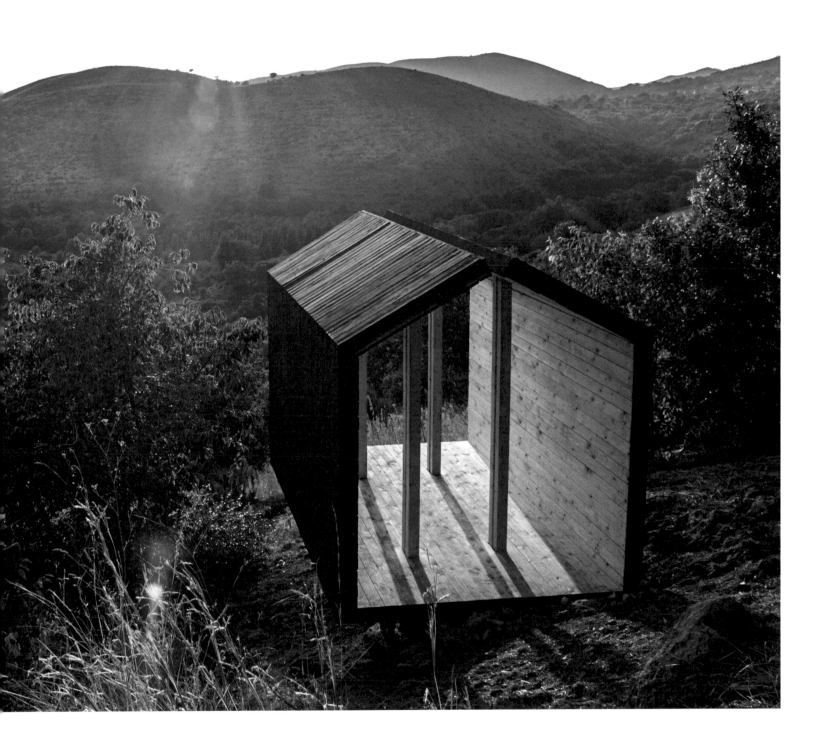

On a summit confronting sweeping valleys, an open-air resting place outlines the familiar symbol of home. The figural folly amplifies the landscape, providing a haven for meditation and prayer. What the shelter omits, the imagination returns. Stripping away the enclosure to its purest form, the ephemeral shelter leaves its two main faces completely open to the vista. A narrow slit at the apex of the roof sets the restful viewpoint aglow in oblique rays of sunlight. The comforting landmark subtly reminds of human presence on the land—a spatial marker denoting the threshold between man and nature. As if burned over time by the Mediterranean sun, the dark wooden exterior gives way to a light golden interior with exhilarating views over the steeply sloping hillside. The tranquil space, surrounded by a rock wall and a stand of Indian fig trees, looks to the hills of Giano Vetusto. Names and dates carved into the leaves of nearby cactus plants trace the fading ardor of bygone summer romance. ◆

A FOREST SERENADE

ARTUN

**Three forest follies
in the shape of giant megaphones
envelope travelers
in the amplified sound-scape of the wild.**

Deep in the Estonian forests, three monumental wooden megaphones rest, scattered between dark-barked fir trees. The surreal larch wood sculptures appear as found objects happened up-on in a forest clearing. The impromptu resting places behave as personal listening booths for tuning in to the sounds of the woods. The angled interiors become supportive spaces for lounging, framing sky on one side and moss and blueberry bushes on the other. A place to rest your feet as well as your thoughts, the massive megaphones take the hiker by surprise. The unexpected juxtaposition amidst the lush, tranquil stands of trees heightens the senses. Elevating the process of listening to an art form, the acoustic megaphones invite passersby to stop and honor the diverse forest sounds. The trio of megaphones amplify nature's soundtrack as they distill the notion of shelter to its most primal form. •

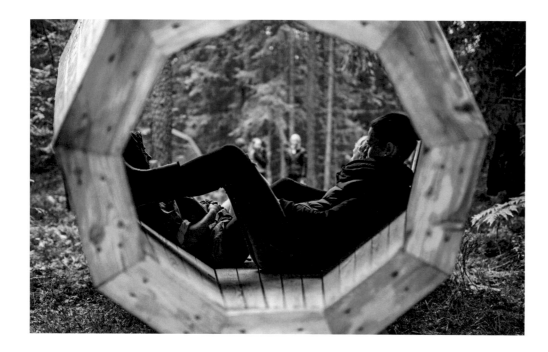

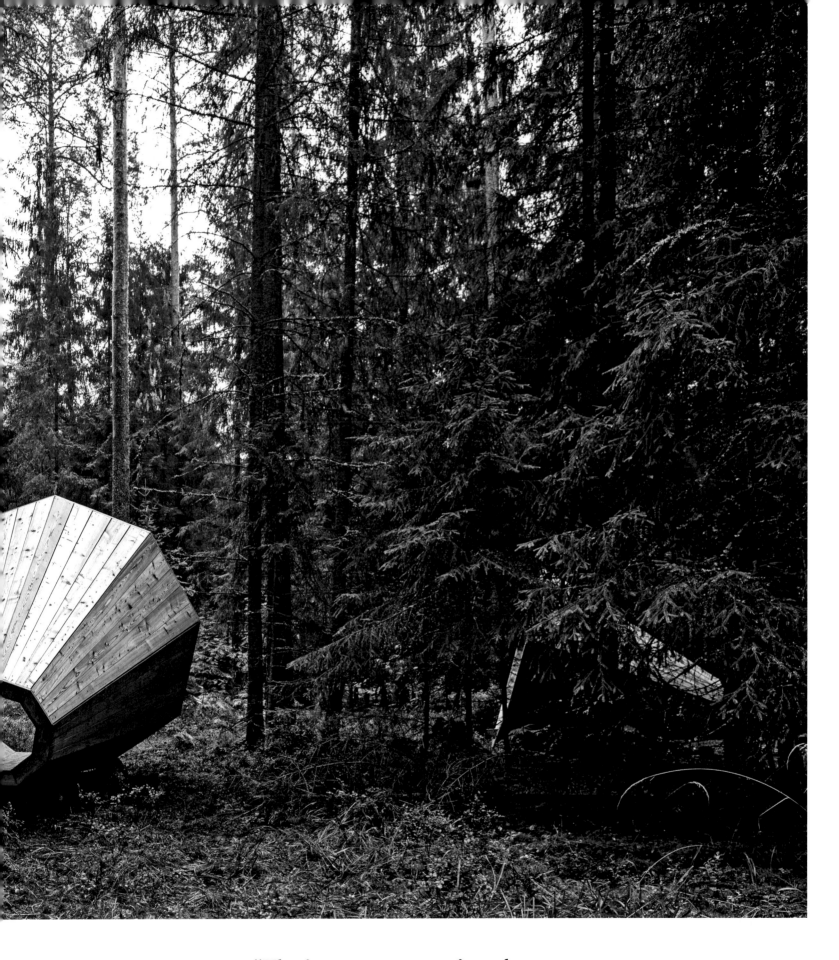

"The impromptu resting places
behave as personal listening booths for tuning
in to the sounds of the woods."

– Scottish Borders –

PAST PERFECT

WT ARCHITECTURE

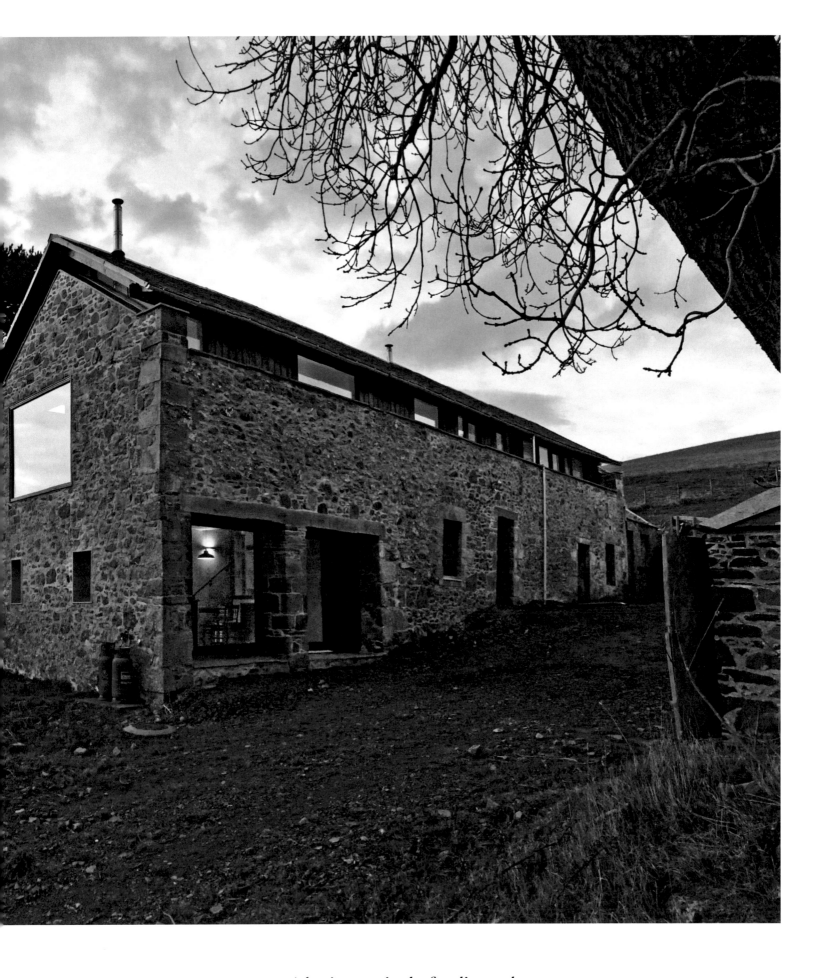

A loving revival of a disused
farm building beckons from
its commanding roost on a bucolic
Scottish hillside.

171

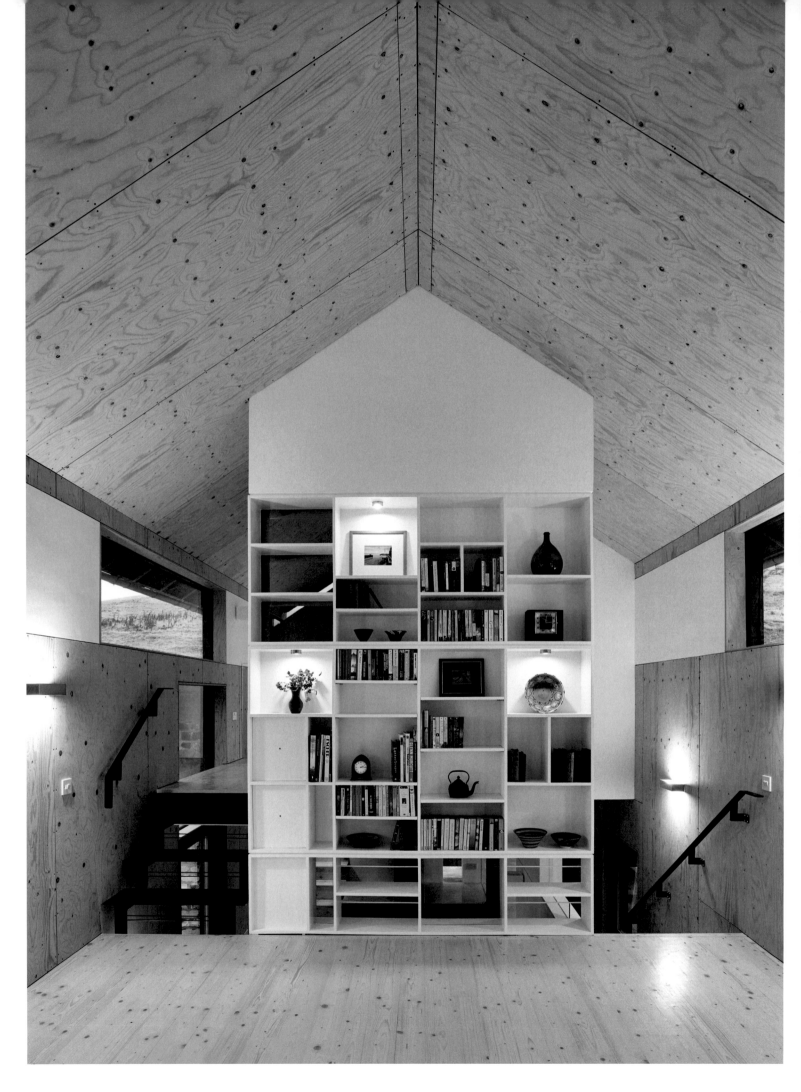

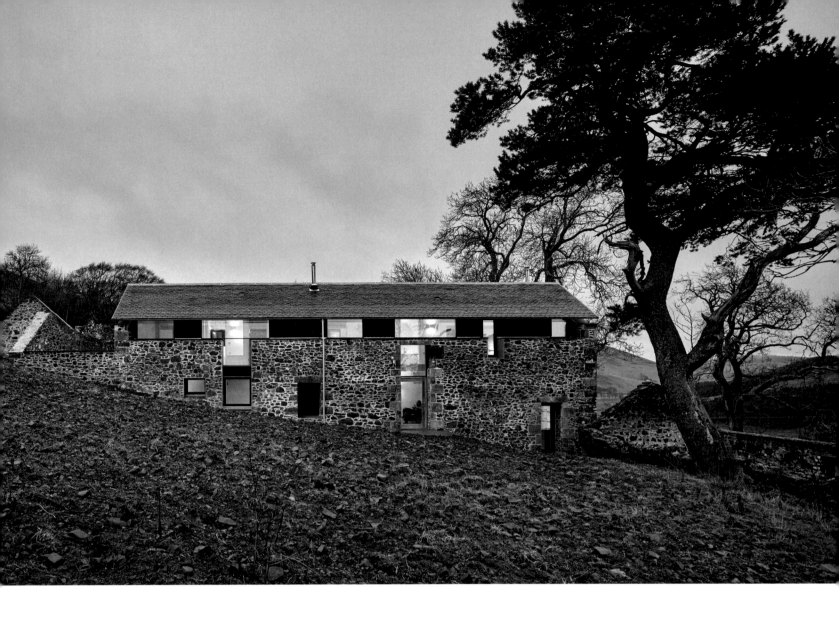

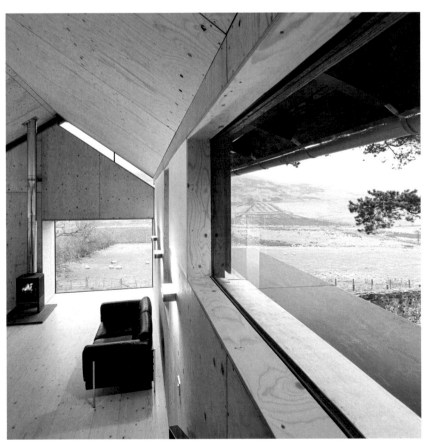

At once exposed and assertive, a country home emerges out of a steep hillside overlooking a remote valley in the Scottish Borders. The distinctive renovation transforms a country ruin into an idyllic sanctuary. Characterized by its forgiving mix of rural materials and historic adaptation, the resurrection of the disused farm building rallies behind an original stone masonry wall. Rising above the walls of its history and towards an enticing future, a clerestory spills sunlight throughout the reposeful interior. Dramatic level changes inspire a prolonged state of curiosity reminiscent of the flutter often felt when seeing something anew for the first time. Rugged yet refined, the restoration preserves a timeless charm that begins with the first knock on the original front door. ◆

173

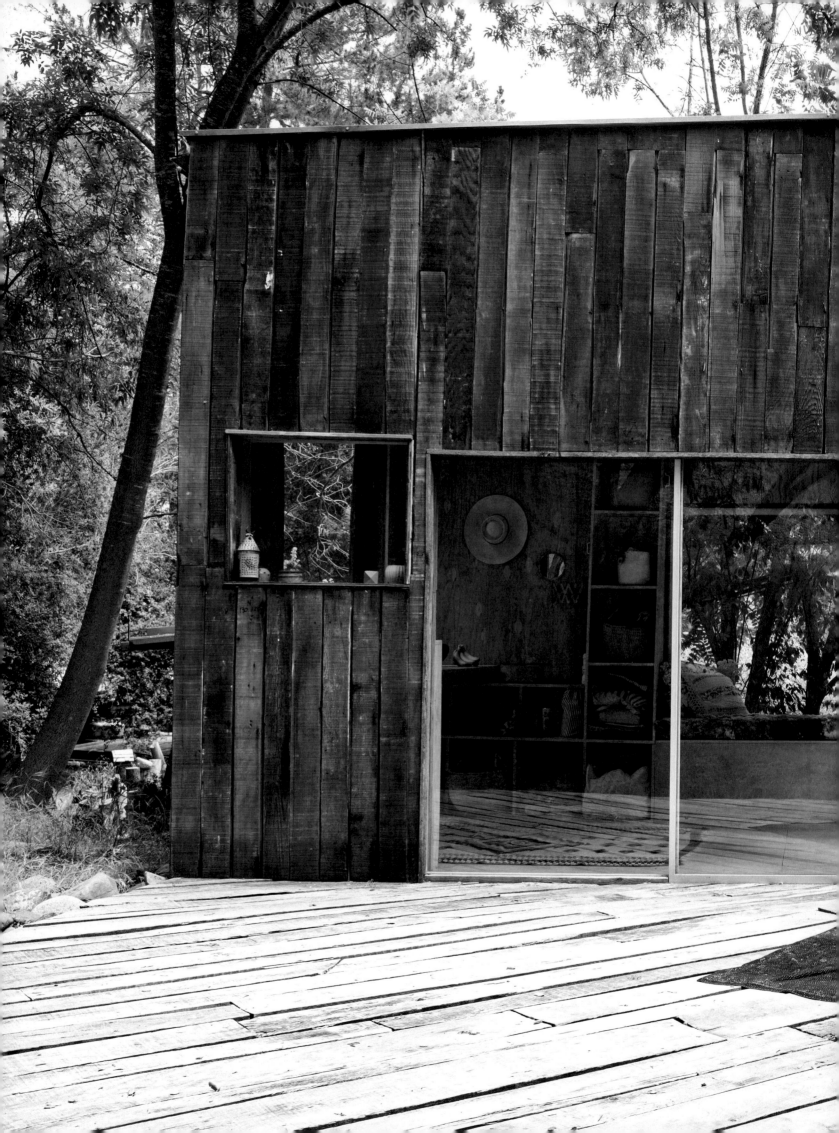

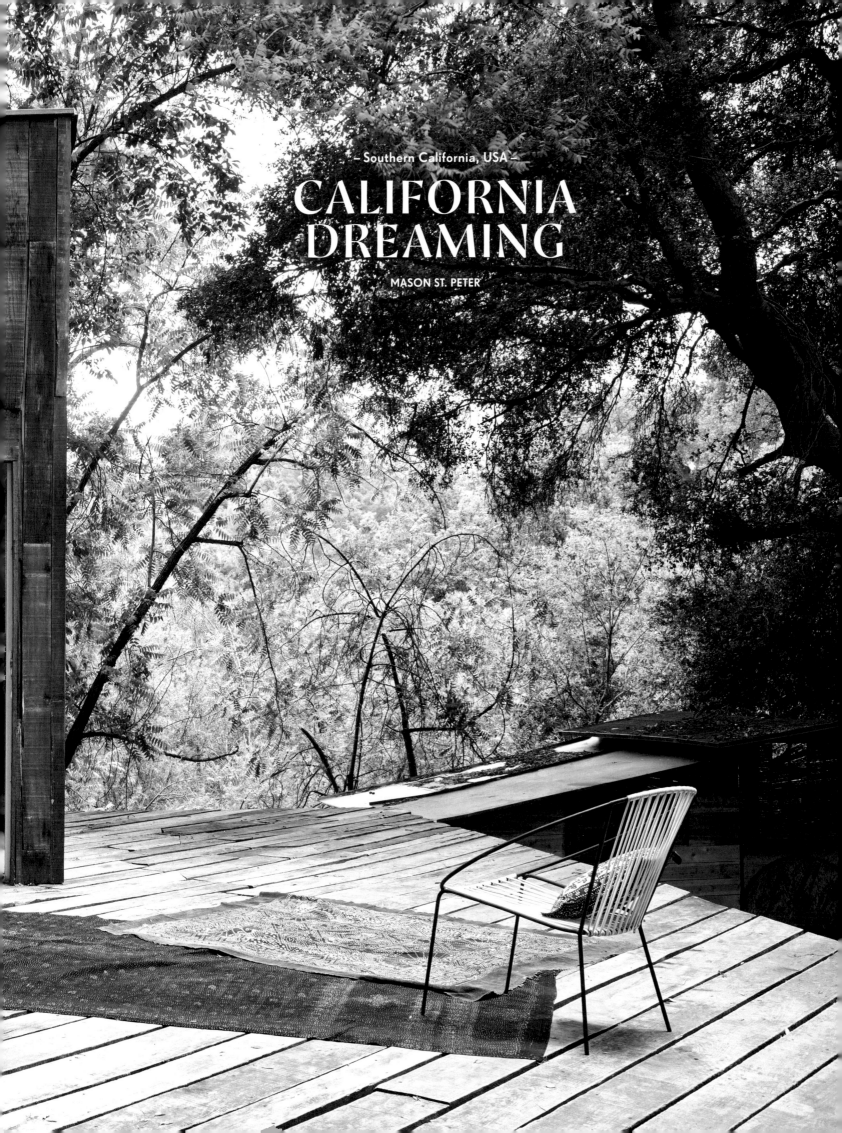

– Southern California, USA –

CALIFORNIA DREAMING

MASON ST. PETER

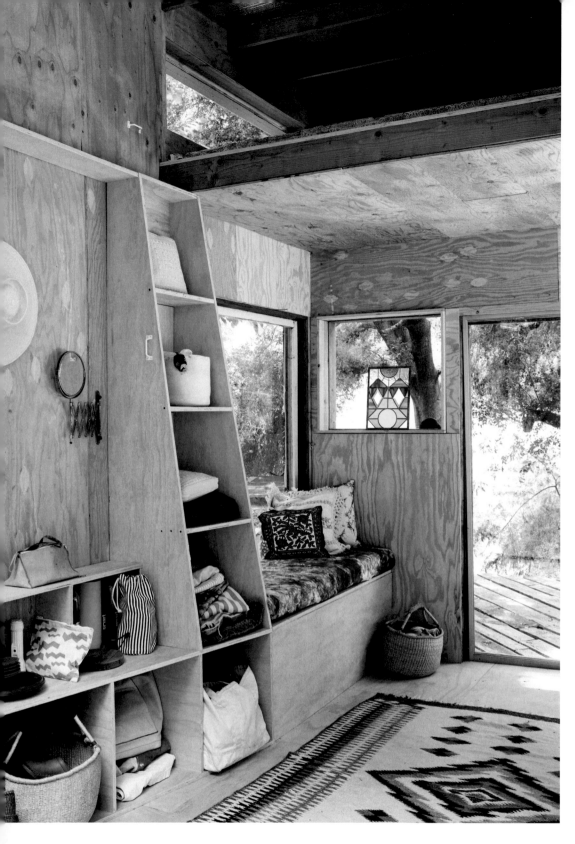

An arcadian surf shack in the sleepy oasis of Topanga Canyon allows the worries of city life to fade from view in the midday sun.

Off the picturesque Pacific Coast Highway, wilderness takes over as the metropolis becomes a distant memory in the rear view mirror. One such secluded spot holds an endearing surf shack. Following an eye-opening visit to a friend's studio in the idyllic Topanga Canyon, an architect pledged to build his very own. An infectious California spirit permeates every corner of the unassuming cabin. Lazing in the southern sun, the simple hideaway—built from the scraps of other cabins—captures the rustic charm of canyon life. The rugged patina of the exterior planks makes the project feel as if it has always existed in these rural woods—a spirited rearrangement of timeless parts. Three of the four sides of the single room cube connect to the outdoors, granting a sense of spaciousness as life moves onto the gracious sundeck. Warm summers melt into mild winters that support a year round indoor/outdoor lifestyle, leaving one to wonder why people live anywhere else. ◆

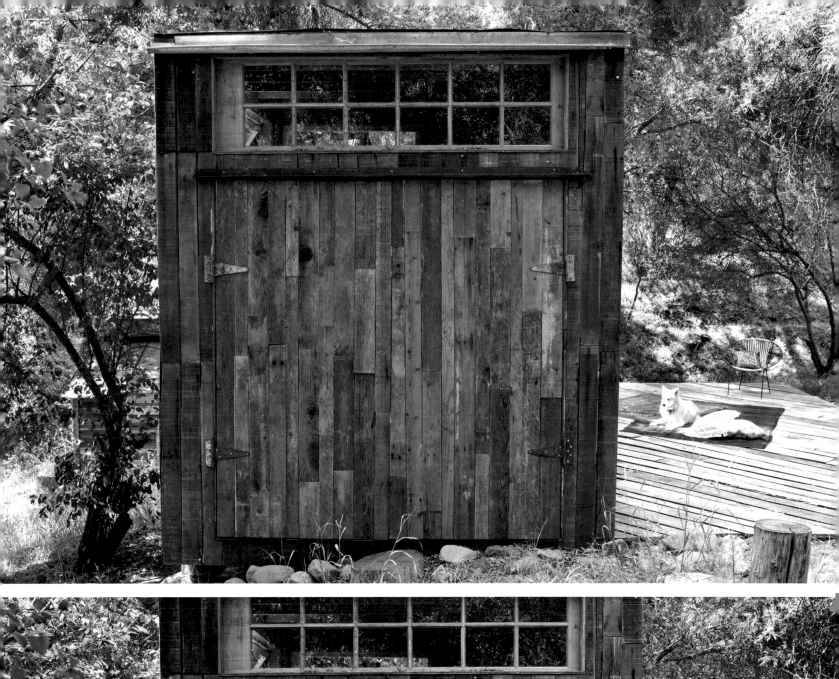
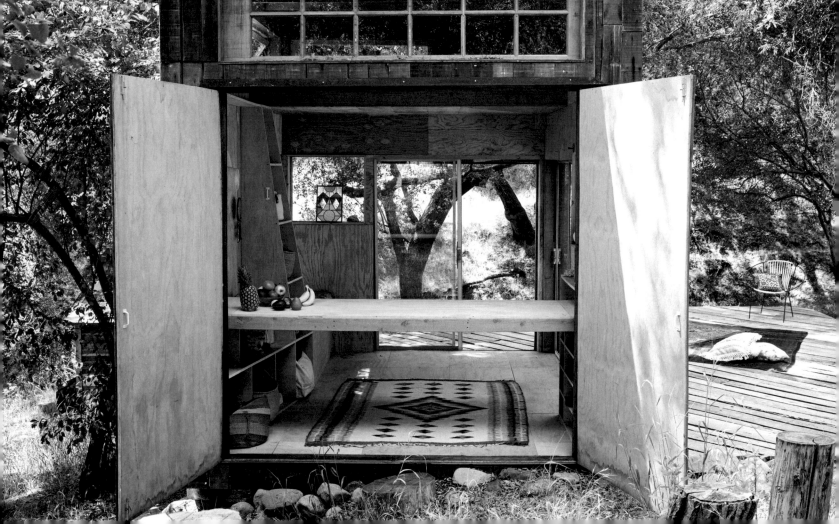

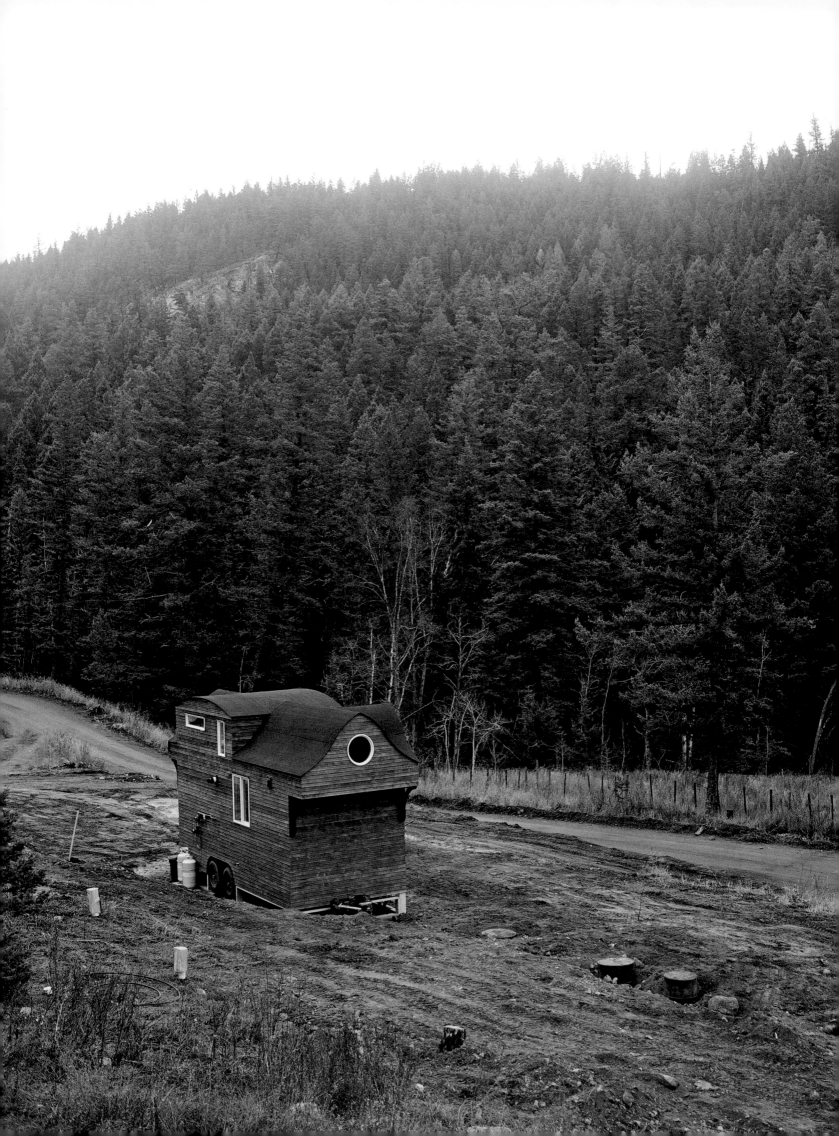

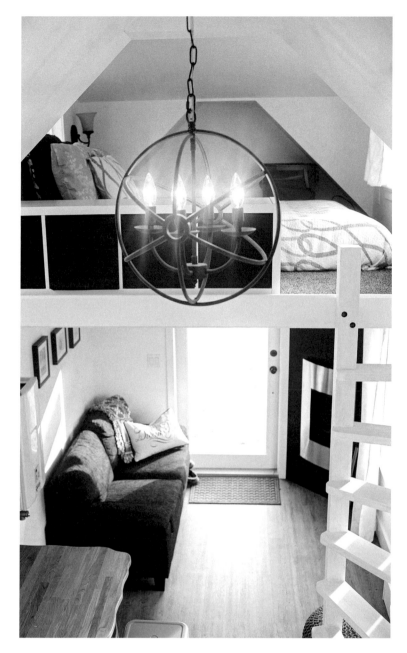
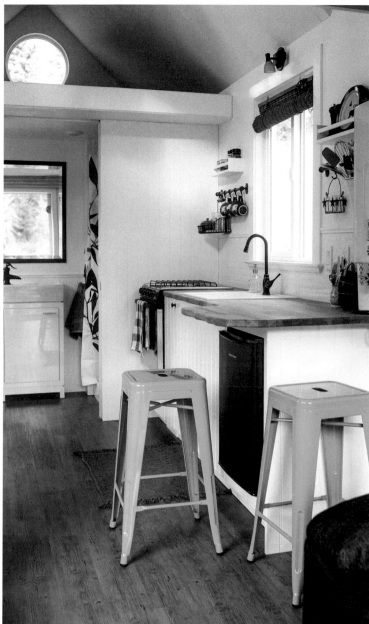

ABOVE THE SACRED GROUND

ROBERT & BETTINA JOHNSON

This spirited tiny home on wheels honors its secluded location in the Secwepemc territory of British Columbia. A testament to history and handcraft, the wooden guest house becomes a noble showcase for traditional Aboriginal art and carvings. Imagery of bear and salmon, whittled into the wood, take up residency over the front door and along the rafters. Spread over two open levels, the cabin retains a spacious feeling in spite of its compact nature. Vaulted ceilings

A diminutive house on wheels pays tribute to the Aboriginal tradition as it treads lightly on the ancient lands of the Secwepemc people.

and a bright white interior contrast with the dark charred exterior. A slender spiraling ladder links the ground floor with the dual sleeping lofts above. Rugged on the outside and cheerfully modern within, the cabin embraces the future while honoring the established culture and vernacular legacy of the region. The exterior's woodsy appearance blends well with the primal forest surroundings. The softly undulating shelter sits atop a trailer, empowering its owners to relocate as the mood strikes. ◆

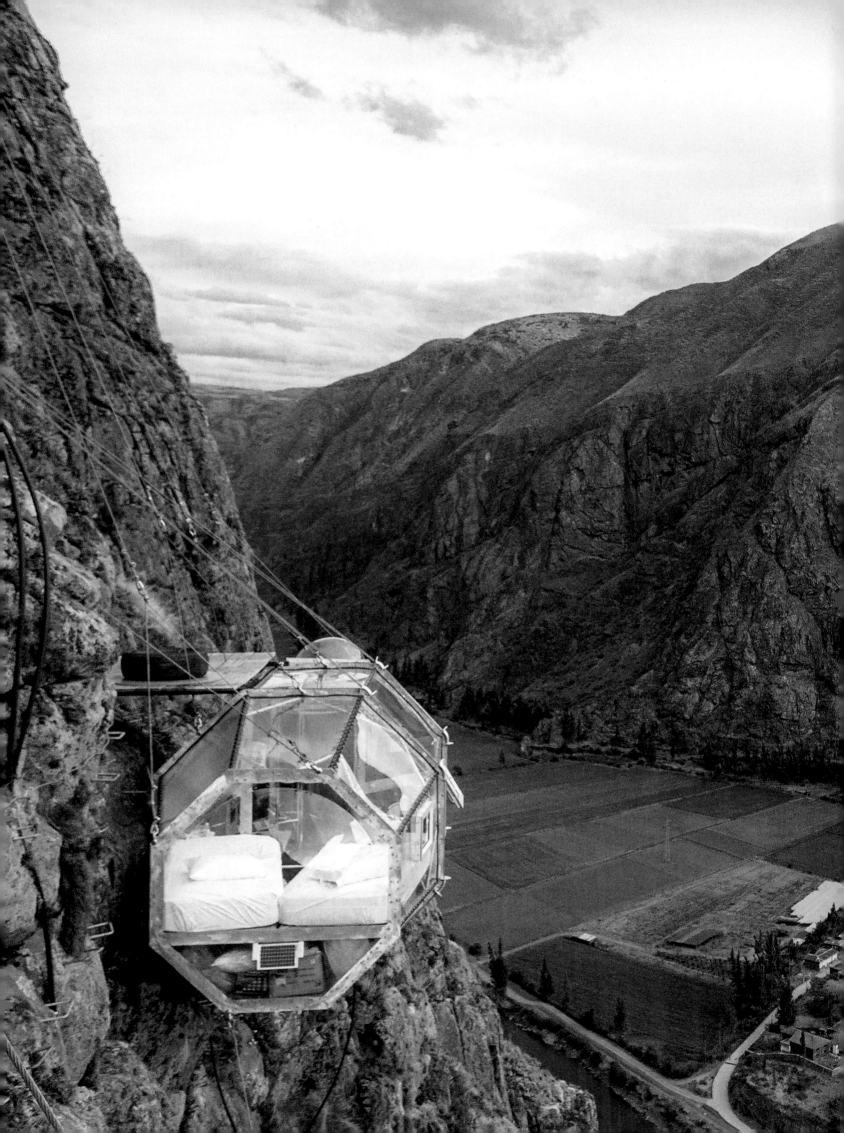

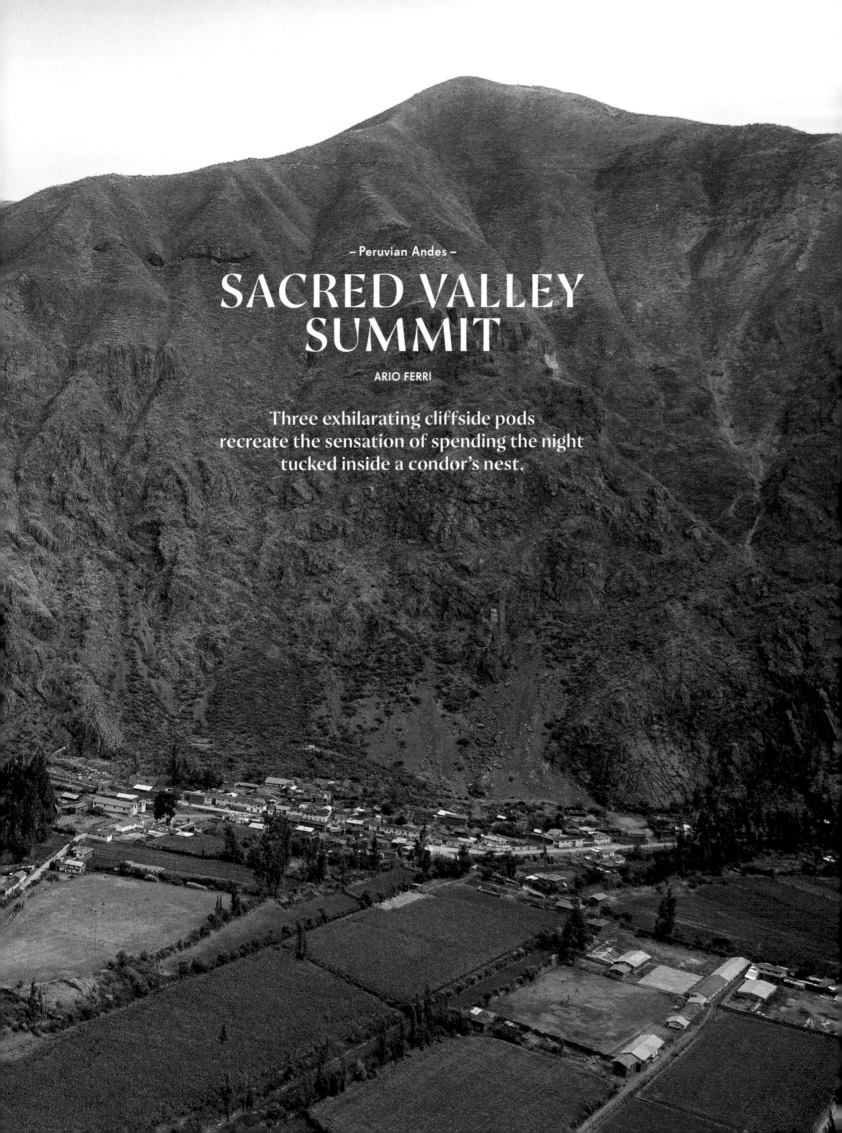

– Peruvian Andes –

SACRED VALLEY SUMMIT

ARIO FERRI

Three exhilarating cliffside pods
recreate the sensation of spending the night
tucked inside a condor's nest.

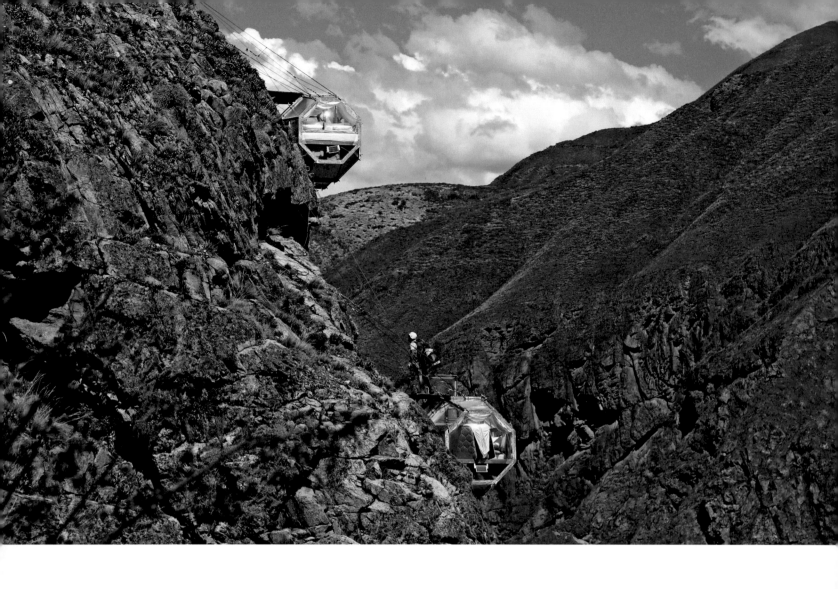

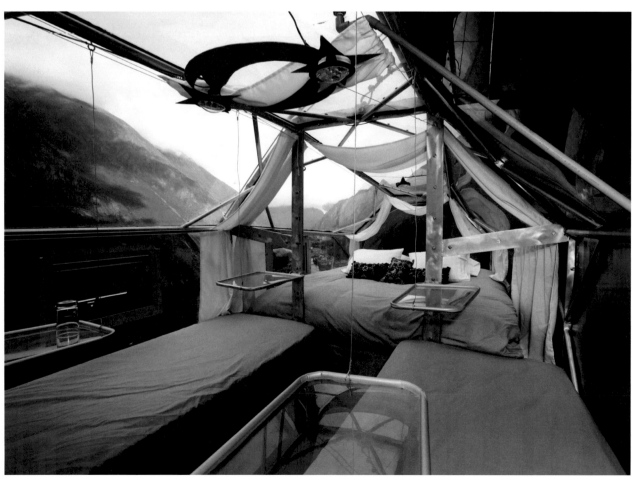

182

Not for the faint of heart but the light of feet, three luxury capsules for overnight adventurers suspend off the side of a mountain 1200 feet in the air. To reach the Skylodge, guests must first scale the precarious Via Ferrata climbing route or hike an intrepid trail linked by ziplines. The high altitude suites include a dining area, a private bathroom, and a sleeping space that makes the heart quicken a beat. The completely transparent bedroom with 300-degree views of the Inca's majestic Sacred Valley strips away all barriers, providing the most ephemeral boundary between guests and the great beyond. Fine white curtains hang from the domed space, warding off the curious gaze of passing condors. Al fresco meals, complete with protective helmets and brightly colored traditional woven tablecloths, are served on a discreet platform on top of each capsule. The magnetic setting and sublime vantage point engrain the exhilaration of ascent into the psyches of those daring enough to visit. ◆

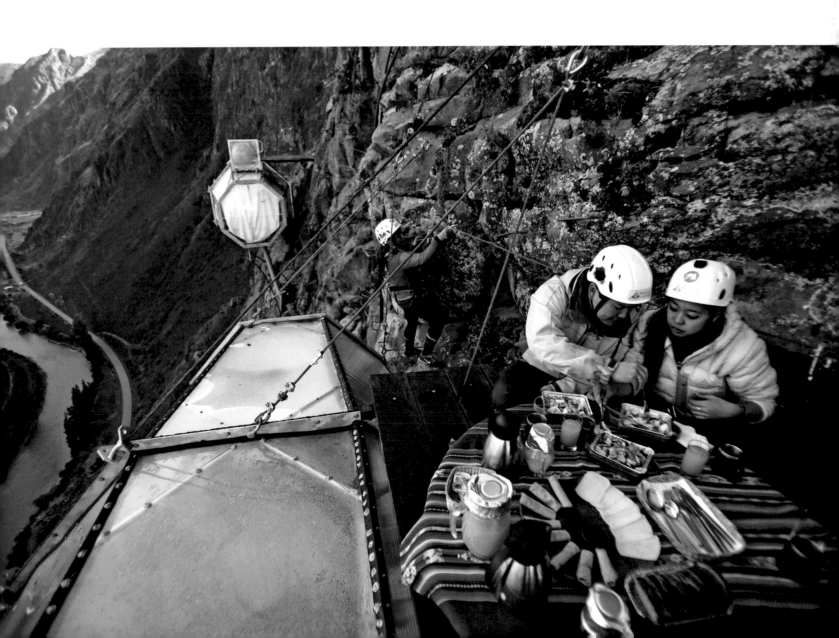

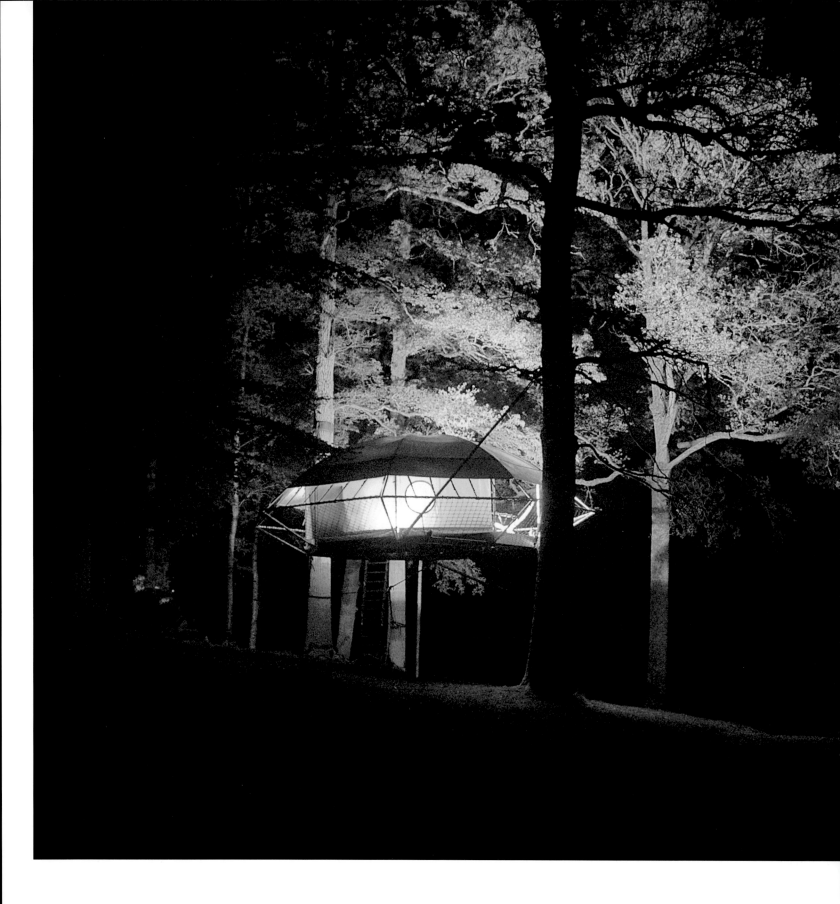

Part futuristic tent and part mysterious cabin, this daring alternative to the traditional tree house choreographs memorable nights under the stars. The hovering hideout spans between two trees without leaving a single trace of wear upon the trunks. Suspended high above the land, the domed shelter introduces touches of luxury typically absent from most outdoor adventures. The plush bedroom, complete with floral bedspreads and bear skin rugs, unfurls onto a wooden balcony floating high about the earth. This elegant arrangement can move from tree to tree and place to place, as the mood strikes and call of new panoramas await. Courting thickets, lakes, and backcountry with equal candor, the treetop haven puts guests in touch with their glamorous wild side. ◆

OUT ON A LIMB

NICOLAS D'URSEL & BRUNO DE GRUNNE

Reminiscent of a spaceship
hovering between the trees, a sculptural tent
elevates the act of camping
off the ground and into a realm of rural luxury.

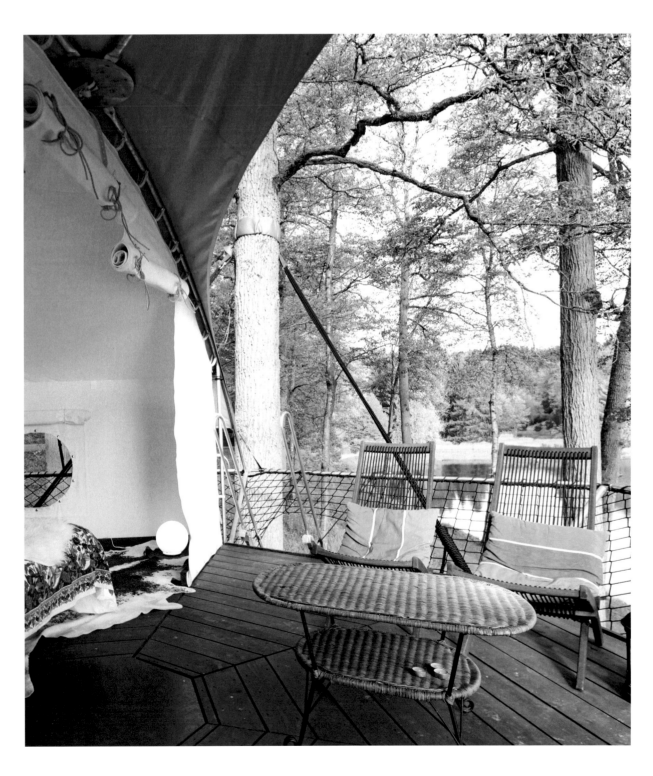

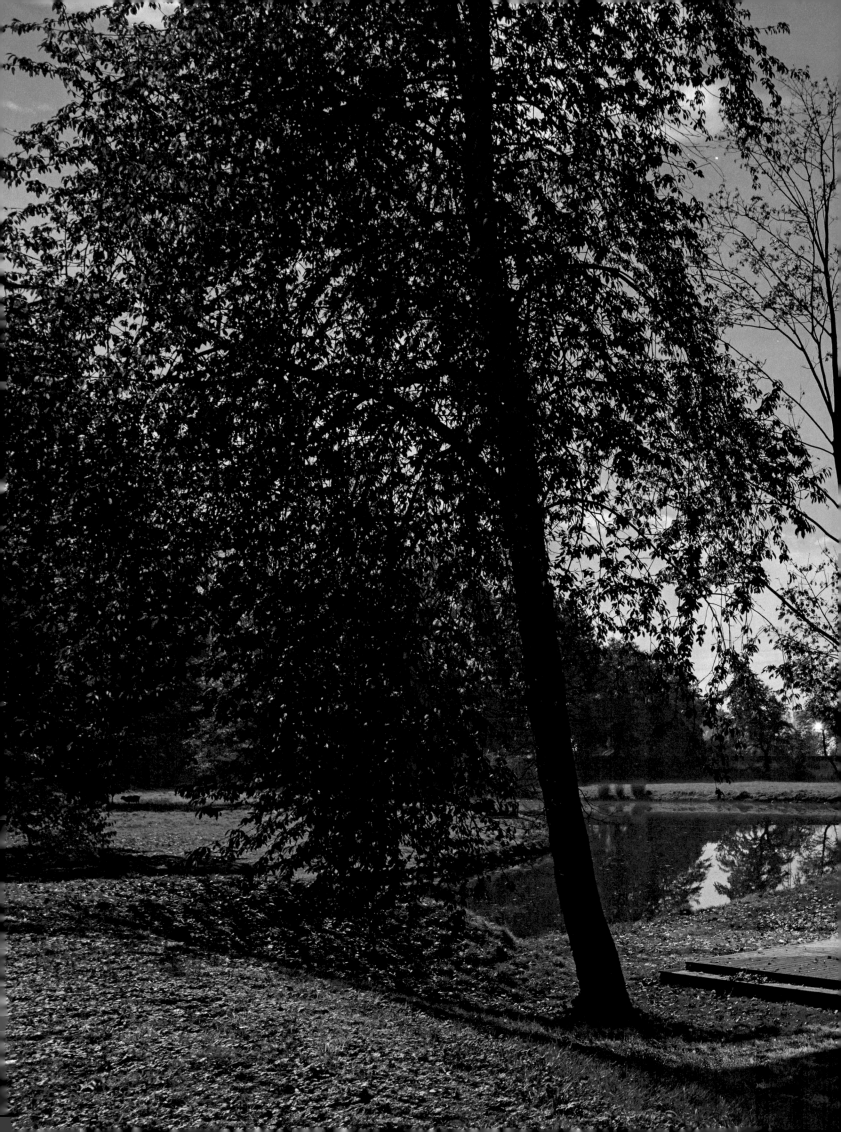

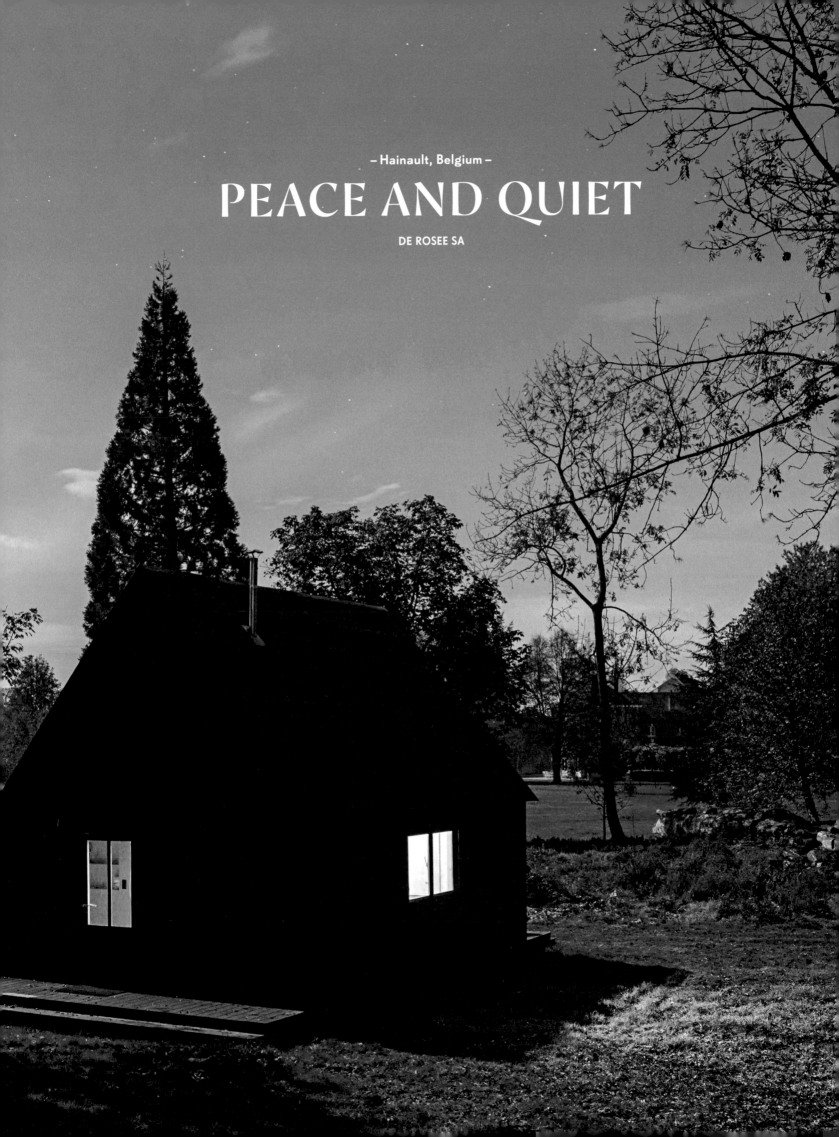

– Hainault, Belgium –

PEACE AND QUIET

DE ROSEE SA

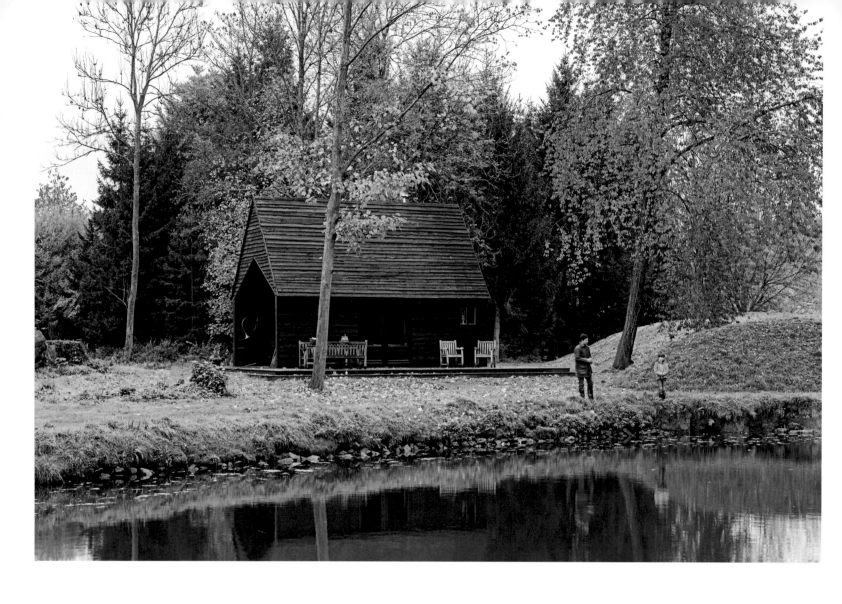

**This archetypal cabin muted
to a charcoal gray casts a familiar shadow
in the water of summers past.**

A familiar woodland cabin at the water's edge invokes the wistful memories of youth and a time when summer felt like it could last forever. The dark finish of the pitched roof silhouette allows the classic holiday home to retreat into the Belgian forest. Salvaged from trees ravaged in a storm, the cabin manifests as a labor of love between an architect and his father. Windows and doors respond to the site's most memorable features and processions to and from the cabin. The high-ceilinged, honey colored interior encourages an effortless flexibility of daily life, where work, rest, and socializing occur in equal measure. When the nights grow cool, the family can huddle around the wood burning stove after a bucolic day spent outdoors. Resurrecting the fallen forest trees, the cabin returns to the earth as much as it takes.

WORK, REST AND PLAY

LEO QVARSEBO ARKITEKT MSA

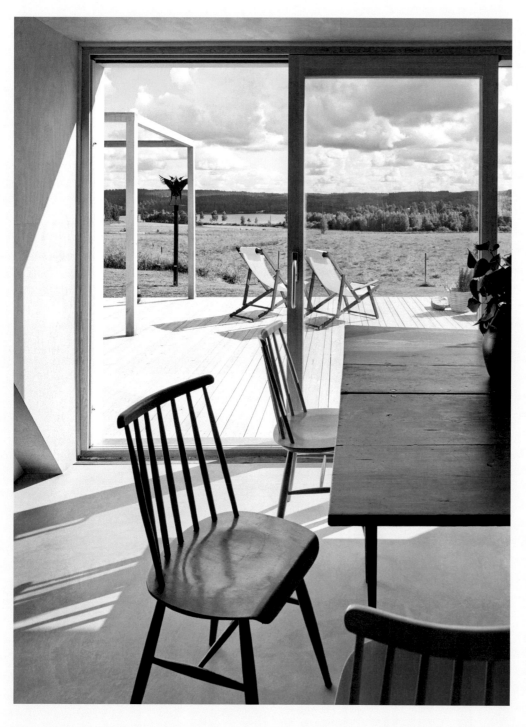

've never found a place that I can be so calm in as Dalarna," says architect Leo Qvarsebo on the pastoral idyll in central Sweden where he decided to build his summer house. "You can go on vacation to some places and be completely blown away by astounding, breathtaking surroundings, but then you're completely exhausted by the time you get home. In Dalarna it's the other way around, it's much more calm. It's a total retreat for the senses."

It may be a serene, restful place to have a summer home, but that didn't stop the Stockholm-based architect from seeking a

> ## "As a Swedish architect, designing your own summer house is a bit like saying, 'this is how I like to see the world'."

bit of drama with this triangular edifice, inspired by treehouses, that he completed in 2014. Made of wood, the sloping façade that looks out across the Dalarna countryside doubles up as a climbing wall and creates a tiered set of living spaces inside for Qvarsebo and his family. It's certainly eye catching, but this conspicuous concept came from the most simplistic of ambitions. ›

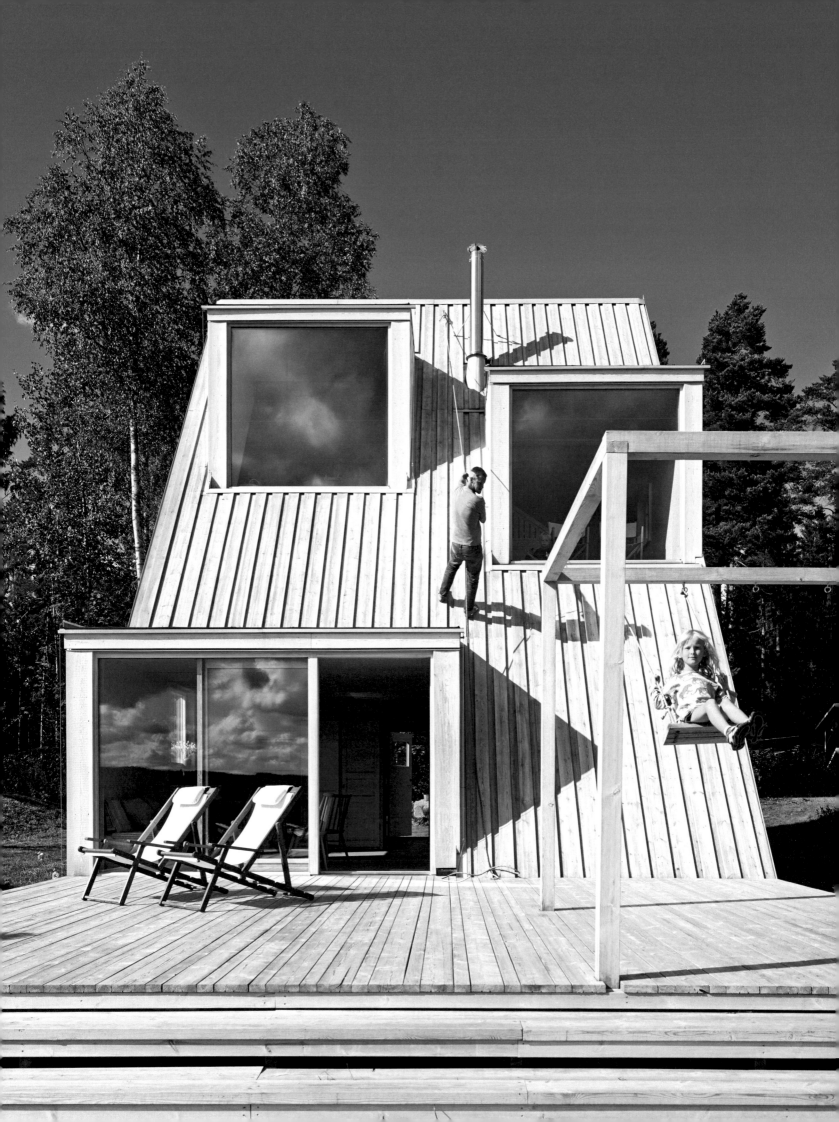

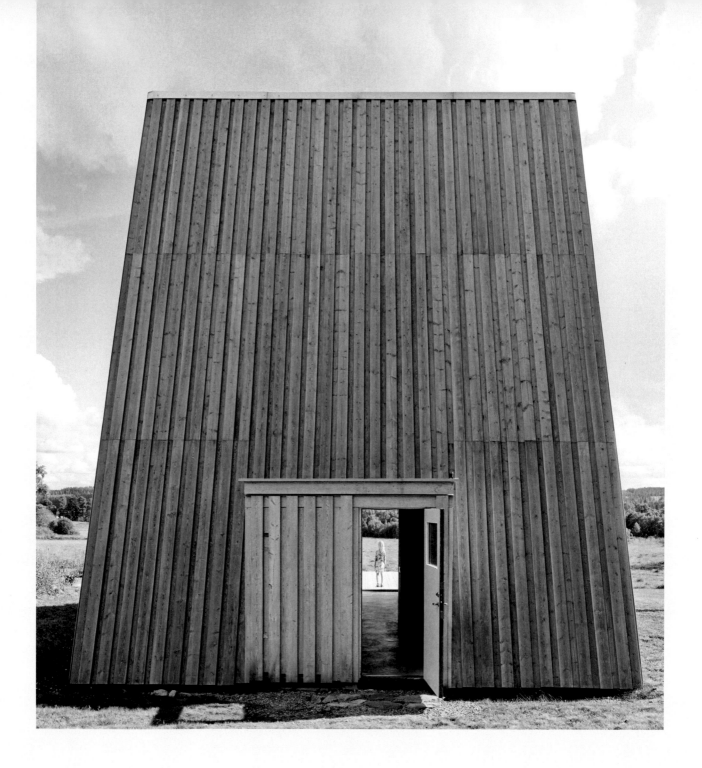

When Qvarsebo set out designing this house, he sought to make the most basic form of architecture. The architect started with what he calls the "obligatory investigation of the traditional Swedish barn house," before deciding to go even further back in time. "I was interested in primordial architecture—where architecture comes from: essentially having two branches leaning towards each other to protect yourself from the climate," he describes. "I wanted to make the basic tent shape visible in my design, but with a sense of recreation. So I took that tent shape and added the three gazebos."

"A façade that can be climbed with the use of a long rope and secret passageways that link up rooms: playfulness is in the bones of this house."

The three gazebos in question—the cubic dormer windows that puncture the sloping façade—serve a number of functions. Not only do they provide platforms to climb up to, but they also help section off areas for what Qvarsebo describes as the most important summer house activities: one is for eating, one is for reading, and the last is for sleeping. Qvarsebo simply stacked up all these functional spaces and then laid the tent shape over them, creating in the process this treehouse effect. "I was fascinated by it, how you climb and you can always see the next level because a treehouse is essentially ›

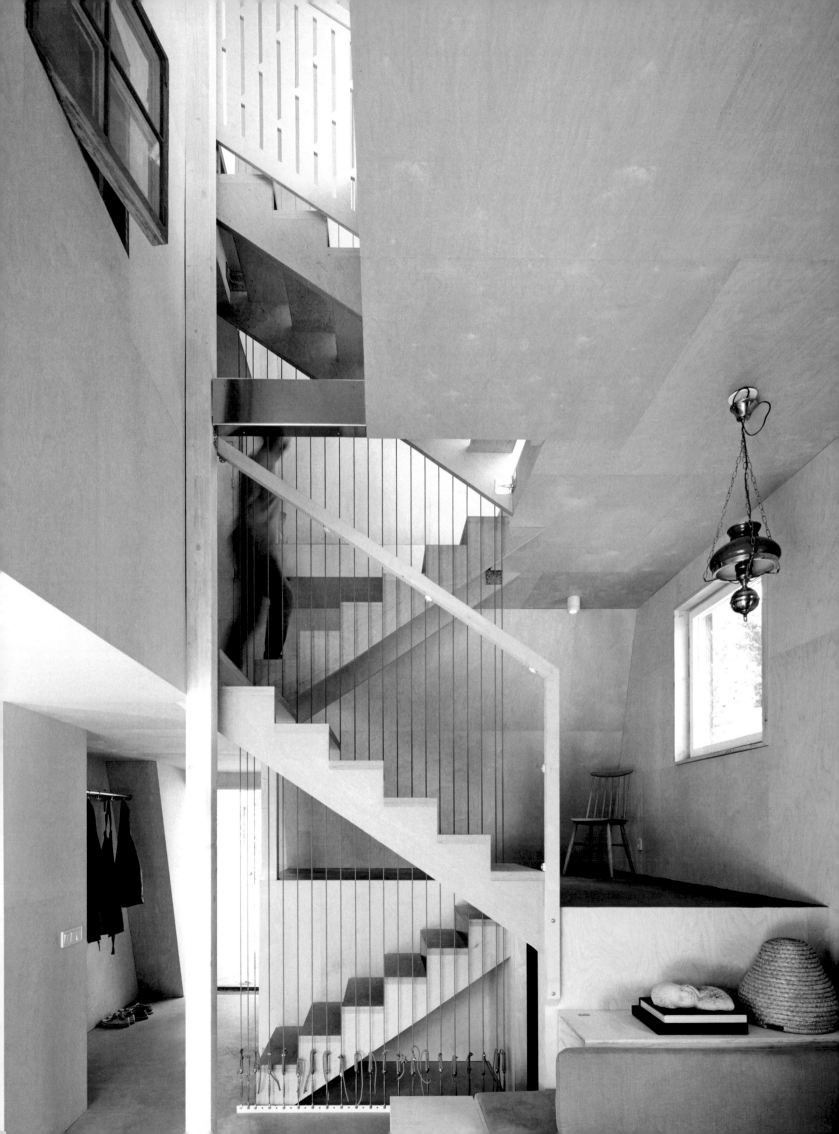

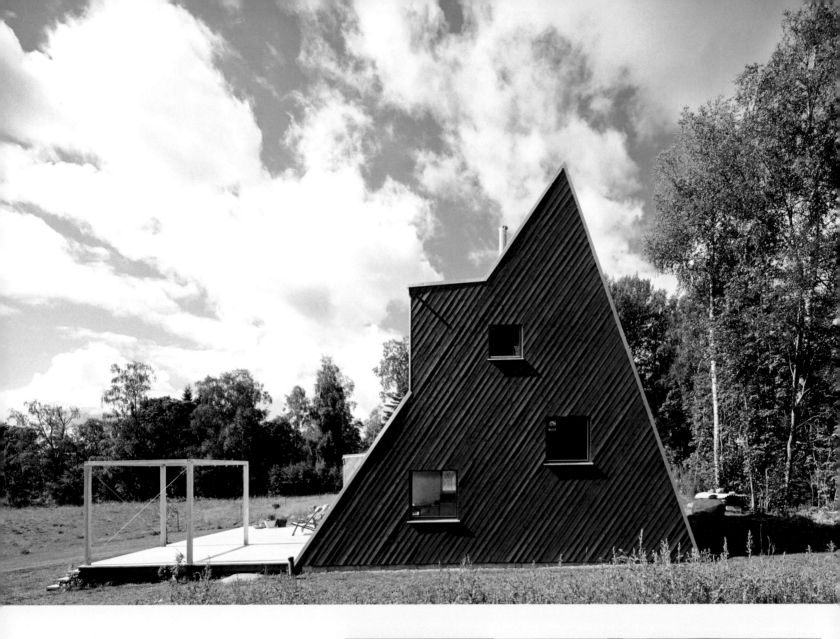

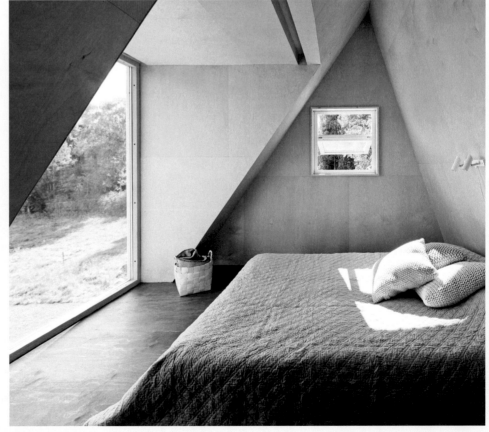

many semi-houses," he explains. "So here you climb and get a new point of view and then you are curious to climb some more."

A façade that can be climbed with the use of a long rope and secret passageways that link up rooms for Qvarsebo's two children to roam: playfulness is in the bones of this house. Quite literally, in fact. The plywood that lines the interior was bought from a nearby jigsaw puzzle factory that was closing down. The architect had a relatively small budget for this project, so everything from windows to refrigerators to stoves were bought second hand, and the plywood was scooped up for less than one euro per sheet. The budget restrictions also meant that the

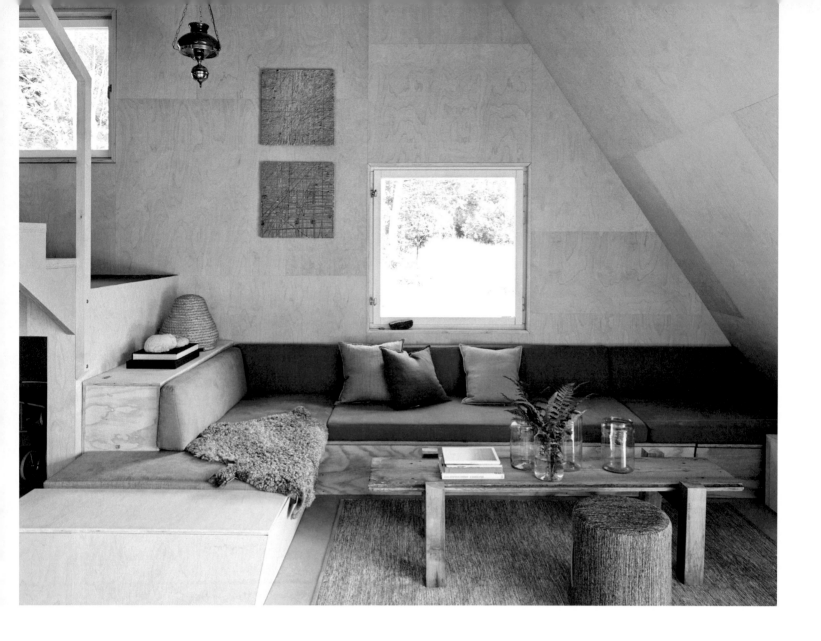

left_ **The windows were purchased second-hand, inspiring the facade's uneven look.**

top_ **The communual area is an important space for the family to come together.**

architect was uncommonly hands-on in its construction. He spent over 2,000 hours working on the land, which he totted up in a notebook. The construction happened slowly, with elements added bit by bit. "When we began the project, there was nothing there. It was just a pasture. There was no electricity, no sewer system," he recalls. The first jobs were getting connected to the grid and drilling for water supplies. Then a toilet was added and, most recently, a dishwasher. "Gradually it is becoming more and more inhabitable," Qvarsebo jokes. But that's not the point. Summer houses in Scandinavia are not about creature comforts, they are hugely important cultural symbols of quality of life, family,

history, rest, and play. "As a Swedish architect, designing your own summer house is a bit like saying, 'this is how I like to see the world'," shares Qvarsebo.

The triangular tent that rises up out of the flat land of Dalarna may seem like an amusement, and in many ways it is, but fundamentally it is a meaningful space for the Qvarsebo family. It's an architectural achievement, but its purpose runs deeper than that. It's a home. "It's an unexpected answer to a quite common thing. All you want with a summer house is nice cooking, a calm place to sit down and read, and maybe a good view," he reflects. "That is what my house is about, I've just given a slightly different answer." ◆

"Summer houses in Scandinavia are not about creature comforts, they are hugely important cultural symbols of quality of life, family, history, rest, and play."

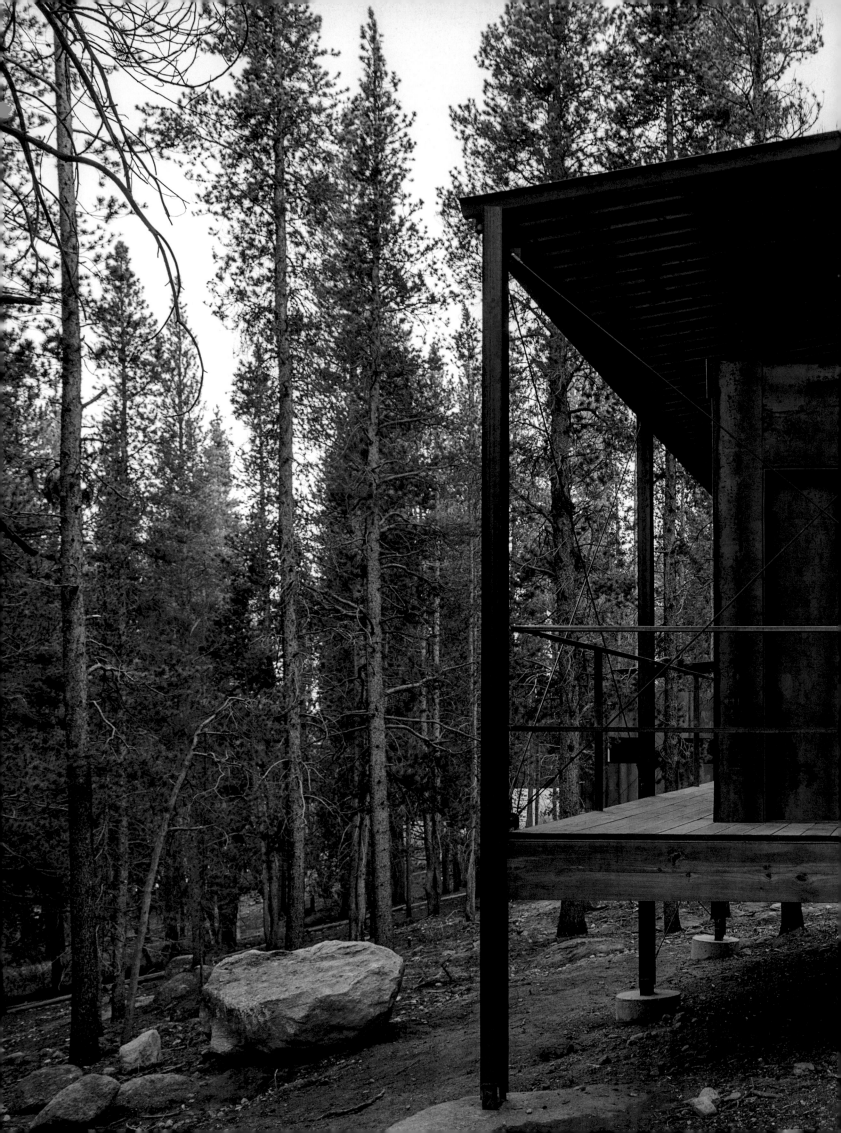

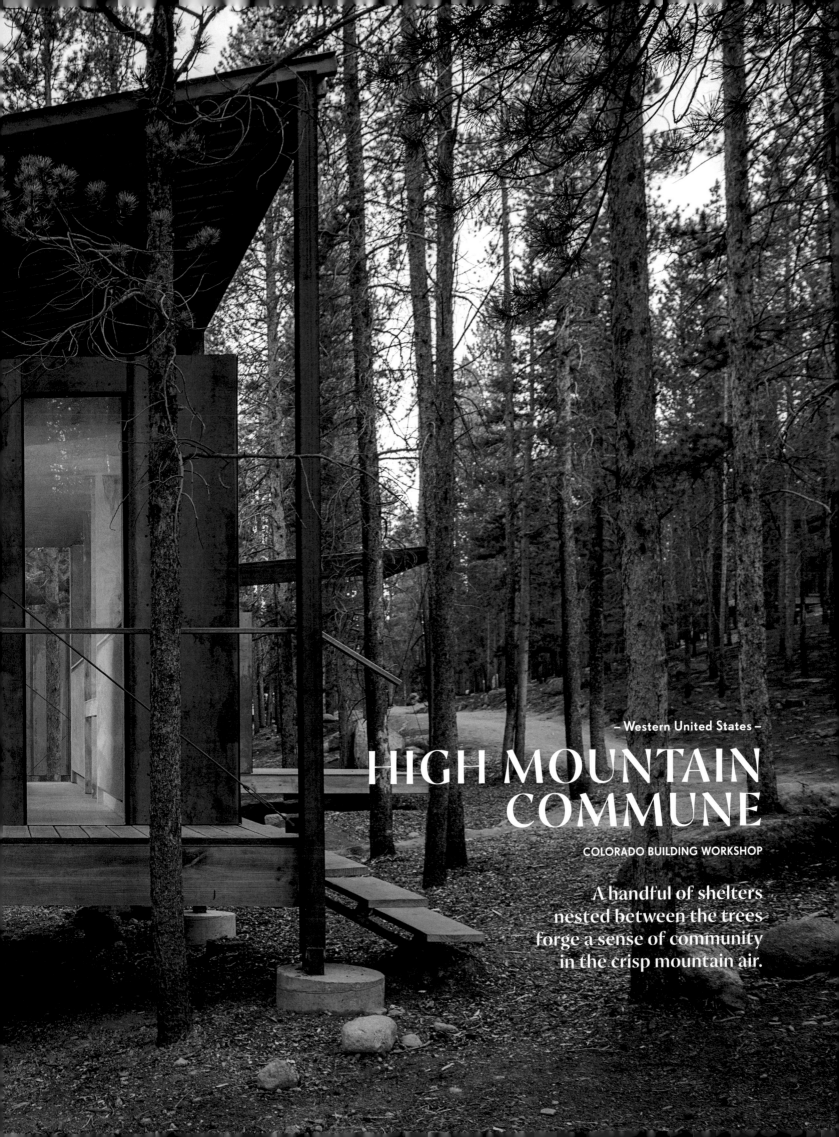

HIGH MOUNTAIN COMMUNE

COLORADO BUILDING WORKSHOP

A handful of shelters
nested between the trees
forge a sense of community
in the crisp mountain air.

"Light birch plywood brings warmth to the simple interiors and connects the cozy spaces back to the woods."

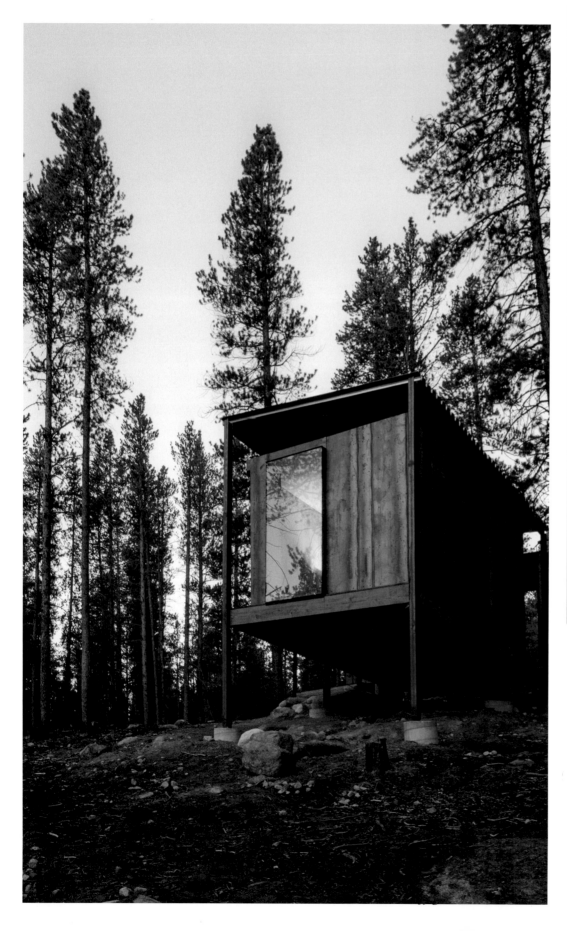

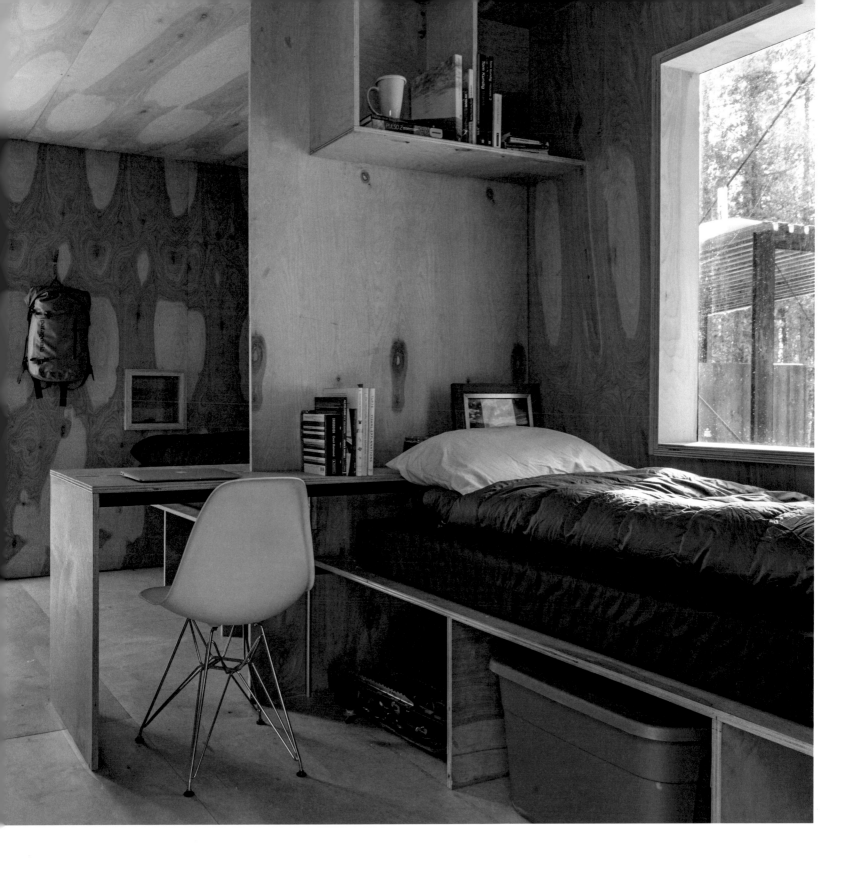

Located on a steep summit in a lodgepole pine forest, these cabins shelter a community of outdoor educators. Each of the structures rest lightly on the landscape, directing views from private spaces towards trees, rock outcroppings, and distant mountain views of the Mosquito Range. The clustering of cabins fosters informal community spaces that spread from the covered front porch to the negative spaces between units.

Light birch plywood brings warmth to the simple interiors and connects the cozy spaces back to the woods. A place to come together while remaining apart, the forest dwellings enjoy a shared aesthetic language at once modern and subtly rustic. Similar to the nuance found in nature, a built-in variation occurs across each cabin that compliments the collective while nurturing the individual.

◆

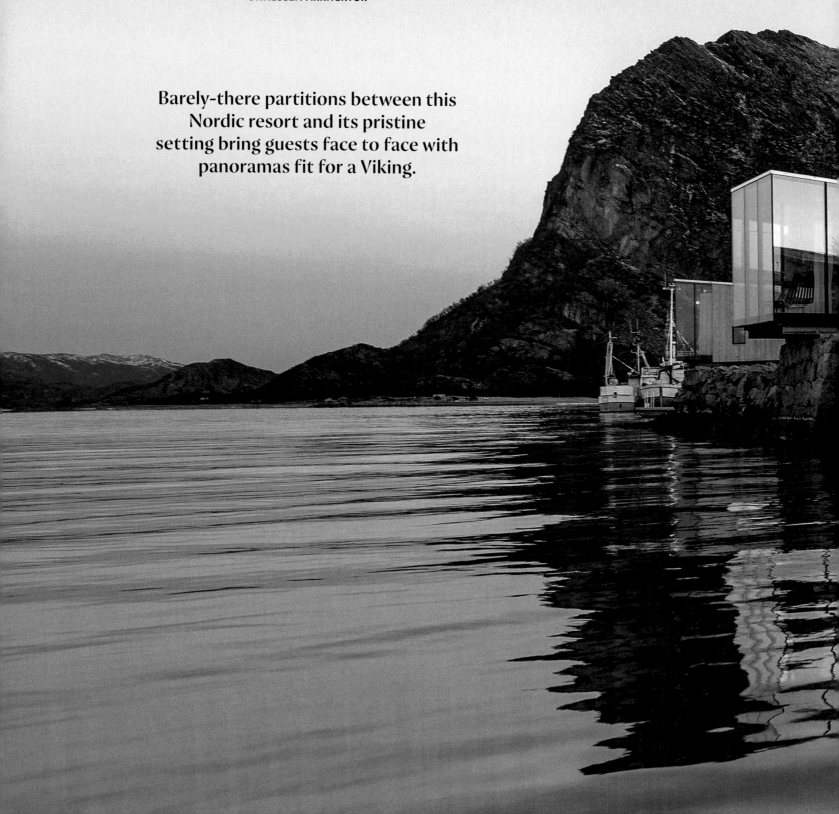

– Nordland, Norway –

DAWN
TIL
DUSK

STINESSEN ARKITEKTUR

Barely-there partitions between this
Nordic resort and its pristine
setting bring guests face to face with
panoramas fit for a Viking.

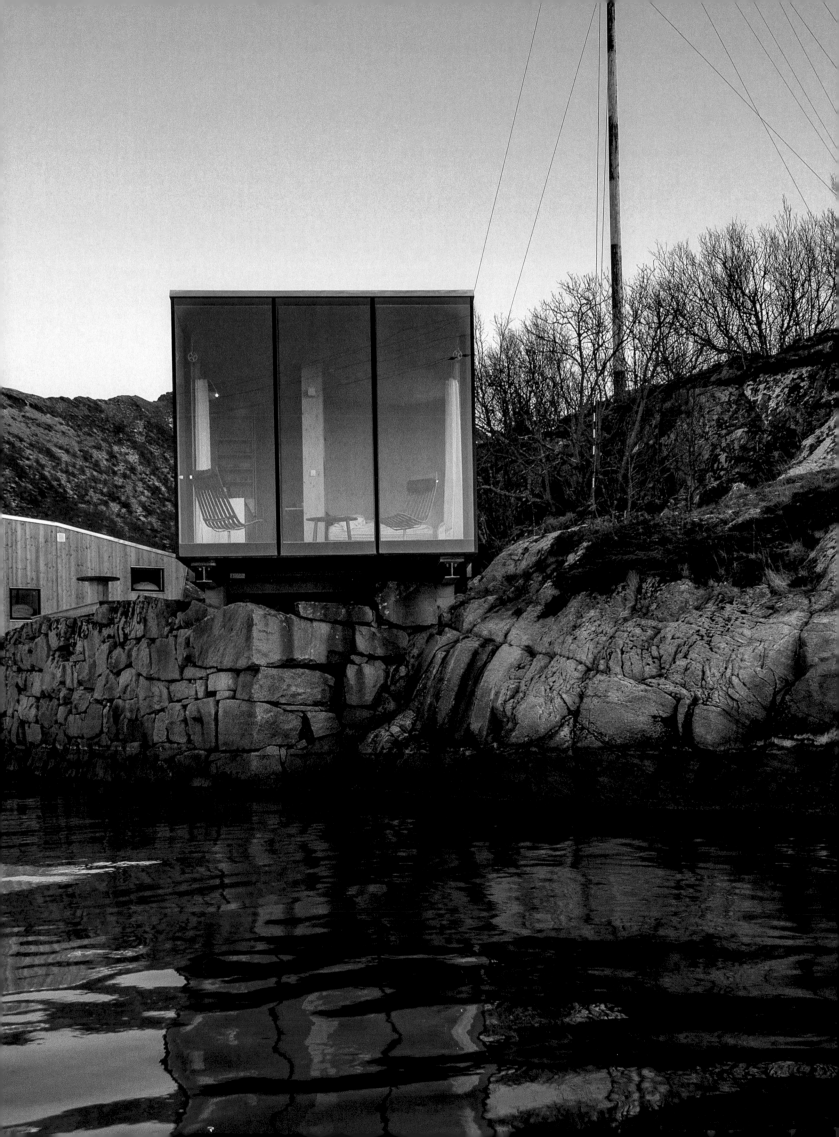

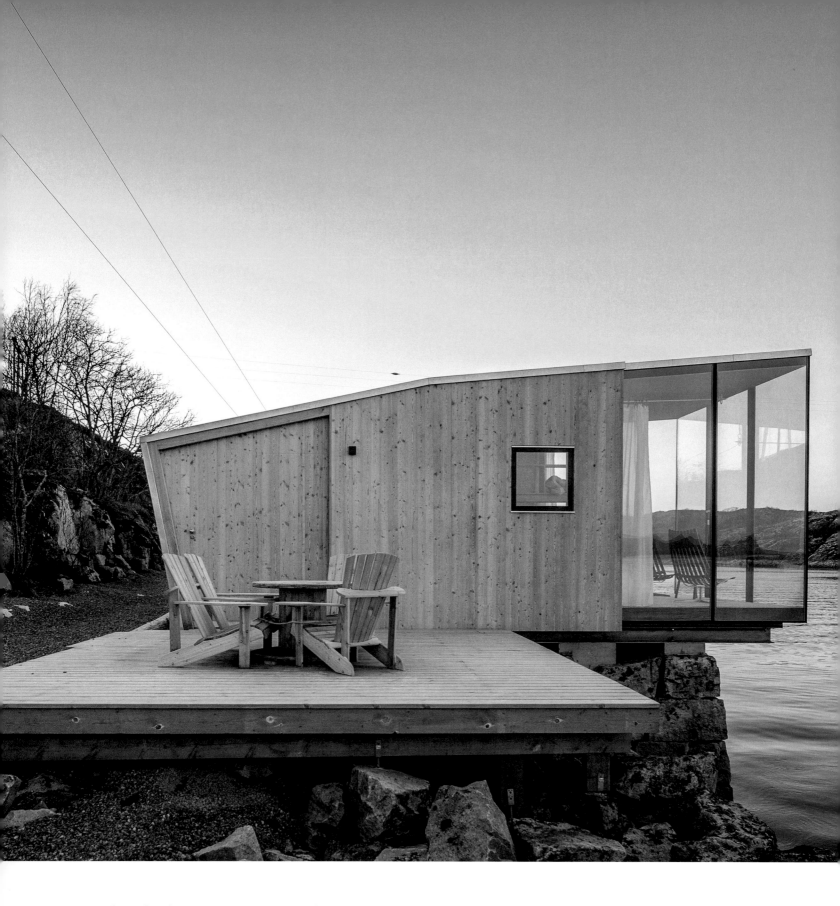

This refined resort concept on Manshausen Island works in concert with the singular character of the Steigen Archipelago in Northern Norway. The proud, angled cabins of glass and wood offer guests shelter and comfort while underlining the natural drama of the site. Outdoor decks demarcated by expansive glass ensure unfettered access to the shifts in sea, land, light, and season. Integrating creature comforts with maximum exposure to the Nordic shores, the cabins deliver visceral yet sheltered around-the-clock connection to the secluded frontier. Planned in concert with the island's topography, the striking cabins cantilever above the sea or perch on a natural shelf on the rocky formations above the stone quays. The positioning and orientation of each cabin unwraps a private panorama for each guest—a personal looking glass for commemorating the setting sun.

◆

"Planned in concert with the
island's topography,
the striking cabins cantilever above
the sea or perch on a
natural shelf on the rocky
formations above the stone quays."

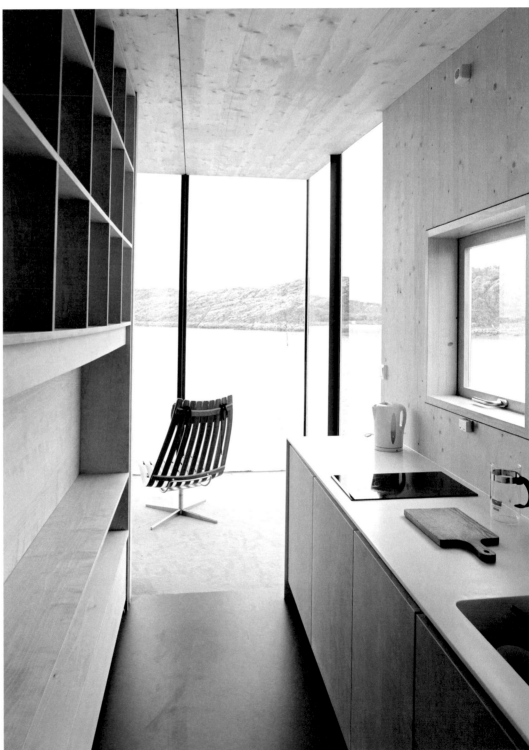

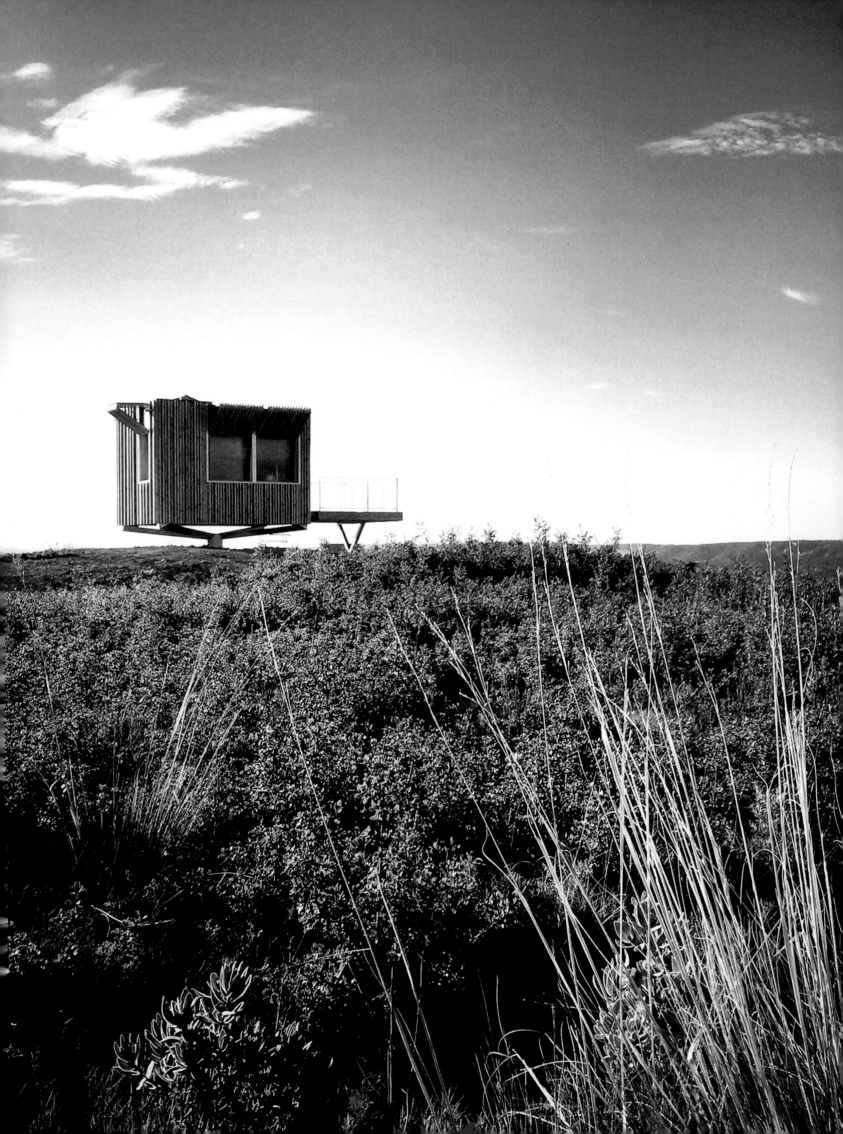

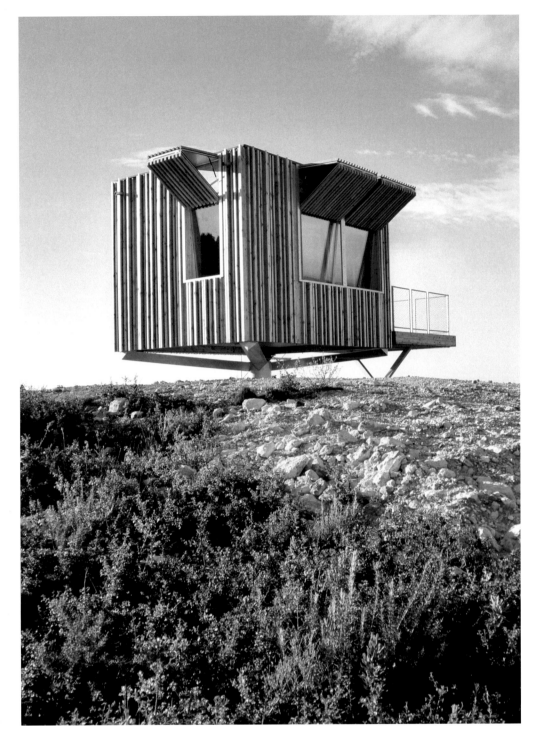

STOIC SURVEYOR

OH!SOM ARCHITECTS

An intrepid cube
on the plains
of southern France
becomes a landmark
and lookout
for a pair
of local rangers.

Dramatically positioned on a sensitive coastal site, a wooden cube commands the land while barely touching it. The cabin cantilevers off of a central core that lifts the haven and its outdoor terrace several feet above the ground. Intrepid and fundamental, the monitoring station offers shelter for two guards. When in use, fold-up panels reveal windows on three of the four walls. These adjustable panels allow the guards to easily survey the remote grounds while on duty and then secure the structure during periods of vacancy. Window locations encourage cross breezes and sunlight to flood the humble interior. Outfitted with a chart table and small bathroom, the lookout mitigates feelings of isolation. Instead, the cabin elevates the solitary nature of the job into a welcome space for soul searching in the presence of endless sky. ◆

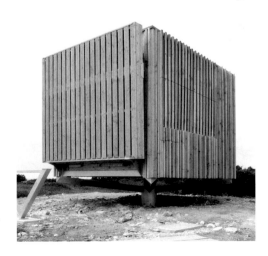

NESTED

PORKY HEFER

**Suspended between
the trees across Africa,
a series of human
scale nests provide
a glimpse into the habitats
of local birds.**

**"Once inside, guests
are greeted by a warm
sunken lounge ideal
for bouts of
prospect and refuge."**

The designer of these treetop habitats spent more than a decade studying the nests of the sociable weaves—a native bird of Southern African known for building the largest and most spectacular nests of any bird. Following principles of biomimicry and adapting to the local vernacular, the organic shelters hover high in the air in the harsh Namib desert. The hideouts warrant a double take, leaving those who happen upon them wondering if they were built by and for a human, or a giant bird. Viewed as a scaled up extension of the sociable weaver's nests, the thatched structures gray gently over time, further blending the treehuts into the environment. The rounded forms reference the mountains behind, rendering the structures nearly invisible in their remote context. Visitors ascend into their private nest via rope later. Once inside, guests are greeted by a warm sunken lounge ideal for bouts of prospect and refuge. Don't forget to look up, or you might miss them. ◆

COUNTRY CHARM

T2.A ARCHITECTS

**Where life starts
and art begins
becomes the source
of creative inquiry
inside a photographer's
mountain home.**

Home and muse coalesce within a mountain hideout. The fruitful collaboration between architect and architectural photographer, this handsome dwelling unifies key aspects and attitudes from the two friends' distinct but complimentary professions. Camouflaging with the woods, light vertical stripes—reminiscent of nearby tree trunks dusted with snow—intermingle with the dark façade. This interplay between dark and light grants the home a rhythmic quality that ties the structure into the secluded timberland. Appearing on the land in just two days, the home becomes a living, breathing structure ripe with the scent of fresh wood. Sheltering from the elements during the winter and letting in the cool evening air in the summer, the retreat oscillates between subject and spectator. As the records of the relationship between home and forest grow from day to day and season to season, the house in the woods becomes the source of rather than the backdrop to the owner's photographic inquiries. ◆

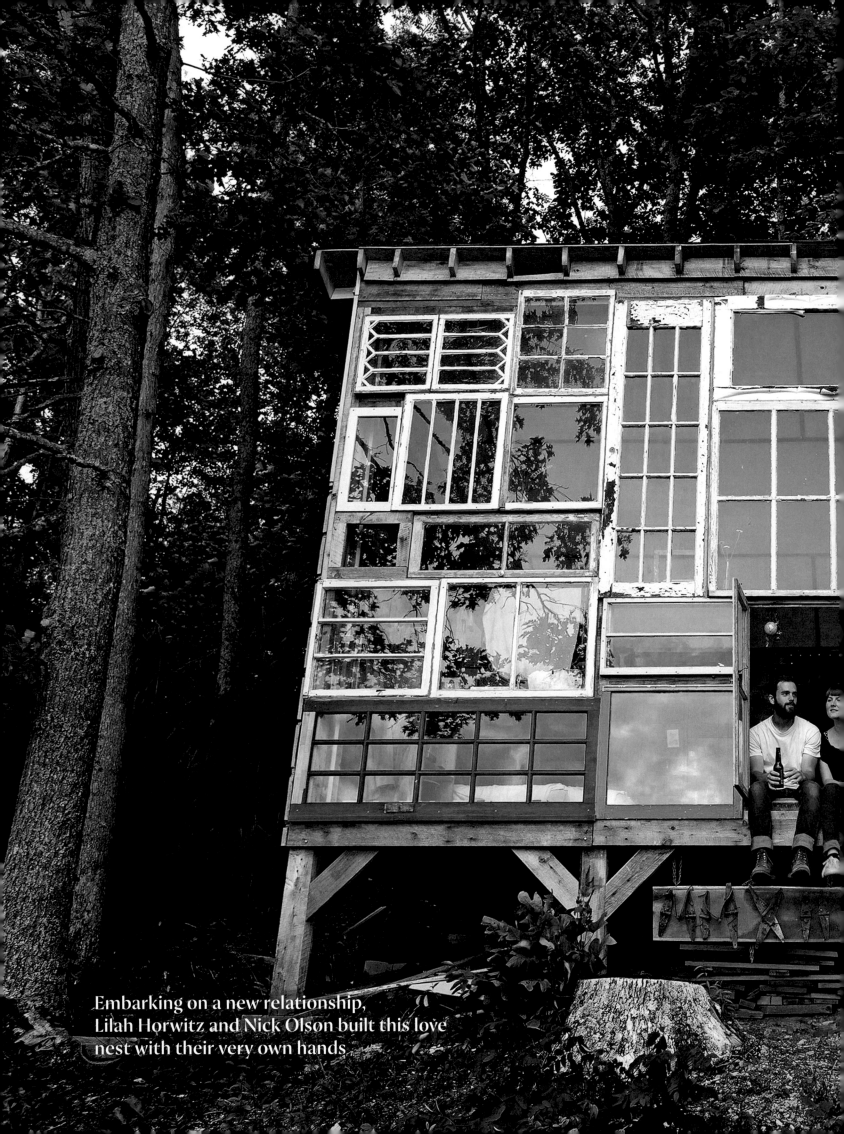

Embarking on a new relationship,
Lilah Horwitz and Nick Olson built this love
nest with their very own hands

A WINDOW ON TO THE WORLD

LILAH HORWITZ AND NICK OLSON

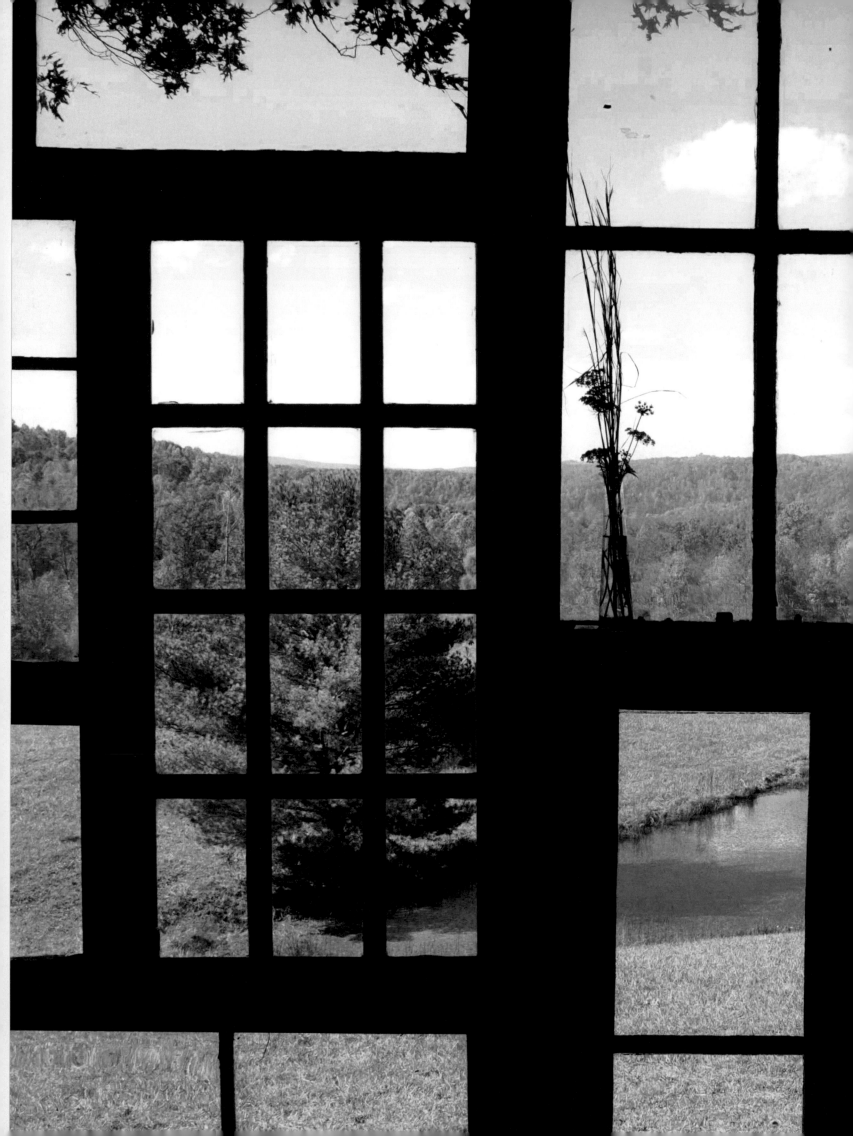

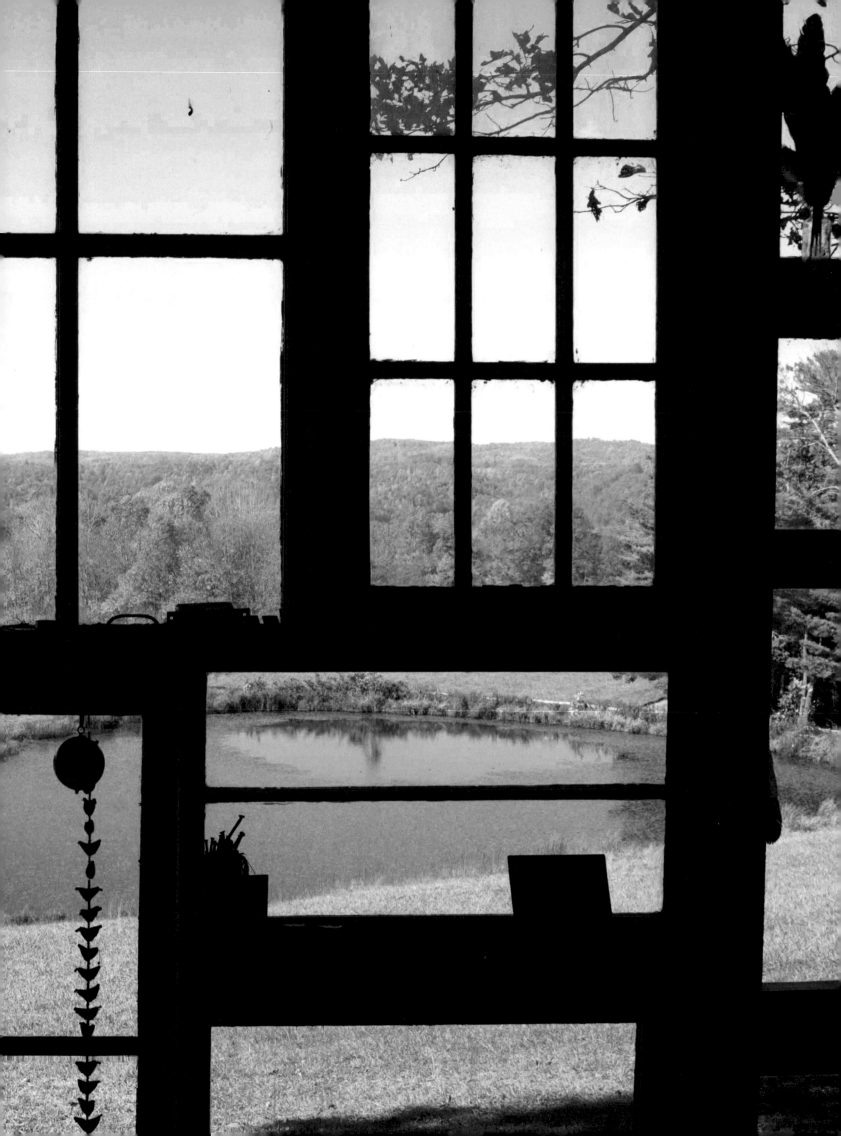

top_ Lilah Horwitz and Nick Olson.
right_ Most of the furniture pieces are junkyard finds, arranged with love by Lilah.

The windows were sourced on a road trip to visit friends back in New York. Along the way, they stopped at any junkyard, salvage yard, antique store, or garage sale they could find. "The windows are from all over the place. One is from the old farm house in West Virginia that Nick's great grandfather built," says Horwitz. "Another is from an architectural salvage shop under the Brooklyn-Queens Expressway next to the apartment where my parents lived in Brooklyn when I was born."

Olson's family originates from West Virginia. They were sawyers that ran a sawmill on the land that the cabin is built on. Horwitz and Olson decided to locate this shack on the edge of the field, half-way into the woods so that it feels tucked away and protected. The wall of windows is on the edge of the forest "so you feel like you are at the edge of the world looking out," explains Horwitz.

The pair built the edifice themselves. The wood was milled from trees on the property and used without varnish, paint, or toxins. "Just trees!" points out Horwitz. The result is pleasantly rudimentary: there is a water spigot, a wood stove, and a fire pit but no electricity, so the pair use kerosene lamps and candles, and go to bed when it gets dark. "It's wonderful to be forced to take it slow," says Horwitz. Furnishings are simple but meaningful. Their most treasured possessions are a set of birds' nests that Olson sent to Horwitz in ›

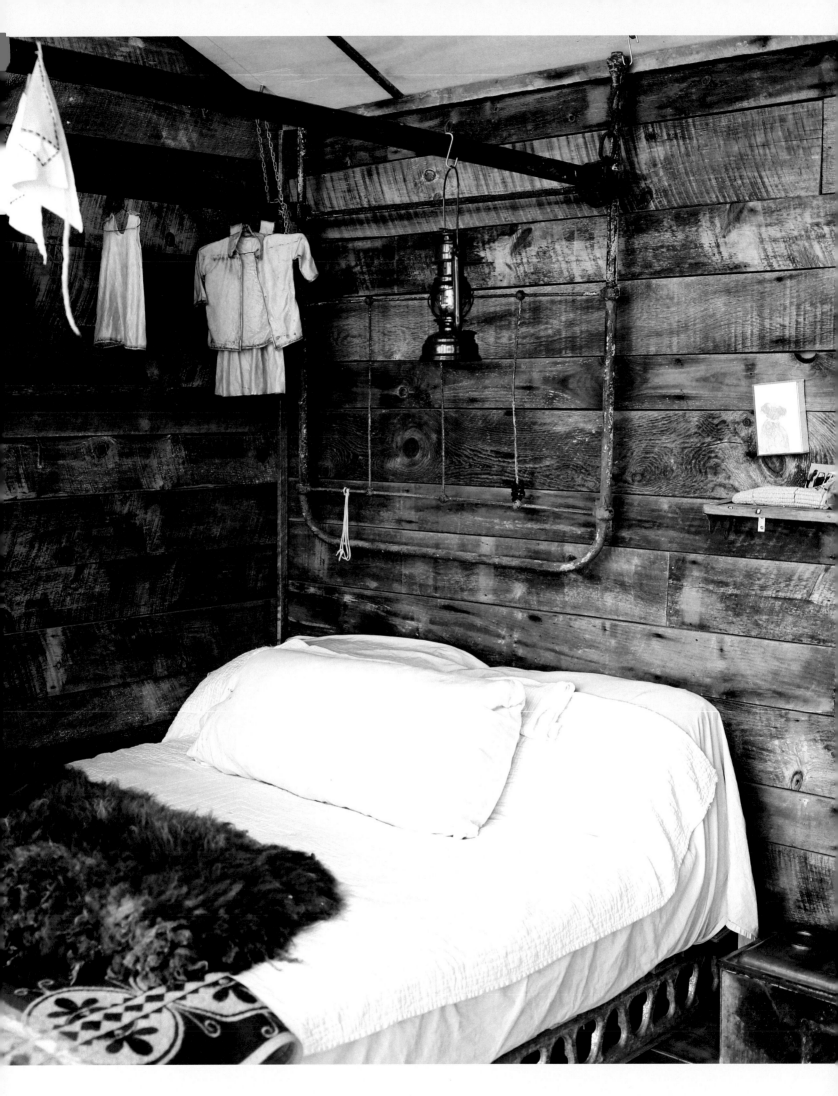

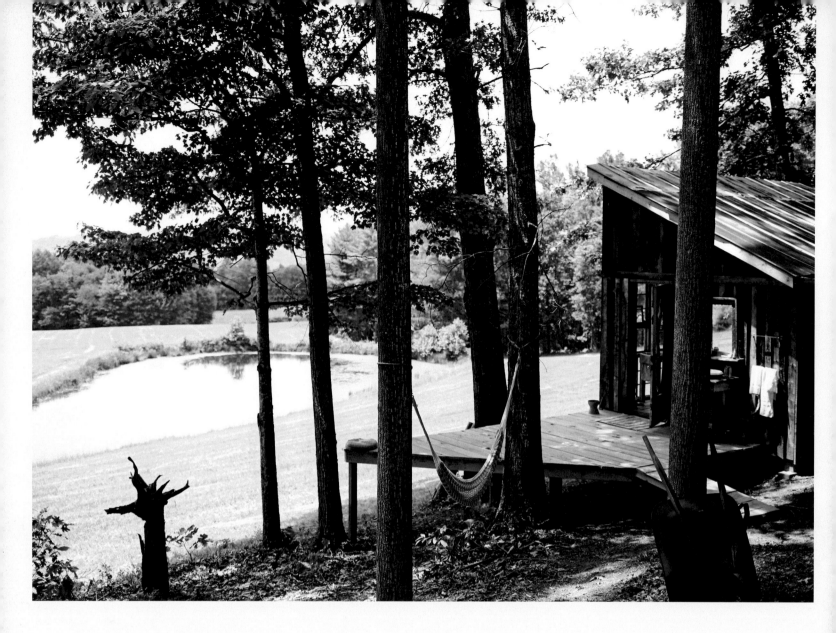

top_ **The house was deliberately sunk halfway into the forest, benefiting from a unique panorama, facing a little pond.**

New York when they were living apart. He would clear trees in the winter and saved every abandoned nest for her.

The nearest town is 30 minutes away—so privacy is not a concern—and the pair leads a slow life at the property, going to the local drive-in movie theater or having a dip in the swimming hole. "It's a place where time slows down and a different way of life is the norm," says Horwitz. "Nick always uses this funny expression 'to set porch,' which means to be on the porch and do nothing but sit, which can be the ultimate escape."

The pair completed the build in 2013 after seven months of work. Life has changed since they finished the house—Olson is now working as a carpenter for a small build company and Horwitz works for a women's clothing company leading a recycle initiative. They spend most of their time in Seattle, so don't get to West Virginia as much as they used to. But the house of windows is still there remaining as a souvenir of young love and a big dream. "We were—and are!—in love and we had an idea and wanted to play it out," says Horwitz. ◆

> "We were — and are! — in love and we had an idea and wanted to play it out."

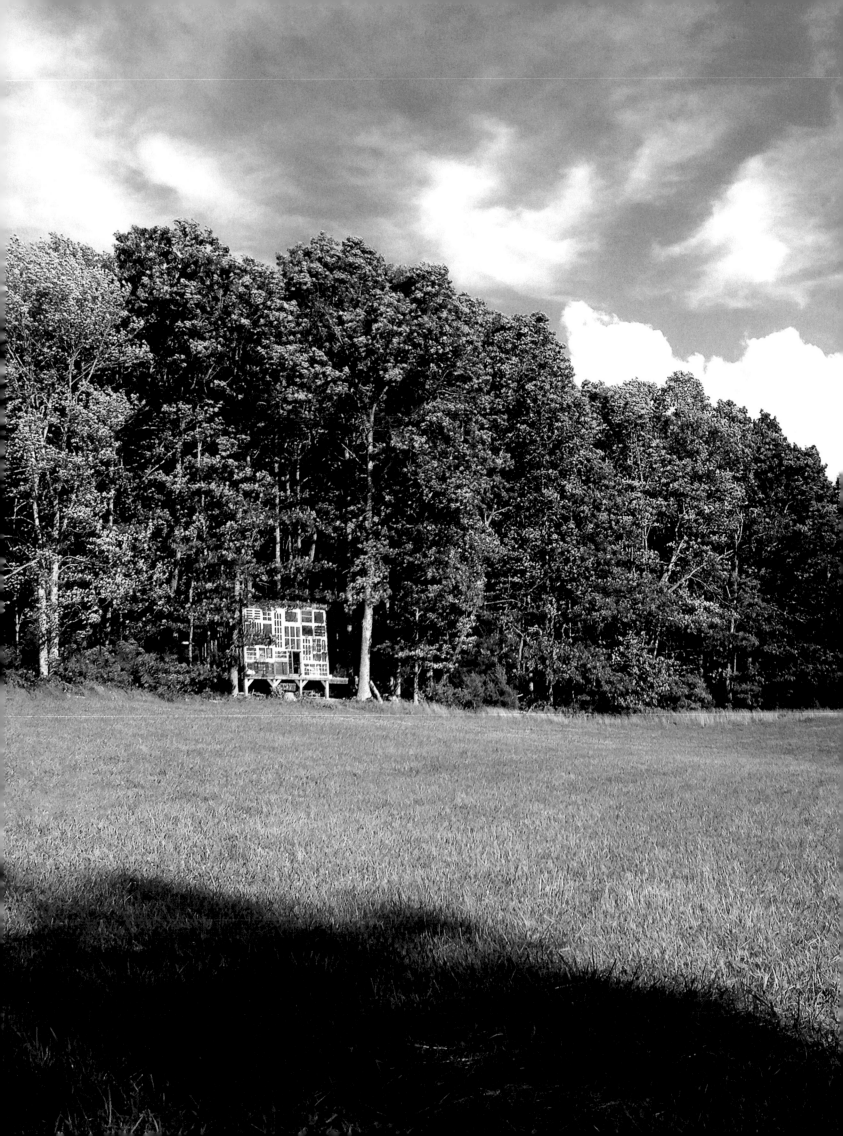

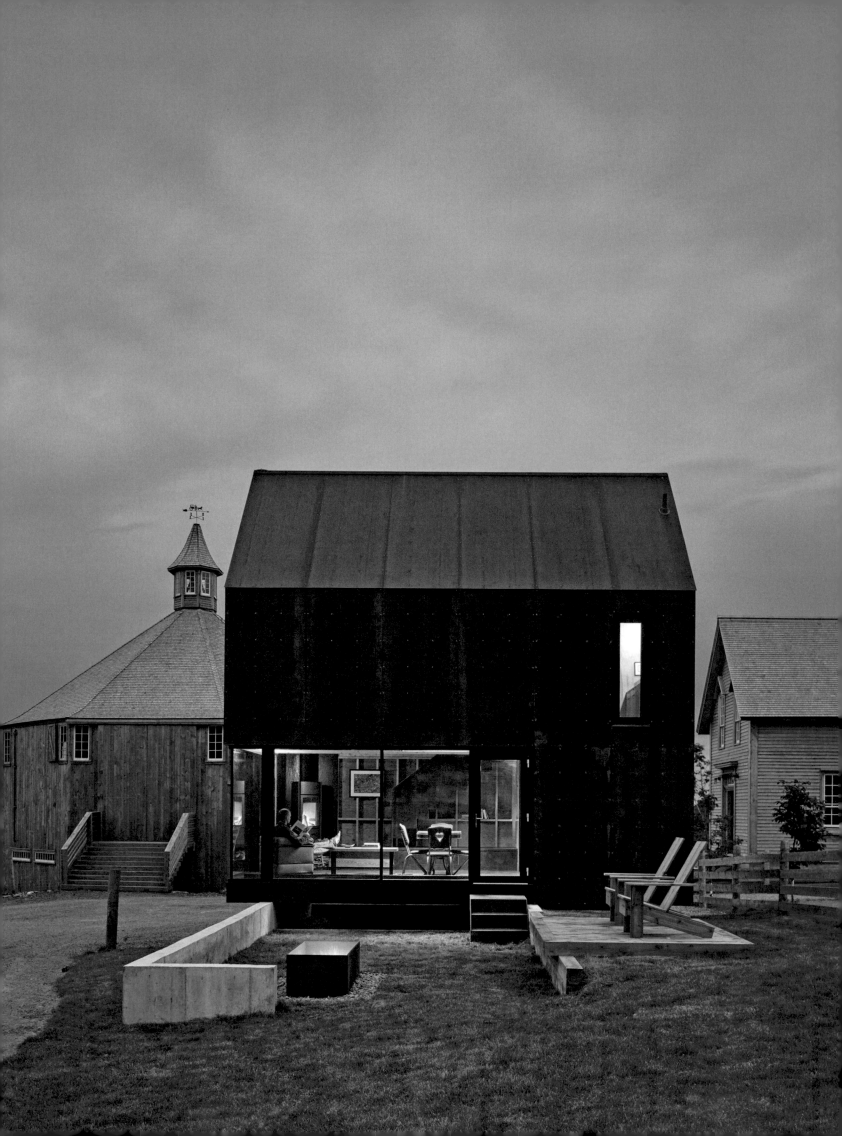

HOME IS WHERE THE BARN IS

MACKAY-LYONS SWEETAPPLE ARCHITECTS

A sleepy waterfront hamlet dating back
to the 17th century receives a new addition that pays
tribute to the village's archetypal vernacular.

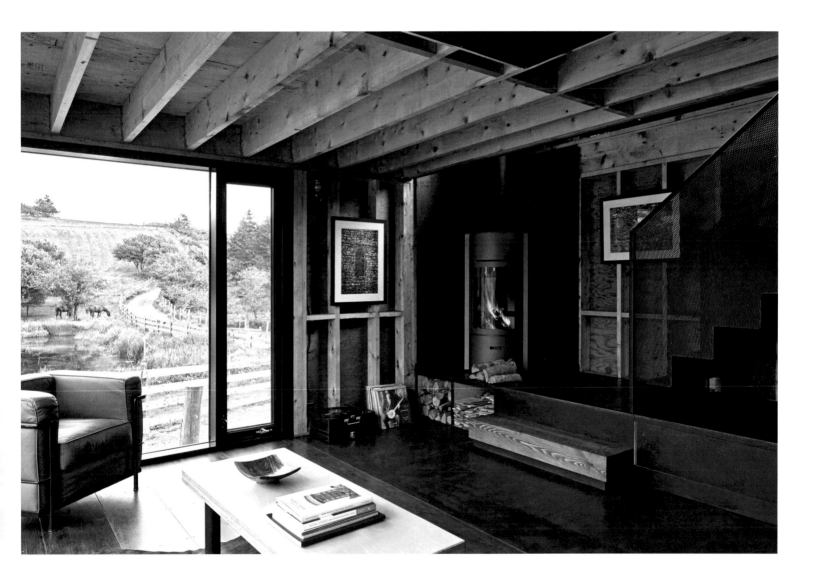

Keeping company with an octagonal barn and schoolhouse dating back to the 1800s, a rusty red gatehouse tactfully takes its place on the historic country site. Through its traditional gabled roof, the residence echoes the familiar silhouettes of its quaint neighbors while catching the eye with its rich auburn patina. The house's pivotal position on the land fosters an active engagement with the extant structures. Framing courtyards, the faintly rustic form optimizes both prospect and refuge. When treated as an instrument for observation, the structure takes ownership over the pastoral valley to the north and east through a massive corner window. Protected from the road, the home basks in its southern exposure and views of Hirtle's Beach. Treating the definition of home as a verb rather than a noun, the cabin stitches into the outdoors through a fire court where the horses come to graze. ◆

225

WALK THE LINE

**SCARCITY AND CREATIVITY STUDIO /
OSLO SCHOOL OF ARCHITECTURE AND DESIGN**

Tiny hut below and poignant boardwalk
above, this iconic folly spans from sunrise in the dunes
to sunset out to sea.

A waterfront shelter forges its own journey to the sea. Embedded in the basin of a sand dune, the unit below supports a dramatic walkway above. This processional path begins on the slope of the dune and stops midair to face the meadow of grazing horses, bay, and Pacific Ocean beyond. The one-room shelter underneath the elevated gangway hosts students and scholars for short retreats. Outfitted with a bed, desk, and small terrace, the plain room supports a stay spent in contemplation and study. Capturing the essence of the site, the compact space reinvents itself over the course of the day. Grains of sand and morning mist make room for an internal light-play, filtering in sunlight blended with the ocean's murmur. The alluring plank establishes a connection between the dunes, the nearby nature reserve, and the distant horizon of the Pacific. Whether taking a walk on the wild side or getting lost in thought, the ubiquitous presence of nature never falls out of sight or out of mind. ◆

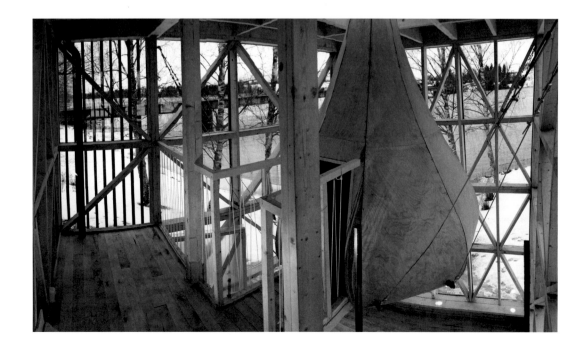

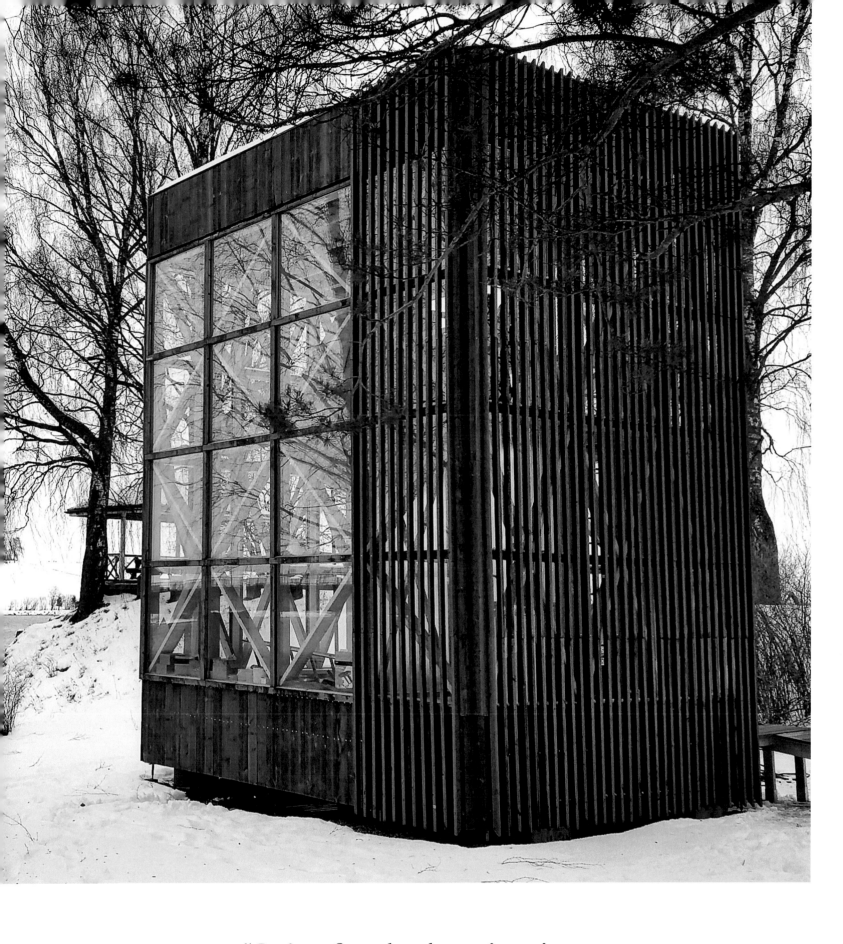

"Grains of sand and morning mist
make room for an internal light-play,
filtering in sunlight blended with
the ocean's murmur."

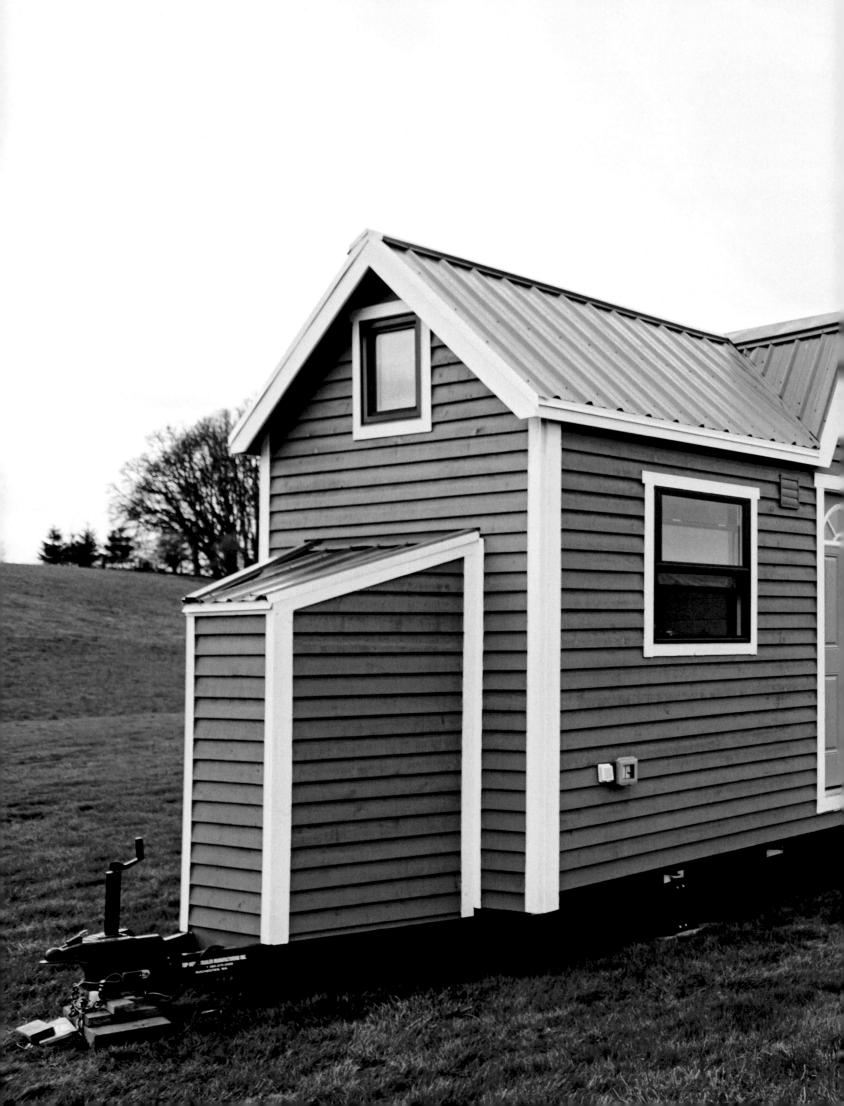

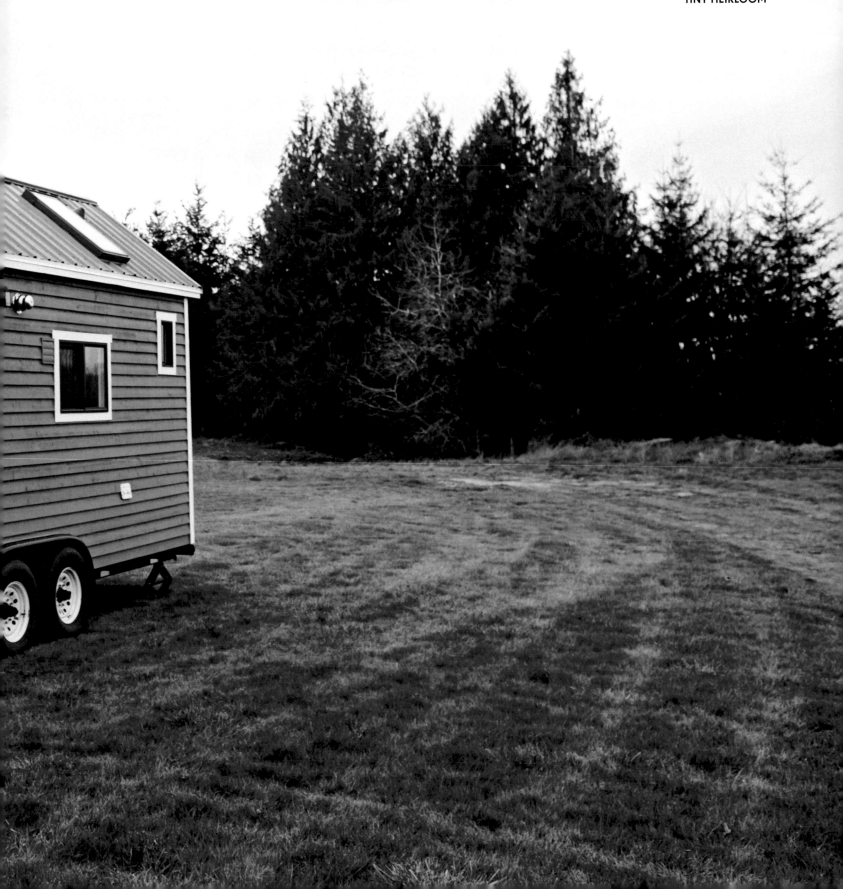

MOBILE HOME
FOR A WILD HEART

TINY HEIRLOOM

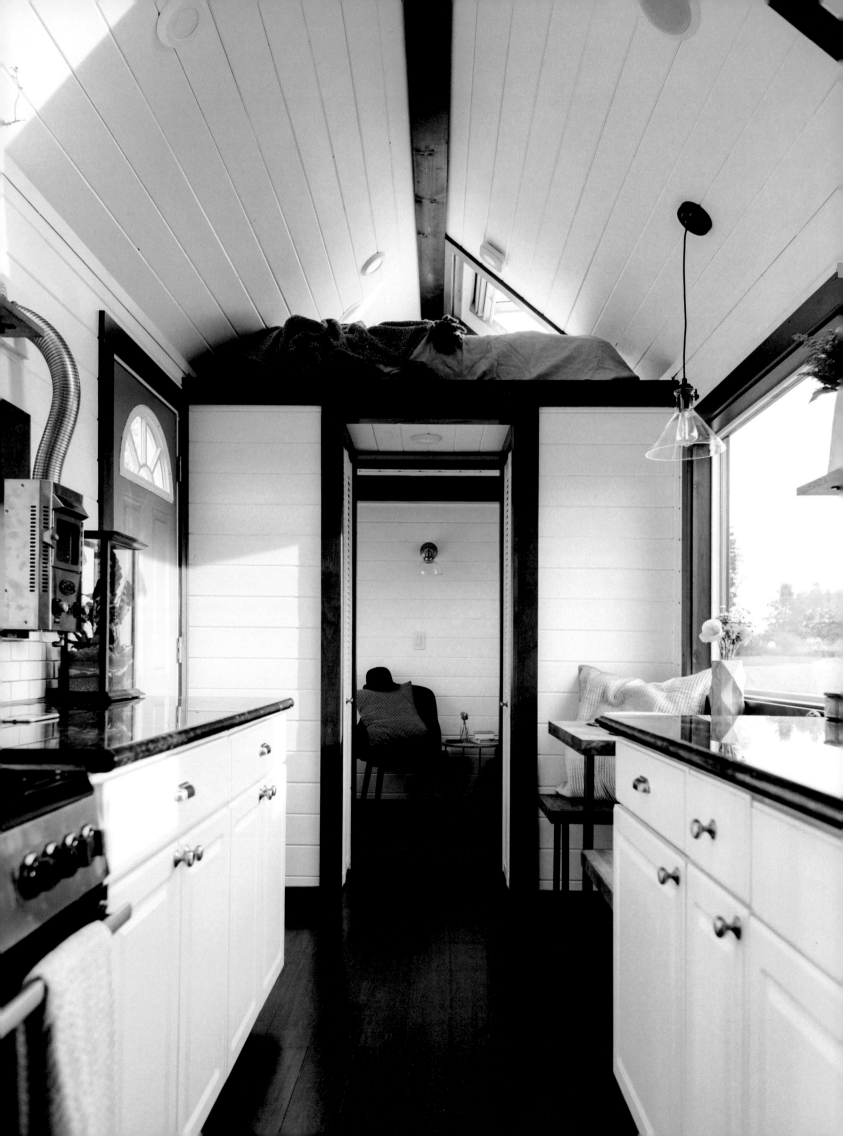

Liberating the notion of home from a fixed location, this house on wheels turns the world into its new backyard.

If home is where the heart is, then most homes should be mobile. These tiny homes support rather than impede the inherent wanderlust in us all. Built on trailer frames, these nomadic units elevate the typology of the mobile home into a personable retreat where a sense of yearning and creature comforts appear in equal measure. Those who sign on to these micro shelters must first shed the weight of their cluttered pasts. Pairing down possessions and obligations to the bare essentials, the owners of the tiny mobile cabins find new balance untethered to the false constraints imposed by the day to day. The functional and enduring interiors mix pragmatism with effortless style—the reassuring constant against a backdrop of ever-changing scenery and company. Cozy nooks abound inside the compact interior, some for sleeping, some for dining, and some for personal reflection over a shifting vista. This home on wheels celebrates the freedom one can find in a light touch on life and on the land.　　　　◆

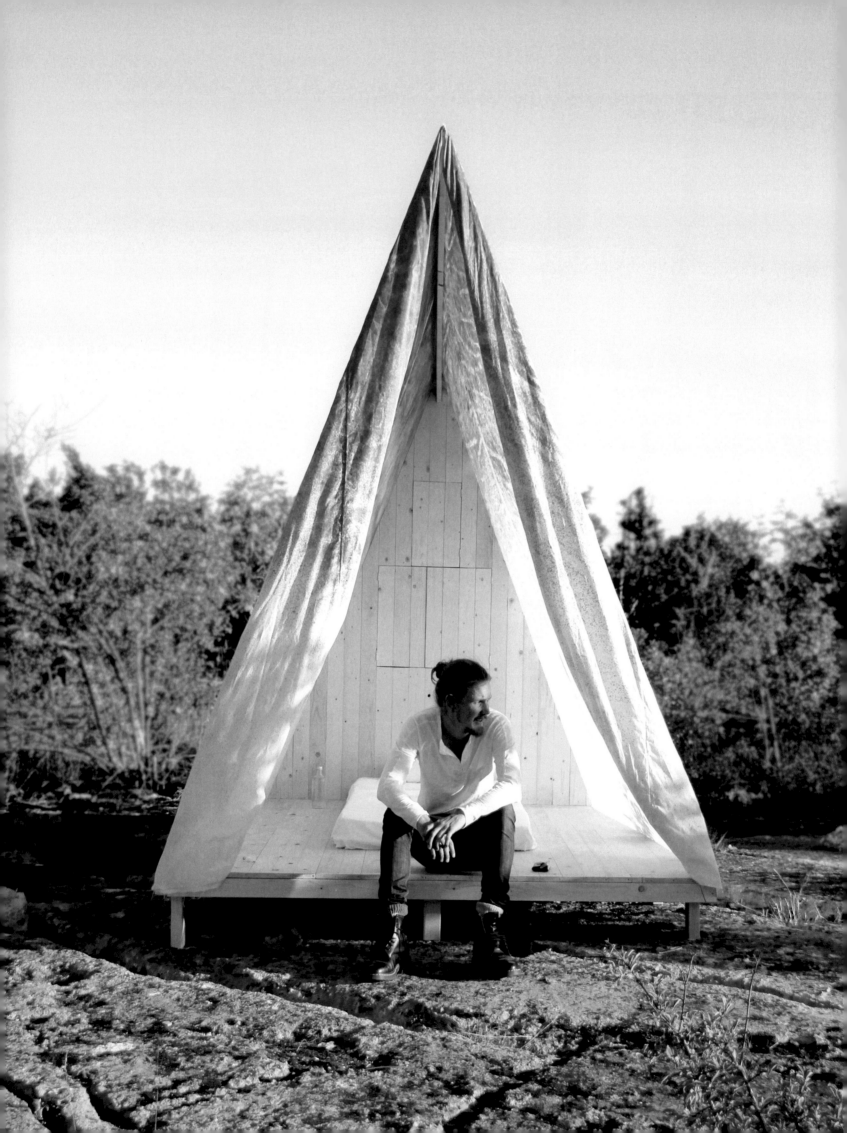

ISLAND EPHEMERA

DESIGNERS ON HOLIDAY

Like leaves that fall together only
to scatter in the wind,
this gathering of humble structures celebrates
the fleeting Scandinavian summer.

An array of temporary shelters dreamt up by designers from around the world converge for a summer on an island in rural Sweden. The whimsical and elegant caravan includes 18 tents, a symbiotic hot tub, a luxury outdoor shower, a one-man sauna, a terracotta kiln, a viewing platform, a waxed cotton sailing boat, and woodland cinema. The campsite acts as a collaborative hub for a diverse commune between art and nature. This collection of transient structures share a primary paired-down simplicity. Built from materials already on the land, the refreshingly understated tents make use of local Swedish pine, limestone, cottons, paints, and pigments. The nomadic shelters tread with care, arranging and rearranging across the land. Packed away each winter, the structures reemerge the following year to greet a new set of ephemeral structures ready to join the fleeting congregation. ◆

GRASS RAISED

BENJAMIN SCHIEF

A hybrid feeding trough allows one to commune with the cows.

The process of civilization has led to very limited contact between humans and other animals—unless said animals happen to be on your plate for dinner. The farming of these creatures keeps them isolated from us as an abstract entree choice. This whimsically simple structure in Saxony returns man and animal to their original natural relationship. An archetypal trough combined with an observation platform makes this connection possible. While cattle are lured to the hay below, visitors may climb up the ladder to the platform above and observe the animals feeding. The first in a greater network of troughs connecting feeding spots and creating interlinking pathways, the hybrid shelter can appear anywhere where animals live from pens and pastures to forests and farms. As man and animal spend time together under one roof and begin to interact, a long lost relationship and ability to relate to one another reawakens. ◆

A PERFECT CIRCLE

LANE SHORDEE, CAITLIND R.C. BROWN & WAYNE GARRETT

On the frozen shores
of Lake Ontario,
a mysterious charred sphere
awaits — a surrealist
addition to
a blustery landscape
of white.

As formidable and fleeting as the Canadian winters, a giant sphere appears along the beach of Lake Ontario. Confounding and captivating passers-by during the course of its four-week waterfront residency, the enigmatic monolith operates as both a mirage and a novel take on traditional lifeguard towers. The imposing and unapologetic form casts a dark, charred aesthetic into the bright white frozen landscape. Drawing nearer, beachgoers encounter an opening in the orb. This curious void, marked by the bottom of a light wooden ladder, beckons the brave to ascend into the belly of the beast. Visitors emerge into a domed sitting space unexpectedly lined in thick, warm fur and a round window pointing towards the sky above the frosty lake. Welcoming and impenetrable, scorched and frozen, isolated and insulated, the stoic sphere comes to life amidst powerful juxtapositions. From this protected vantage point, guests find a cozy sanctuary to thaw slowly and gaze into the icy gray winter sky.

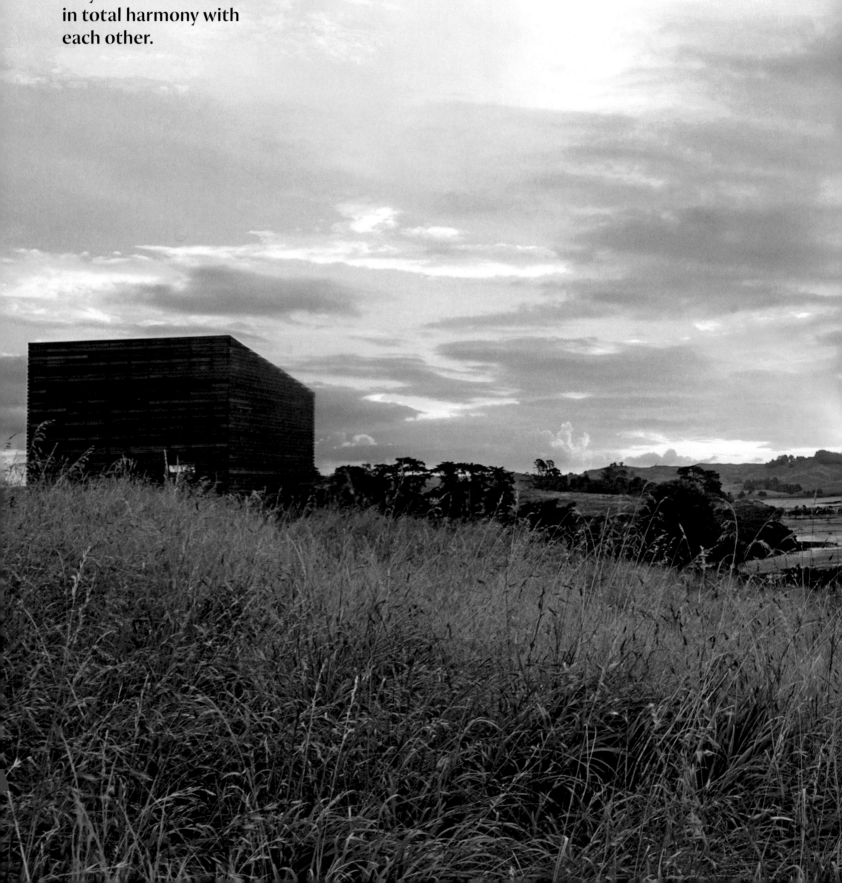

TWIN PEAKS

CHESHIRE ARCHITECTS

Two cabins for two
very different clients that remain
in total harmony with
each other.

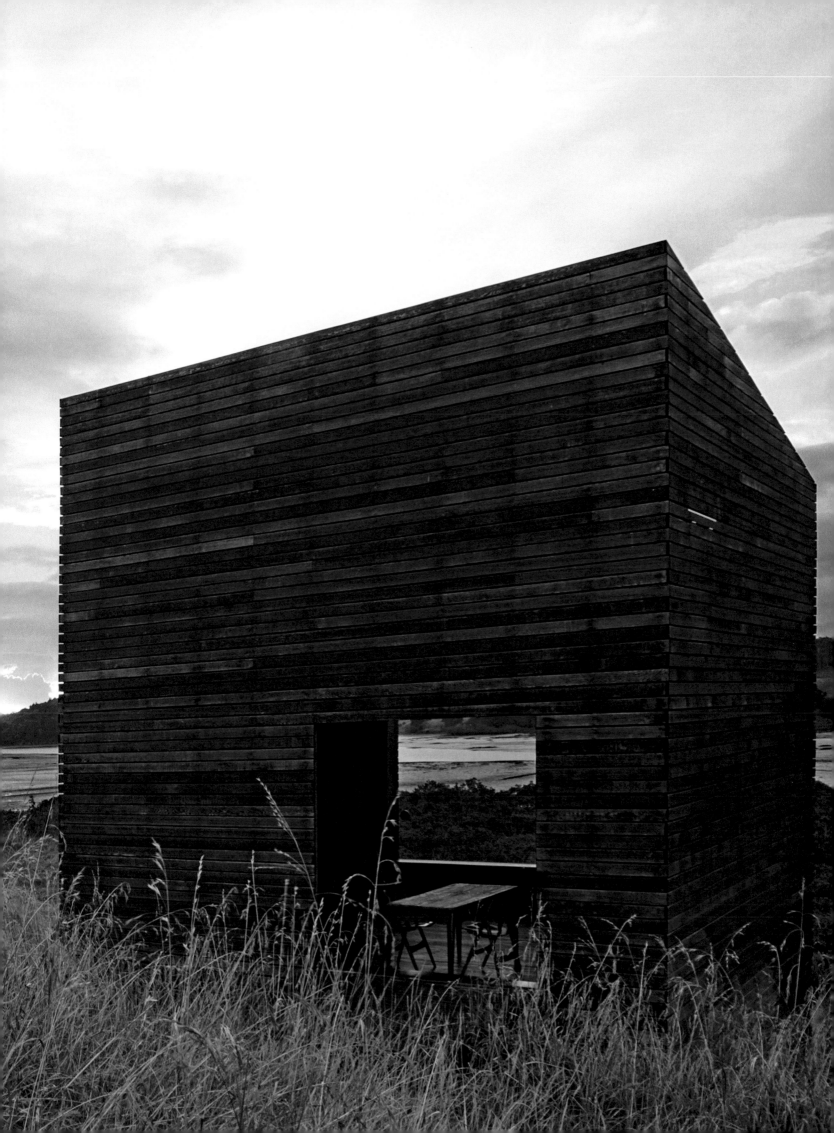

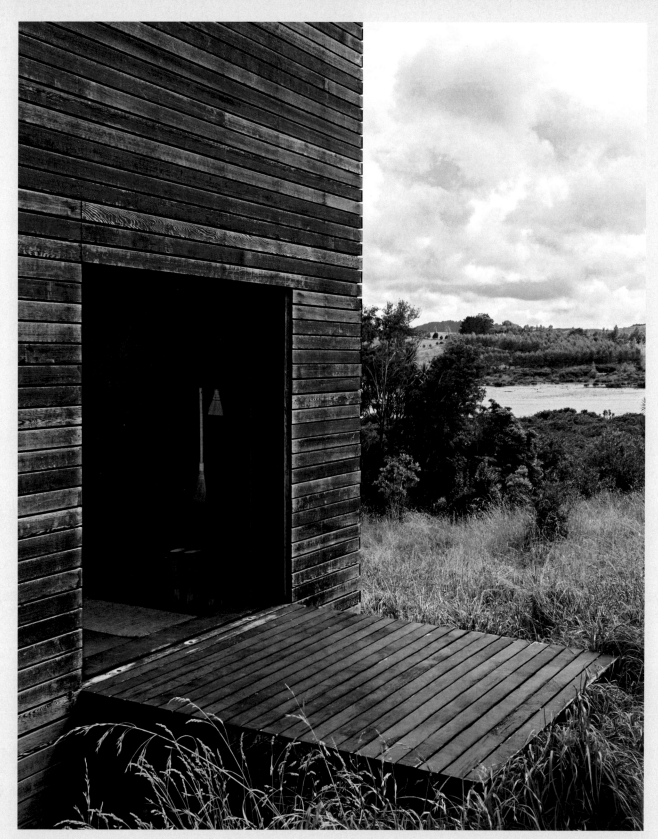

left_ **Since there are no doors to the cabins, they are entered through cleverly placed walkways.**

right_ **Windows slide right back and disappear to reveal the view.**

We erased everything: no roof, no door, no floor plane, no flashings," says Auckland-based architect Nat Cheshire of these eerie twin edifices in the Kiwi countryside. "Nothing familiar."

When two close friends leading intense urban lives approached Cheshire Architects to build them each a quiet retreat on a patch of farmland, the progressive architect had an intriguing thought: "to miniaturize the idea of a 'house,' trading scale and amenity for the extraordinary," as Cheshire puts it. The result, these two 29-square-meter cabins, breaks rules not just of the rural locale but of residential architecture as a whole. Ditching the usual trappings of house building was a radical gesture employed to create a space that completely zones out. "We wanted to shock you, to engage you very directly, so that by the time you had climbed a boulder and stepped in through an aperture, every sense was engaged. We wanted you to be part of here," the architect continues.

And it's hard not to feel embedded in the landscape because of this. The ›

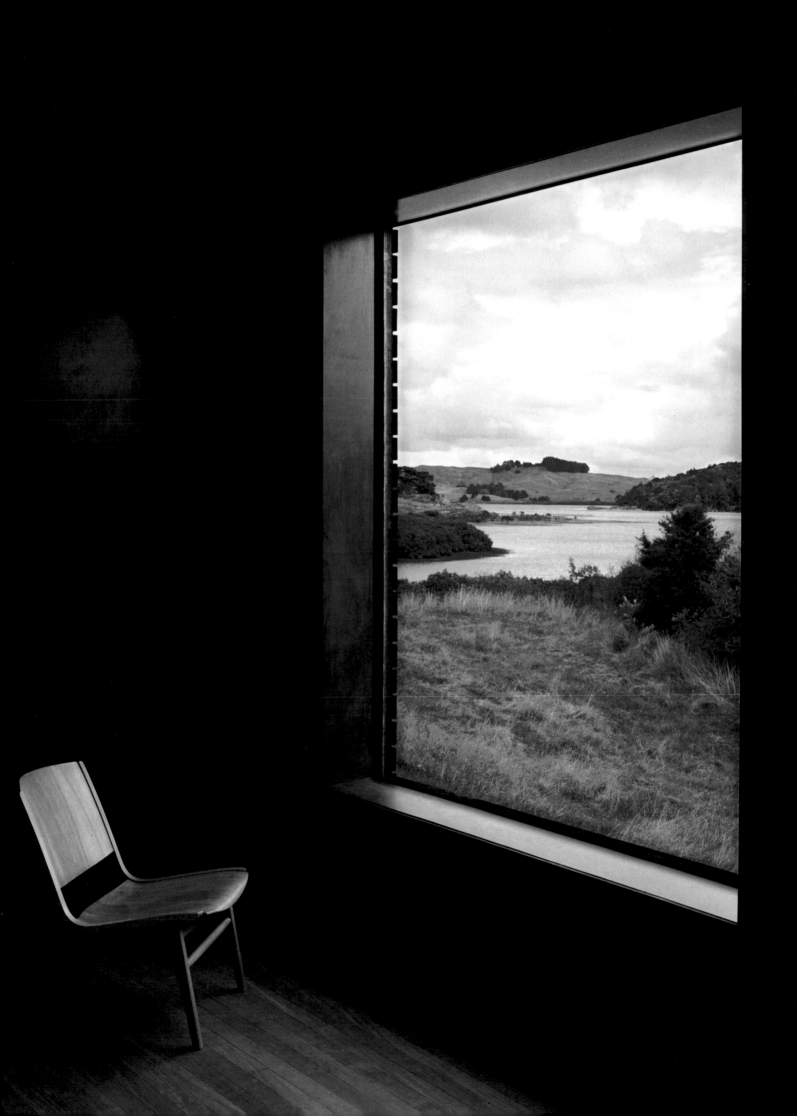

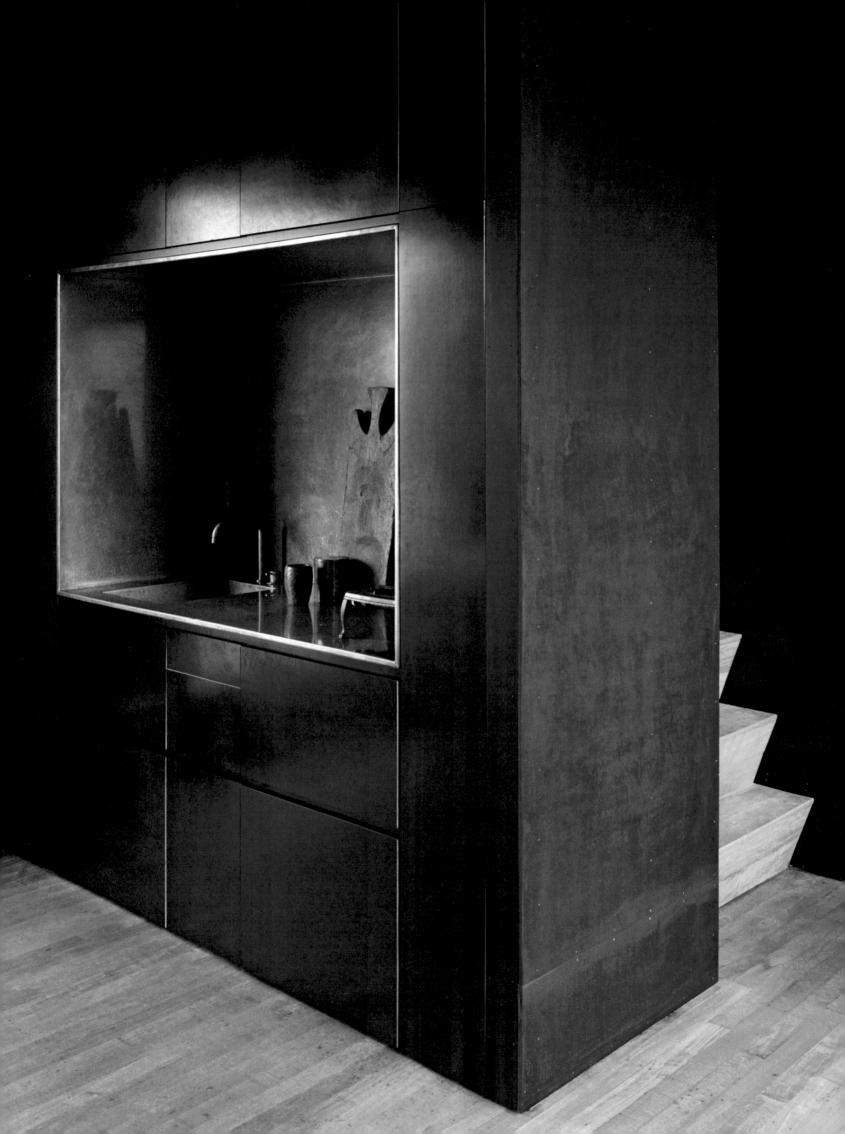

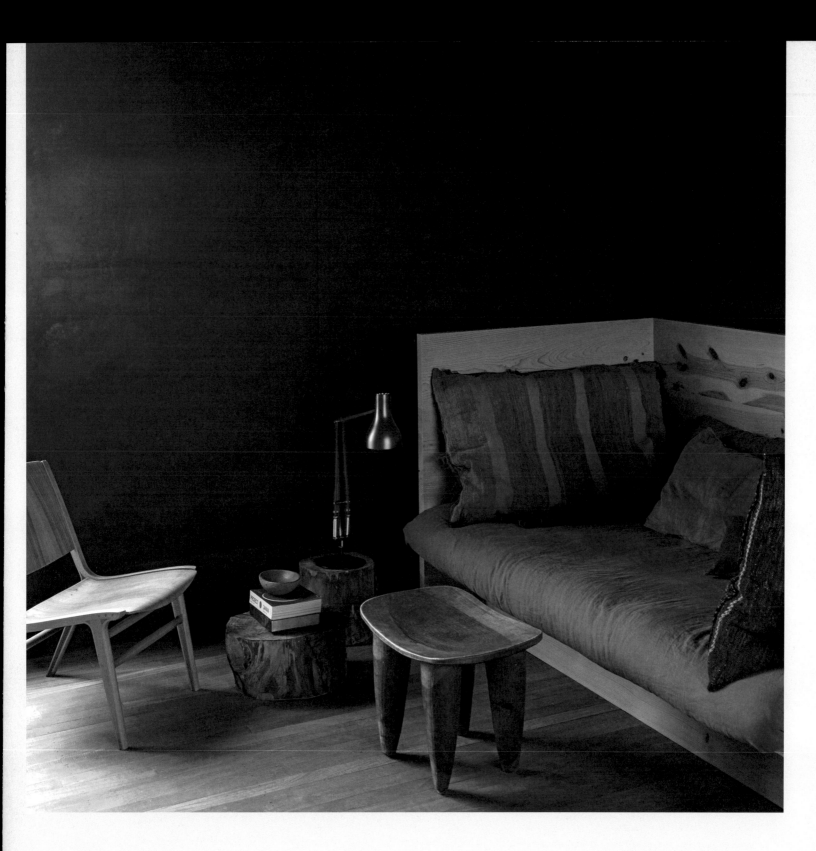

exteriors of the two cabins are made of indiscernible charred timber and the pitched roofs slope down, subtly matching the angle of the land they sit on. The site rolls downhill to the estuary of Kaiwaka Harbour on New Zealand's northwest coast. They both have windows that slide inside the house, and when they are tucked away, the house entirely merges with its surroundings rather than being hermetically sealed from it. There are no doors—these windows are also used to enter the house—nor are there any paths leading to the property.

Not knowing how to get in might seem a little strange at first; but not knowing how to get out offers a certain satisfaction. This is a place of total seclusion.

The formerly disused stretch of farmland has very little development and infrastructure around it, which means total peace and quiet. It also means the homes are completely off grid. "The sense of isolation and autonomy is very satisfying—it feels more like camping than going to a holiday home," says Cheshire. Once you've clambered into either of them, the ›

"Ditching the usual trappings of house building was a radical gesture employed to create a space that completely zones out."

243

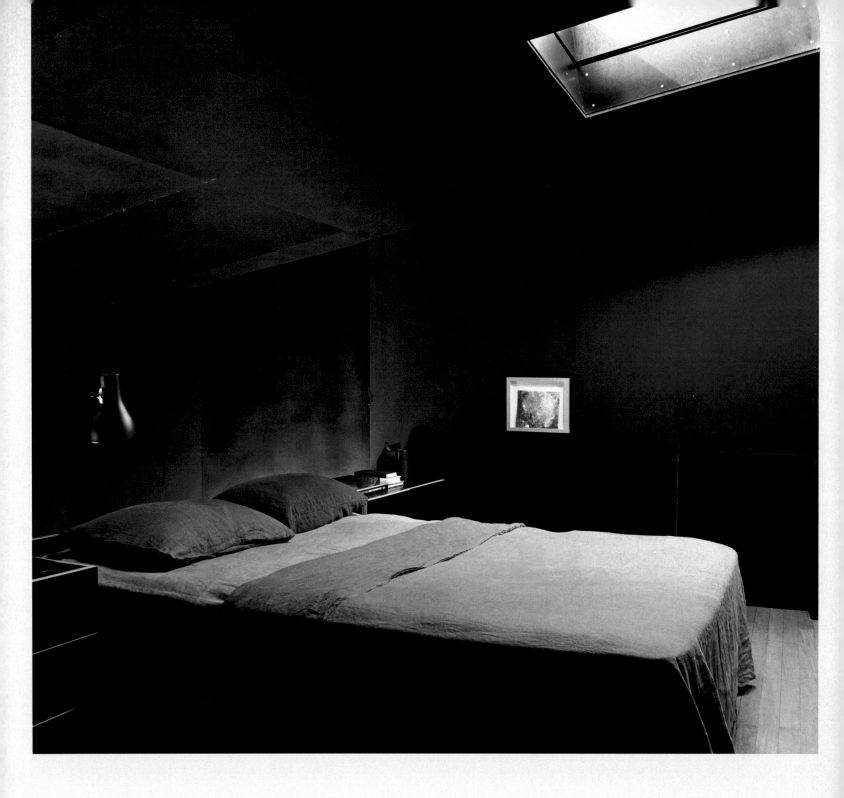

top_ One of the cabins is relentlessly dark inside, like a cozy, inky cave, while the other is distinctly light by comparison.

right_ Comfort is never sacrificed with the limited but beautiful furniture selection.

twin cabins differ remarkably inside. The first client was extremely literate in design and willing to trust the architects entirely, who suggested coating the inside with glossy black paintwork. It's difficult to tell where the wall begins and ceiling starts. Essentially, it's a black hole. It was a challenging idea, but makes for a powerful experience. "Its interior is so potent that the landscape beyond seems to float like an image, almost like a film projection," describes Cheshire. There's a saying in New Zealand, "Don't like the weather? Wait 15 minutes," such is the ever-changing sky in this part of the world. This particular black box makes a great cinema seat to watch it all from. "It's extremely unusual—you feel at once indoors and out, a bit like sitting ❯

"This is a place of total seclusion."

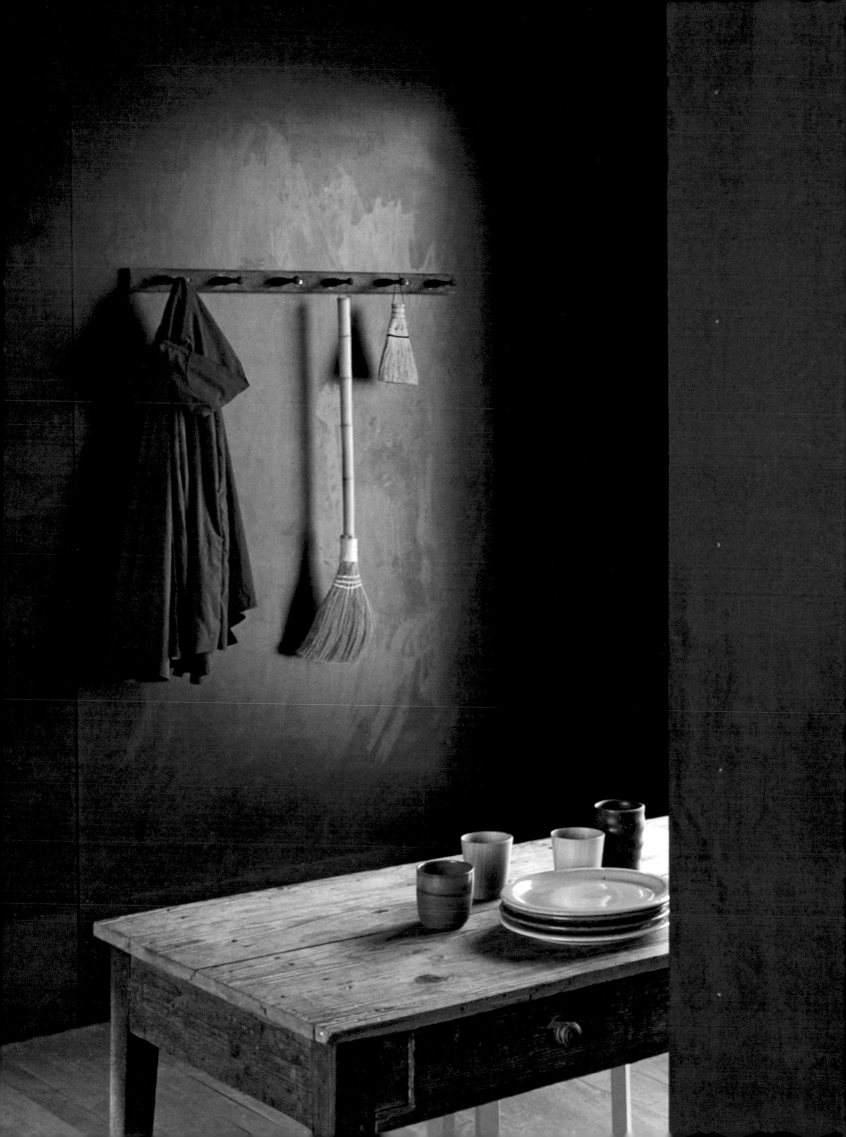

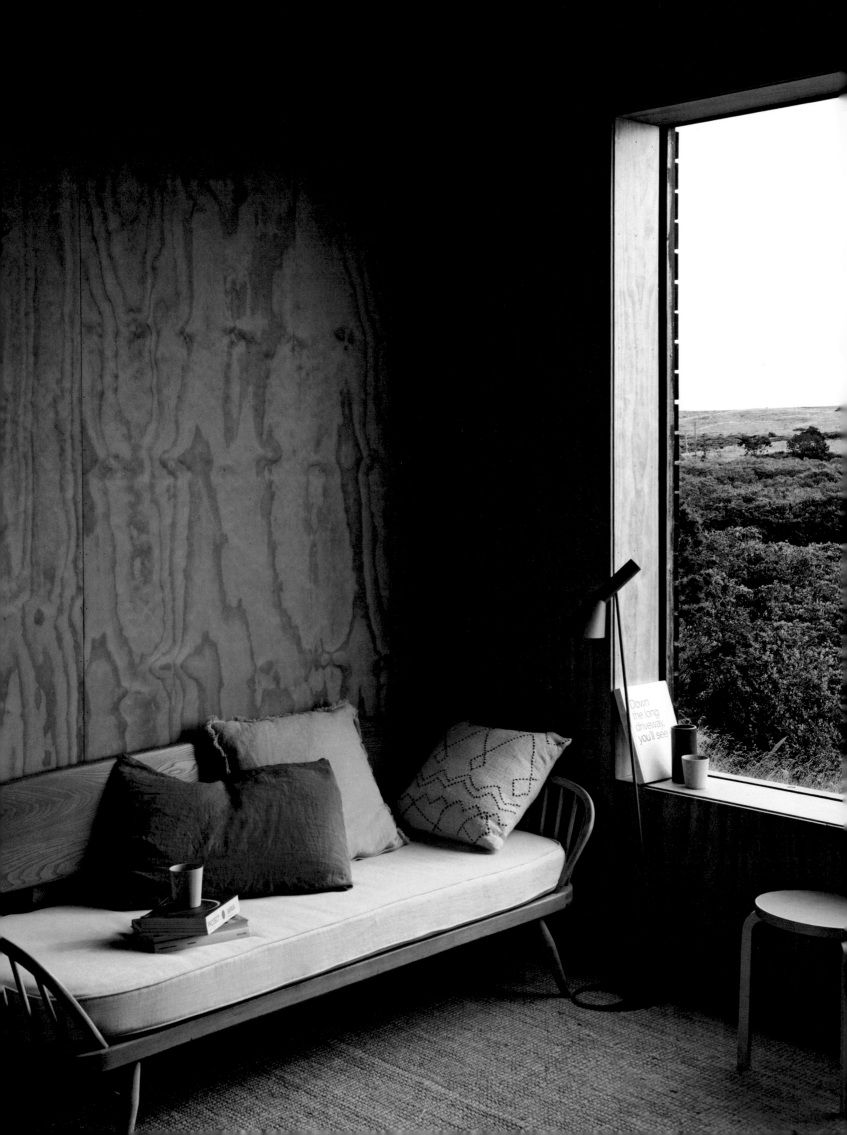

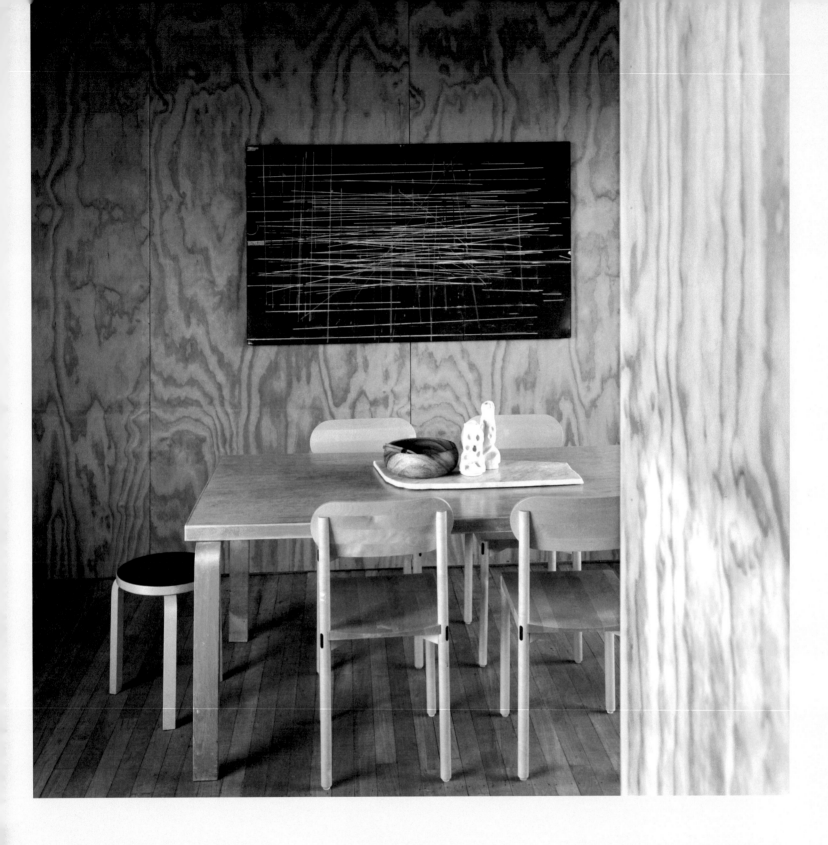

near the mouth of a cave. It's profoundly peaceful," Cheshire observes.

The second client had a different idea of what a retreat should be and wanted an interior that was slightly more traditional. So Cheshire Architects decided to use plywood inside. "This cheap, warm material seemed an ideal counterbalance," he explains. Both cabins are furnished simply, with the clients and architects collaborating with Auckland stylist Katie Lockhart to

make a welcoming selection of furniture. The look and feel of both interiors is inviting, handmade, and low-key, and there are very few pieces of furniture that demand much attention—just as the team wanted. The layout in both is identical: the downstairs holds an open-plan living area (with a small bathroom tucked away); upstairs there is a low-hung bedroom area sitting under the sloping roof on a mezzanine. Basic, but beautiful.

These houses upend the belief that coastal homes need to be glass-and-steel, cantilevered palaces, as the New Zealand shore is increasingly blighted by. This piece of land originally had planning permission for a 1,500-square-meter mansion. Cheshire Architects chose not only to ditch doors and windows, but also to entirely redefine what a country home can be: in short, tiny and radical. So is small best? As Cheshire asserts: "In this case, yes."　◆

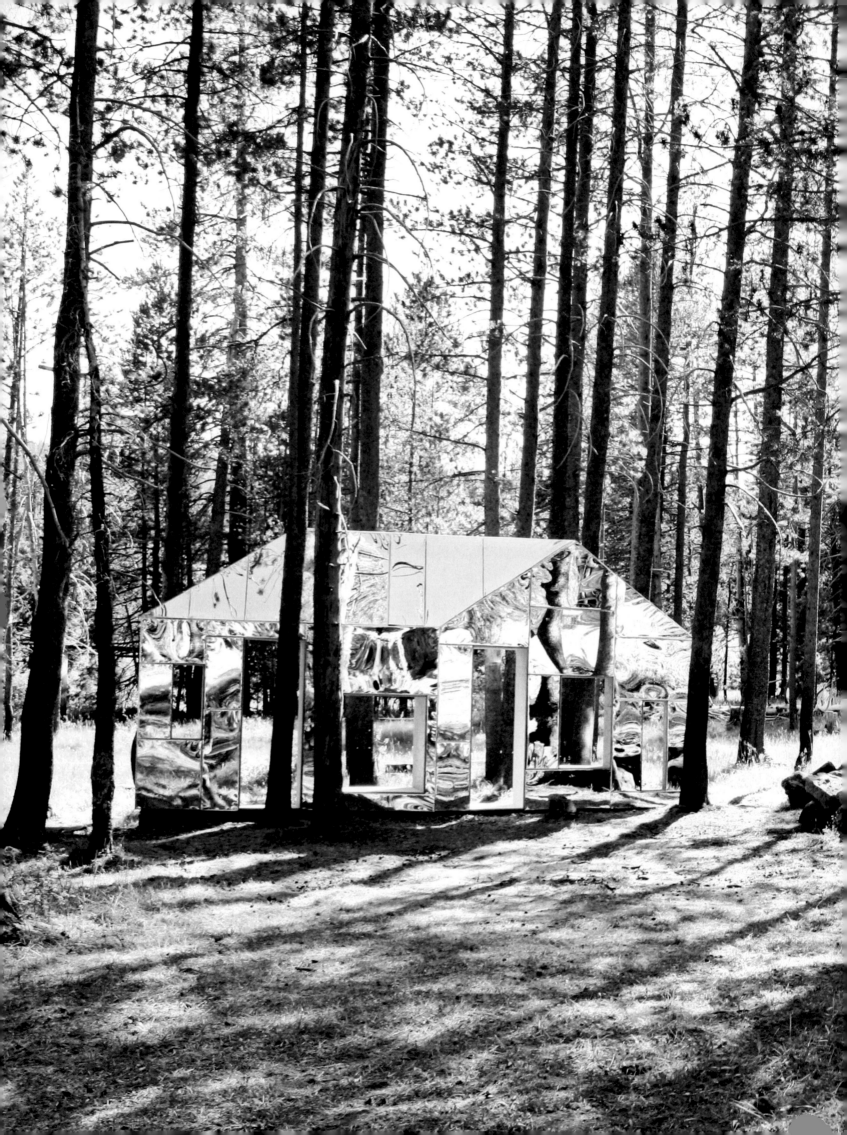

– Western United States –

THE VANISHING CABIN

STPMJ

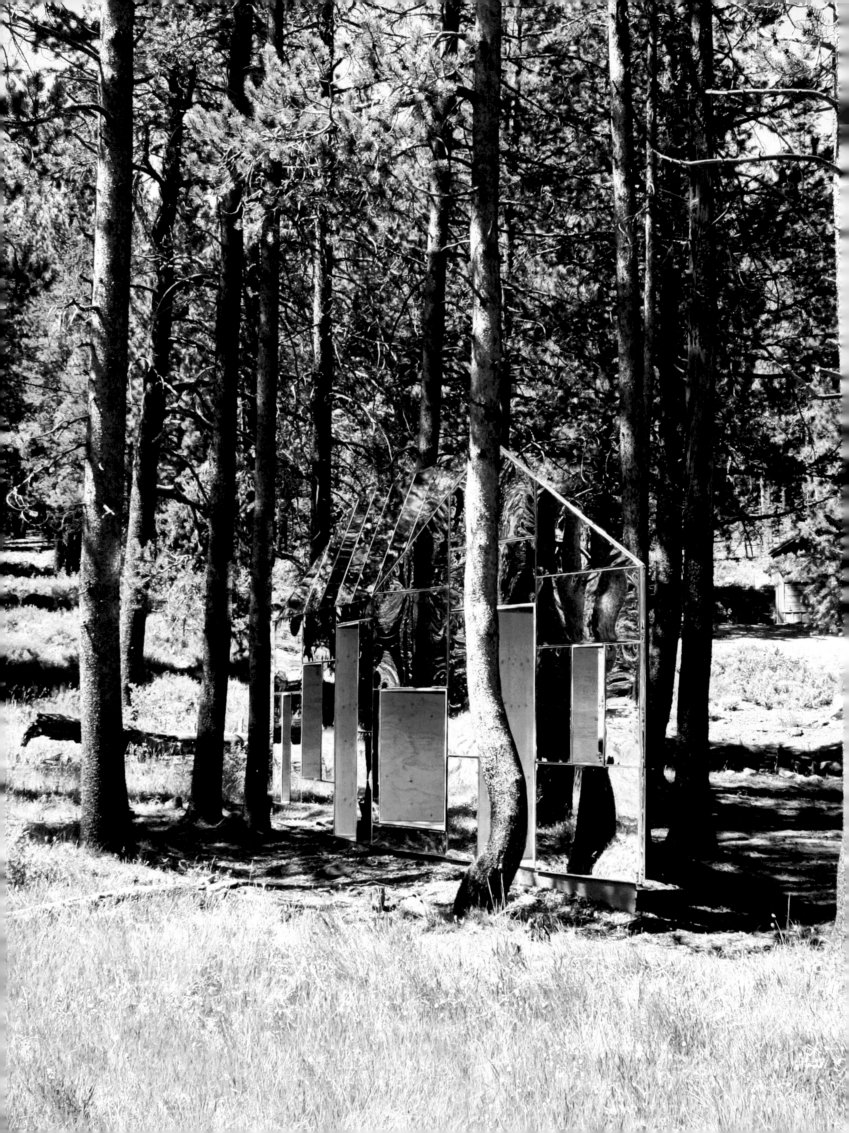

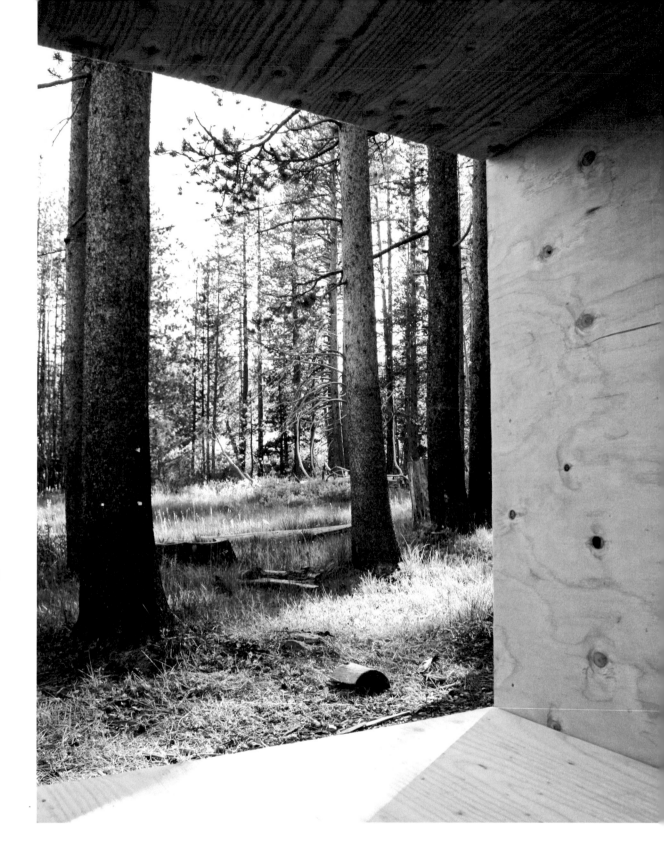

Now you see it now you don't: A furtive cabin adopts a protective forest camouflage ensconced behind a wall of mirrors.

An elusive mirror-finished folly blurs the boundaries of its forest surrounds. The occupiable optical illusion recontextualizes nature by projecting the verdant landscape onto its barn-shaped frame in an act of uncanny camouflage. Commanding and confounding the eye, the reflective hideout all but vanishes in the midst of an enclosed grove. The shape-shifting cabin reflects back the trees, plants, sky, and ground in an artful slight of hand. These fluctuating reflections vary on the location of the viewer, allowing the structure to smoothly assimilate into the earth only to then suddenly leap back into view. A series of plywood incisions penetrate the folly, forming points of egress. This visual trickery makes the framed openings appear to float midair, upending distinctions between the real and mirrored landscape. Shaped as a slender parallelogram, the barn masterfully erases its man-made presence while introducing a cunning universe of interactive simulacra to all who happen upon it. ◆

THE ARCTIC TRIANGLE

**HELGA-MARIE NORDBY & CULTURAL ENTREPRENEUR
ERLEND MOGÅRD-LARSEN**

On an Arctic beach of Northern Norway,
an intrepid A-frame reconnects
visitors with the seasonal
rhythms of the remote landscape.

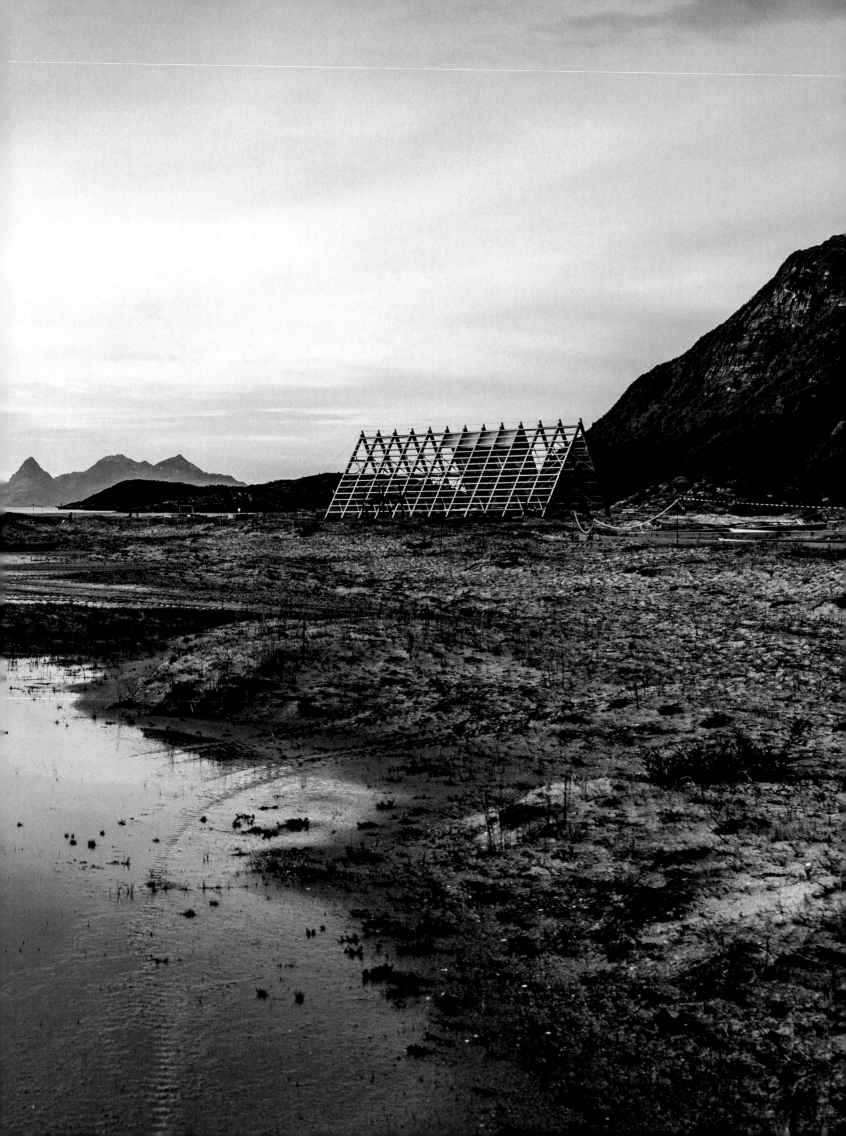

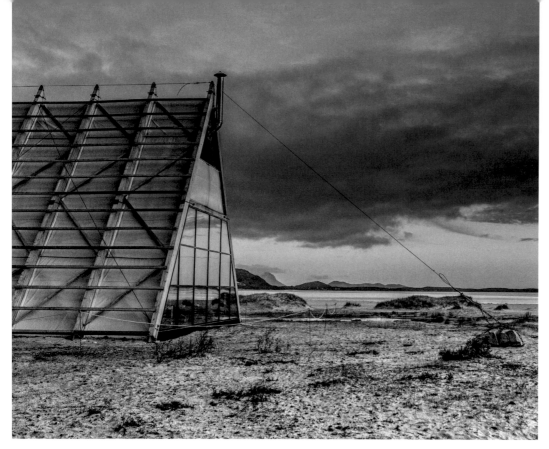

"While the sun never retreated from the sky, the celebration of endless summer commenced with indoor and outdoor concerts to tantalize the senses."

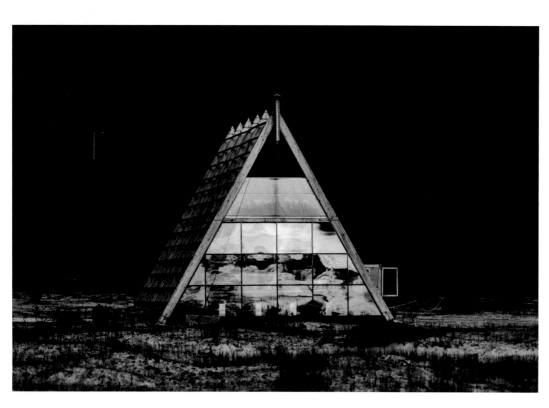

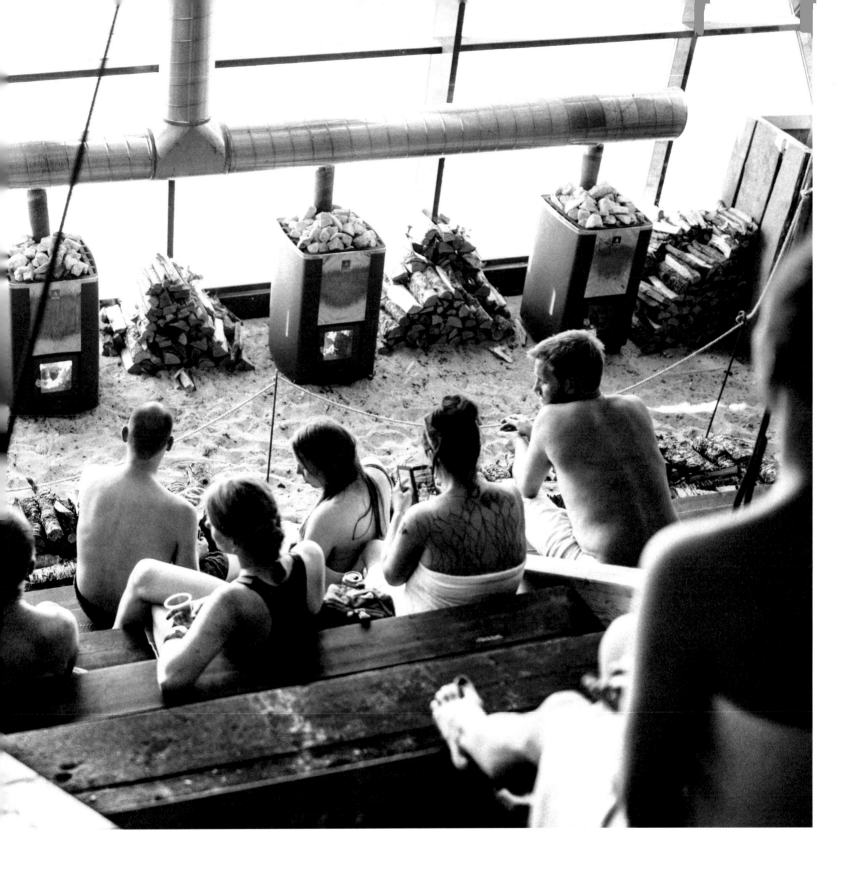

For millennia, people have followed the movement of animals and the changing of seasons in the Arctic landscape. Footprints are few. Salt, a cultural festival, builds on this heritage at the shores of the island of Sandhornøya. The first incarnation of this nomadic event centers around a commanding A-frame that juts out of the raw earth and into the tempestuous polar skies overhead. The iconic sojourn, a nod to the traditional racks used to dry fish, hosted two site-specific artworks—one for the dark season and one for the light. While the sun never retreated from the sky, the celebration of endless summer commenced with indoor and outdoor concerts and experimental performances to tantalize the senses. In the winter, the space transformed into a social sauna for thawing the chill from one's bones and a site to gather for fireside storytelling. As fleeting as the nature around it, Salt will continue to traverse and temporarily linger upon the northernmost reaches of the planet. ◆

LOOKING DOWN AT THE WORLD

PETER BECKER

Peter Becker had lived in Berlin for seven years, running a bar and gallery in Kreuzberg, when he decided to escape city life and move back home to his parents' house in Hessen, Western Germany. He had always been an avid traveler, but found himself leaving the city more frequently to backpack around South America or Asia for months at a time. "I'd sleep outside on the riverside or in the forest there," he says. "I started reconnecting with nature more and more and was getting a little sick of Berlin."

So Peter returned home to the countryside, working for his father's recycling company at first. One day, as he was walking with a close friend through a dense beech tree forest, he had an ›

top_ **Peter Becker in one of the treehouses.**

right_ **The contemporary treehouse, the Baumhauskugel, swinging between the trees.**

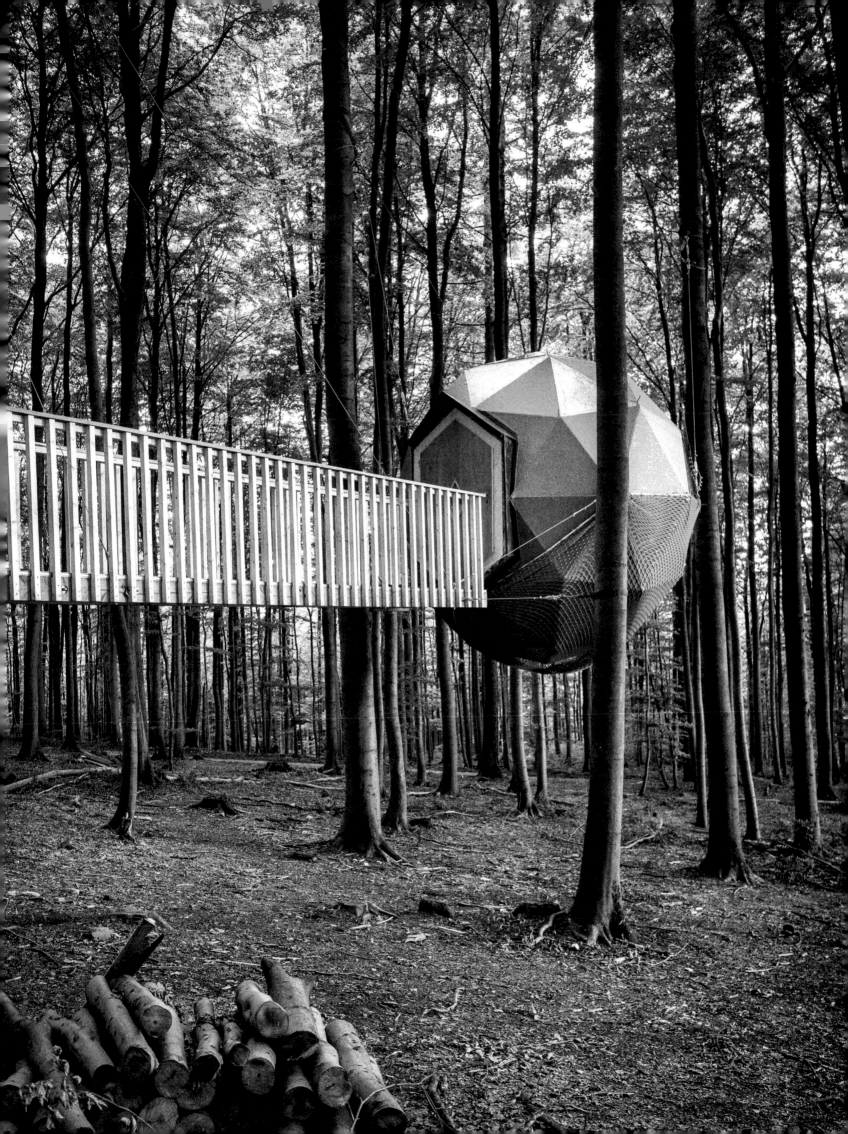

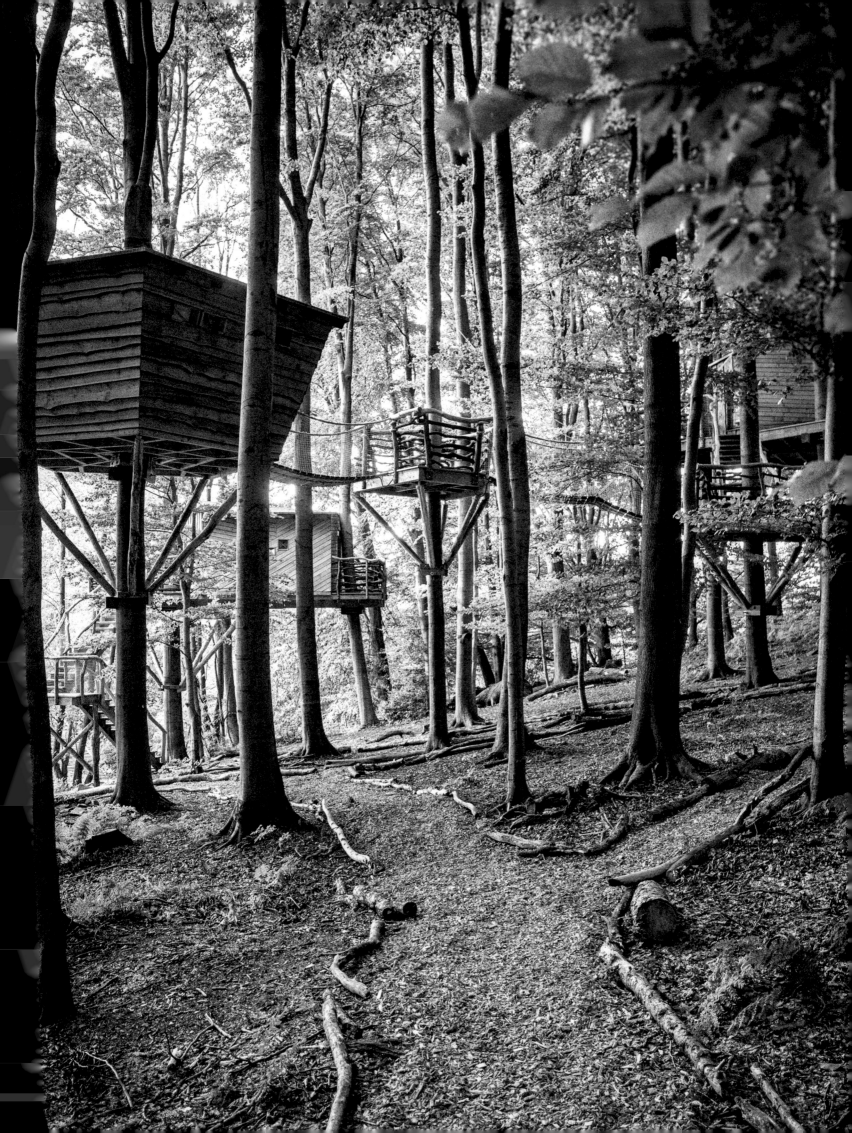

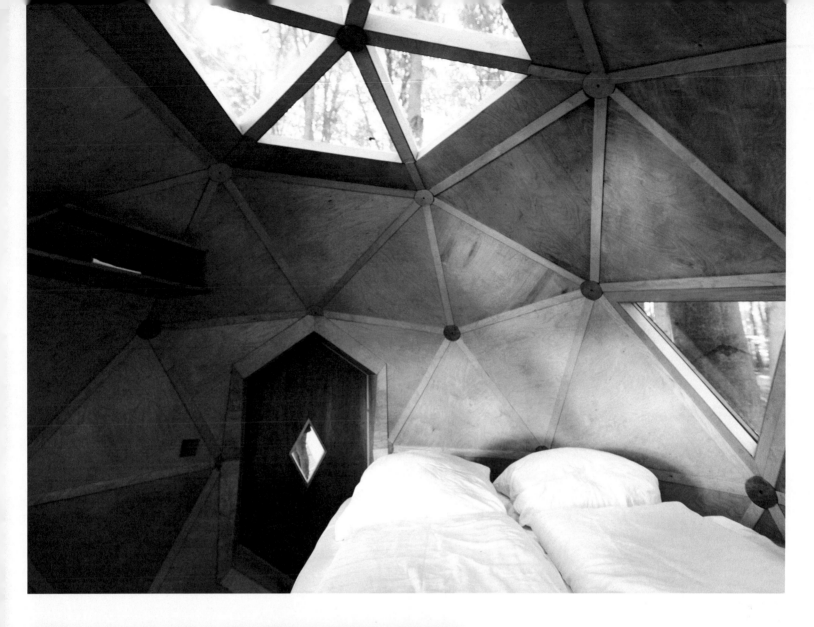

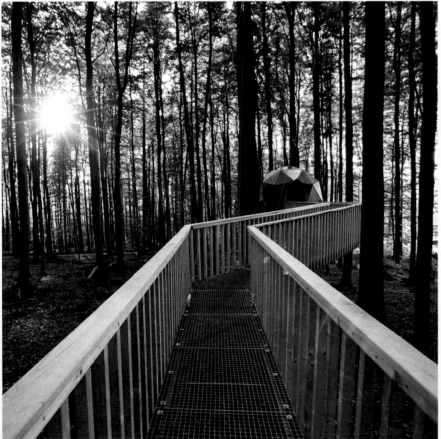

top_ **The cozy interior of the Baumhauskugel.**
below_ **One of the raised walkways leading
to the Baumhauskugel.**
left_ **The community sits up in the birch
tree forest.**

idea. "How cool would it be to create big
cobwebs in the trees that we could hang
out in like Spiderman?" his friend asked.
Peter thought it sounded nice, but was at
a loss as to how to turn the idea into a vi-
able project. It was then that he thought
about a treehouse community: a place for
those looking to get back in tune with na-
ture just like him.

Peter and his friend were walking in
the shadow of Schloss Berlepsch, a fairy-
tale medieval castle whose turrets rise up
from the peak of land it sits on and which
is surrounded by dense woodland beyond
its fortress walls. Peter soon suggested the
idea of a series of holiday treehouses to the
owner, who was immediately enthused ›

259

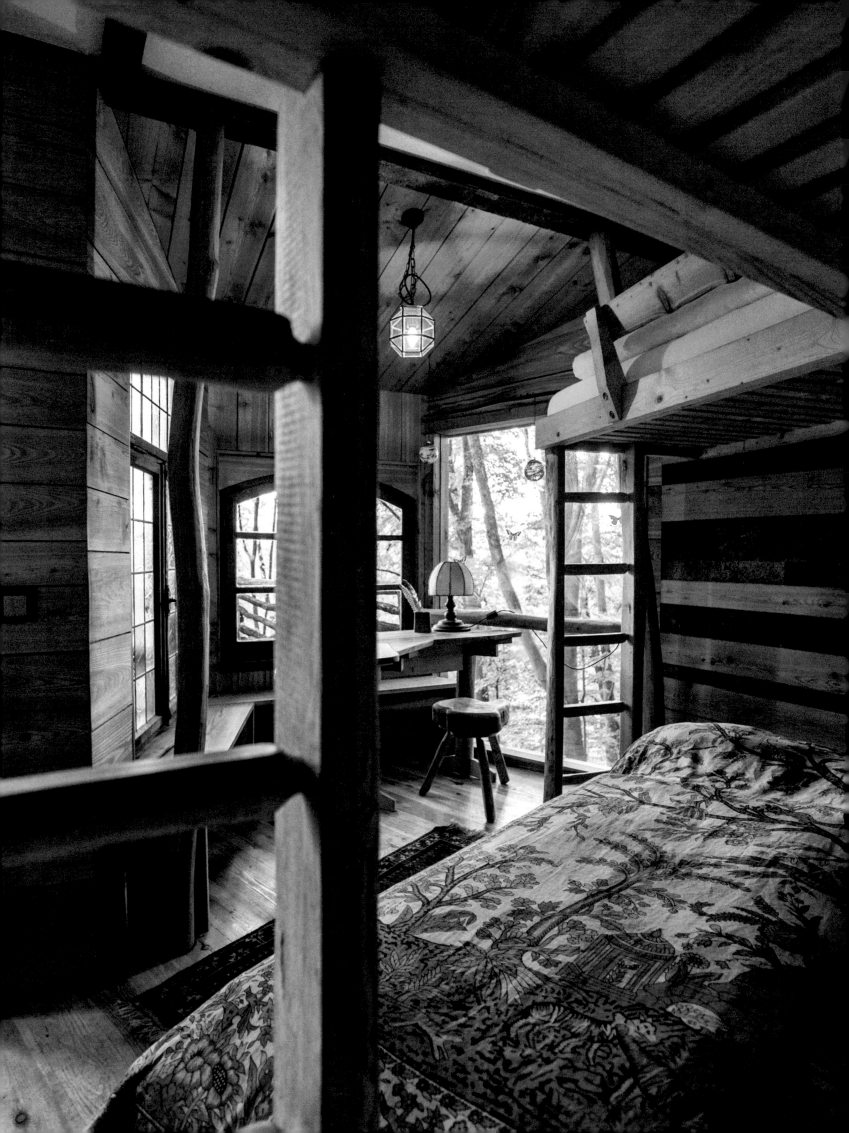

left_ **Bunkbeds provide cosy places for sleeping.**
right_ **Interiors are equipped with handcrafted pieces.**

by the concept. Peter then spent six months living in the woods in a tepee developing the project. It took almost four years to map out a detailed plan for it and obtain permission, but in 2014, Robins Nest—an appropriately medieval name—opened.

Three small treehouses are nestled five to seven meters up into the trees, each one accommodating four people. They're reached by a series of hanging walkways and have peaceful terraces up among the branches. There is also a contemporary bubble house—the Baumhauskugel—which sleeps two, and a larger edifice at ground level—the Stelzenhaus—which can sleep eight.

Fittingly, Peter had a gang of merry men to create Robins Nest. To execute the design, he worked with Emu Stahlmann, a treehouse expert from Berlin, and ❯

built the houses with a group of 12 young people from Witzenhausen called the Handerwerker Kollektiv. He took on all the

"You have time here to think about what you are and what you are doing."

finishings himself: "All the interior design and furniture and old windows, I put in. Every detail in the house," he shares. "I often rummage through flea markets and occasionally spend entire nights on eBay."

The rustic simplicity is naturally part of the charm. Just like Peter, many of the visitors who come and stay at Robins Nest are those seeking something more significant than city life. They include families, but also writers who want some peace in which to develop their literary craft, university professors, or couples who have gotten married in the castle and then wish to spend their wedding night up in the intimacy of the tree branches. They all have one thing in common: "People are looking to get out of the fast life, with their big houses and cars. When they are here, all they have is a small house and fire and some food. You have time to think about what you are and what you are doing. People here recognize what is important for them and their kids—what it is that they really need," Peter reflects. "Young children on holiday with their parents will say 'Mama, Papa, look what I've found in the forest!', and they've never seen anything like it. They're discovering the world outside of the city limits!" he exclaims.

There is peace at Robins Nest, but entertainment too. Peter lives nearby and spends much of his time at the campsite working in Waldbar, the onsite shack where he serves waffles for breakfast or prepares cocktails for guests to drink around the campfire in the wee hours. Guests can spend their days abseiling, rock climbing, sailing down ziplines, or orienteering. A stay at Robins Nest is more than about being simply at one with nature. Peter's desire is to show the excitement of being in the forest, that it's a place to reside in and be thrilled by, just like Robin Hood and his merry men. Peter's project is about teaching young kids and urbanites that life under the trees can be as exhilarating as life among the bright lights of the city.

Although he is settled in the forest, Peter's wanderlust remains and he would like to find another spot in the world one day to create a treehouse village. "There are so many nice places I want to discover," he explains. "I am very happy in the forest—it is the best place to be for the moment—but you never know where life may take you." ♦

left_ **Peter Becker outside the onsite bar and café, Waldbar.**

right_ **The raised treehouses offer a calm night's stay and amazing views.**

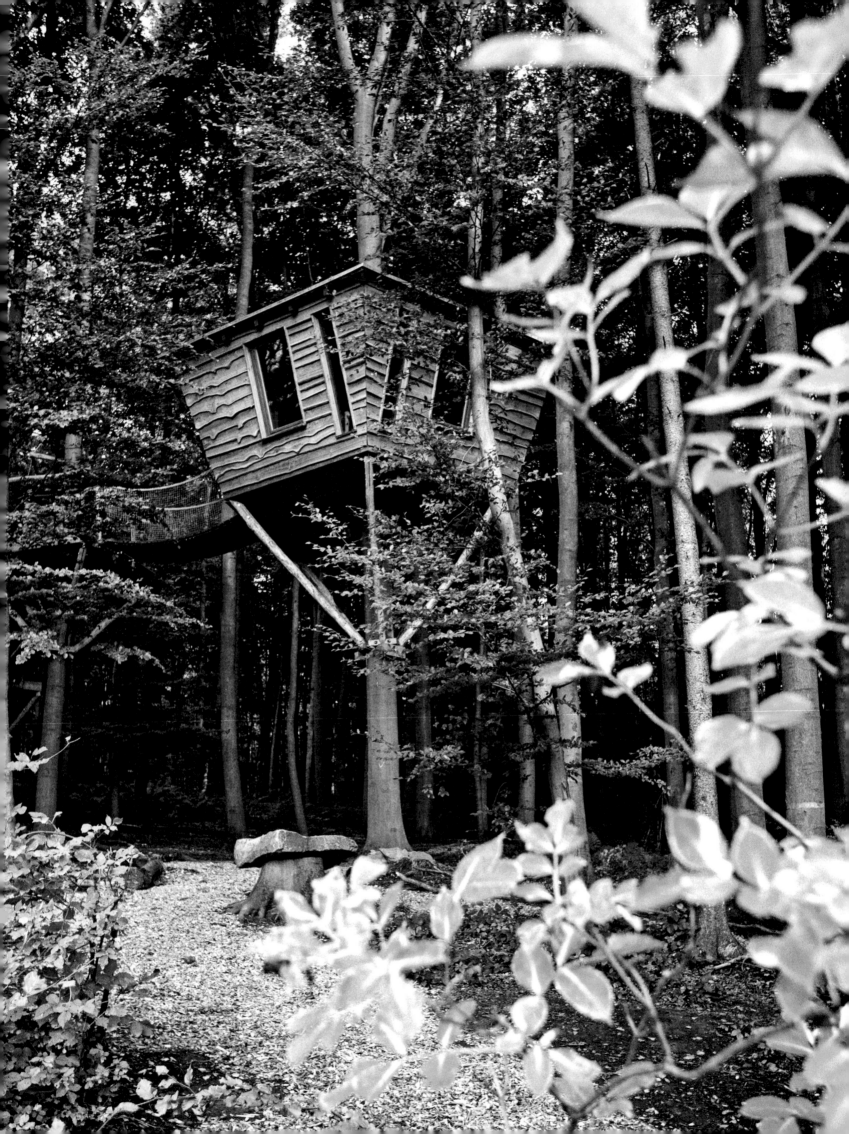

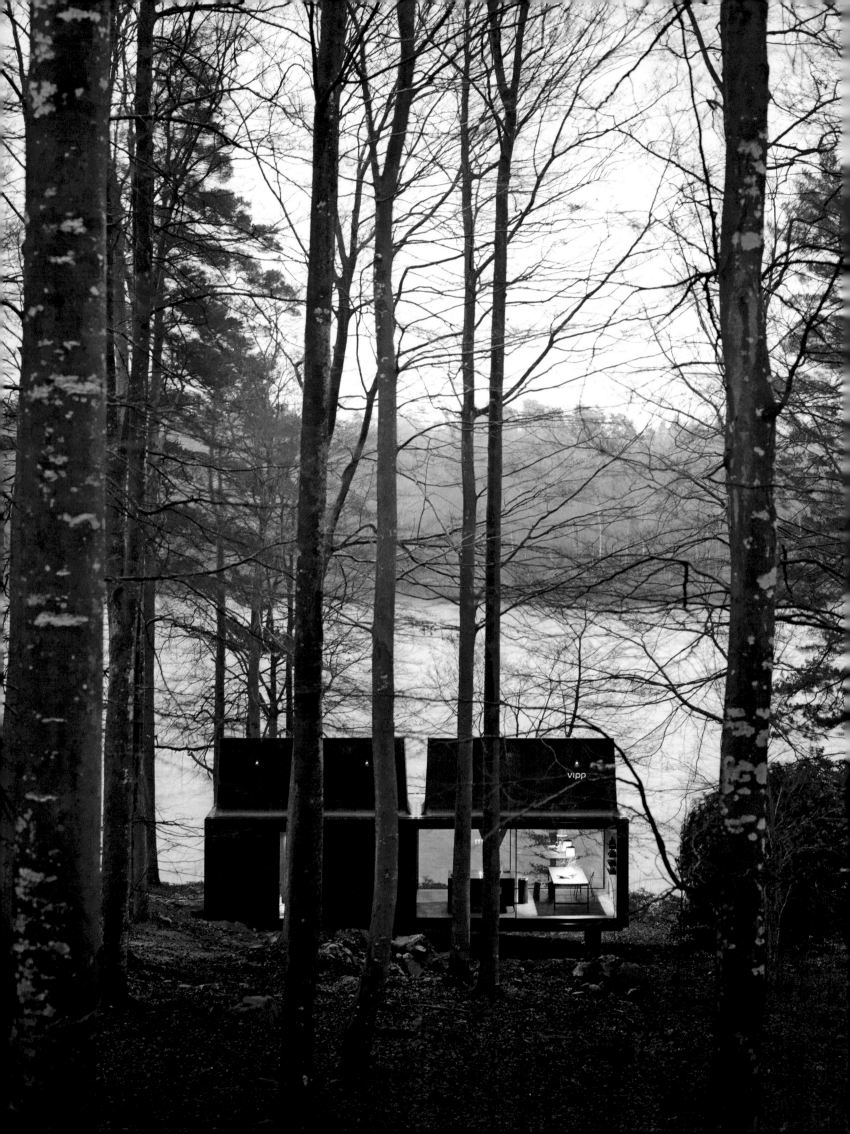

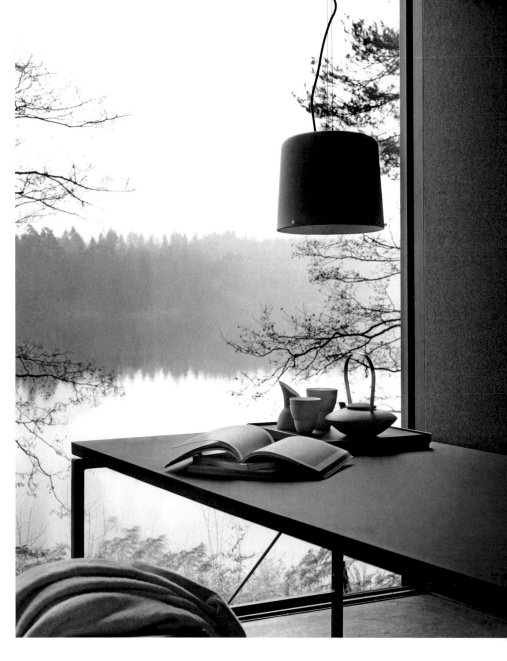

SHELTER AT THE SHORE

VIPP

Shrouded
in mystery,
this lakeside hideout
in the Scandinavian
wilderness appears
between
the leaves—a place
to get lost and
a place to be found.

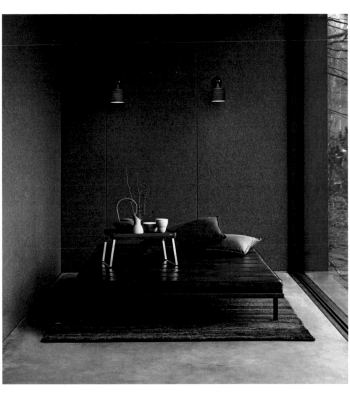

Through the woods and near the lake, an elegant retreat bewitches all who happen upon it. The noble shelter, far removed from the din of city life, choreographs an all-inclusive pilgrimage into nature. Designed as a modular plug and play system that can be relocated from the lake, to the mountain, and beyond, the contemporary take on the rural cabin fosters meaningful escape from the stresses of urban dwelling. The two-level structure of charcoal gray tones dissolves into the untamed panorama on the ground floor. Floor-to-ceiling sliding glass doors encourage life to spill into the landscape. Above, the second level supports a more introspective atmosphere. Guests access this contemplative space—illuminated by a ceiling of skylights—via a discreet ladder. This private zone situates a sleeping loft that frames the sky and treetops. A place to retreat and recharge that lasts a lifetime, the shelter plays the liminal backdrop to an omnipresent wilderness. ◆

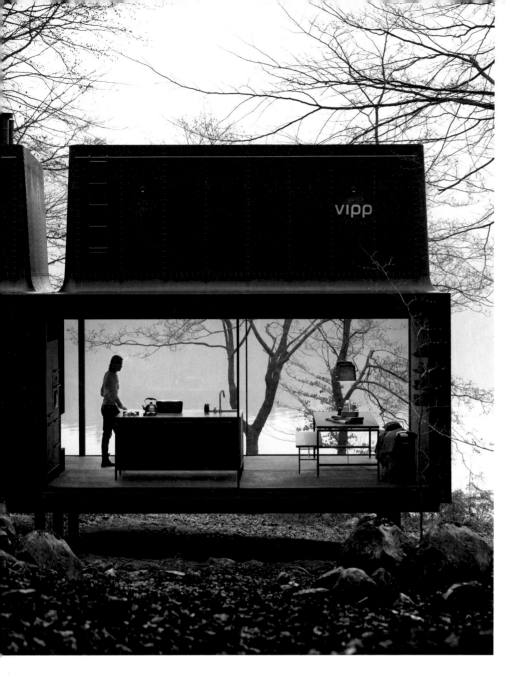

"A place to retreat
and recharge
that lasts a lifetime."

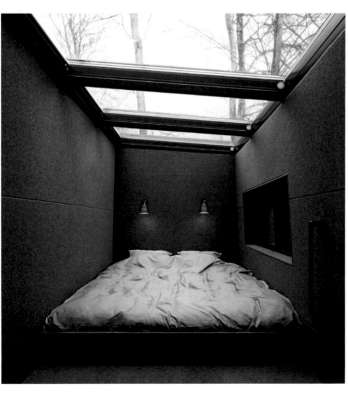

266

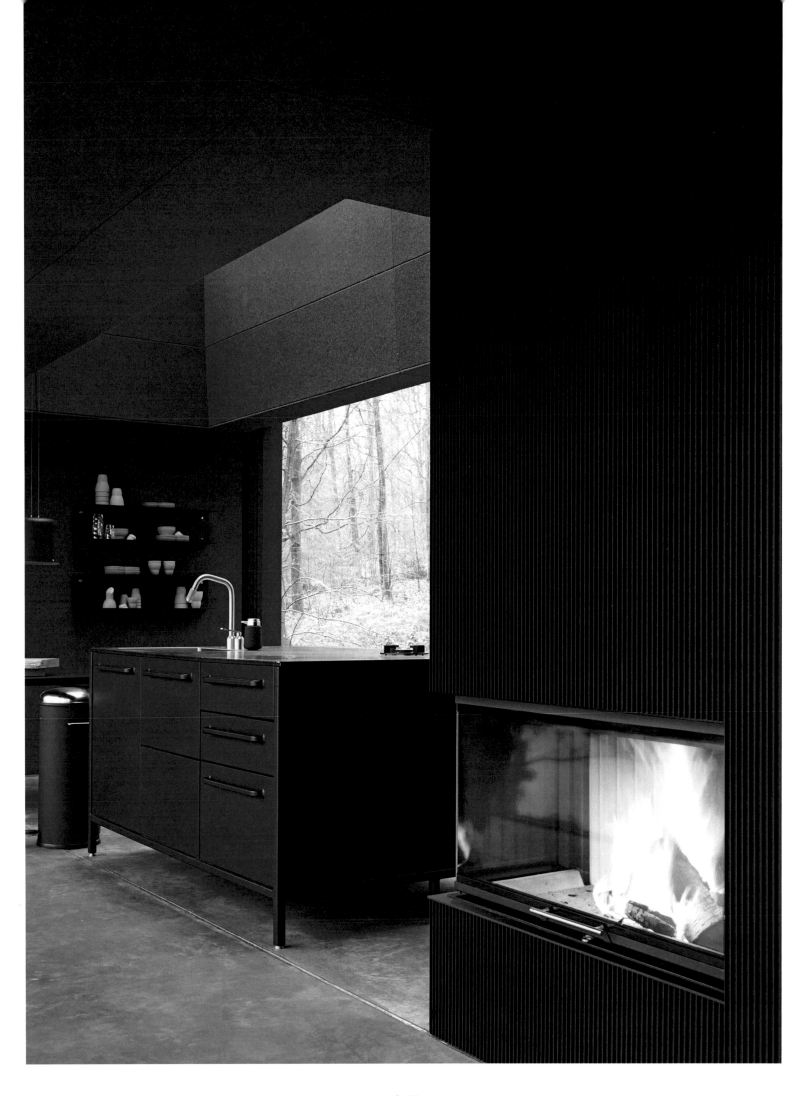

SKY LIGHT

TOMEK MICHALSKI

In a Polish forest shrouded in mist,
a vision for a sculpted cabin rises out of
a designer's imagination.

A break in a lush forest reveals a clearing where deer come to graze—an optimal setting for a woodland cabin. This imagined project manifests as a welcome respite from city life. Keeping in close contact with the forest's flora and fauna, the retreat rises out of the cold, misty surrounds as a beacon that attracts explorers from afar. The alluring angled planes of the dark exterior promise a warm and bright internal haven. Limiting human influence on nature as much as possible, the cabin lifts off of the gently sloping site. The light raw plywood interior sets up a striking contrast with the stealth exterior. Inside, parties of up to three may gather in the main living space framed by books and forest or ascend to an upper sleeping area to rest with their head in the clouds. Gracious floor-to-ceiling windows and a monumental triangular skylight let nature become an ethereal form of enclosure. These large apertures cast a warm glow out into the woods in the evening. •

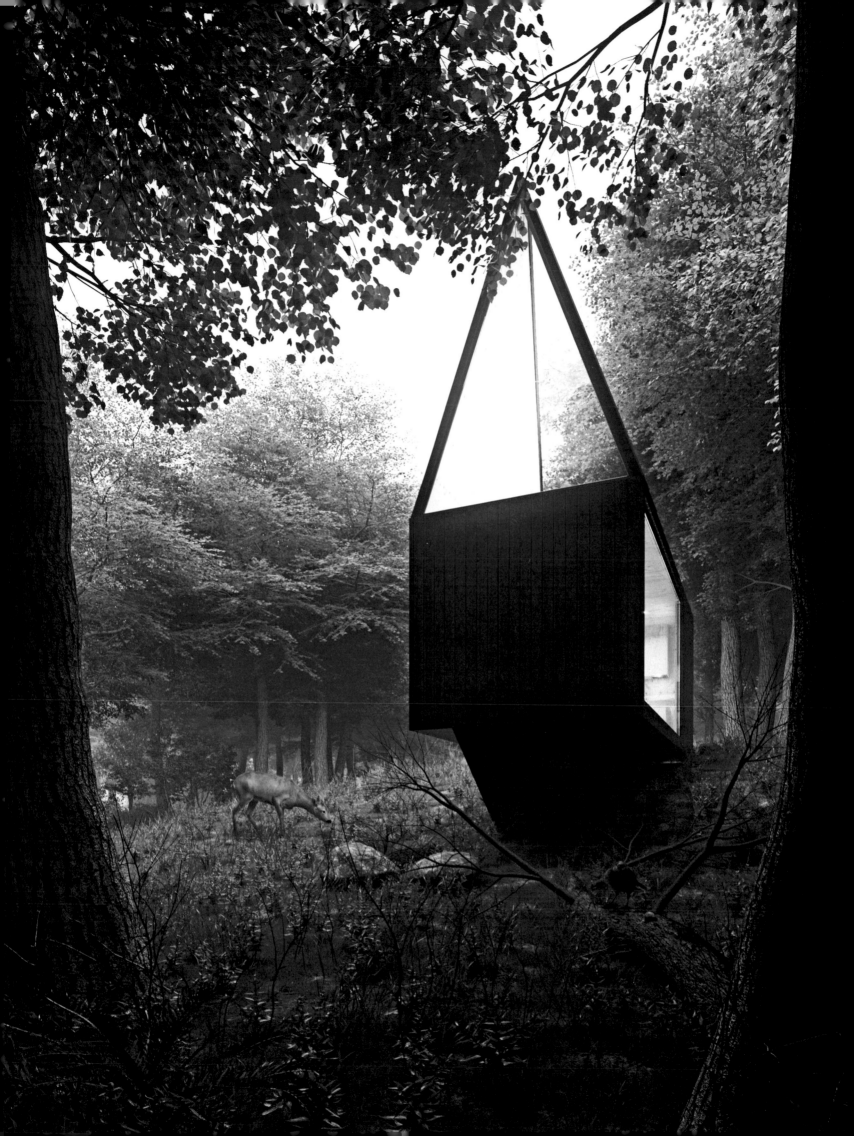

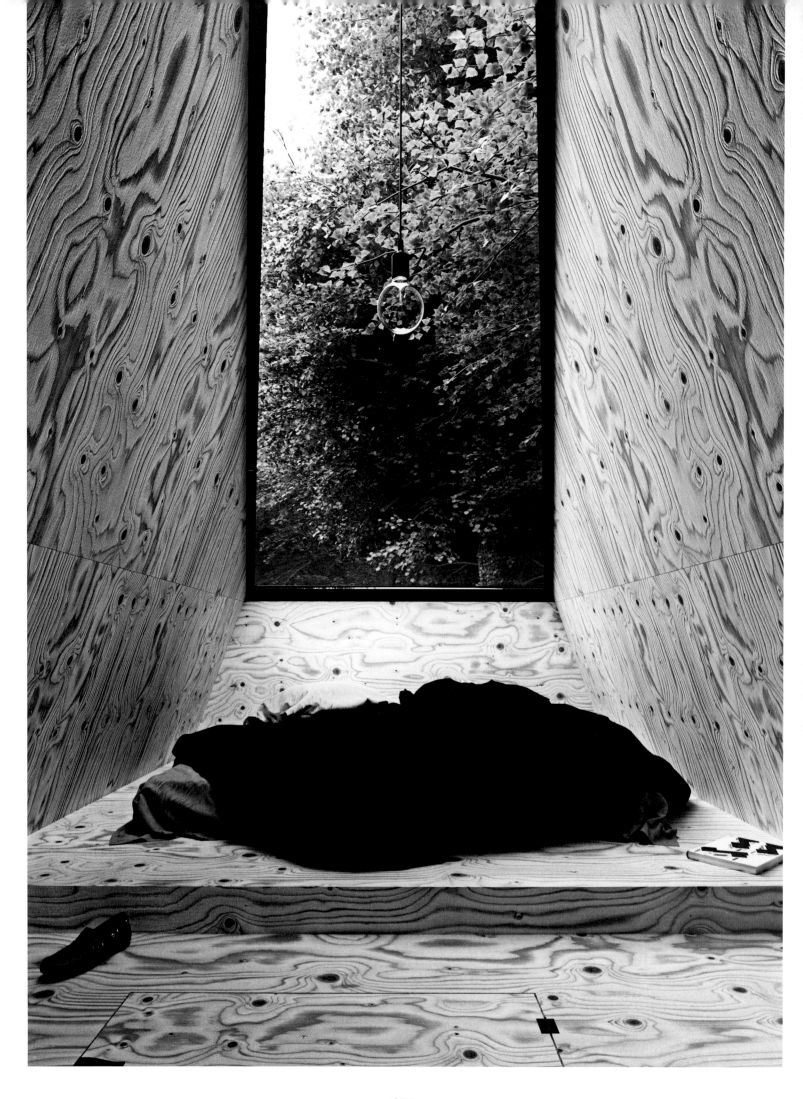

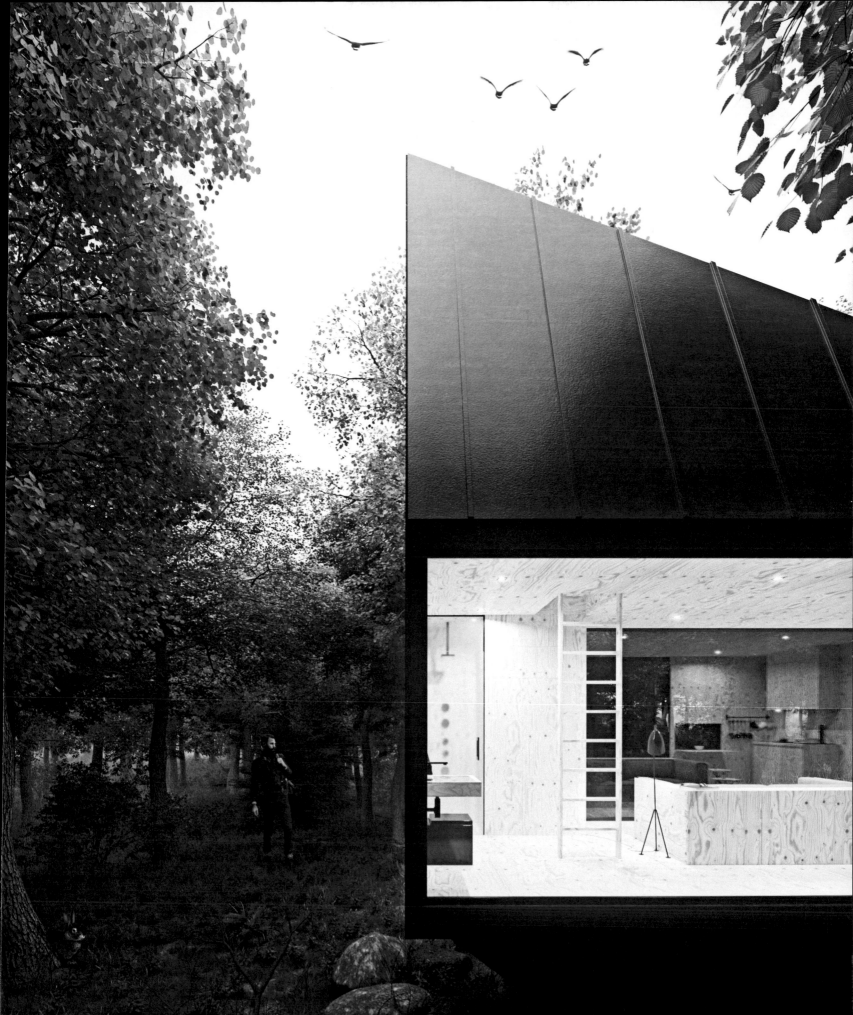

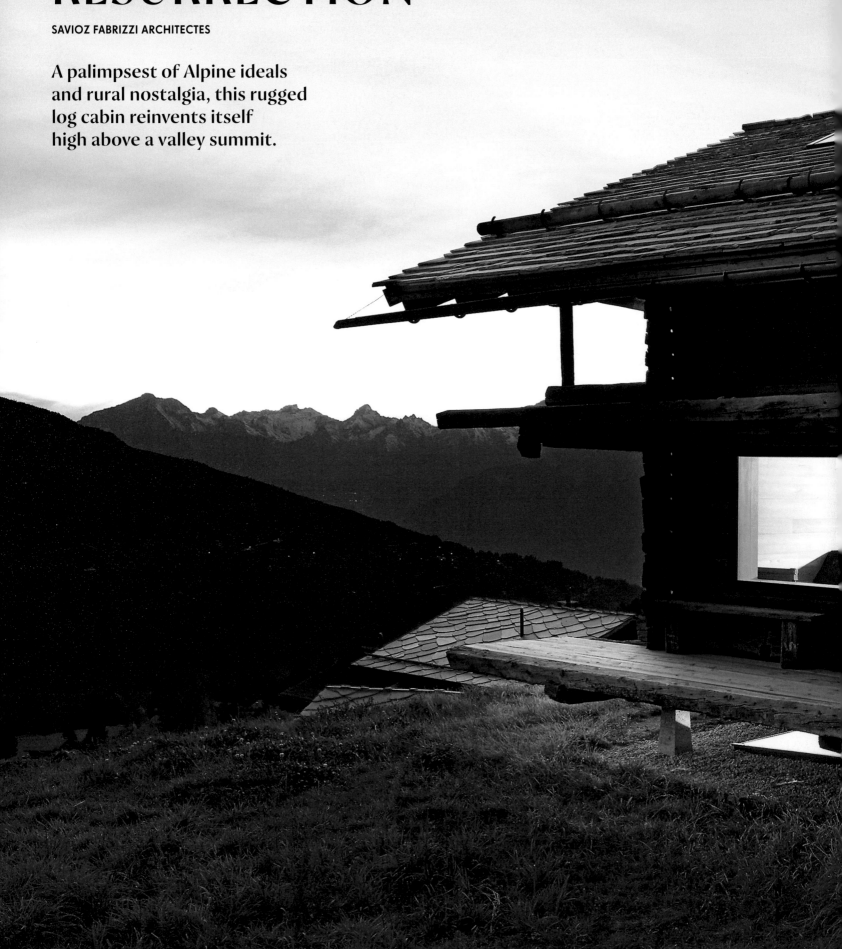

– Valais, Switzerland –

RUSTIC RESURRECTION

SAVIOZ FABRIZZI ARCHITECTES

A palimpsest of Alpine ideals
and rural nostalgia, this rugged
log cabin reinvents itself
high above a valley summit.

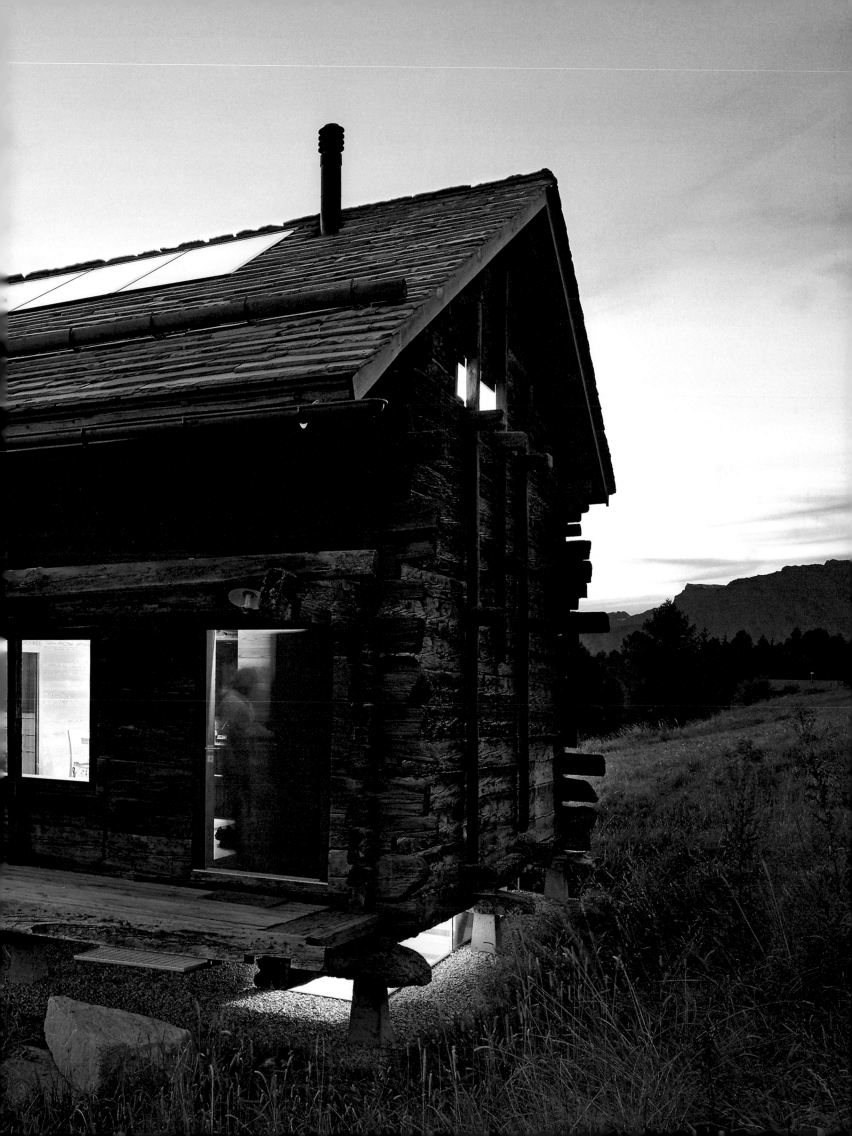

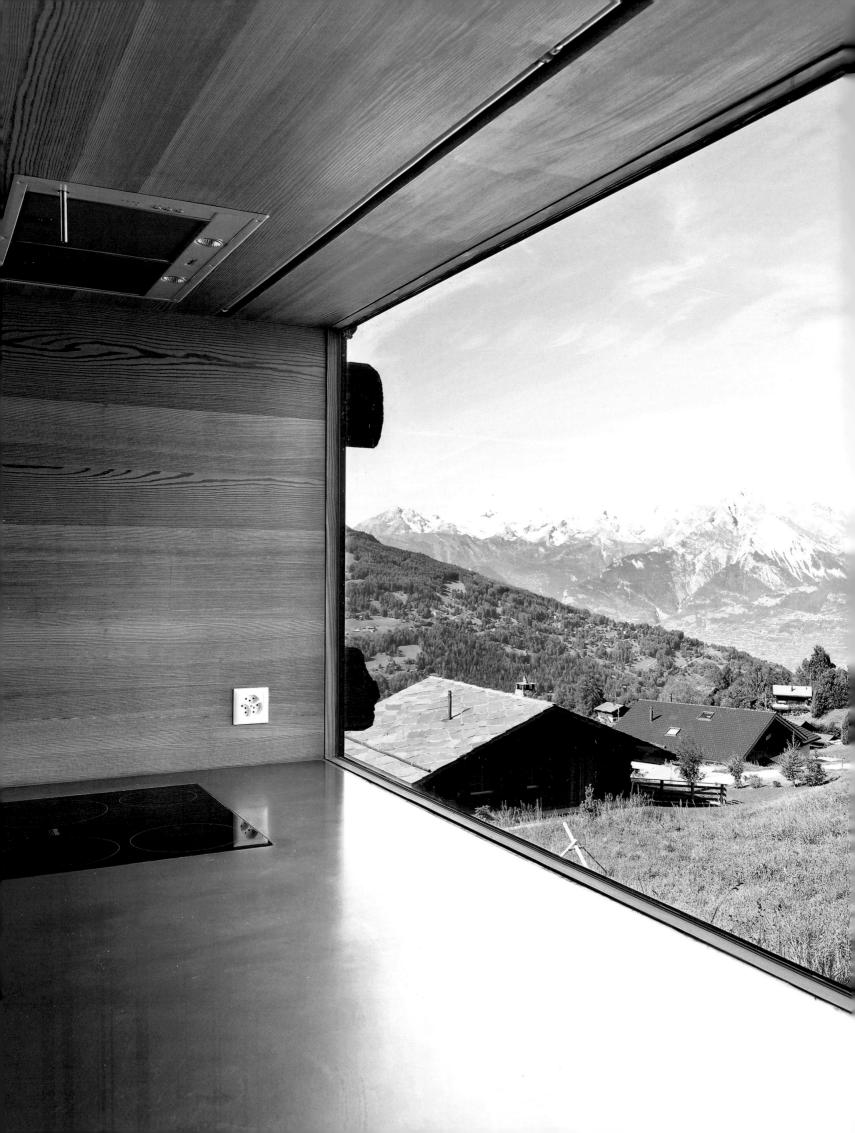

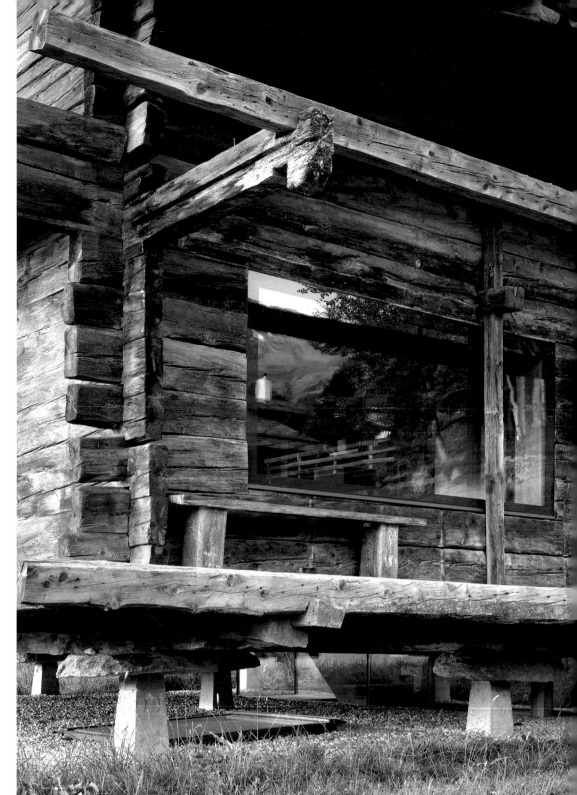

> ## "The flush windows and their dark frames disappear into the timber façades."

Saved from demolition and lovingly repurposed, an unused granary in the Swiss Alps enjoys its second life as a second home. The thoughtful renovation retains the dimensions of the original structure, safeguarding its essential character while adding needed updates. Aside from floating the cabin off the ground on elevated foundations to add an underground games room, the exterior's rustic vernacular remains largely untouched. The two-story pitched roof structure includes covered balconies and porches that revel in prime Alpine vistas. Several large windows punctuate the weathered façade, framing new connections to the picturesque landscape from the shared spaces below and bedrooms above. The flush windows and their dark frames disappear into the timber façades. This historic shell leads to a completely updated interior. Clad in larch, the contemporary interior enjoys a refreshing simplicity unencumbered by the weight of time. ◆

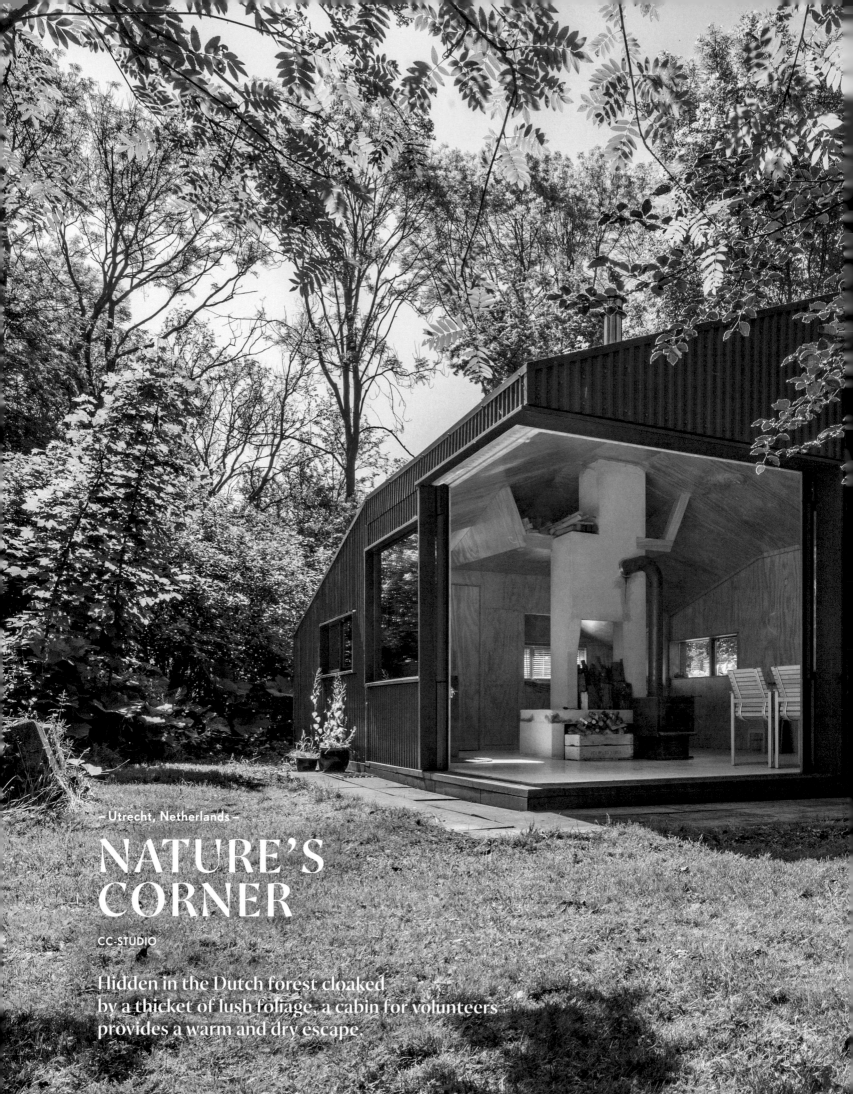

– Utrecht, Netherlands –

NATURE'S CORNER

CC-STUDIO

Hidden in the Dutch forest cloaked
by a thicket of lush foliage, a cabin for volunteers
provides a warm and dry escape.

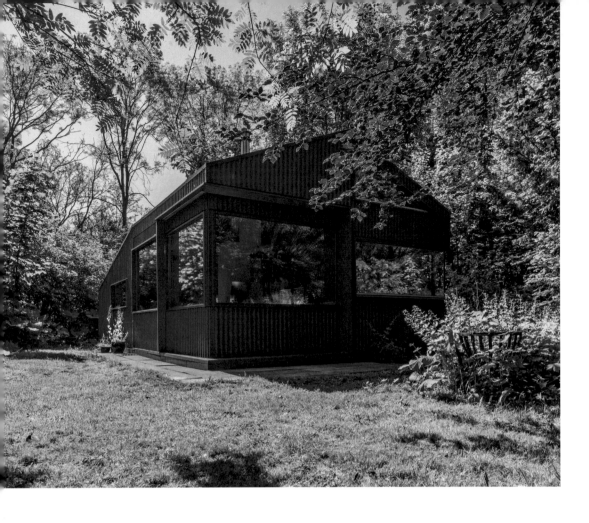

"Subtly sculptural, the cabin's presence in the clearing only reveals itself at the very last moment."

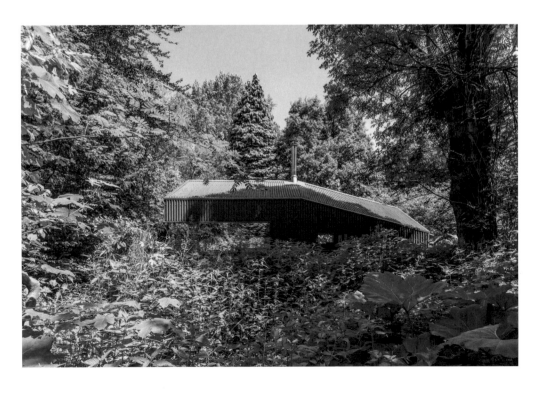

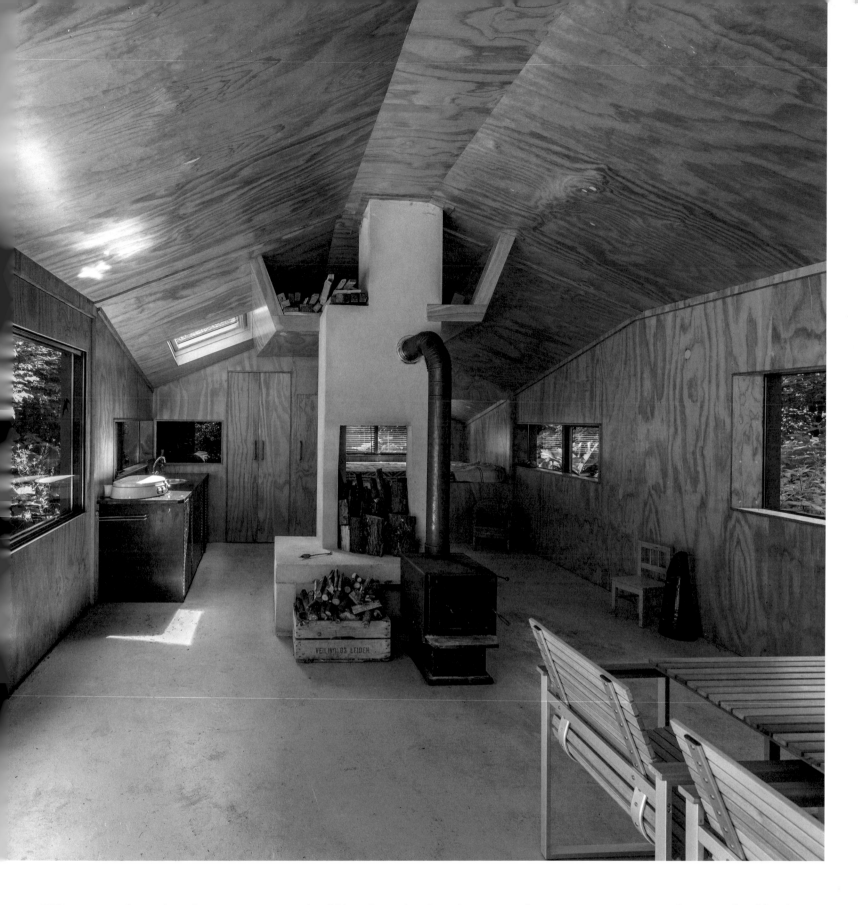

Discreetly sited on the sweeping grounds of Noorderpark in the Netherlands, this cabin for local volunteers embodies the infectious spirit of summertime. The forest-green structure blends into the verdant scenery in an act of deft country camouflage. Elegant but rudimentary, the volunteer shelter keeps life off the grid. With no running water or electricity, visitors must rely on local firewood to fuel the kitchen and fireplace. This sculptural hearth forms the heart of the cabin. The hearth supports the protective yet open roof canopy that bleeds into the surrounding flora. Designed with the image of Thoreau at his cabin on the lake in mind, the shelter compliments the pastoral grace of the park. Subtly sculptural, the cabin's presence in the clearing only reveals itself at the very last moment. Two large sliding doors erase the entire corner of the building, stretching the interior into the green meadow where the sheep graze to keep the young trees at bay.

◆

INDEX A-Z

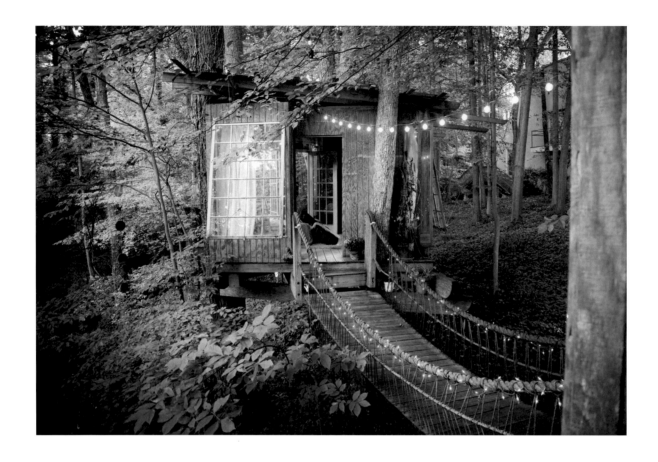

THE
HINTERLAND

CABINS, LOVE SHACKS
AND OTHER HIDE-OUTS

This book was conceived, edited,
and designed by Gestalten.

Edited by Sven Ehmann and Robert Klanten

Preface and profiles by Tom Morris
Project texts by Sofia Borges

Editorial management by Sina Kernstock
Editorial support by Sofia Borges and Caroline Kurze
Text edited by Noelia Hobeika
Proofreading by Felix Lennert

Creative Direction Design by Ludwig Wendt
Cover by Ludwig Wendt
Design and Layout by Sarah Peth
Typefaces: Proza Display by Jasper de Waard and
Super Grotesk by Svend Smital

Cover photography by Tomek Michalski
Back cover photography by Faruk Pinjo (top left),
Half Cut Tea (top right), Matthieu Salvaing (middle left),
Espen Folgerø (middle right), Relja Ivanić (bottom left),
Marcello Mariana (bottom right)

Printed by Nino Druck GmbH, Neustadt / Weinstraße
Made in Germany

Published by Gestalten, Berlin 2016
ISBN 978-3-89955-663-6
© Die Gestalten Verlag GmbH & Co. KG,
Berlin 2016

For more information, please visit www.gestalten.com.

Bibliographic information published by the Deutsche
Nationalbibliothek.
The Deutsche Nationalbibliothek lists this publication
in the Deutsche Nationalbibliografie;
detailed bibliographic data are available online at
http://dnb.d-nb.de.

This book was printed on paper certified according to
the standards of the FSC®.